A Century of American Printmaking, 1880–1980

American

James Watrous

Printmaking

A Century of American Printmaking 1880–1980

The University of Wisconsin Press

Published 1984

The University of Wisconsin Press
114 North Murray Street
Madison, Wisconsin 53715

The University of Wisconsin Press, Ltd.
1 Gower Street
London WC1E 6HA, England

First printing

Printed in the United States of America

For LC CIP information see the colophon

ISBN 0-299-09680-7

Contents

Acknowledgments

A recounting of one hundred years of American printmaking was first proposed more than a decade ago by students whose interest in the art led to frequent queries about the printmakers and the circumstances surrounding the creation of prints in the United States. I am grateful, therefore, to former students who urged the writing of this story.

Support for the research and writing also came from other quarters. Members of the Brittingham family, through the Brittingham Fund, Inc., have been generous benefactors for many special projects in art and music at the University of Wisconsin. A subvention from the Brittingham University of Wisconsin Trust allowed the author to locate and examine original impressions of prints in museums and private collections across the country, supplement the resources of the Kohler Art Library with books, periodicals, and exhibition catalogues, add to the collection of American prints in the Elvehjem Museum of Art, and acquire photographs that illustrate this book.

Curators and staff members of museums, private collections, galleries, and workshops offered many courtesies. I am grateful to Stephen B. Andrus, Director, Impressions Workshop and Gallery, Boston; Peter Briggs, Registrar, University Art Museum, University of New Mexico; Victor Carlson, Curator of Prints and Drawings, Baltimore Museum of Art; Sylvan Cole, Jr., Director, and Susan Teller, Director of Publications, Associated American Artists, New York; Verna P. Curtis, Associate Curator, and Terrence Marvel, Archivist, Milwaukee Art Museum; Janet S. Ela, Curator of Collections, and Robert Schroeder, Registrar, Madison Art Center; Ebria Feinblatt, Senior Curator of Prints and Drawings, Los Angeles County Museum of Art; Janet A. Flint, Curator of Graphic Art, and Martina Norelli, Assistant Curator, National Museum of American Art, Smithsonian Institution; Lucinda H. Gedeon, Assistant to the Director, Grunwald Center for the Graphic Arts, University of California, Los Angeles; Bill Goldston, President, Universal Limited Art Editions, West Islip, Long Island; Charles Helsell, Curator, University Gallery, University of Minnesota, Minneapolis; Sinclair H. Hitchings, Keeper of Prints, Boston Public Library; Robert Flynn Johnson, Curator in Charge, and Judith Eurich, Curatorial Assistant, Achenbach Foundation for Graphic Arts, San Francisco; Evelyn Klebanoff, Assistant Registrar, and Elizabeth de Fato, Librarian, Seattle Art Museum; Ellen S. Jacobowitz, Acting Curator of Prints and Drawings, and Sarah McNear, Curatorial Assistant, Philadelphia Museum of Art; Professor Arnold Lewis, College of Wooster; Joann Moser, Curator of Collections, University of Iowa Museum of Art; Sue W. Reed, Assistant Curator of Prints and Drawings, Museum of Fine Arts, Boston; Louise S. Richards, Chief Curator of Prints and Drawings, and Jane Glaubinger, Assistant Curator, Cleveland Museum of Art; Kristin L. Spangenberg, Curator of Prints, Drawings and Photographs, Cincinnati Art Museum; Esther Sparks, Associate Curator of Prints and Drawings, Art Institute of Chicago; Wendy Weitman, Curatorial Assistant, Museum of Modern Art, New York; Harvey West, Director, and Chris Bruce, Curator of Collections, Henry Art Gallery, University of Washington.

Colleagues and friends at the University of Wisconsin gave valuable assistance. Louise K. Henning, Librarian at the Kohler Art Library, found answers to many obscure, and sometimes puzzling, references. Arthur O. Hove, author and Assistant to the Chancellor, read early drafts of the manuscript and suggested pertinent revisions. Lisa Calden, Registrar, and Timothy Quigley, Print Room Assistant,

at the Elvehjem Museum of Art responded graciously to many requests to examine prints and verify documentations.

At the University of Wisconsin Press I am especially indebted to Elizabeth Steinberg, Chief Editor, Peter J. Givler, Acquisitions Editor, and William Day, Assistant Editor, and grateful for the selection of Jocelyn Riley as editor of the manuscript and Richard Hendel as the designer of the book. Publication began during the tenure of Thompson Webb, Jr., director of the press, who, for the second time, lent enthusiastic support for a book by the author, a commitment continued by his successor Allen Fitchen.

And finally, I am grateful to Peg Watrous, whose unfailing encouragement was given to this and many other kinds of artistic ventures undertaken during more than half a century.

Foreword

The art of printmaking—spawned from six centuries of European-American traditions—is flourishing in America. Printmaking is a vigorous artistic enterprise in which creative compositions of artist-printmakers are converted, through the processes of printing, into multiple impressions, each accepted as an original work of art. In recent years, contemporary American prints—with their evocative content, elaborate illusions, and bold chromatic array—have stimulated more public interest and critical notice than sculpture while often rivaling painting in conceptual originality, technical innovation, and lushness of visual and tactile display. The seminal character of contemporary printmaking has lured an astonishing number of artists into the practice of the art, whetted the acquisitive appetites of private collectors and museum curators, and provided the incentives for a host of proprietary workshops of master-printers and countless contracts for the printing of limited editions, which are then published by dealers or other entrepreneurs of the marketplace.

The current prominence of American prints, in the frequency of their creation, exhibition, and exchange in commerce, reflects the emergence of printmaking from the consignments of the past as a lesser art. Prints had been a province of the arts in which the works of talented, but scarcely known, career printmakers were supplemented by the scatter of fine prints created by distinguished painters, whose printmaking was often viewed as graphic digressions incidental to their major artistic accomplishments. The rich diversity of contemporary prints in style, content, scale, chromatics, materials, and processes has erased other assumptions of the past. Printmaking had been considered an art of small works, of strictly graphic transcriptions and expressions, and of a finesse in execution consonant with traditional media and nuances

of black-and-white printing—features which in the best and most brilliant impressions were acknowledged as visually handsome and aesthetically gratifying but relished, for the most part, by print collectors, curators, and dealers who had a cultivated appreciation of the delicious subtleties of the art.

During the nineteenth century, the United States had an abundant production of another kind of print—the facsimiles made by artisans hired, directly or indirectly, by printing establishments and publishing houses. Those prints, with their commercial purposes, were used as illustrations. The artisans, using wood-engraving, metal-engraving, and lithography, replicated the works of European and American master-painters and the hundreds of thousands of original drawings and paintings by American illustrators and commercial artists. Although the commonplace facsimile prints of commerce were often inept in craftsmanship, exceptional replications by highly skilled artisans translated superbly the tones and textures found in the original masterpieces or the linear succinctness in drawings by the best illustrators of American life and topical events. The facsimiles were graphic accompaniments and, when well printed, enrichments to advertisements, books, and articles in newspapers and magazines. Others were assembled in elegant pictorial albums or published as single-sheet "works of art." Many of the old facsimile prints command our admiration as relics of virtuoso craftsmanship, as documentations of historical events and architectural and geographical landmarks, or as descriptions of an earlier Americana.

Meanwhile, in contrast to the preponderant tradition of facsimile printmaking, the creation of original prints as fine art occurred haphazardly before the last quarter of the nineteenth century, typified by the occasional landscape lithographs of excellent painters, such as Thomas

Cole and Thomas Moran, or the etchings of George Loring Brown. Then, with surprising suddenness in the 1870s and 1880s, an urge to create prints as an art of artists became irresistible to a notable number of Americans. They made enthusiastic commitments to the arts of original etching and wood-engraving and, with equal fervor, sought to join the mainstream of printmaking as it was exemplified by the fine art of European *peintre-graveur*. The exuberance with which the artists created prints and organized professional etching and wood-engraving societies, coupled with the staunch support of their ventures by American dealers, publishers, and critics, generated high expectations for printmaking as a fine art in this country. "Original" was the symbolic word which affirmed that a print was not the work of a craftsman who was an artisan only but was a composition created by an artist who also was a printmaker. The designation "original" was intentional and frequent in exhibition catalogues, critical reviews, the sales lists of print dealers, and the published portfolios of prints created by artist-etchers and wood-engravers. Moreover, some of the artists made the point as apparent as possible by inscribing "original" or "inv[enit]" within their compositions when they etched the plates or cut the blocks.

The mounting values now placed on prints which were created in the late nineteenth century and later, the thriving state of contemporary printmaking, and the lavish features of modern prints that are inducements to current collectors have all deepened the interests and compounded the queries about American prints, their creators, and the historical evolvement of printmaking in the United States. An ample response to those interests, and answers to many questions they evoke, must await new art-historical chronicles—each, in its own way, telling the story of a century filled with artistic ventures and concurrent events that influenced the course and character of printmaking in this country. The tracing of the story has so far received scant attention from American art historians, who have left the studies and writings about printmaking to a small circle of print curators, dealers, and younger scholars whose research and insights have been published in essays in print exhibition catalogues, articles for museum bulletins and professional journals, or in monographs, *catalogues raisonnés*, and doctoral dissertations devoted to works created by a few artist-printmakers.

During the late decades of the nineteenth century, America became the beneficiary of the first concerted and sustained effort of artists and sponsors who, in both statements and ventures, were explicit about their quest for an art of quality that would rival the printmaking of Europe. Because the mission was a fresh beginning, the following story starts with the events of a hundred years ago. It ends, after a century of creative printmaking had passed, with the often-dazzling displays of the 1970s. For such a chronicle to be informative about prints, personalities, and events at the same time that it recounts the continuity of developments during ten decades, it must be selective in its telling. This story, therefore, includes historical references, data, quotations, and anecdotes that are germane to a tale of prints and printmakers, of individuals who played supportive roles as dealers, publishers, curators, collectors, and critics, of art institutions, clubs, and printmaking workshops, of crucial events and influencing innovations—and most important—of the ways in which they affected the emergence and subsequent changes in the art during a century of American printmaking from 1880 to 1980.

A Century of American Printmaking, 1880–1980

I

Entering the Mainstream of Printmaking

Peintre-graveur and the American artist-etchers

The fine art of printmaking flourished in Europe from the fifteenth century forward. In the late nineteenth century the artistic tradition was adopted wholeheartedly by a cluster of American artists who enthusiastically embraced the art of etching. They were supported in their creative efforts by American print dealers and collectors who were already indulging their tastes for prints by European masters.

The American artists who became printmakers during those decades were aware of the renewal of the art of etching in Europe and also mindful of the ease with which etching allowed visions of landscape and cityscape to be transcribed, and then converted, into handsome prints. Moreover, their printmaking ventures were encouraged by the prospect that they might qualify as fellow participants in a nineteenth-century revival of etching within the European tradition of *peintre-graveur* (the artist as printmaker). The renewal of interest in etching had been initiated and sustained from the middle years of the century to its end by French artists who were fine etchers. In France, and then England, splendid prints created in the medium became honored, and as American artists developed their skills in etching, and sought to join the mainstream of the movement, they were exhilarated by the thought of sharing in the artistic adventure.

The revival of the art of etching in France had received its early impetus from several of the artists whose genre and landscape paintings are now known as the art of the "Barbizon School." Théodore Rousseau, who was one of the first to discover the charming environment around Barbizon, created a few fine etchings. But more important, Charles-Émile Jacque, who etched numerous images of peasant life in the surrounding countryside, dedicated his career to the art of printmaking. From 1830 onward, Jacque created a succession of appealing genre and landscape prints (fig. 1.1) that made him a leader of the revival whose etchings were ardently sought by American print collectors for their portfolios. The painter Charles-François Daubigny also was attracted to the medium (fig. 1.2) and, by the 1850s, had created splendidly etched visions of nature, calm and benign, in landscapes with genre figures. Another French master, whose paintings and prints were to be purchased eagerly by Americans, also made his contributions to the trend. Jean-François Millet etched a score of peasant and landscape subjects (fig. 1.3) which, in their simple, earthy conceptions and heavy figures, were counterparts of his celebrated paintings.

As the interest in etching spread among artists and an appreciation of the creations of one or another painter-etcher mounted, younger French, and then English, masters made their appearance. The prints of Maxime Lalanne (fig. 1.4) and Charles Meryon (fig. 1.5), with their striking images and evocative views of Paris and other great cities, set standards of excellence by which later generations of British and American etchers were to judge the qualities of their architectural vignettes and urban panoramas. Along with the influential prints of the French, the superb cityscapes and landscapes by James A. M. Whistler, the expatriate American in England, and by Dr. Francis Seymour Haden were to provide inspiration for young American etchers. Certainly the approbation in Europe of an art of prints by artists and the attractions of etching with which personalized styles were autographically transcribed when drawing with the needle encouraged American artist-etchers to emulate French and English models.

By the late 1870s and early 1880s,

1.1
Charles-Émile Jacque
*Swine Herd, Watched by a Maiden
Holding a Staff*
Etching (1868) 7⁵⁄₁₆ × 9½
*Minneapolis Institute of Arts. Ladd
Collection.*

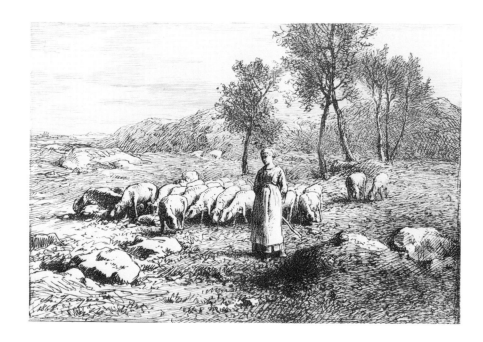

1.2
Charles-François Daubigny
Le bac de Bezons (The Ferry at Bezons)
Etching (1850) 4½ × 7⁷⁄₁₆
*Minneapolis Institute of Arts. Ladd
Collection.*

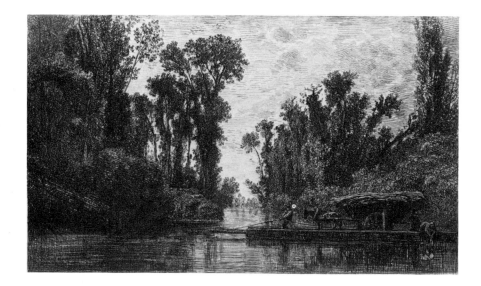

1.3
Jean-François Millet
La grande bergère (The Shepherdess Knitting)
Etching (1862) 12⅝ × 9⁵⁄₁₆
An impression of the print was lent by Samuel P. Avery of New York for the first important exhibition of etchings in the United States, organized by the Museum of Fine Arts, Boston (January 1879).
Minneapolis Institute of Arts. Ladd Collection.

1.4
Maxime Lalanne
Démolitions pour le percement de la rue des Écoles
Etching (1865) 8¼ × 12¼
Published by the Société des Aquafortistes (December 1865).
Minneapolis Institute of Arts. Dunwoody Fund.

1.5
Charles Meryon
Tourelle de la rue de la Tixéranderie
Etching (1852) 9¾ × 5¼
An impression of the print was shown in the
first important exhibition of etchings in the
United States, organized by the Museum of
Fine Arts, Boston (January 1879).
Minneapolis Institute of Arts. Dunwoody
Fund.

the shared interests of the American printmakers led them to organize etching clubs and societies. Those leagues were formed a decade after a curious and abortive effort of the kind had been attempted in New York by a visiting Frenchman, Alfred Cadart.

In 1862, Cadart, the Parisian dealer, editor, and publisher of prints, had collaborated with French printmakers in founding La Société des Aquafortistes. For a decade and a half the Société was successful in publishing and selling fine prints, among them Maxime Lalanne's *Démolitions pour le percement de la rue des Écoles* (fig. 1.4). Cadart, who envisioned similar societies in other countries, arrived in New York in 1866 with a cargo of French paintings, prints, and etching supplies. It may never be known how many prints published by the Société were sold by Cadart to American collectors. One probable purchase, however, was Adolphe Martial's *Siège de la Société des Aquafortistes* (fig. 1.6), a view of the headquarters in Paris. This etching later received the dealer's stamp of Edward G. Kennedy and, in 1904, was presented to the Grolier Club by William F. Havemeyer. During his brief stay, Cadart promoted a "French Etching Club" in order to introduce the practice of the medium, and probably also to sell his supplies. That must have been the attraction for John M. Falconer and J. Foxcroft Cole to attend and accept the advice of Cadart, an entrepreneur who was himself an etcher of modest talent.[1] Among his several promotions, Cadart sought to encourage the establishment of etching clubs in New York, Boston, and Philadelphia which would lead to "une vaste Société d'Aquafortiste sur le territoire fédéral," linked in an artistic confraternity with the French.[2]

The emergence of etching clubs in America occurred eleven years later, but not under the auspices of Cadart. The name did not appear again

1.6
Adolphe Martial
Siège de la Société des Aquafortistes
Etching (1864/1865) 9⅞ × 14¹³⁄₁₆
Courtesy of Christie's, New York.

until 1885 when Sylvester Rosa Koehler of Boston, the energetic advocate of fine prints, published advice to American printmakers—who were having difficulties in acquiring good etching presses—that they might import the fine presses furnished by Cadart's widow, at 56 Boulevard Haussman in Paris.[3]

Conditions had changed by the late 1870s and the founding of etching associations began in earnest. In 1877, during a meeting at the studio of James D. Smillie, the New York Etching Club was launched.[4] Smillie, one of two principal organizers, became a printmaker of regional landscapes from Eastern Pennsylvania and the Hudson River Valley to *Marble Head Neck* and *Old Cedars—Coast of Maine* (fig. 1.7). Other artists, in the early complement of over twenty etchers in the club, included J. C. Nicoll, Henry Farrer, R. Swain Gifford, and Samuel Colman. Colman succinctly stated justification for joining, "When the New York Etching Club was founded, in 1877, and its members came into possession of presses of their own, I took it up [etching] with new zest."[5]

In rapid succession etching clubs were established in other cities: the Etchers Club in Cincinnati in 1879;

the Philadelphia Society of Etchers and the Boston Etching Club in 1880. The Brooklyn Etching Club, founded in 1881, was of a different kind since it published etchings for its collector-members and sold limited editions of the prints it sponsored. The following year, however, the Brooklyn Scratchers Club was organized for professional artists only.[6]

Meanwhile, American printmakers had ample opportunity to view works by English and French etchers in the galleries of New York print dealers and the holdings of private collectors who had been acquiring prints by Whistler, Haden, Millet, Meryon, Jacque, and Lalanne. Whistler and Haden were bitter rivals in etching and personally incompatible as well, although they were stepbrothers-in-law. Both artists would have direct influence on American etchers through events of the early 1880s.[7]

Haden was a leader in the Provisional Council that founded the So-

1.7
James D. Smillie
Old Cedars—Coast of Maine
Etching (1880) 5 × 7
Original impressions of the etching were bound among the pages of Sylvester R. Koehler's American Art Review *(1880), and the etching was shown in the Exhibition of American Etchings, organized by the Museum of Fine Arts (Boston, 1881). Museum of Fine Arts, Boston. Gift of the American Art Review.*

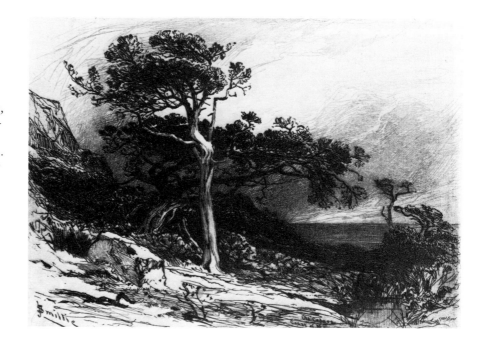

ciety of Painter-Etchers (London) in 1880.[8] In anticipation of the society's first exhibition in 1881, artist-etchers of several countries were invited to submit works to the jury. In response, a substantial number of American etchers accepted the challenge to test their talents in an international competition.

Concurrently, a few Americans, nicknamed "Duveneck's Boys" because their mentor was the American painter Frank Duveneck, were in Venice creating prints of the picturesque canals, quays, and architecture.[9] They received encouragement from Whistler who was etching the city and lagoons on commission from the Fine Art Society (London). When the exhibition of the Society of Painter-Etchers was announced, Whistler wrote an admonishment to one of the "boys," Otto Bacher. "Don't dream of it, my dear Bacher!—The Society of Painter-Etchers is already ridiculous and I intend that it shall die the death of the absurd. So just 'wait a bit'—and send nothing to this Seymour Haden game. . . ."[10] However, Bacher had already submitted seventeen prints to the jury and his *Fon-*

damenta della Zattere (fig. 1.8) was designated a "diploma" print, the requisite for election as a Fellow in the Society.

At the same time, three etchings by Duveneck, including *The Riva degli Schiavoni* (fig. 1.9), were submitted to the exhibition, unbeknownst to the artist. The prints were attributed, mistakenly, to Whistler by the jurors Haden and Alfonse Legros who had unfounded suspicions that the monograms on the etchings [𝔅] and the unknown name, Duveneck, was another trick perpetrated by Whistler who was well known for his eccentric and often outrageous behavior.[11]

When the exhibition was assembled at the Hanover Gallery, Haden wrote to the New York art auctioneer, collector, and benefactor, Samuel Putnam Avery,

38 Hertford Street, May Fair, W 1, March 30
My dear Mr. Avery,—I do not wait for its opening to ask you to find some means of conveying to the American etchers our sense of the excellence and number of their contributions to the exhibition (now all hung) of the painter-etchers. We have, I assure you, been

fairly taken aback by the quality of the works, no less than by the promptitude and spirit with which our invitation has been responded to by our brothers on your side of the water.[12]

Furthermore, an encouraging number of Americans were elected Fellows in the Society. In 1881, Otto Bacher, Albert Bellows, F. S. Church, Frank Duveneck, John M. Falconer, Henry Farrer, Swain Gifford, James D. Smillie, Stephen Parrish, Thomas Moran, and Mary Nimmo Moran received their "diplomas" and, in 1882, Joseph Pennell, Charles A. Platt, and Kruseman van Elten became Fellows when they were among the Americans who displayed prints in the second exhibition of the Painter-Etchers at the rooms of the Fine Art Society.[13]

During the exhibition of 1881, Mary Nimmo Moran—for years the only woman member of the New York Etching Club—received a "diploma" for *A Goose Pond* (fig. 1.10) and was elected a Fellow in the Society.[14] A Scot by birth, she evoked the varied humors of her adopted land by the scudding clouds behind the windmill of *A Goose Pond* or by lending a Burnsian sensibil-

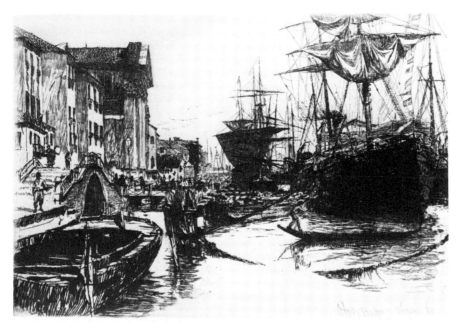

1.8
Otto H. Bacher
Fondamenta della Zattere
Etching (1880) 7⅛ × 10½
Shown in the first exhibition of the Society of Painter-Etchers (London, 1881) and designated a "diploma" print, requisite for election as a Fellow in the Society.
Toledo Museum of Art.

ity to place and time in *'Tween the Gloamin' and the Mirk, When the Kye Come' Hame* (fig. 1.11). Both prints were created near the Morans' studio and seasonal home at East Hampton, Long Island.[15]

Other events were to link Haden and Whistler with the American artist-etchers and with dealers, collectors, critics, and the public in the United States. Haden received invitations to visit this country in 1882–1883 and a touring exhibition of Whistler's etchings was presented in three major cities during 1883–1884.

Haden's reputation had preceded his visit. At the United States International Exhibition of 1876, assembled in the centennial year of the American Declaration of Independence, he displayed two etchings. One was the *Breaking Up of the Agamemnon* (fig. 1.12), which depicted the old wooden man-of-war in its last berth at Deptford with the sun declining toward the Thames River horizon near Sir Christopher Wren's twin domes of the Royal Naval College at Greenwich. It was one of Haden's larger and most sentimental etchings. In 1879, over

forty of his prints, including the *Agamemnon*, were featured in the landmark exhibition of etchings organized by the Museum of Fine Arts, Boston, and in the following year American readers were informed of Haden's achievements by *Scribner's Monthly* in a lengthy article by the noted English editor, author, critic, and sometime etcher, Philip Gilbert Hamerton, illustrated by *Kilgaren Castle* (fig. 1.13) and other Haden etchings from the collection of Samuel Putnam Avery of New York.[16]

In reporting the anticipated arrival of Haden, the American correspondent for the *Magazine of Art* (London) used the occasion to commend the works of the American artist-etchers. "The expected visit of Mr. Seymour Haden to the United States, and his lectures on etching, will doubtless have the effect of attracting renewed attention to the subject. The progress which has been made in etching on this side of the Atlantic is such as to justify the belief that the American etchers will take a highly creditable position among the practitioners of the art."[17]

Haden arrived in New York City aboard the *Germania* on 4 November 1882 and, shortly thereafter, was honored with a reception and dinner at the Lotos Club where remarks in praise of the Englishman were presented by Whitelaw Reid, president of the club, distinguished journalist, and future ambassador to the Court of Saint James. Among the special guests were the promising American etchers Kruseman van Elten, Mary Nimmo Moran, and her husband Thomas Moran. The three listened to Haden's reply which extolled the tradition of *peintre-graveur* and, during the evening, had the pleasure of viewing over fifty of his etchings. The prints had been lent for display in one of the club's parlors by Frederick Keppel, the New York dealer and individual most responsible for Haden's visit to the United States.[18] Haden's lecture tour took him to New York, Boston, Philadelphia, Cincinnati, Chicago, and Detroit. In December, when the fledgling Philadelphia Society of Etchers presented its first exhibition, at the Pennsylvania Academy of the Fine Arts, he was the guest at a reception arranged by

1.9
Frank Duveneck
The Riva degli Schiavoni
Etching (1880) 13⅛ × 8⅝
Shown in the first exhibition of the Society of Painter-Etchers (London, 1881) and in the retrospective exhibitions, Americans at Home and Abroad: Graphic Arts, 1855–1975, at the Elvehjem Museum of Art (1976), and The Print in the United States from the Eighteenth Century to the Present, at the National Museum of American Art (1981).
Elvehjem Museum of Art. Humanistic Foundation.

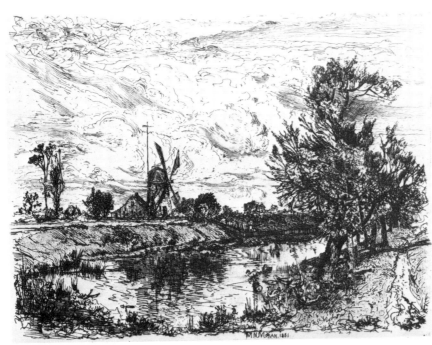

1.10
Mary Nimmo Moran
A Goose Pond
Etching (1881) 7¹⁄₁₆ × 9¹⁄₁₆
The "diploma" print for Mrs. Moran's election as a Fellow of the Society of Painter-Etchers (London, 1881). Shown in the Exhibition of American Etchings organized by the Museum of Fine Arts (Boston, 1881), the Exhibition of the Work of the Women Etchers of America at the Union League Club (New York, 1888), and the Universal Exposition (St. Louis, 1904).
Minneapolis Institute of Arts. Ladd Collection.

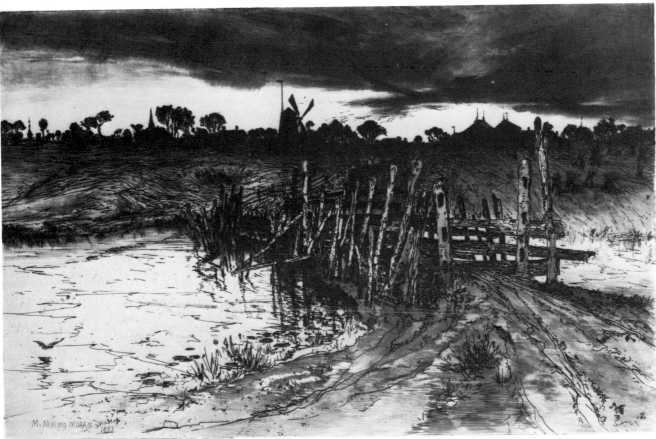

1.11
Mary Nimmo Moran
'Tween the Gloamin' and the Mirk, When the Kye Come' Hame
Etching/roulette work (1883)
7⁷⁄₁₆ × 15⁵⁄₁₆

Published in Koehler's Original Etchings of American Artists *(1883). Shown in the exhibition of the New York Etching Club at the National Academy of Design (1884), the Exhibition of the Work of the Women Etchers of America at the Union League*

Club (New York, 1888), and the Universal Exposition (St. Louis, 1904).
Minneapolis Institute of Arts.

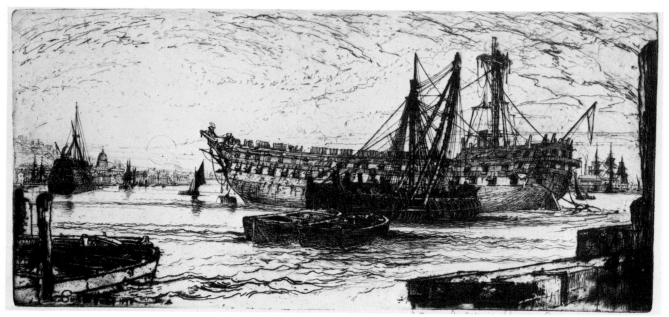

1.12
Seymour Haden
Breaking Up of the Agamemnon
Etching (1870) 7⁹/₁₆ × 16³/₁₆
Shown at the United States International
Exhibition in Philadelphia (1876) and the
first important exhibition of etchings in the
United States, organized by the Museum of
Fine Arts (Boston, 1879). An impression
was acquired by Dr. Frederick James for his
collection of etchings by Haden which he
donated, in 1891, to the Buffalo Fine Arts
Academy (Albright-Knox Art Gallery).
Minneapolis Institute of Arts. Dunwoody
Fund.

1.13
Seymour Haden
Kilgaren Castle
Etching (1864) 5⁷/₈ × 4⁵/₁₆
One of the etchings by Haden, from the
collection of Samuel P. Avery of New York,
that illustrated the article on Haden's
prints by Philip Gilbert Hamerton in
Scribner's Monthly *(August 1880).*
Minneapolis Institute of Arts. Ladd
Collection.

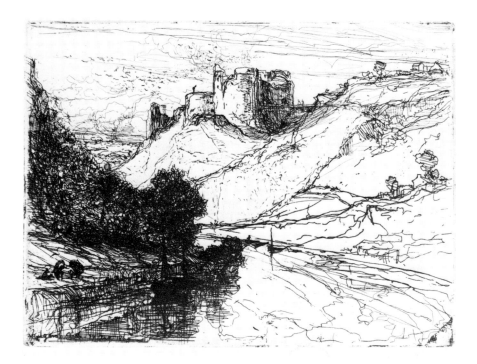

the young etcher Joseph Pennell.[19] At Chickering Hall in New York, on 5 and 8 February 1883, Haden presented his discourses and demonstrations with slides and stereopticon. The principles and practice of etching were his lecture themes, but he also urged his audiences to recognize the role of etching as a fine art.[20] During Haden's stay in this country, Frederick Keppel arranged for another exhibition of the Englishman's prints, this time at the dealer's New York gallery, and the distinguished visitor also joined the members of the New York Etching Club in a display of works at the prestigious Union League Club.[21]

On the other hand, Whistler's art, which had evoked controversies in England, was also controversial in America. When an exhibition of his prints was shown in the United States during 1883–1884, New York newspaper and periodical critics took pains to doubt or affirm the merits of his etchings. The exhibition was first presented at the gallery of H. Wunderlich & Company, New York. White and yellow draperies were installed to comply with the title of the exhibition, Arrangement in White and Yellow. *Nocturne in Black and Gold: Falling Rocket*, a then-controversial painting, was flanked by yellow vases, and fifty-one etchings and drypoints were displayed, unorthodoxly, in white frames. Among the prints was *The Traghetto* (fig. 1.14), which Bacher and Whistler judged to be one of the latter's finest Venetian etchings.[22] The entrance to Wunderlich's gallery was attended by "a boy in white and yellow livery," even to his gloves, who "peddled slim catalogues at thirty-five cents each" that listed the prints but were devoted mainly to Whistler's sharp ripostes to art critics. The exhibition stirred mixed reactions and one critic, with a gratuitous allusion to the "malarial" yellow of the gallery decor, wrote that "upon entering the emporium of H. Wunderlich & Co.

there is a universal call for quinine." Later, the exhibition was presented at the Noyes & Blakeslee Gallery in Boston and again, with similar settings, at the Pennsylvania Academy of the Fine Arts where it closed on 3 May 1884.[23]

The Arrangement in White and Yellow was the first flamboyant demonstration of Whistleresque showmanship for Americans. It was nearly a repeat performance of his exhibition, installed with yellow draperies, at the rooms of the Fine Art Society (London) the preceding year. In London, however, the preview was attended by selected guests and royalty, and the calculated effects exploited more whimsically. Whistler was on hand, dressed in yellow sox that showed above his boot tops; he presented to the ladies yellow and white butterflies, counterparts of his famous monogram.[24]

Etching (and the variant, drypoint), with its facile accommodation to autographic draftsmanship and spontaneity of effects, was the favored intaglio medium of celebrated European printmakers during the period. It also became the preferred process by which the Americans set forth to achieve a printmaking art of artists. An attractive feature of etching was that artists could create images on the plates without any unwanted intercessions of the alien hands of artisans working in the engraving and lithographic trades. Moreover, the printing of an etching required less technical knowledge and training than lithography and some of the American printmakers—James D. Smillie, Stephen Parrish, Thomas Moran, and Joseph Pennell—were complimented for their skill with the etching press and the excellent impressions pulled from the copper or zinc plates.[25] And, finally, there was the convenience that the image could be created on the plate either in the studio or during an etching excursion into the countryside or city. An etching excursion, described as

working "directly from nature," was cited explicitly as an assurance to the beholder, and collector, of the artist's personal conception and execution of the plate when original impressions of *The Path to the Shore* (fig. 1.15) by R. Swain Gifford and landscape etchings by Peter Moran, Kruseman van Elten, and Samuel Colman were bound among the pages of the *American Art Review*.[26]

In the late nineteenth century, sponsors published, exhibited, and collected American prints enthusiastically. Sylvester Rosa Koehler was such a sponsor; he was tireless in his support of the printmakers.[27] In 1879 Koehler initiated the *American Art Review*, a periodical that presented articles on historical and contemporary fine arts of all kinds. Koehler demonstrated his commitment to American printmaking during the brief two-year span of the *Review*'s life by writing an unusual number of biographical and critical essays on the leading etchers. Furthermore, he had one or more original etchings (fig. 1.16) bound into each issue, providing subscribers with a commendable collection of works by American artist-printmakers.

Upon the demise of the *American Art Review* in 1881, the *New York Tribune* lamented its passing, then stated that "[Koehler] . . . was enthusiastically interested in the art of etching, and did all that lay in his power to develop it and aid its growth in this country by giving commissions to artists to make etchings for his *Review*."[28] Koehler's purpose in publishing the series of essays and original etchings in the *Review* was revealed clearly when he wrote of an American artist ". . . that his name should be included in the *Peintre-Graveur Américain*, for which I am trying to lay the foundation in [the series] *The Works of the American Etchers*. . . ."[29]

In 1880 Koehler undertook the translation of Maxime Lalanne's famous *Traité de la graveur à l'eau-*

1.14
James A. M. Whistler
The Traghetto
Etching (1880) 9¼ × 12
Shown in the touring exhibition of Whistler's prints, in 1883–1884, at the galleries of H. Wunderlich & Company (New York), Noyes and Blakeslee (Boston), and at the Pennsylvania Academy of Fine Arts (Philadelphia).
Boston Public Library Print Department.

forte. When it was finally published in 1885 under the title *A Treatise on Etching*, it became the most comprehensive technical manual readily obtainable by American etchers.[30] The termination of the *American Art Review*, presumably for financial reasons, did not deter him when, in 1882 and 1884, he compiled the two volumes of the first *United States Art Directory and Year-Book* which included reports on numerous print exhibitions, awards, clubs, and publications. Koehler was indefatigable, and in 1883 wrote the introduction and commentaries for *Original Etchings by American Artists*, published by Cassal & Company of New York. The large folio carried original impressions by twenty etchers whose names by then were becoming familiar.[31] Koehler's *Etching*, published in 1885, was oversized and equally imposing. A historical and technical treatise, it was enriched by a number of original etchings—one of them *A Fallow Field* by Smillie (fig. 1.17)—with the impressions printed by Kimmel and Voight of New York before being bound amidst the letterpress pages of the text.[32]

In 1887, the year Koehler was appointed the first curator of prints at the Museum of Fine Arts, Boston, he assembled the Exhibition of the Work of the Women Etchers of America. The display was presented

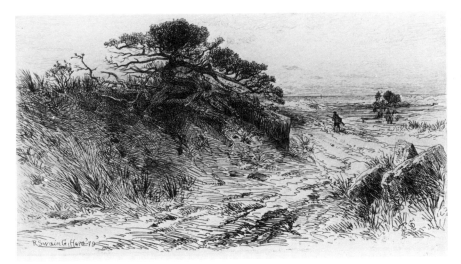

1.15
R. Swain Gifford
The Path to the Shore (near New
Bedford, Massachusetts)
Etching (1879) 4⅜ × 7⅞
*The etching was commissioned by S. R.
Koehler and original impressions were pub-
lished in the* American Art Review
*(1879). Shown in the Exhibition of Ameri-
can Etchings, organized by the Museum of
Fine Arts (Boston, 1881).*
*Kohler Art Library, University of
Wisconsin-Madison.*

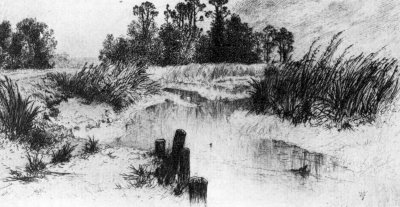

1.16
Thomas Moran
The Passaic Meadows
Etching (ca. 1879) 5⅜ × 8½
*Original impressions of the etching were
bound among the pages of S. R. Koehler's*
American Art Review *(1879).*
*Kohler Art Library, University of
Wisconsin-Madison.*

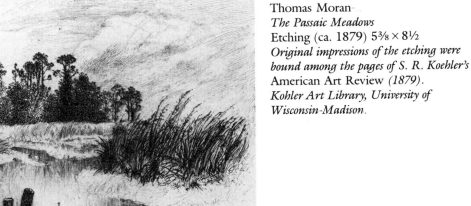

1.17
James D. Smillie
A Fallow Field (Montrose, Susquehanna
County, Pennsylvania)
Etching (1883) 6 × 11⅞
*Shown in the exhibition of the New York
Etching Club at the National Academy of
Design (1884). Original impressions were
published in S. R. Koehler's* Etching
(1885).
*Kohler Art Library, University of
Wisconsin-Madison.*

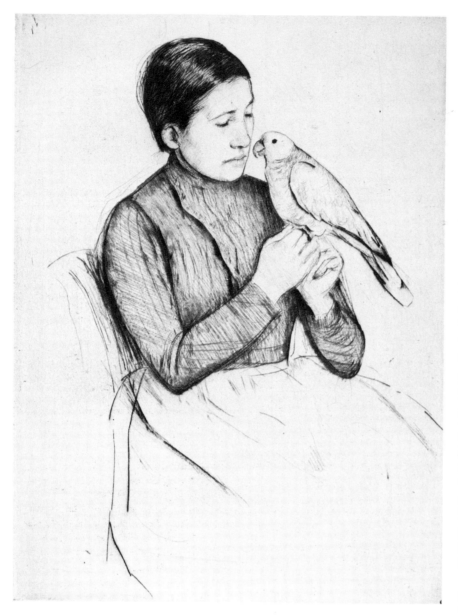

1.18
Mary Cassatt
Girl with Parrot
Drypoint (1891) 6⅜ × 4¹¹⁄₁₆
*Shown in the exhibition of the New York
Etching Club at the National Academy of
Design (1893).*
Art Institute of Chicago.

tivities that promoted etching on these shores. Nonetheless, her prints were imported for collecting and exhibiting. *Girl with Parrot* (fig. 1.18) was displayed by the New York Etching Club in 1893 although Cassatt was neither a resident nor nonresident member. Then as now, she was claimed as an American by the critics, with the *New York Tribune*, in a review of the Exhibition of the Work of the Women Etchers of America, praising the ". . . feeling for the value of color as well as line in the work of Miss Cassatt."[33]

The idea of publishing original prints, that Koehler had seeded conscientiously, was acted upon by various companies and clubs. In 1882, the Art Interchange Publishing Company of New York initiated semimonthly portfolios, *American Etchings*, edited by the critic Ernest Knaufft.[34] Not to be outdone by Boston and New York publishers, Richter & Company of Philadelphia completed a similar venture, *Selected Etchings of American Artists*, with twelve original plates (1884). A reviewer for the *New York Tribune* commended the etchings by asserting that ". . . the skill of American painter-etchers is considerable, and compares favorably with that of the same class of etchers anywhere."[35]

Print clubs also published originals; the Brooklyn Etching Club was organized for that purpose. The New York Etching Club offered documentary and artistic printings. During the years 1882–1893, in conjunction with the annual exhibitions at the National Academy of Design, the club published illustrated catalogues. They were elaborate, informative, and of more than transient intent as was made clear by a statement that "the object of this catalogue is to furnish a permanent record rather than merely a guide to the exhibition." Each catalogue listed the exhibitors and etchings, the officers of the club, the hanging committee, and the twenty-five to thirty resident and nonresident

a second time at the Union League Club of New York in the following year. The exhibition included several dozen prints by Mary Nimmo Moran and Mary Cassatt. *A Goose Pond* (fig. 1.10) and *'Tween the Gloamin' and the Mirk* . . . (fig. 1.11) were among those on view, while another of Mrs. Moran's original landscape etchings served as the frontispiece for each copy of the catalogue.

Mary Cassatt, although an American by birth, was an expatriate artist in Paris and therefore did not participate personally in clubs or the ac-

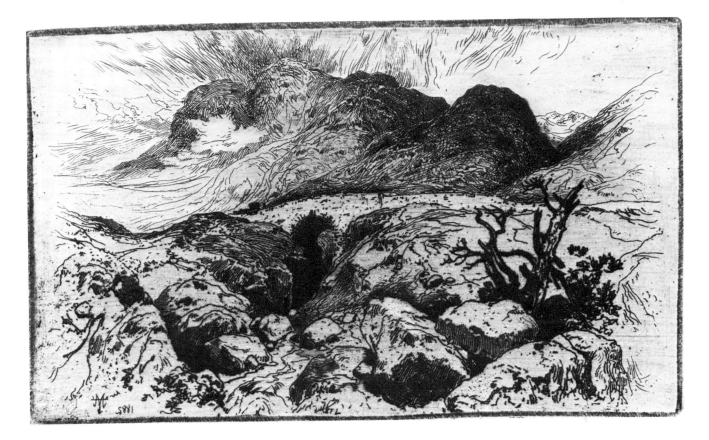

members, including their addresses. Each catalogue published original impressions of eight of the compositions on display, some reduced to a smaller plate by the hand of the artist. A splendid example in the catalogue of 1883 was Thomas Moran's *The Pass of Glencoe* (fig. 1.19) in Argyllshire—memorable as the site of a treacherous massacre of Macdonalds in 1692—an etching with dynamic reordering of landscape forms and expressive linearisms. The print undoubtedly was one of the compositions created when he and his wife, Mary Nimmo Moran, visited their lands of birth, England and Scotland, and the regions of Wales and Cornwall as well.

Those were stimulating years for the artist etchers, but they were not alone in their enthusiastic efforts. Print dealers and collectors also were very active. Frederick Keppel of New York, art dealer, lecturer, and writer, was enterprising in innumerable personal and professional initiatives. He cultivated the ac-

quaintance of Charles-Émile Jacque, Whistler, Haden, and Pennell. When Haden ended his printmaking career he handed his etching needle to Keppel with a symbolic gesture and proclaimed, "I shall etch no more." [36] Keppel was the purchaser of the plates of Whistler's *Thames* set, after the Fine Art Society (London) printed the edition of 1879, and had final impressions pulled before canceling the plates. [37] In 1887, his gallery exhibited the etchings of Jean-François Millet that Keppel had acquired on one or another of his frequent trips to Europe. [38] And it was to Keppel that Jacque revealed, shortly before the death of the famous French printmaker in 1894, that the greatest collection of his etchings on either continent was held by Samuel Putnam Avery, the New York collector and auctioneer. [39] Keppel also was interested in the printmakers of the United States and, from time to time, published the works of American etchers. The same kinds of publishing ven-

1.19
Thomas Moran
The Pass of Glencoe
Etching (1882) $3\frac{3}{4} \times 6$
Published in the catalogue of the exhibition of the New York Etching Club at the National Academy of Design (1883). Kohler Art Library, University of Wisconsin-Madison.

tures occurred under the auspices of H. Wunderlich & Company and the gallery of Christian Klackner & Company. Some dealers, including M. Knoedler & Company, Radtke, Lauckner & Company, and Fishel, Adler, and Schwartz, arranged for copyright protection by depositing impressions with the Library of Congress.

The collecting of prints from various countries and periods became a serious interest of Americans by the second half of the 1800s. Francis C. Gray left 4,000 prints to Harvard in 1857. Koehler, a collector in addition to his other activities, arranged in 1897 for the purchase by Boston's Museum of Fine Arts of 23,000 impressions that had been assembled by the New York merchant, Henry F. Sewall.[40] Connoisseurship had grown remarkably by the late years of the century, exemplified by accessions of Samuel Putnam Avery and Howard Mansfield of New York, Dr. Frederick James of Lancaster near Buffalo, James L. Claghorn of Philadelphia, and Sylvester Rosa Koehler of Boston. Avery, an engraver who had been persuaded to become an art auctioneer by the Baltimore collector William T. Walters, added prints to his personal collection during business trips to France and England. Avery was the generous donor of more than 17,000 works that formed the basis for the splendid print collection at the New York Public Library. Mansfield, a successful lawyer, wrote a descriptive catalogue on the etchings of Whistler and became a trustee of the Metropolitan Museum of Art. He had purchased over 200 prints by Whistler when he encouraged Charles L. Freer in 1887 to try print collecting, an interest that led to the largest holding of Whistler etchings and lithographs in the world.[41] Mansfield also acquired the works of French masters; from the group of etchings by Charles Meryon that he assembled, 140 were sold to the Art Insti-

tute of Chicago (1909) where they remain as the Mansfield Collection.[42] Dr. Frederick James purchased many of the impressions that Seymour Haden had brought with him when he visited the United States in 1882. Subsequent accessions made James's the finest collection of Haden's etchings, drypoints, and mezzotints in America. Then, in 1891, three years before James was elected President of the Buffalo Fine Arts Academy—now the Albright-Knox Art Gallery—he donated 217 trial proofs and various states to the institution.[43] James L. Claghorn was a prominent merchant, banker, and civic leader in Philadelphia who laid the cornerstone for the present building of the Pennsylvania Academy of the Fine Arts in 1872. Estimates of the number of prints in his collection ranged as high as 50,000. Some of them were purchased later by T. Harrison Garrett and donated subsequently to the Baltimore Museum of Art. Claghorn's collection included works by Haden and Whistler. Joseph Pennell recalled that as a student ". . . my love of Whistler's work dates from the First Day afternoons I spent at James L. Claghorn's in Philadelphia looking at [Whistler's] prints. . . ."[44]

In June 1888, the Society of American Etchers was formed, presumably with the intention that it would be a national organization for the best artist-etchers. However, little information is to be found about the Society's activities except that most of the founding members belonged to the New York Etching Club and that there was a group exhibition at the Ortgies Gallery in November. On 1 January 1890, Frederick Keppel & Company was appointed the exclusive publishers for the Society and, thereupon, republished the statement of purposes that had appeared in the *New York Times* in the year of the association's founding. It was brief but illuminating: "First, the elevation of the art of etching; and second, the limita-

tion of editions; every proof being guaranteed by the stamp of the Society."[45] That is, the improvement of artistic quality, an exclusive number of original impressions pulled from the plates, and assurance given to collectors of the authenticity of prints. Both the society and Keppel approved the practice of limiting the size of editions, and the dealer suggested the destruction of the original plates: ". . . we assure very limited editions of [prints published exclusively by us], and in many cases we take the further precaution of destroying the copper plates so as to prevent the possibility of subsequent printing from them, thus insuring the rarity and permanent value of the original editions."[46] The destroying or canceling of plates had gained favor during the nineteenth century as the art of *peintre-graveur* became increasingly prestigious and a rarity of fine prints lent additional inducements to collecting.

Some etchings and drypoints created by late-nineteenth-century American printmakers were cityscapes, harbors, portraits, or anecdotal genre. The majority, though, bore a charm of unpretentious landscape, such as *An Apple Orchard* (fig. 1.20) by Thomas Moran which he identified as a grove near the Morans' summer studio; he inscribed in the plate, "Mulford's Orchard, Easthampton, Long Island." The intimate landscapes or glimpses of nature seem to reflect the artists' appreciation of etching as a medium that was responsive to the making of modest and quickly executed images. Whether they had etched "directly from nature" or returned to studios with preliminary sketches, their landscapes, more often than not, were artistic recreations of identifiable locales of the Northeast. The place names in the titles served to evoke a sense of the familiar: Gloucester, Annisquam, Easthampton, and Passaic; and the rivers, shores, and harbors of the Housatonic, the Shepaug, the Hackensack,

Cape Ann, Oyster Bay, and Three-mile Harbor. The more memorable and expressive prints offered sensations of quiet and solitude to the beholders, who then were invited to trail a lonely hunter across New Bedford dunes, circle the moody wetlands that guarded muskrat lodges on the far reaches of Long Island, follow slowly browsing sheep through the fields of the Susquehanna Valley, or pause beside the ancient and twisted cedars on a rocky shore of Maine. Among the most attractive were the etchings of R. Swain Gifford, James Smillie, Thomas Moran, and Mary Nimmo Moran. They combined fine draftsmanship and sure pictorial shorthand in images that seem familiarly "American" in landscape conformation and character. Surely, they were discovering and revealing our landscapes as Jacque, Whistler, and Haden had rediscovered, with new graphic vision, the French and English rivers and countrysides. But not all of the artist-etchers were as committed to American subjects. Charles A. Platt and Samuel Colman found architectural vignettes in the United States and Europe equally stimulating, while Otto H. Bacher and Joseph Pennell established reputations as peripatetic etchers who wheeled around Europe on sketching tours of Old World cities and hamlets.

On 26 April 1881, Sylvester Rosa Koehler had written a review of the Exhibition of American Etching at the Museum of Fine Arts for the *Boston Advertiser*. He informed his readers that the display was, ". . . the first attempt to bring together in one collection the productions of what—for America—may be termed a new art. Twenty or even ten years ago, such an exhibition would have been utterly impossible, not only because the technical means needed were then unknown to our artists, but because the qualities best fitted for the development of etchings were entirely wanting in our art."

In the years following Koehler's

1.20
Thomas Moran
An Apple Orchard (Mulford's Orchard, Easthampton, Long Island)
Etching (1883) 12 × 18
Shown in the exhibition of the New York Etching Club at the National Academy of Design (1884). Original impressions were published in Selected Etchings of American Artists *(1884).*
Courtesy of Henry Behrnd, Madison, Wisconsin.

early assessment of the state of the art, American etchers joined the mainstream of printmaking. It was a conservative stream that was to continue steadily on its way despite a few radical innovations that were being introduced into late-nineteenth-century European printmaking by unorthodox etchers such as James Ensor and Edvard Munch. Still, to enter the mainstream at all required unusual initiative and support where little had existed before. Thus, by the 1890s, through the combined efforts of artists, curators, publishers, dealers, and collectors a role for painter-printmakers had been created in the arts of the United States. From then on etching as a fine art was to have continuing attractions for the future printmakers of America, notwithstanding the ventures into other media and the gradual emergence of new artistic conceptions that were reflections of changing cultural values during the first half of the twentieth century.

The New School of American Wood-Engraving

Wood-engraving had fallen into artistic disrepute in both Europe and the United States by the latter part of the nineteenth century. The stigma of its reproductive role in the printing trades and the arduous training needed to master the craft seem to have discouraged most artists from choosing it as a medium for creating original prints. The tools, materials, and technical strictures of wood-engraving restrained a spontaneity of execution and easily feigned pictorial illusion which so many nineteenth-century painters prized. Nonetheless, it was a very important and widely used craft, serving the printing industry as the major means by which images could be replicated in the letterpress method of printing books, periodicals, and advertisements. The utilitarian function continued during the

last quarter of the century although it was apparent to practitioners and commentators that wood-engraving was nearing the end of its flourishing as a commercial art and a vocation of trained craftsmen.

During those decades, two phenomena occurred in the United States that affected both the craft and the art of wood-engraving. The first was the relentless advances in photomechanical technologies of reproduction that posed a threat to artisans who were wood-engravers, as well as a graphic tradition that had evolved from the wood-engravings of Thomas Bewick and his followers in the late eighteenth and early nineteenth centuries. By the early twentieth century, images reproduced by photomechanical processes had supplanted those from wood-engravings and eliminated the need for apprentices trained in the craft.

Despite the menacing prospect of the extinction of commercial wood-engraving, a second phenomenon occurred when a group of Americans set forth to achieve two kinds of excellence. On the one hand, with demonstrations of the greatest technical virtuosities of the time, they cut replica wood-engravings of such finesse that they became internationally acknowledged as masters among wood-engravers. And, on the other hand, they embarked upon a search for what they defined as *originality*. They were successful in both tasks and, as a consequence, hailed as the leaders of a "New School of American Wood-Engraving."

Timothy Cole, Frederick Juengling, William B. Closson, Elbridge Kingsley, and Henry Wolf were major figures among the wood-engravers who formed the New School. Between 1870 and 1880, the Americans initially ". . . got the fever and followed the idea of original work in their separate fields, all endeavoring to make a creative artist out of the former mechanical engraver."[47] Although they continued to produce wood-engravings for

black-and-white facsimiles—as did Juengling, in 1880, when replicating *Kilgaren Castle* (fig. 1.21) for Hamerton's article on the etchings of Seymour Haden—they made no apologies and had obvious pride in their professionalism. Because of the skillful transcriptions of works by master artists, they sought and received high commendations for the artistry of the blocks.

In order to establish credentials as artists rather than artisans, the wood-engravers rebelled against the stifling standards of the workshops, including the divisions of engraving labor that had denigrated the profession. Timothy Cole revealed those conditions when he recalled his early experiences in the wood-engraving shops of the trade. The artisans who engraved sections of a block that depicted sky and foliage were nicknamed *pruners*; those who cut draperies were called *tailors*; the more skilled engravers that replicated flesh were dubbed *butchers*; and young artisans assigned the task of cutting images of machinery—as was Cole—were scornfully tagged *mechanics*. Furthermore, the wood block was drilled horizontally for bolting, cut into sections, then separated and distributed so that each artisan could work on his assigned part. When all of the units had been engraved, the sections were reassembled, bolted together, and the whole "touched up" with the graver in the hand of the master of the shop.[48]

As the Americans of the New School achieved technical brilliance in their works, there were paradoxes related to their methods, nonetheless. They developed varied techniques in order to transcribe, more effectively than ever before, the textural and chiaroscuro illusions of original paintings and, in doing so, used a deftness of cutting in ways that obscured or denied the inherent nature of the wood block. Moreover, although they viewed with dismay the encroachment on their

1.21
Frederick Juengling
Kilgaren Castle (after Seymour Haden)
Wood-engraving (1880) 2¾ × 3¾
The wood-engraving was made after the original etching by Seymour Haden (fig. 1.13). Samuel P. Avery graciously permitted this and several other Haden prints to be replicated for Philip Gilbert Hamerton's article, "Mr. Seymour Haden's Etchings," published in Scribner's Monthly *(1880).*
Memorial Library, University of Wisconsin-Madison.

profession of the photomechanical processes—which Kingsley described as the threatening ". . . nightmare of the process plate . . ."—they embraced and became vocal advocates of the use of photography to transfer to the block the images that they were to replicate in engraving.[49] The practice formerly had been to draw on the block, in reverse, a linear counterpart of the painting or illustration. Now, a projected photographic transparency of the original masterwork allowed a precise proportional reduction and simple reversal of the image onto the wood block, and an obvious display of the tonal nuances to be replicated. As a consequence, the engravers of the New School sought to improvise ways of cutting, crosslining, stippling, and pricking as the painterly effects in originals were simulated through new ingenuities of craft. In some instances the wood-engravers feigned illusions of brushwork, a tour de force that raised outcries against overemphasis on textural replication. Subtleties of tone and texture, however, were two effects that evoked high praise for the skills of the Americans from other commentators.[50]

By the early 1880s, Americans were gaining recognition as master-engravers of unusual distinction. Juengling and William B. Closson,

the latter a career painter of merit, were the first Americans whose wood-engravings were accepted for exhibition in the Paris Salon. In 1881, Juengling received a *mention honorable* for his print *The Professor* (fig. 1.22). It was a replication of the original oil painting by Duveneck and a wood-engraving that had been commissioned by Koehler for publication in his *American Art Review*.[51] Koehler continued to exert his influence on behalf of American printmakers by sponsoring a display of works by wood-engravers as he had done for the artist-etchers.[52] The Exhibition of American Engravers on Wood at Boston's Museum of Fine Arts (1881), the first of major importance in the United States, led the correspondent for the *Magazine of Art* (London) to inform the English that the engravings of the Americans were exceptional in their excellence.[53] The following year, M. G. van Rensselaer reported the growing international reputation of the New School to readers of the *Century Magazine*: ". . . whatever the strictures that may have been passed on it [the New School] at home, it has been almost universally praised abroad. In England as in France critics have been lavish in their commendation. When we find, for example, 'L'Art' reprinting a series of cuts from the 'Scribner

Portfolio,' and even the [London] 'Saturday Review' ranking American work above all that is done in other countries, we cannot be blamed for feeling a responsive glow of self-approval."[54]

As would the artist-etchers later, the wood-engravers of the New School sought identity through a national organization and, in 1881, Juengling and Gustav Kruell were responsible for the founding of the Society of American Wood-Engravers.[55] Six years afterward, the Society issued an impressive album, *Engravings on Wood*, that displayed the accomplishments of some of its members. The *Edition de luxe* of 100 copies was printed from the original blocks on Japan paper and the impressions were made with a hand-press by the chief proof printer of Harper & Brothers. William Mackay Laffan, publisher of the *New York Sun*, wrote a laudatory text: "Since illustration became so prominent a feature of our higher periodicals there has been a more marked progress in engraving upon wood than in any other branch of art practiced in our country. It has achieved a character more original and pronounced, and more nearly national, than any other. That is to say, an engraving made in America is not to be mistaken for one that has been produced elsewhere, while a paint-

1.24
Elbridge Kingsley
A Quiet Spot. "Original Engraving"
Wood-engraving (1893) 7⁹/₁₆ × 5
*India proofs from the original wood block
were published in* The Art of the American Wood-Engraver *(1894).*
*Kohler Art Library, University of
Wisconsin-Madison.*

1.23) with the additional citation that the print was "Engraved from Nature," and Elbridge Kingsley cut "Original Engraving" into the block of *A Quiet Spot* (fig. 1.24), his contribution to the folio.

In 1889 a group of American wood-engravings had been exhibited at the Universal Exposition in Paris. Kingsley was awarded a Gold Medal and fellow engravers received silver, bronze, and honorable mentions.

Displays soon followed at the Hamilton Club in Brooklyn, the Grolier Club in New York, Boston's Museum of Fine Arts, and an exhibition by the Society of American Wood-Engravers toured the country. By that time, there was complete confidence that the Americans were the best wood-engravers in the world. Laffan was scornful of French wood-engravers—an opinion shared by the French artist-printmakers Félix

Buhot and Paul Gauguin[60]—and scoffed at the British: "England, since W. J. Linton became a resident of America, has no wood-engravers, only workmen on wood, who cut fac-simile blocks for publishers so timid and conservative that they have not yet wholly overcome their fear of the invention of process plates."[61]

However, praise for the wood-engravers of the New School was

not unanimous. The leading opponent was William J. Linton, England's most distinguished wood-engraver, who had come to visit the United States in 1866, and then to stay permanently. He settled in quickly on these shores, was honored at a dinner of the earlier Society of Wood-Engravers, induced to teach a class at Cooper Union, and persuaded by Frank Leslie to work for his *Illustrated News*.[62] Linton was a persuasive writer on technical and artistic matters of wood-engraving. On several occasions he published objections to the work of the New School, deploring the use of photography on the block and of seeking tonal illusions by crosslining, stippling, and pricking the wood surface with the point of the graver. He believed in the efficacy of line and linear effects alone, regardless of the features of the original art work, and observed that, "the white line refers of course to the peculiar method of engraving followed by Bewick and his best pupils, Clennell and Nesbit, and which, my life through, I have sought to maintain as the only artistic method of engraving on wood."[63]

The Americans were given ample opportunities to state their side of the dispute and Juengling, considered by Linton to be the most remarkable exponent of the New School, candidly answered, "The advantages and superiority of the new school over the old school may be summed up as follows: First, latitude of reproduction. Second, absence of exclusive method, of conventionalism, of formalism; no set way for producing an effect. For each work in hand special ideas are originated, special means are invented. Mr. Linton thinks that such an aim is an unworthy one. The method of the old school is to adapt the original to the means; the method of the new school is to adapt the means to the original."[64] Henry Wolf, in contrast to the Old School master Linton, commended the use

of photography on the block for commercial replication: "When, late in the seventies, the drawings were photographed on the block and the engravers were asked to reproduce the original as faithfully as possible, wood-engraving took a higher flight. The drawing could then be made on paper, on canvas, and in any medium [by the artist who produced the original]—pencil, wash, charcoal, gouache, etc.—and in any size; the photographer would reduce it to the size of the page."[65]

The wood-engravers of the New School were aware of the accomplishments of the American artist-etchers and Closson, Kingsley, Wolf, Frank French, and John P. Davis sought an art that was comparable by creating their own compositions. Juengling, who had done some etching, considered it the ideal artistic medium of all those which required the services of printing, while Kingsley followed the practice of the etchers by limiting the editions of some of his original wood-engravings. He made sorties into nature in a horse-drawn "studio-car," often with a small boat-trailer hitched on behind. Kingsley's favorite landscapes were in the region of his boyhood around Hadley, Massachusetts, and the nearby valley of the Connecticut River in the vicinities of Mount Holyoke, Mount Tom, and Whately Glen. Occasionally other wood-engravers would camp with Kingsley in the "studio-car," creating original works such as French's *The Lily Pond* and Davis's *Autumn Hillside*.

Scribner's and the *Century Magazine* published many of Kingsley's original wood-engravings, always so identified by explicit notations of their having been "Engraved from Nature,"[66] while both Kingsley and Wolf would incise into the blocks or add to their penciled signatures either "original engraving" or "inv & sculp."

Wolf's reputation as a master-engraver was supported, in no small

part, by his original compositions. Most notable were *Morning Star*, a view over New York City's Central Park, *The Evening Star* (fig. 1.25), based on a motif from Pine Hill in the Catskills, and the highly praised cityscape, *Lower New York in a Mist*, (fig. 1.26), as seen from a Pennsylvania Railroad boat. He received more and more awards at international exhibitions and expositions and, in 1911, Frederick Keppel & Company, which had been so active in the sponsorship of American etchers, presented a special exhibition of the wood-engravings of Timothy Cole and Wolf. The climax of the many honors came when Wolf was invited to exhibit over 100 prints in the American section of the Panama-Pacific International Exposition (San Francisco, 1915) and was awarded the Grand Prize in graphics.[67] Wolf displayed his talents both in splendid commercial work and original prints.[68] James Huneker, respected essayist and art critic, lauded Wolf's two kinds of accomplishment when he wrote that "Henry Wolf is a great master of a fast dying art. . . . An artist, literally to his finger tips, artist as well as supreme craftsman. . . ."[69]

The profession of wood-engraving became a fatality of one of the conflicts between handcrafts and modern technologies. One may leaf through the pages of the *Century* or *Harper's* and find, after 1900, that the photomechanical processes had triumphed almost completely, and wood-engravings rarely published. In 1911, Wolf observed sadly that "since the beginning of the century only two engravers have been kept busy,—one for *Harper's* and another for the *Century Magazine*," and his belated prophecy of the demise of the profession was in fact a post-mortem: "Artistic wood-engraving is bound to become a dead art; in a few years it will have ceased to exist. There are no more apprentices or students because there is no encouragement."[70] Wolf was right

1.25
Henry Wolf
The Evening Star. "Inv. & Sculpt."
Wood-engraving (ca. 1910) 4⅞ × 7¾
Museum of Fine Arts, Boston.

about wood-engraving as a craft associated with publications of the printing trades. What he could not foresee was that wood-engraving and woodcut, the companion process in the relief media, would survive under the aegis of a few fine artist-printmakers, among them Thomas W. Nason, Rockwell Kent, Max Weber, and J. J. Lankes, until there was a reawakening of interest in the aesthetic and technical merits of the media in the middle decades of the twentieth century.

The members of the New School of American Wood-Engraving as contemporaries of the artist-etchers —and heirs of similar artistic traditions—revealed like choices in landscapes and occasional genre subjects that were created with comparable conservatism of artistic conceptions and styles. No one would suggest that the qualities of originality in the works of American wood-engravers matched the conceptually radical ele-

ments of the startling relief prints produced by Edvard Munch and Paul Gauguin in the 1890s—wood-engravings and color woodcuts that, later, had far-reaching influences on twentieth-century printmaking, here and abroad. Nonetheless, as the members of the New School spiritedly sought to elevate the fine art of prints in the United States, the international recognition that they received—for being the most skilled engravers on wood, anywhere—was a feather for the cap of the American wood-engraver. Moreover, after many decades of artistic upheavals in this century and a concurrent indifference toward the accomplishments of those earlier wood-engravers, there now is a gradual rekindling of the former appreciation of the skills, and revelations of American life and landscape, that permeated the prints from wood which were created in the late nineteenth century.

1.26
Henry Wolf
Lower New York in a Mist. "Original Engraving"
Wood-engraving (1910) 9⅛ × 6¼
Museum of Fine Arts, Boston.

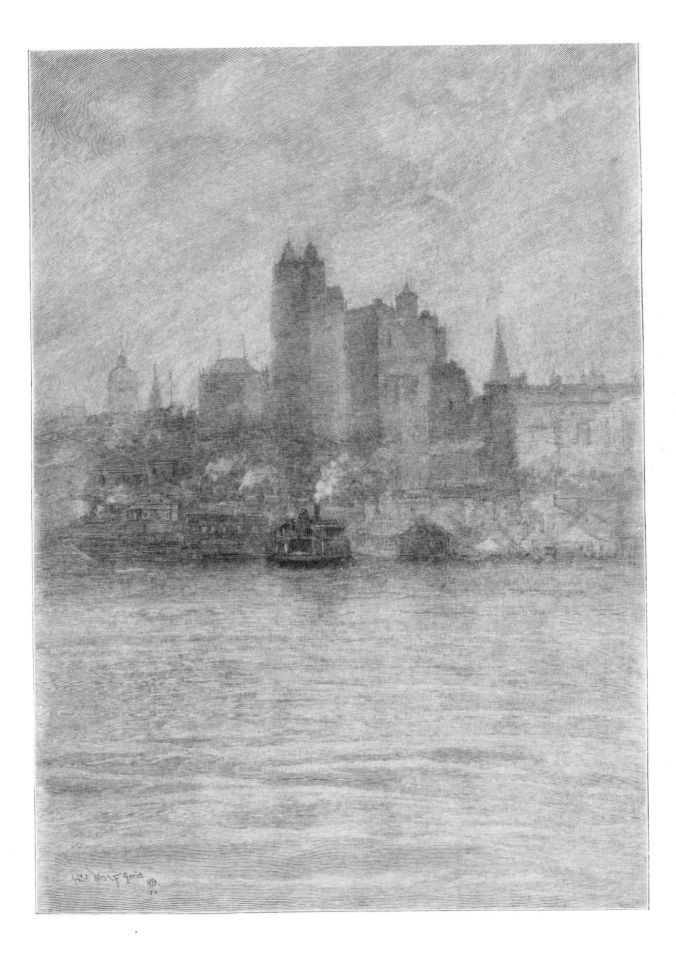

2

The Constant Advocacy of Joseph Pennell, Dean of American Printmakers

The creative vitality of American printmaking and the splendid initiatives in behalf of etching and wood-engraving, to which so many artists and supporters had contributed in the 1880s and 1890s, diminished as the old century passed and the new began. As in the life of any artistic movement, time removed the leaders and eroded the strengths derived from shared or corresponding creative commitments. "The New School of American Wood-Engraving," victim of the improved technologies of photoprocess reproduction, expired abruptly at the height of its flourishing, thus silencing the many public expressions of exultation over the artistry of American engravers on wood. The waning of the creative impulses that had characterized the first phase of the adopted tradition of *peintre-graveur* in etching was gradual and, as it turned out, a more complex story.

By the end of the century almost all of the artists who had been involved in the emergence and successes of late-nineteenth-century etching had died, were aging, or had turned to painting as a more commanding and rewarding artistic enterprise. The careers of Albert F. Bellows, Mary Nimmo Moran, J. Foxcroft Cole, and Stephen Parrish were over before 1900. Otto Bacher, John M. Falconer, Henry Farrer, Swain Gifford, Kruseman van Elten, and James D. Smillie were gone before the end of the first decade of the twentieth century. Frank Duveneck had abandoned etching long before, in 1885, and Thomas Moran became engrossed in his role as a famous American "artist-explorer," painting the awesome landscapes of the Rocky Mountain West.

Winslow Homer had turned to etching in 1884, recreating compositions of his paintings of people and the sea which were published by the dealer Christian Klackner. Only eight were printed, however, and a graphic vignette among his brilliant watercolors and oils of fishermen, hunters, and guides in remote spots of the Eastern wilderness, *Fly Fishing, Saranac Lake* (fig. 2.1), was the last of his etchings. Maurice Prendergast, John Twachtman, and J. Alden Weir, all advocates of American Impressionist painting, tried printmaking of one kind or another. Between 1892 and 1905 Prendergast produced more than 200 color monotypes—a process of laying artists' colors on plate, glass, or other carrier and pulling a single impression by rubbing the back of the paper or by printing. They are treasured, along with monotypes by later artists, but had slight influence on the major currents of American printmaking. Twachtman (fig. 2.2) and Weir offered gracious etchings though the art was incidental to their careers. On several occasions they exhibited with the New York Etching Club, but Twachtman seemed apathetic and few impressions were made until long after his death when F. Keppel & Company, in 1921, printed editions from plates that had been in the possession of the family for years. Twachtman encouraged Weir to try etching and the latter produced a number of fine portraits as late as the 1890s, including the likenesses of Twachtman and Theodore Robinson, another leader in American Impressionist painting. Weir's most ambitious printmaking project was an early one of 1889 when he created a suite, certainly inspired by Whistler's several "sets," known by the title-page etching as the *Isle of Man* series (fig. 2.3). Their interest in the art of printmaking had ended before the new century began.

The etching societies, having lost their principal members and leadership, no longer bustled with activity or had disbanded without public notice. The New York Etching Club presented its last annual exhibition in 1893 and from then on artist-etchers displayed works as adjuncts to the exhibitions of the American

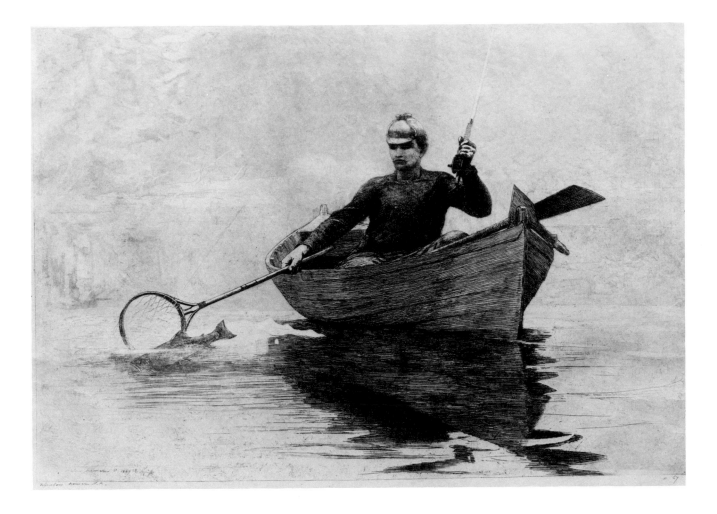

Watercolor Society at the National Academy of Design. Subsequently, after 1910 and the founding of the Chicago Society of Etchers which held exhibitions at the Art Institute for many years, there was a revival of print clubs.[1] Some were of short tenure, but all were leagues organized for etchers who were rarely venturesome conceptually. By 1920, the multitude of prints by conservative professionals and aspiring amateurs led Joseph Pennell to comment, with his tendency toward exaggeration, that ". . . millions of more or less bad ones are being ground out. . . ." in America.[2]

Sylvester R. Koehler, mentor of the early etchers who had revealed his dream of a *Peintre-Graveur Américain*, died in 1900. The nineteenth-century American prints he had assembled at the Boston Museum of Fine Arts, the accessions at the turn of the century for the New York Public Library, and the prints in the Library of Congress, some of them submitted by artists or dealers as "depository" impressions for copyright purposes, became the principal repositories of etchings and wood engravings of the earlier period.

In the decades before and after the beginning of the century the founding or expansion of art museums across the country accelerated the accessioning of prints, but fortuitously, with little or no curatorial guidance. In 1900, Frank Weitenkamp became curator of the first print room in New York City soon after Samuel P. Avery donated the large collection to the New York Public Library. And the Metropolitan Museum of Art—which had declined the Avery gift—was

2.1
Winslow Homer
Fly Fishing, Saranac Lake
Etching/aquatint (1889) 17⅜ × 22⅜
*Published by Christian Klackner &
Company.*
*Shown in the retrospective exhibition,
Americans at Home and Abroad: Graphic
Arts, 1855–1975, at the Elvehjem Museum of Art (1976).*
*Elvehjem Museum of Art. Humanistic
Foundation and Anonymous Fund.*

2.2
John H. Twachtman
Winter, Avondale (Cincinnati)
Etching (1879 or 1882) 5⅛ × 8³⁄₁₆
Published by F. Keppel & Company.
Shown in John Henry Twachtman: A Ret-
rospective Exhibition, at the Cincinnati Art
Museum (1966).
Elvehjem Museum of Art. Harry and
Margaret Pryor Glicksman Endowment
Fund.

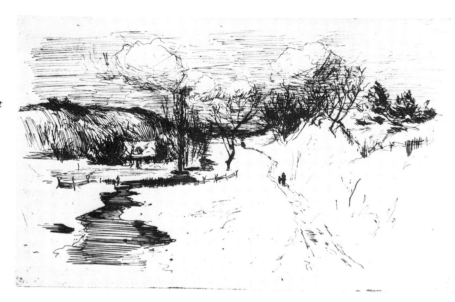

2.3
J. Alden Weir
Sulby Glen, Isle of Man
Etching (1889) 8⅞ × 11¾
Shown in the retrospective exhibitions, The
Etchings of J. Alden Weir, at the Univer-
sity of Nebraska Art Galleries (1967), and
J. Alden Weir: An American Printmaker,
at the National Museum of American Art
(1972).
Cincinnati Art Museum. Gift of the artist.

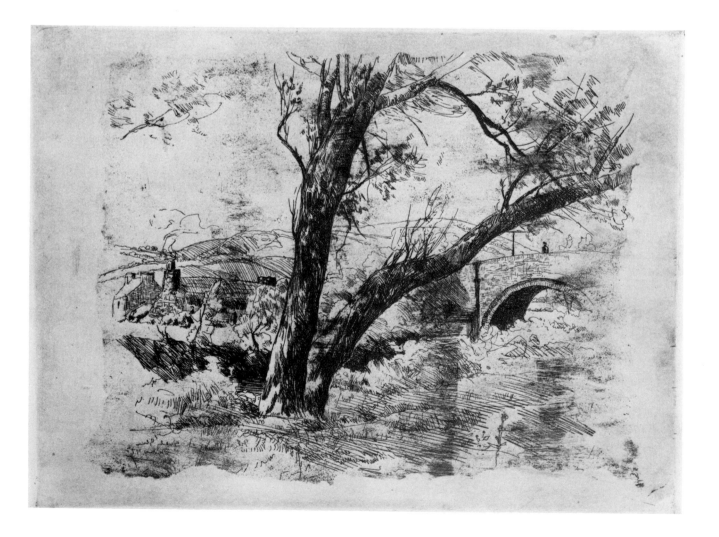

without a curator of prints until William M. Ivins, Jr., was appointed in 1916. Not surprisingly, as the collections grew, the most coveted impressions were master works representing pinnacles of Western printmaking from the fifteenth century onward. And as for prints of the modern era, the etchings and drypoints of Jacque, Meryon, Whistler, Haden, or their counterparts were favored over the works by Americans.

New York dealers displayed comparable preferences as the twentieth century started and by advertisements and exhibitions emphasized their portfolios of the same or equally famous nineteenth-century European masters. The prints were similar to the purchases by earlier American collectors, but now the new clients were assured of an aura of unimpeachable reputation surrounding the creators. Occasionally American printmakers were sponsored, notably Joseph Pennell whose works were exhibited repeatedly by F. Keppel & Company. Albert Roullier of Chicago featured many second-generation American etchers although he, too, was very active in selling the best of nineteenth-century Europeans as well as prints of the great old masters that he was able to bring to the marketplace.

In the early years of the new century, critical writings about current American printmaking were infrequent in the art journals or metropolitan newspapers and the occasional bland feature article, presenting the prints of one or another of the succeeding generation of etchers, offered little substantive information or perceptive discussion of the talents of the artists. Frederick Keppel, who must have been sensitive to the paucity of scholarship and reporting on fine prints whatever the country of origin or historical period, initiated the *Print Collector's Quarterly* under the editorship of Fitzroy Carrington in 1911. The few discursive articles on contempo-

rary American printmakers comprised a minority which, unaccountably, became even more slight after 1913 when publication of the *Quarterly* was moved from New York to Boston where Carrington was appointed to the curatorship of prints and drawings at the Museum of Fine Arts.[3] However, there had been few innovations made by younger American artist-etchers to which editors or authors could alert readers.

Meanwhile, the excellence of second-generation printmakers lay in the facility with which they etched pictorial renderings that pleased the tastes of conservative buyers. And because many of them became transatlantic printmakers in search of picturesque views of Old World cities and byways, architecture and peoples, one must suppose that their European prints were in response to a growing audience of countrymen who had visited, or hoped to tour, the Continent. Herman Webster, George Charles Aid, Lester Hornby, and Ernest D. Roth seemed to be on frequent artistic journies or in prolonged residence in Europe, as was Donald Shaw McLaughlan when he etched *Le Quai des Grands Augustins, Paris* (fig. 2.4), one of his *French Series* published by the Albert Roullier Art Galleries in Chicago. A few artist-etchers were intrigued by the landmarks or neighborhoods of American cities as in renderings by Charles H. White, B. J. Olssen-Nordfeldt, or Charles F. W. Mielatz who displayed the *Entrance to Brooklyn Bridge* (fig. 2.5), in the last annual exhibition of the New York Etching Club (1893) and thereafter, for several decades, was listed as the only nominal officer of the inactive club. For most of the American etchers, however, an indispensable requisite for a successful career was to have etched, at least once, a "series" of views of Italy, France, England, Germany, or of London, Paris, and Venice in the manner of the roaming Otto Bacher, who had "done Eu-

rope" so well in the 1880s and 1890s, or of the even more redoubtable traveler, Joseph Pennell.

Pennell was America's leading illustrator-etcher in the late nineteenth century. In the early 1880s he had etched historic landmarks in American cities, such as the *Yard of the Plow Inn* (fig. 2.6).[4] From 1883 onward, etchings of European as well as American architecture and landscape were subjects with which he illustrated travel articles and books for American publishers and, at the same time, built up his stock of hundreds of original prints for international exhibitions, for sale by his dealer, Keppel, and for gifts and sales to museums, galleries, and collectors abroad as well as in the United States.

In 1904, James Smillie, then seventy-one years old, was invited to assemble an exhibition of American prints for the Universal Exposition in St. Louis, held in commemoration of the Louisiana Purchase. It turned out to be a random selection with little assurance that new concepts in printmaking might emerge as the twentieth century began. Works of the deceased were resurrected in groups of etchings by Kruseman van Elten, Mary Nimmo Moran, John Twachtman, Albert Bellows, and Henry Farrer, the last two represented by prints still in the portfolios of C. Klackner & Company. J. C. Nicoll, Dr. Leroy Yale (an amateur cofounder of the New York Etching Club in 1877), J. Alden Weir, Smillie, and Otto Bacher were all advanced in age; only Nicoll and Weir would survive the decade. There was a miscellany of works by members of a later generation of etchers, including Mielatz, MacLaughlan, Aid, and Roth. Some etchings by Pennell were shown, among them *The Most Picturesque Place in the World* (Le Puy en Velay—fig. 2.7), as if to imply that no exhibition of American printmaking should be assembled without at least token representation of his work

2.4
Donald Shaw McLaughlan
Le Quai des Grands Augustins, Paris
Etching (ca. 1919) 8¹⁵⁄₁₆ × 13¹¹⁄₁₆
One of McLaughlan's French Series *published by the Albert Roullier Art Galleries.*
Minneapolis Institute of Arts. Ladd
Collection.

2.5
Charles F. W. Mielatz
Entrance to Brooklyn Bridge
Etching (1892) 12¹⁵⁄₁₆ × 8⅞
Shown in the last annual exhibition of the
New York Etching Club at the National
Academy of Design (1893).
National Museum of American Art
(formerly National Collection of Fine
Arts), Smithsonian Institution. Museum
Purchase.

and, possibly, because Pennell served on the London committee which recommended prints of Americans who were resident in England at the time. On the whole, the exhibition was a flaccid forum of American prints that offered only slight hints of things to come in a few New York genre subjects by Maurice Sterne and the five etchings of John Sloan, selected from the many he was creating as illustrations for the novels of Charles Paul de Kock.[5]

There would be stimulating ventures in printmaking before the first quarter of the century was over, but they were to occur without the communality of enterprise that had marked the developments in etching and wood-engraving in the late nineteenth century. John Sloan, George Bellows, John Marin, Arthur B. Davies, Max Weber, Edward Hopper, Rockwell Kent, and even

the older Joseph Pennell would display diversities in choice of subject matter, interpretive content, styles, and printmaking media rather than the pictorial similarity of landscapes and city views, albeit handsomely rendered, which was a conservative constant for most second-generation etchers. The prominent printmakers of the following decades would create works that symbolized the spirit of independence and reflected the multifaceted features of American art which evolved during the first thirty years of the twentieth century.

Joseph Pennell had many kinds of ties to both the earlier and later periods of printmaking. A résumé of the art from the 1880s to the 1920s recalls his endless artistic, literary, and promotional initiatives. As a very young man, the Philadelphia Quaker elected a dual role as

2.7
Joseph Pennell
The Most Picturesque Place in the World
(Le Puy en Velay)
Etching (1894) 15³⁄₁₆ × 11¹³⁄₁₆
Shown at the Universal Exposition,
St. Louis (1904).
Minneapolis Institute of Arts.

or transfer lithographs *en plein air* with a speed that astonished his artist friends and admirers. England, France, Spain, Italy, Germany, Holland, Russia, Hungary, and Greece were etched, lithographed, or drawn in pen and ink once or several times. And in the Americas, favorite themes were the old and picturesque structures in Philadelphia and New Orleans, or later the new and dramatic skyscrapers and industrial

complexes in or near New York, Chicago, Pittsburgh, San Francisco, and—one of the great wonders of the world—the Panama Canal under construction.

Pennell's art bore no radical features when compared with the prints of artists who were creators of avant-garde trends in the late nineteenth and early twentieth centuries in Europe and America. Still he was an enthusiastic sponsor of Aubrey

Beardsley, whose work in the 1890s was shocking to the British, and he had purchased the first album of the French *L'Estampe originale*, decorating his dining room with the original impressions from that landmark publication of post-Impressionist prints.[7] In a photograph of Pennell working at his etching press one recognizes the celebrated eight-color lithograph (fig. 2.9) by Henri de Toulouse-Lautrec—the cover of the

2.8
Joseph Pennell
The Ponte Vecchio (Florence)
Etching (1883) 9¹⁵⁄₁₆ × 7¹⁵⁄₁₆
Pennell's first European etching, completed while he was creating illustrations for William Dean Howells's "A Florentine Mosaic." Reproduced as the "frontispiece" for the article of the same title in Century Magazine *(1885). Meanwhile, the original print was published in Koehler's* Original Etchings by American Artists *(1883) and shown in the annual exhibition of the New York Etching Club at the National Academy of Design (1884).*
Elvehjem Museum of Art. Mark and Katherine Ingraham Fund.

first album—hanging on the wall of Pennell's London studio. For the eighth album of *L'Estampe originale*, issued in 1894, Pennell was invited to join the publishing venture with *The Thames*, a broadly illusional aquatint/etching that must have been influenced by the amorphous tusche tonalities with which Whistler had created vague nocturnes or fog-enshrouded views of the great river in some of his lithographs.[8] However, Pennell was an opponent of artistic extremes and decried the works of the Expressionists which were considered "ultramodern" and outrageously unconventional by many contemporary critics and fellow artists. Surely there must have

been a touch of irony in the situation at the Panama-Pacific International Exposition in San Francisco (1915). Pennell was honored by an entire gallery for his prints that had won so many medals at European and American expositions. However, as a member of the jury, he was *hors concours*, while in the nearby galleries of the international section, Edvard Munch, Norway's great exponent of Expressionism, exhibited paintings and fifty-six of his provocative, shocking, and stylistically radical etchings, color woodcuts and color lithographs for which he was awarded a Gold Medal.[9]

Pennell was admired by his contemporaries for countless successes,

among them the innovative images of an industrial age that were revealed in an impressive number of powerfully composed etchings and lithographs created between 1905 and 1914. A few artists, on very scattered occasions, had painted the new and soaring skyscrapers of America, but Pennell became a leader of those who were fascinated by the peerless commercial structures (fig. 2.10) of the New World, architectural symbols that were to be recreated in a novel array of artistic idioms and images in American art during the following decades. Also in those years, Pennell sought out the enormous industrial and earth-changing enterprises of Europe and

2.9
Henri de Toulouse-Lautrec
L'Estampe originale
Color lithograph (1893) 22½ × 25¹¹⁄₁₆
The eight-color lithograph, which served as

the cover of the first album issued under the editorship of André Marty in Paris, hung on the wall of Pennell's studio in London. Milwaukee Art Museum. Gift of Mrs. Harry Lynde Bradley.

surrounding a gigantic floating granary, careening from the violence of stormy waters within a normally sheltering harbor. *In the Zeppelin Shed, Leipzig* (fig. 2.13) was composed with a selective simplicity of clean, almost abstract forms that he assigned to the remarkable lighter-than-air craft then being pioneered by the Germans. The lithograph reveals, more than most, a kinship with the vocabulary of visual abstraction that was to be a prevalent feature of artistic choice in much of twentieth-century art. Pennell, however, was never willing to submerge completely the descriptive elements of pictorial rendering to which he owed his professional success as a leading illustrator during the greatest period of that kind of American periodical art. His opportunistic reporting on the Panama Canal (fig. 2.14) under construction was promptly reproduced as a special feature—without text—by the *Century Magazine.*[10] These lithographs combined descriptive illustrations of the stupendous engineering feat—hailed by Pennell as the "apotheosis of the wonder of work"—with some of the compositional strengths that evolved in a mature style.[11]

Earlier, Pennell's respect for lithography as a technique of fine art had derived from his perceptive observations and then personal practice in the medium. Always alert to timely and promising prospects in the graphic arts, Pennell sensed the widening interest in lithographic printmaking on the part of late-nineteenth-century artists and collectors. Consequently, he became an advocate of lithography to the English and Americans who, unlike the French, had been laggardly in a creative use of the process. Then he became a student of the history of the medium and finally, for his own creative purposes, a superb lithographic draftsman.

His close association with Whistler had familiarized him with the spontaneously drawn and delicately

America. In many instances, and in a manner revealing his instincts for and fascination with metaphoric titles, he assigned various prints or series to an overall theme—*The Wonder of Work.*

The light, linear manner that had marked his etchings in the earlier years became modified by broad, tonal areas, providing a stronger patterning of forms and a resonance of atmospheric effects. Those stylistic and visual transformations began to appear in his prints by the time he created the dramatic renderings of industrial might in the *Gun Factory, Creusot,* and *The Lake of Fire, Charleroi* (fig. 2.11). Pennell was one of the first Americans to understand the potentialities of lithography as a medium of fine art in contrast to its earlier role as a graphic means of commercial replication. The broadly suggested illusions that it encouraged and, in Pennell's case, the powerful patterns that could be executed rapidly with lithographic crayons on paper and then transferred to stone, contributed to some of his most unforgettable prints. In 1914, he created two splendid lithographs in Germany, proofing them at the Pan Press in Berlin just before his flight from the Continent ahead of the invading armies of World War I. *The Grain Elevator, Hamburg Harbor* (fig. 2.12) was theatrically conceived with tempestuous darkness

2.10
Joseph Pennell
New York, from Brooklyn Bridge (with the
Singer Building dominating the skyline)
Etching (1908) 11 × 8⅜
Published by F. Keppel & Company
Shown in the Joseph Pennell Memorial Ex-
hibition, at the Library of Congress (1927).
Cleveland Museum of Art. Bequest of
James Parmelee.

2.11
Joseph Pennell
The Lake of Fire, Charleroi (Belgium)
Lithograph (1911) 22⅜ × 17⁷⁄₁₆
Shown in the Joseph Pennell Memorial Ex-
hibition, at the Library of Congress (1927).
Museum of Fine Arts, Boston.

composed lithographs which the
older American had been produc-
ing, after 1878, under the tutelage
of the master printer of London,
Thomas Way. Although Pennell had
dabbled in the medium as a youth,
his first involvement with the craft
as an adult artist occurred in 1893
when he and a few colleagues were
invited to a technical demonstration
by Way. The master printer carted
lithographic stones and a litho-
graphic press to the Art Workers
Guild at Barnard's Hall Inn. There,
one evening, Way coached the artists
in the making of drawings with
crayons and the transferring of im-
ages onto stones from transfer

papers. At the conclusion of the ses-
sion and on the spot, Way pro-
ceeded to print their first trials from
the stones.

Pennell was aware of the striking
successes of fine French artists. The
great Symbolist painter and print-
maker, Odilon Redon, was still
creating his enigmatic and evocative
lithographic suites and had contrib-
uted to *L'Estampe originale*. The
multicolored prints of Jules Chèret,
lithographer and master poster
designer, were being admired by
British and American poster artists
and, by the 1890s, sought eagerly
by a new group of collectors who
were caught up in the current craze
for the art of posters. Then too,
there were the color lithographs of
younger French artists, including
Bonnard, Vuillard, and Toulouse-
Lautrec, with some of the dazzling
posters of Lautrec commissioned by
English and American firms and
others considered to be "astound-
ing" designs when they were ex-
hibited in the United States.[12]

In 1895, Pennell made a point of
visiting Paris and Düsseldorf where
centenary exhibitions were being
staged in honor of the German dis-
coverer of lithography, Alois Sene-
felder. As a promoter in so many
ways, it seems inevitable that Pen-
nell was among those who urged a
similar exhibition of celebration at
the Victoria and Albert Museum in
1898, the actual centenary year.
Meanwhile, in 1896, Pennell had
made his first serious attempt with
transfer lithography in the *Alhambra*
drawings created in Spain. That
autumn, the prints, proofed by
Thomas or his son T. R. Way, were
exhibited at the Fine Art Society. Al-
though the introduction to the cata-
logue was written by Whistler, the
exhibition received little attention
and no acclaim. Pennell candidly ad-
mitted his dismay but ascribed the
negligence, in part, to a reluctance,
and even hostility, of the British to-
ward an acceptance of lithography
as a fine art medium. About then,

2.12
Joseph Pennell
The Grain Elevator, Hamburg Harbor
Lithograph (1914) 15⅝ × 15¹³⁄₁₆
Shown in the Joseph Pennell Memorial Exhibition, at the Library of Congress (1927).
Library of Congress, Prints and Photographs Division

Pennell conceived the idea that a volume on the history, art, and technique of lithography would be an opportune venture. He persuaded the publisher, Unwin, of its merits and, with Elizabeth Robins Pennell, plunged into the research and writing of *Lithography and Lithographers*, which was published in time for the centennial of Senefelder's invention. The book was released in both London and New York.[13] The few manuals on the craft of lithography that had appeared in English during the

hundred years were technical books addressed to professional lithographers of the printing trades or briefs composed for curious amateurs. The volume by the Pennells was the first work written for the edification of English-reading peoples in which there was a presentation of lithography within an art-historical context and as a printmaking medium of distinguished nineteenth-century artists. The book was another stimulating project for Pennell, one of many unflagging efforts to convince

2.13
Joseph Pennell
In the Zeppelin Shed, Leipzig
Lithograph (1914) 13¼ × 21⅝
Library of Congress, Prints and
Photographs Division.

the English and Americans of the significance of prints as art. His ceaseless lecturing and writing, and his service in behalf of American printmakers as a member of innumerable exhibition juries in Europe and the United States, made Pennell the major crusader of the time, however different in kind his promotions and persuasions were from the earlier advocacies of Sylvester R. Koehler.

Pennell's tireless efforts and his finest creative accomplishments be-

gan to diminish in the years following the outbreak of World War I He wrote in sorrow about the "death" of the old Europe and England that had offered him so many artistic opportunities, cultural attractions, social amenities, and friendships. And after 1917, when he returned to a final residency in the United States, his reactions to a changed social and industrial America led him to write and lecture with disparate extremes of bitterness and enthusiasm. Pennell was an opinion-

ated and often self-contradicting individualist. While he continued to marvel at the vast industrial complexes and skyscraper-studded cities to which he assigned a complimentary grandeur in many of his prints, he deplored the growing presence of recent immigrants and blacks who, nonetheless, as sources of cheap labor were a considerable factor in the building of those landmark structures. Moreover, he railed at the industrialists and financiers, the newly rich and powerful entrepreneurs,

2.14
Joseph Pennell
End of the Day, Gatun Lock
Lithograph (1912) 21⅞ × 16⅝
Shown at the Panama-Pacific International Exposition, San Francisco (1915).
Cleveland Museum of Art. Gift of Myron T. Herrick.

condemning them, sometimes unfairly, as insensitive and unsupporting of the fine arts. William M. Ivins, Jr., Curator at the Metropolitan Museum of Art, understood a comparable paradox of the renegade Quaker from old Philadelphia and celebrated printmaker of the Western world when, in the year of Pennell's death, he wrote that the man was a curious inversion of an extreme individualist, in that "he became the pictorial laureate of the last phase of the industrial revolution, the celebrant of the period in which the individual was lost under the size and weight of the corporate load." [14]

In the final decade of his life Pennell continued to produce prints although, more often than not, they displayed his experienced skills rather than evolving artistic growth. Despite periodic ill health, he continued to devote his limited energies to the cause of printmaking. He wrote, lectured, and taught. In 1922, only four years before his death, he took charge of the class in etching at the Art Students League and quickly improved one of the few programs of instruction in printmaking by inducing Charles Locke to offer a course in lithography and Allen Lewis to teach the art of woodcut. His stated hope—by

then a belated one—was the establishment of an "American School of Graphic Arts." [15]

Pennell was an internationally prominent figure. His prints had been honored by impressive awards, acquired by innumerable museums and private collectors in Europe and the United States, and his reputation heightened by investitures as a Fellow in august academies of many countries. Never an extreme expatriate as were other American artists, Pennell's loyalty to and deep affection for his country and colleagues were constant. His prolonged residencies in England did not diminish his continuous and deeply felt inter-

est in American printmaking which was expressed vigorously in correspondence or in action during the visits to his homeland. In Ivins's judgment, "[Pennell] did more for the future of graphic arts in this country than any one other man."[16] At one time he was described as the dean of American printmakers, an accolade for a creative artist about which there was no dispute. In quite different ways, Pennell and his wife Elizabeth Robins Pennell made contributions to the appreciation of the art of prints and the welfare of printmaking in the United States. The original works that they had acquired when writing *Lithography and Lithographers* were donated to the New York Public Library and they gave to the Library of Congress a collection of Pennell's prints as well as the Whistler memorabilia that they had assembled during the years in London. Finally, to the Library of Congress they left the generous bequest that established the Joseph and Elizabeth Robins Pennell Fund, by means of which the purchase of works by living American printmakers has been assured in perpetuity.

3

Twenty-five Years of Artistic Diversity and Professional Progress: 1905–1930

The stimulating ventures of the late-nineteenth-century American artist-etchers and encouragements of their efforts slackened as the new century began. Printmakers became less innovative and sponsors' enthusiasms for American printmaking diminished. Many of the second-generation etchers continued for years to emulate the prints of the French and Whistler and Haden. Although their conservative etchings revealed modestly individualized conceptions and personalized styles, they became latter-day heirs and, in some degree, victims of a dominating heritage handed down by the European artist-etchers who had nurtured the revival of the art in the nineteenth century. A comparable preference, and a veneration, for the works of foreign masters persisted among collectors and dealers as their interest in prints by current American etchers subsided into the routine acquisition and sale of skillfully wrought pictorials. So, a time had come for new conceptions by American printmakers who were impelled to seek different artistic goals and to temper the proliferation of prints from an aging tradition that could no longer foster fresh conceptions and progressive change.

Such interludes in the history of an art form are blessed, sometimes, by the appearance of one or more artists gifted with new ideas and talents which, in tandem, generate seminal works that bestow upon the art of a time and country an infusion of artistic vitality. Fortunately that occurred in American printmaking with reassuring frequency in the first three decades of the twentieth century. Those were years' when there emerged both artists with new ideas in printmaking and a scatter of younger collectors, curators, and less-well-established dealers who chanced the exhibition and publication of progressive and a few avant-garde prints.

In contrast to the immediate past, when almost all of the earlier American etchers and some of the wood-engravers welcomed election to the National Academy of Design as Associates or full Academicians, the first quarter of the new century was marked by artistic mavericks who were disenchanted with the conservatism of the Academy and sustained by a spirit of independence laced with intransigence. Splinter groups of progressive artists formed and reformed in opposition to established standards and practices of art organizations and rigidities of institutions during a time of contending concepts of visual styles or the choice and interpretations of subject themes. Inevitably, few of the "independent" artists were assured of a critical consensus about the merits of their creations and for some of the artist-printmakers, such as John Sloan, Max Weber, John Marin, and Edward Hopper, recognition and rewards for either their paintings or prints must have seemed exasperatingly slow in coming.

The career of John Sloan, during the first two and a half decades of the century, was linked to the forces and counterforces that were swirling in and around the art circles of New York City. His liberal social and political attitudes coupled with a then-progressive call for depicting the actualities of contemporary American urban life led him to involvement with the alliances of artistic "independents." Sloan had been a free-lance commercial artist in Philadelphia and then an illustrator for the *Inquirer* and the *Press*. A yearning to become a serious painter and the lure of New York led Sloan to a close association with Robert Henri and the "new realists," foretelling Sloan's development into an incisive recorder of the intimacies of teeming life on the streets and roofs, and behind the tenement doors of the greatest American metropolis.

As an artistic journeyman Sloan had taught himself the craft of etching with the aid of *The Etcher's Handbook* by Philip Gilbert Hamer-

3.1
John Sloan
Turning Out the Light
Etching (1905) 4¾ × 6⅞
One of the New York City Life *series. This print was among thirteen etchings offered as premium prints with a year's subscription to the [old]* Masses *(October 1913). Shown in the retrospective exhibition,* Americans at Home and Abroad: Graphic Arts, 1855–1975, *at the Elvehjem Museum of Art (1976).*
Elvehjem Museum of Art. Oscar Rennebohm Foundation.

ton, the English critic and occasional etcher.[1] The prints Sloan produced between 1888 and 1894 were a miscellany of architectural renderings, calendars, greeting cards, and other commercial items. A decade later, Sloan created fifty-three etchings as illustrations for the novels of Paul de Kock. Sloan's prints also received casual attention when five were displayed at the Universal Exposition in Saint Louis, an exhibition that was marked by the haphazard selection of works by American printmakers, both living and dead. Soon thereafter Sloan, whose powers of observation had been sharpened when he worked as a topical illustrator for Philadelphia newspapers, created the *New York City Life* prints, the ten etchings of 1905–1906. *Turning Out the Light* (fig. 3.1) was one of the unalloyed transcriptions of city life that typified the intimacy and truth of Sloan's visual documentations. On an impression of this print, once in the collection of John Quinn, Sloan inscribed "Rear 24th St.,"[2] testimony that his etchings depicted identifiable places, were selections from the abundant genre of daily life and labors of New York City dwellers, or contained a biographic

scatter of recognizable likenesses, including those of his mentor Henri and other artist friends who were decried as the "Black Gang" or members of the "Ashcan School."

During the years when Sloan was painting and etching many of his finest images of American social behavior, he managed to exhibit his work in a random way although there were very few purchases and the financial returns were shockingly meager. The earliest of the infrequent sales of the *New York City Life* etchings was in February 1906, when Henry Ward Ranger, whose artistic outlook must have been more liberal than those of his fellow painters elected to the National Academy, chanced upon a set at Sigmund Pisinger's small Modern Gallery and framing shop.[3] Later in the year, the series created a minor furor and an embarrassment for the etcher Charles Mielatz. As Secretary—the only residual officer—of the moribund New York Etching Club, Mielatz invited Sloan to display the group at the annual exhibition of the American Watercolor Society in the galleries of the National Academy of Design. The hanging of the etchings led to a charge that four of them were vulgar and a demand that

they be withdrawn, an accusation and threat that infuriated Sloan and triggered an outraged protest.[4] Finally, in 1909, a rare published compliment for his prints appeared when Charles Barrell praised Sloan's work in "The Real Drama of the Slums, As Told in John Sloan's Etchings," an article in *The Craftsman* illustrated with several prints from the *New York City Life* set.[5] Sloan made a heartening print sale the following year to John Quinn, the flamboyant and eccentric New York lawyer and friend of artists, who later served without compensation as the legal counsel for the Armory Show. Sloan received $340 for a set of his fifty-three prints illustrating the novels of de Kock, as well as several other etchings and a lithograph; Quinn also added other prints to his collection from time to time. But Sloan's lack of a good dealer and consistent market for his etchings made him willing to try more than one unusual ploy. In 1912, he designed an illustrated brochure for a mailing to sixteen hundred addressees selected from *Who's Who*, offering the ten prints of *New York City Life* and two additional etchings for $35. There were only two purchases.[6] In the same

year Sloan accepted the position of unpaid Art Editor of the [old] *Masses*, a reformist and socialist journal of opinion edited by Max Eastman. The inside back cover of the issue for October 1913 presented a premium offer which, in hindsight, seems irresistible. Reproduced in photoengraved illustrations were all ten of the *New York City Life* etchings plus three additional prints. The accompanying text informed readers of the bargain (fig. 3.2):

JOHN SLOAN'S ETCHINGS

The Original Etchings, shown in reproduction, on this page, are on plates about 5 × 7 inches, printed on imported French etching paper with good margins. The regular price of these proofs is $5.00 each.

YOU CAN HAVE ANY OR ALL OF THEM AT $2.00 EACH, PROVIDED YOU ADD TO YOUR ORDER $1.00 FOR A

YEAR'S SUBSCRIPTION TO THE MASSES

91 Greenwich Ave. – New York

(from the [old] *Masses* 5.1 [October 1913]: 23)

The "loss leader" should have attracted opportunists, if not steady subscribers, but on Sloan's personal copy of the October issue is his handwritten comment, "Not one order was received for this offer / John Sloan."[7] Of his five etchings accepted for the Armory Show, the single sale—to William Macbeth for $10—was *The Picture Buyer* (fig. 3.3), an amusing portrayal of the art dealer in his Macbeth Gallery, attentive only to a favored client whose decision about a purchase hung in the balance.[8]

The controversies about art that erupted in those years were of many kinds, but the criticism of Sloan centered on the subjects considered to be seamy realities, unworthy of fine art. *Love on the Roof* (fig. 3.4), showing a youth and a woman hanging out her husband's wash, was such a

realistic subject. It prompted Sloan to remark, "I just saw it and etched it" (from his studio window).[9]

Sloan's descriptive draftsmanship and understanding of social realities converted readily to satirical commentaries. Satire is an art of critical judgment-making that begins with a familiar reality before it is transformed, through selective or exaggerated overstatement, into a commentary of ridicule, either humorous or deadly serious. Unlike the prints of satirists such as Gillray or Daumier, Sloan's were rarely filled with scintillating wit or rapierlike thrusts. Rather, his transcriptions of realities were mild and amusing satirical restatements of eternal human frailties and follies reenacted—typified by the covey of girls who pause fleetingly in front of *The Showcase* (fig. 3.5), intrigued by a display of ladies' intimate paraphernalia, while one turns quizzically toward a woman leaning on the arm of an escort, whose fashionable conformation comes from the busks and bustles featured by the emporium of "Madame Ryanne" (at West 23rd Street and 6th Avenue).

Sloan enjoyed observing life, and responded by recreating delightful street scenes such as the three shopgirls, their arms filled with lilies, strolling blithely through an April shower on an *Easter Eve, Washington Square* (fig. 3.6). This print, and many others that Sloan created during the two decades after 1905, represents the lively urban genre that he introduced into American etchings, while preserving for us one of many settings and insights of life in New York in an earlier time.

Sloan occasionally worked in other media. Among his few relief prints were several placards announcing annual exhibitions of the Society of Independent Artists at the Waldorf-Astoria Hotel, posters that are of interest mainly as art-historical memorabilia. His random efforts in lithography reflected the

usual frustrations of artists untrained in the techniques of lithographic printing. In August 1905, Sloan acquired W. D. Richmond's late-nineteenth-century *Grammar of Lithography*[10] and, about the same time, had his first lithograph, *Goldfish*, proofed by a pressman working for *Judge*, the famous humor magazine of the period. Apparently he had a sudden vision, though unfulfilled, of becoming a leader among American artist-printmakers who might adopt lithography, and wrote to his wife Dolly, "I'm glad that I have made the first lithograph of the crowd. In case they all start, it gives me prestige, makes me the father of them. In fact I want to go it alone if possible."[11] But the difficulties of lithographic printing seemed formidable and a subsequent flurry of work in 1908, when five prints were produced, was a collaboration with Carl Moelman, a professional printer from the Ottman Lithographic Company of Elizabethport, New Jersey. Their struggles with the press and proofing were comically drawn as a lithographic cartoon on one of the stones. For the last few lithographs, made in the early twenties, Sloan turned to Bolton Brown, one of the two newly established master printers who were to assist many American artists in creating fine planographic prints.

In France or England, artists could work closely with the lithographic printers in the workshops of Lemercier and Ancourt in Paris or Thomas Way in London. But there had been no similar partnerships for printing in the United States. Impressed by the successes of the French, in 1896 Montague Marks, editor of the *Art Amateur*, sponsored an American Society of Painter-Lithographers. Beyond a few artists who attempted a handful of lithographs there was no interest and the Society foundered.[12] Lithography in this country was still burdened by the tradition of replication in ways comparable to those that ex-

3.8
George Bellows
Village Prayer Meeting, No. 2
Lithograph (1916) 18½ × 22¼
Printed by George Miller.
Shown in the exhibition, George Bellows:
Paintings, Drawings and Prints, at the
Art Institute of Chicago (1946).
Santa Barbara Museum of Art. Gift of
Mr. and Mrs. John D. Graham.

3.9
George Bellows
The Sawdust Trail
Lithograph (1917) 25½ × 20
Shown in the exhibition, George Bellows:
Paintings, Drawings and Prints, at the
Art Institute of Chicago (1946).
Elvehjem Museum of Art. Department of
Art History Purchase.

Ashby "Billy" Sunday were traveling spectaculars. A baseball player turned evangelist, Billy Sunday barnstormed across America drawing unprecedented crowds during his campaigns for Christ. In January 1915, the *Metropolitan Magazine* sent Bellows and John Reed, the radical writer, to report on Sunday's revival meetings in Philadelphia. *The Sawdust Trail* (fig. 3.9), a ribbon of wood chips blanketing the dirt floor of the great tabernacle, alluded to the path to Billy's blessing—and salvation. At the front of the stage, between the table for the press corps and the display of gifts from devoted followers, Sunday leaned down to grasp the hand of a skid-row bum as attendants and friends offered support to the converts overcome by the emotions of the moment. A choir filled the pavilion with hymns of praise, its anthems rising to the loft of the wooden tabernacle where a great banner proclaimed CHRIST FOR PHILADELPHIA—PHILADELPHIA FOR CHRIST.

The flamboyant histrionics of the evangelist were dramatized in a second lithograph, *Billy Sunday* (fig. 3.10). Leaping upon the makeshift tables built for the callous, but ever-present, members of the working press, Billy threw out his accusations of sin and challenged the throng to be saved. During Sunday's crusade in Philadelphia, 41,724 "came forward" for Christ.

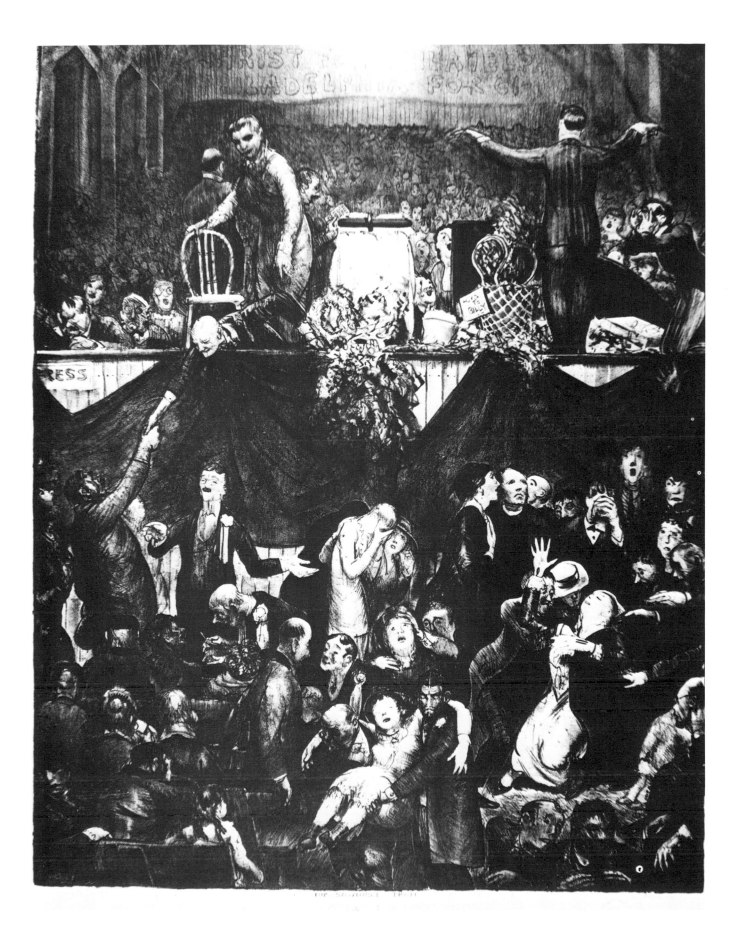

3.10
George Bellows
Billy Sunday
Lithograph (1923) 8¹⁵⁄₁₆ × 16³⁄₁₆
Countersigned by the master-printer,
"Bolton Brown imp."
Shown in the exhibition, George Bellows:
Paintings, Drawings and Prints, at the
Art Institute of Chicago (1946).
Cleveland Museum of Art. Gift of
Leonard C. Hanna, Jr.

None of Bellows's lithographs of American religion were complimentary and most became scathing commentaries on moral hypocrisy, especially *The Spiritual Potentate* of the Anglican Church or a *Benediction in Georgia* bestowed upon black prisoners of a chain gang. Bellows also expressed his deep distaste for Billy Sunday and his evangelistic demagoguery in words, "Do you know, I believe Billy Sunday is the worst thing that has ever happened to America? He is against freedom, he wants a religious autocracy, he is such a reactionary that he makes me an anarchist." [19]

Bellows had been a successful illustrator for New York periodicals before John Sloan, upon accepting the art editorship of the [old] *Masses*, persuaded him to contribute to the struggling liberal journal. Between 1913 and 1917 twenty-five drawings by Bellows were published, some of them serving as prototypes for the subject-matter themes and compositions of later lithographs. [20] In July 1913, *Splinter Beach* (fig. 3.11) appeared in the

Masses as a drawing of frolicking boys loafing, quarreling, and swimming that had been anticipated by Bellows in two earlier paintings, the *River Rats* (1906) and *Forty-Two Kids* (1907). Three years after the drawing was published, the composition, reversed, was converted into *Splinter Beach*, the lithograph. Bellows described the action and locale as ". . . bathing urchins under Brooklyn Bridge . . . ," with a stubby tugboat plying waters of the East River. Then with a lithographer's needle he scratched his name into the section of the stone that represented the pilothouse, feigning, for his own amusement, "Bellows" as the name of the small harbor craft. [21]

Identifications of people, place names, or locales offer dimensions of interest in works of art that increase their attractiveness to viewers or prospective purchasers. Many of Bellows's prints displayed personalities and places in the lithographs of prizefights, and none more dramatically than in his reconstruction of the Luis Firpo–Jack Dempsey

splinter Beach Geo Bellows

3.11
George Bellows
Splinter Beach
Lithograph (1916) 15 × 19¾
The composition, in reverse, was first published as a drawing in the [old] Masses *(July 1913).*
Los Angeles County Museum of Art. Gift of Mr. and Mrs. Ira Gershwin.

match at the Polo Grounds when the "Wild Bull of the Pampas" knocked the "Manassa Mauler," and World Champion, through the ropes. The incident was shocking and was compounded by controversy as to whether a spectator had helped Dempsey back into the ring. The match was reported and argued on sports pages everywhere, which increased the topical appeal of Bellows's print.

Earlier in the century, public prizefights were illegal in New York and *A Stag at Sharkeys* (fig. 3.12) was Bellows's recollection of a "private" event in one of the old boxing clubs. Tom Sharkey, former fighter and Westside saloonkeeper, promoted bouts in the back room, using the subterfuge that they were

legitimate events for "dues-paying members of a club" though, in truth, anyone who patronized the saloon on a boxing night could attend the fight. A "stag night" was for men only. Bellows's print showed an exhibition of boxing that deteriorated into a brawl between ponderous heavyweights. The darkened arena, the lusty ringside crowd, and the spotlighted pugilists recreate the vivid atmospherics of an American genre that was familiar to sport enthusiasts anywhere—New York or Kansas City alike.

Although Bellows had once created an admirable etching of a studio—*Robert Henri's Night Class*, with the members at their easels painting the nude model—he favored lithography which satisfied

3.12
George Bellows
A Stag at Sharkeys
Lithograph (1917) 18¾ × 23¾
Printed by George Miller.
Shown in the exhibitions, George Bellows: Paintings, Drawings and Prints, at the Art Institute of Chicago (1946), and George Miller and American Lithography, at the National Museum of American Art (1976).
Achenbach Foundation for Graphic Arts, the Fine Arts Museums of San Francisco.

more readily his preferences for a broad kind of draftsmanship, frequently combined with a pervasive chiaroscuro of atmospheric lights and darks. The responsiveness of the medium to Bellows's varying needs for dramatic effects—sensations of power and strength, luminous clarities, or linear simplicities—was a demonstration to other American artist-printmakers that lithography could serve well in achieving splendid coalescences of content, style, and technique.

In contrast to the long struggles for recognition that plagued John Sloan and Edward Hopper, the sudden artistic success of Bellows marked him as an extraordinarily young "master." In 1907, only three

years after his arrival in New York from Columbus, his painting *River Rats* was accepted for the spring exhibition at the National Academy of Design and, in 1908, some of his paintings were purchased for the permanent collections of the Pennsylvania Academy of the Fine Arts and the Metropolitan Museum of Art. In 1909 he was elected the youngest Associate in the history of the National Academy. Soon after he adopted lithography in 1916, his prints began to command a comparable attention. With great alacrity, F. Keppel & Company arranged a display in 1918 and, during the next year, Albert Roullier in Chicago and the Doll & Richards Gallery of Boston featured exhibitions

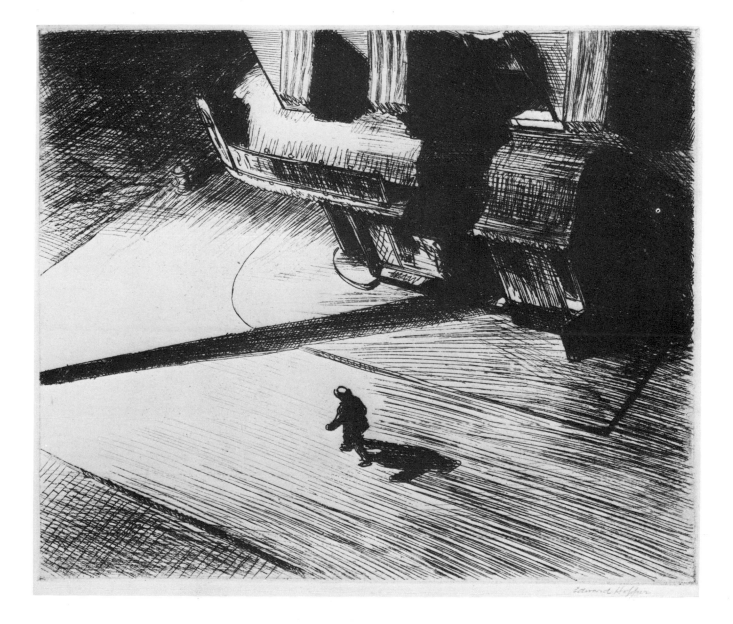

James Smillie, and the Morans, or the realities of American life and urban settings recreated by Sloan, Bellows, and Hopper, Davies conjured up figures and landscapes, at once remote, poetic, and ageless. As in his paintings, allegorical imagery predominated and the idealized nudes that were even more prominent in the lyrical landscapes of the prints assured an evocation of timeless realms. They were features rarely found in American printmaking of any period.

William Macbeth, the dealer, sponsored Davies as early as 1893

and, shortly thereafter, persuaded Benjamin Altman, the New York merchant, benefactor, and collector, to finance the artist's first visit to Europe. Davies must have observed that Whistler and, to a greater degree, the French were proving by their prints and posters that lithography was a process with which brilliant works of art could be created. And Davies, always willing to try a variety of historical techniques, added the medium to his repertoire by some early printmaking in lithography (fig. 3.20), technical ventures that were unusual though not

3.18
Edward Hopper
Night Shadows
Etching (1921) 6⅞ × 8³⁄₁₆
In 1924, this etching and five other originals by American printmakers were offered as a portfolio with a year's subscription to the New Republic, *all for $9. Shown in the retrospective exhibitions, American Printmaking: 1913–1947, at the Brooklyn Museum (1947), and Americans at Home and Abroad: Graphic Arts, 1855–1975, at the Elvehjem Museum of Art (1976). Elvehjem Museum of Art. Anonymous Fund.*

3.19
Premium advertisement of six original etchings and a year's subscription to the *New Republic* 41.526 (31 December 1924): III.

unique for an American painter in the late nineteenth century.

Macbeth mounted a one-man show for Davies in 1896 and, for several decades thereafter, his oils, watercolors, and prints were sought by collectors who were unacquainted with or unprepared to accept either the frank realism espoused by Henri and his followers or the radical directions taken by the post-Impressionists and early-twentieth-century avant-garde European artists. Most critics, reflecting the cautious tastes of all but a few American collectors, ranked Davies as one of the country's foremost painters, a judgment marked especially by the writings of Royal Cortissoz and James Huneker. Huneker, a critic of music, literature, and art, was an internationally admired essayist. In *The Pathos of Distance* he paid homage to "Arthur B. Davies: A Painter-Visionary" and in *Unicorns* he included a charming essay, "In Praise of Unicorns." Ambivalent imagery of visionary worlds, ephemeral yet timeless, led Davies to the creation of *The Unicorns*, a precious painting of elegant allegory that was hailed by critics and acquired by Miss Lillie Bliss as an ornament for her collection of contemporary art. And Huneker's praise of visionary imagination was easily bestowed upon Davies's conceptions. Thus, in 1918, the privilege was granted to reprint Huneker's "In Praise of Unicorns" as the prelude to the catalogue of prints and paintings exhibited at the Macbeth Galleries.[28]

As one might infer from his art, Davies was a dignified, charming, and very private person. To the astonishment of his unsuspecting fellow artists, he had considerable powers of persuasion and unusual organizational abilities that were revealed brilliantly by his energetic leadership on behalf of the Armory Show of 1913 and its large quota of controversial exhibits of avant-garde European paintings and sculptures. Although hardly a radical, Davies admired contemporary European art, understood the threads of its historical development, and became a persuasive advocate to American patrons including Miss Bliss and other ladies. Earlier he had joined artists who opposed the rigidities of the National Academy of Design. In 1907, he became a member of "The Eight," who shared a bond of

3.20
Arthur B. Davies
The Picnics
Lithograph (1895) 5¼ × 9
New York Public Library, Prints Division.

artistic independence. Davies was a founder, and then president, of the American Association of Painters and Sculptors, the league of independent-minded artists committed to the promotion, exhibition, and selling of progressive American art. Paradoxically, the major effort of the association during its short existence was a diversion from its avowed purposes, engineered by Davies, Walt Kuhn, and Walter Pach in their determination to assemble, as a substantional portion of the Armory Show, the most comprehensive array of modern European art ever displayed on either continent.[29]

The reactions of the public and critics to the avant-garde art objects were mixed but mostly derisive, while those of some American artists were bitter. Jerome Myers, painter, printmaker, and member of the association, recollected that, ". . . Davies had unlocked the door to foreign art and thrown the key away. Our land of opportunity was thrown wide open to foreign art, unrestricted and triumphant; more than ever before, our great country had become a colony; more than ever before we had become provincials."[30]

American artists received considerable representation, but prints were given scant attention. A few prints by Pach, Sloan, Weir, and Frank Nankivell, were displayed, as well as three etchings by Charles H. White that were uninvited but accepted after a review by the committee on American art. The European section of the Armory Show, with works by Matisse, Brancusi, Braque, Picasso, and Duchamp, generated shock waves and long-lasting reverberations. Even Davies was to be influenced, although briefly, when he dabbled in a manner of Cubism in some of his works. The drypoint of 1917, *Bathing Woman and Servant* (fig. 3.21), was among those that were digressions from his usual conceptions and style. Davies created it during a time when his interest in printmaking was reviving. In 1916,

Kuhn had urged him to create a few prints that could be invited for display in the third annual exhibition of the New York Society of Etchers at the Montross Gallery. The seven drypoints that Davies produced quickly must have stimulated him to continue and, in 1918, he displayed twenty-four prints in the one-man exhibition at the Macbeth Galleries, most of them filled with the visionary and poetic features that had become the touchstones of his art.

Both 1920 and 1924 were productive years of printmaking for Davies and among the gracious allegories, mythologies, and nudes was *Maenads* (fig. 3.22), an aquatint with allusions to the maidens who attended Bacchus, the god of wine.

3.21
Arthur B. Davies
Bathing Woman and Servant
Drypoint (1917) 6⅛ × 3½
Shown in the exhibition of Davies's works at
the Macbeth Galleries (1918).
Art Institute of Chicago. Gift of Emily
Crane Chadbourne.

by Davies's biographer, Frederic Newlin Price of the Ferargil Galleries, or Carl Zigrosser of the Weyhe Gallery, who knew Davies and purchased prints for his personal collection.[31] Zigrosser, in proposing titles with seeming correspondences, chose *Pleiades* (fig. 3.23) for the print of seven maidens—implying a connection with the Greek myth of the daughters of Atlas who were pursued by the giant hunter Orion and, after death, miraculously transfigured as seven stars and transported to the vault of the firmament near the constellation Orion.

Lithography and etching/aquatint combinations were the media of preference for Davies, but more than any other American printmaker of the time he tested a range of other techniques including drypoint, mezzotint, woodcut, linocut, and, in late works, the color aquatints and lithographs that were displayed at the Weyhe Gallery in 1922.[32] Davies relied frequently on the assistance of master-printers. Ernest Haskell and Frederick Reynolds, respected etchers in their own right, printed many of his intaglios; the aquatints of the early twenties were pulled from the plates by Frank Nankivell, his artist-friend and an excellent etcher. Many of the lithographs were assigned to George Miller whose shop, at one time threatened by lack of funds, received a timely advance from Davies.[33] Others were consigned to Bolton Brown who, more prideful of his abilities than most master-printers, countersigned impressions of Davies and Bellows with the penciled inscription "Imp[rimé]. Bolton Brown."

The descriptive realism that was so important to printmakers who sought to identify the social milieu and visual environment of the United States held no interest for Davies. And neither the modest abstraction with which he composed his visionary images nor his toying,

The idealized nudes and imaginary landscape of *Maenads* became more illusory in a veil of color when the aquatint was printed on sheets of seventeenth-century "Venetian blue" paper that Davies had acquired somehow and then turned over to Frank Nankivell, etcher and masterprinter, who pulled and countersigned the brilliant impressions of the edition. In a manner akin to Odilon Redon, for whom Davies had great admiration, his titles were frequently enigmatic or ambiguous. Moreover, after his death, prints without captions were given them

3.22
Arthur B. Davies
Maenads
Aquatint (1920) 7⅞ × 10⅞
Printed and countersigned by Frank Nankivell.
Shown in the exhibition of prints by Davies at the Albert Roullier Art Galleries (Chicago, 1921).
Madison Art Center. Langer Collection.

3.23
Arthur B. Davies
Pleiades
Soft-ground etching/aquatint (1919)
6 × 7⅞
Shown at the Weyhe Gallery (1919) and assigned the title Pleiades *by Carl Zigrosser.*
Philadelphia Museum of Art. Harrison Fund Purchase.

for a time, with the more extreme kind of abstraction conceived by the Cubists placed his prints in the vanguard of modern trends that were being cultivated by other Americans. Major strides toward abstract concepts and styles, tempered with personalized and Expressionistic content, were taken more boldly by Max Weber and John Marin. The very early etchings that Marin created while in Europe between 1905 and 1911 revealed his artistic debts to Whistler's style and skills or the visual shorthand in picturesque renderings that Pennell and other turn-of-the-century etchers had exploited in thousands of European architectural panoramas or vignettes. On the other hand, a few of Marin's early etchings bore hints of an unleashed verve, as in his unorthodox treatment of the cathedral of Rouen (fig. 3.25). They were forecasts of the radical transcriptions of the skyscrapers, bridges, and cityscapes of New York which his later prints contributed to the emerging multiplicity of features in American printmaking.

After a brief career in architectural offices, Marin turned to a casual and unrewarding study of art at the Pennsylvania Academy and the Art Students League.[34] Then in 1905, with some diffidence and at the advanced age of thirty-four, he sailed for Europe with a copy of Sylvester R. Koehler's translation of the old and celebrated manual by Maxime Lalanne, *A Treatise on Etching*, in his luggage.[35] Within a year the Louis Katz Art Galleries in New York and Albert Roullier in Chicago were selling Marin's views and landmarks of Amsterdam and Venice, as well as Paris and other French cities. By 1908 they were undoubtedly delighted, as dealers would be, that some of the prints enjoyed notice when original impressions were inserted, or etchings were reproduced, in *L'Art Décoratif* and the *Gazette des Beaux Arts*.[36] They were handsome graphics but generally re-

flected the conventional conceptions that were found in the prints of the junketing American etchers favored by Roullier and Katz.

Chartres Cathedral (fig. 3.24) was one of many etchings by Marin that the Albert Roullier Art Galleries had published, stocked, and then promoted in an *Illustrated Catalogue of Etchings by American Artists*. H. H. Tolerton, the Chicago critic, was the author of the catalogue commentaries which noted that *Chartres Cathedral* was ". . . considered by many critics as one of the best renderings in black and white that has been made of that beautiful edifice."[37] Even before the admired view of Chartres had been etched, harbingers of change emerged in some of Marin's prints. In *Cathedral, Rouen* (fig. 3.25) he reduced substantially the usual picturesqueness and tectonics in conventional treatments of great Gothic buildings, substituting a more ephemeral illusion by the skein of strokes which he scored spontaneously and vigorously into the etching ground with the needle. The *Cathedral, Rouen*, or a similar print, was probably the etching of dispute when Marin, upon meeting Alfred Stieglitz in Paris, was led to recall that, "When my dealers, Roullier in Chicago and Katz in New York were here recently and saw this, they threatened to discard me if I did any more wild stuff like it."[38] The "wild stuff" that troubled the conservative dealers was an early and modest aberration and, soon thereafter, Marin set forth on a pathway of infinitely more radical direction.

Alfred Stieglitz, a great photographer, became a crusader for avant-garde art by 1907, two years after he opened the Photo-Secession Gallery at 291 Fifth Avenue. In an exhibition program of modern art that antedated the notorious Armory Show, "291" became a center for displays of controversial works by contemporary Americans—Marsden Hartley, Arthur B. Carles, Abra-

ham Walkowitz, Arthur Dove, Alfred Maurer, Max Weber, and Marin—interspersed with presentations of Cézanne, Matisse, and Picasso. Marin received mounting support from Stieglitz after the artist's return to America in 1911. Unquelled, and in reaction to the sensory stimulations of a tumultuous New York, Marin converted the simmering verve of early prints to dynamic artistic metaphors in his etched views of avenues, bridges, and skyscrapers—notably so in *Woolworth Building (The Dance)* (fig. 3.26). And when Cass Gilbert dropped in at "291" he was stunned into speechlessness upon seeing a version of his internationally famous architectural triumph transformed into a reeling apparition in a cityscape made frenzied by the intensities of Marin's new interpretations.[39] Few printmakers had ever envisioned a city with comparable subjectivity and the etchings that Marin created in 1915 had no contemporary counterparts in the printmaking of France or America. The prints of that year alone reveal a wide range of expressive transcriptions of familiar New York landmarks. The sinuousness assigned to the Gothic shapes in his etching of *Trinity Church Yard* (fig. 3.27) or the collisions of man-made structures below a symbolic sunburst in *Brooklyn Bridge from Brooklyn (The Sun)* (fig. 3.28) were emotional responses and artistic restatements that would have been incomprehen-

3.24
John Marin
Chartres Cathedral
Etching (1910) 11¹⁵⁄₁₆ × 9
Published by the Albert Roullier Art Galleries.
Shown in the retrospective exhibition, Americans at Home and Abroad: Graphic Arts, 1855–1975, at the Elvehjem Museum of Art (1976).
Elvehjem Museum of Art. Mark and Katherine Ingraham Fund.

3.25
John Marin
Cathedral, Rouen
Etching (1909) 9⅞ × 7⅞
*Published by the Albert Roullier Art
Galleries.*
Art Institute of Chicago.

3.26
John Marin
Woolworth Building (The Dance)
Etching/drypoint (1913) 12¹⁵⁄₁₆ × 10⅞
*Shown in the traveling exhibition, Fifty
Prints, sponsored by the American Institute
of Graphic Arts (1926), and the retro-
spective exhibition, The Print in the United
States from the Eighteenth Century to the
Present, at the National Museum of
American Art (1981).*
*Minneapolis Institute of Arts. Dunwoody
Fund.*

sible to those who admired New
York City for the spreading pan-
orama of its skyline as had Pennell
in his etching of *New York from
Brooklyn Bridge* (fig. 2.10).

Stieglitz, who provided Marin
with a modest subvention so that he
could create without the usual finan-
cial concerns or the often-oppressive
pressures for productivity, assumed
the role of patron-agent as much as
that of a dealer. He kept first-choice
impressions for his personal collec-
tion and, never having a spacious
gallery, "farmed out" Marin's etch-
ings for exhibitions—thirty-three of
the European prints at Kennedy &
Company in 1911 and thirty-one,
including New York City subjects, at

the Weyhe Gallery in 1921.[40] Surely
Stieglitz must have approved the
publication of Marin etchings in the
New Republic's portfolios that were
awarded to subscribers in 1924 and,
as well, agreed to the steel-facing of
Marin's plates—*Downtown, the El*
(fig. 3.29) and *Brooklyn Bridge*—be-
fore the portfolio impressions were
printed by Peter Platt.[41]

During the few years before and
after 1920, when Bellows, Hopper,
Davies, and Marin were creating
their most important prints, little
notice was taken of the woodcuts of
Max Weber despite the display of
samplings in his one-man shows.
Perhaps the silence was a conse-
quence of the unpretentious manner

3.28
John Marin
Brooklyn Bridge from Brooklyn (The Sun)
Etching (1915) 10¾ × 12¹³⁄₁₆
Published by Alfred Stieglitz.
Art Institute of Chicago. The Alfred
Stieglitz Collection.

3.27
John Marin
Trinity Church Yard
Etching (1915) 9¹³⁄₁₆ × 7⅞
Published by Alfred Stieglitz.
Art Institute of Chicago. Gift of Georgia
O'Keeffe for the Alfred Stieglitz Collection.

with which he ventured into print-making, the diminutive sizes of his relief prints, and the minor role they had in his exhibitions. But it was more likely that the claim for attention warranted by the prints was ignored amidst the harsh critical appraisals that swirled around his paintings and the controversies evoked by the several radical concepts that he had been introducing into American art, one after another, following his return from Paris in 1909. Weber was a determined advocate of a variety of modern trends in his poems and essays as well as his paintings, prints, and sculptures. His admiration for the art of Cézanne, the color of Matisse

and the Fauves, the compositions of Cubism and Futurism, and the simplicity of primitive arts were integrated into works that Weber reduced to extreme abstractions or filled with a personalized Expressionism that also reflected the dizzying pace of change in the arts of Europe. Edward Steichen, the photographer, was one of the young American rebels with whom Weber had become acquainted in Paris. At the time, Steichen was acting as an artistic scout for Stieglitz and his commendations of the works of Weber, as for those of Marin, had assured exhibitions at the "291" gallery.

Personal incompatibilities caused

3.29
John Marin
Downtown, the El
Etching (1921) 6¹⁵⁄₁₆ × 8¹³⁄₁₆
In 1924, this etching and five other origi-
nals by American printmakers were offered
as a portfolio with a year's subscription to
the New Republic, *all for $9.*
Milwaukee Art Museum. Acquisition
Fund.

Stieglitz and Weber to sever relations in 1911. Weber, who could be stubborn, refused in 1913 to exhibit in the Armory Show because the committee for the selection of American art voted to hang only two of his paintings rather than the eight that Weber felt he deserved. Weber's self-evaluation was that he was the most prominent representative of modern art among American artists.[42]

In 1914, Weber's small volume called *Cubist Poems* was published in London and, in 1918, *Essays on Art* was printed in New York. The literary excursions were followed by another digression from painting and sculpture with the creation of small woodcuts, some possibly as early as 1918. They added to the variety of American printmaking with their novel rough cuttings and bold images. Moreover, Weber produced the prints by rudimentary processes. Weber later ascribed his procedures to an ignorance of simple woodcut tools and techniques and a spirit of experimentation. One is tempted to believe, however, that he had reasons such as economy or a con-

templation of concordance between the rudeness of processes and the starkness of designs. He chose cherry or pine for some of the woodcuts. For others he used the thin basswood slips—with which frames were made for collecting comb honey in beehives in those days—then cut the images into the soft basswood with an ordinary penknife. Any of the four pieces of the frames restricted the woodcuts to small sizes and when Weber used the carved horizontal parts of comb-honey frames, for *Mother and Child* (fig. 3.30) or other relief cuts, the formats of the prints were recessed along the sides. Moreover, he was content with a crude process of printing. On the floor of his studio he laid the paper on a soft cloth, then transferred the impression by placing a book over the back of the wood slip and pressing the whole thing with his foot. Some were color impressions and Weber varied the chromatic choices for each print when he applied artists' oil colors to the thin wood "blocks" with his fingertips.[43]

Weber's prints bore unmistakable

similarities to contemporary European art. A few had effects that resembled the light, open compositions of the last relief prints created by Paul Gauguin at the turn of the century. The arts of primitive cultures that were assimilated in compositions by Picasso and some of the German Expressionists also were reflected in the design idioms of *Head* (fig. 3.31) and other early woodcuts by Weber. The radical features of such prints also had contemporary correspondences to the *Kristus* portfolio by Karl Schmidt-Rottluff who, in 1918, had published his severe woodcut images of Christ, Mary, and Peter in symbolizations of New Testament tales and miracles. Weber's temporary involvements with Cubist painting had their counterparts in several of the woodcut compositions, among them *Portrait* (fig. 3.32), which was one of nine prints reproduced as decorations on random pages of the little magazine *Broom* in 1922.[44] At best, it was a modest gesture of approval by the American editors of the small-circulation, short-lived literary journal then being published in

Rome. Although the woodcuts were slighted—the titles were not given, nor did Weber's name appear with some of the prints in *Broom*—still, he was in good avant-garde company when the editors featured woodcuts by the French moderns, Léger and Lurçat.

In 1920, the Montross Gallery exhibited Weber's sculpture with a selection of his woodcuts and he was pleased when his fellow artist, Arthur B. Davies, purchased several of the prints. But Weber's high regard for his own paintings and, presumably, woodcuts must have led him to place unusually steep prices on the latter. In 1925, Henry McBride, taken aback by Weber's lack of sales, sought comparisons in the print market. He scolded Weber for his prohibitive prices and wrote with dismay of the continuing sales successes of the venerable, and still popular, Pennell: ". . . when I asked a well-known dealer in prints which of his men sold best, he replied, and not much to my surprise, 'Oh, Joseph Pennell, by long odds.' . . . I was almost scandalized at the round figures my dealer said Mr. Pennell earns each year. . . ."[45] McBride's statement was in a rare and almost offhand notice of Weber's woodcuts dropped into one of his monthly reports on "Modern Art" for the *Dial* magazine. Belatedly, a few Weber impressions, especially those with color, were acquired for museum print rooms, though thirty years passed before the woodcuts first received deserved attention in 1948 in an article by Una Johnson of the Brooklyn Museum.[46] Finally, in 1956, the Weyhe Gallery organized an exhibition of Weber's relief prints accompanied by a deluxe catalogue published in an edition of twenty-five copies.[47] By those late dates, however, the singularity of style and techniques that the woodcuts had once represented in American printmaking by their stark designs, rough cuttings, and additions of color was diminished by a rich array of

modern relief prints created in midcentury.

Weber penciled salutations to Zigrosser on several prints, such as "To my old friend Carl Zigrosser with affection—from Max Weber" on *Head* (fig. 3.31). Rockwell Kent inscribed "To Carl" on an impression of *Northern Night* (fig. 3.34) and other printmakers added longhand testimonials on prints in gratitude and high regard for Zigrosser, the distinguished curator, scholar, and author. In the wake of his professional activities, Zigrosser also enjoyed a connoisseurship in behalf of his own collection of American prints and drawings. As a young man, Zigrosser had become a knowledgeable dealer at the gallery of E. Weyhe where he initiated exhibitions and urged the sale of prints by contemporary artists. In his mature years, as Curator of Prints and Drawings at the Philadelphia Museum of Art, Zigrosser acquired landmark prints for its collection and, among his many books on prints, wrote the scholarly *catalogues raisonnés* on the graphic works of Edward Hopper and John Marin. Although an admirer of prints of all cultures, for half a century his devotion to the art of American printmaking received additional nourishment from the friendships of leading printmakers.

Among the many artists whose prints Zigrosser sponsored at the Weyhe Gallery and to whom he gave personal encouragement was Rockwell Kent who acknowledged that the "fruit of my friendship with Carl Zigrosser was to be my wood engraving."[48] In late 1918, when Kent and his young son set forth for a winter in the wilderness of Fox Island off the Alaskan coast, Zigrosser furnished him with wood blocks and engraving tools, confident that Kent's draftsmanship possessed incisive characteristics that could be transposed effectively into relief printing. Although only two small blocks were cut at Fox Island,

3.30
Max Weber
Mother and Child
Color woodcut (ca. 1919) 4½ × 2
Shown in the retrospective exhibition, Max Weber: Prints and Color Variations, at the National Museum of American Art (1980).
National Museum of American Art (formerly National Collection of Fine Arts), Smithsonian Institution. Museum Purchase.

3.31
Max Weber
Head
Woodcut (ca. 1919) 4¼ × 1¹⁵⁄₁₆
Shown in the retrospective exhibition, Max Weber: Prints and Color Variations, at the National Museum of American Art (1980).
Philadelphia Museum of Art. Gift of Carl Zigrosser.

they were the first of the many wood-engravings that were to be eagerly sought as book illustrations and ornaments, institutional advertisements and logos, or, as fine prints in their own right, for private and public collections.

Kent was of the same generation as Weber, Hopper, and Bellows, but his prints bore little resemblance to those of the other three. Kent was critical of the kinds of European abstractionisms advocated by Weber and, although he voiced admiration for Henri's avowed realism, he rejected the genre of America as recorded by Bellows, Hopper, and

Sloan in favor of symbolic images of man, ideally conceived, or the romantic allegories of man amidst the vast, elemental reaches of remote lands and seas of the world—Greenland, Tierra del Fuego, Alaska. Frequently, he reduced the images in his wood-engravings to a single figure (fig. 3.33) as a metaphor of one or another of humanity's fundamental experiences or recurring destinies. Kent also starkly symbolized the harsh forces of nature or the frozen wastes of the earth against which man struggles and prevails as in *Northern Night* (fig. 3.34) where the sleeping figure finds shelter in shielding rocks of granitic mountain ranges surrounded by arctic seas.

Naturalistic details that were sublimated in Kent's paintings were distilled further in the wood-engravings by simple compositions and terse contrasts of blacks and whites. The precise manipulations of engraver's tools on end-grain blocks and the clarity of his images lent themselves to reproductions for handsome letterpress printing. He received, therefore, innumerable commissions as an illustrator of limited-edition books, his own adventure volumes, or sophisticated prints for corporate advertisements —notably the twelve for the American Car and Foundry Company including *Bowsprit* (fig. 3.35)—wood-engravings Kent thought were among his best.[49] The prints of no other American wood-engraver of the late twenties and early thirties were more publicized, but an appreciation of their merits was not unanimous. John Cotton Dana, Director of the Newark Museum of Art, wrote to Kent, "I never cared much for your wood engravings, though by jingo, I have bought them for our collection; for I take particular pains in these days,—being an old man and well behind the times!—to act as a librarian and a director of a museum should, and am especially keen on buying things that I disapprove of."[50]

3.32
Max Weber
Portrait
Color woodcut (ca. 1919) 4½ × 1⅞
Reproduced as a black-and-white page decoration in Broom *(August 1922).*
Museum of Modern Art, New York. Gift of Abby Aldrich Rockefeller.

The popularity of Kent's prints and the many reproductions of them that appeared in a broad array of books, periodicials, and advertisements tended to overshadow the accomplishments of Rudolph Ruzicka, John J. A. Murphy, Allen Lewis, and J. J. Lankes whose relief prints were admired with less fanfare. Lankes created a multitude of woodcut and wood-engraved landscapes with some serving as attractive book decorations, as were those published in the limited edition of the poem "New Hampshire" by Robert Frost.[51] All of Lankes's prints were conservative in con-

ception and revealed his personal preference for a heaviness of woodcutting style even when he collaborated with Charles Burchfield, the gifted painter of watercolors, who furnished designs while Lankes incised the blocks. Henry McBride, always lavish with praise of Burchfield's art in the columns he wrote for the *Dial*, must have sponsored the reproductions of those collaborative prints as special inserts in the literary magazine. One of the three, *Carolina Village* (fig. 3.36), was chosen for the "modern" section of *Fifty Prints* in 1926 during the years when the American Institute of Graphic Arts sponsored annual exhibitions under the same title and arranged their tours to museums and galleries across the country.[52]

By the end of the third decade, the modest flourishing of relief prints as illustrations for books and periodicals, and the prominence of Kent's wood-engravings, led to an appraisal by Frank Weitenkampf, Curator of Prints at the New York Public Library, that unlike contemporary American lithography, "A more hustling competitor [to etching] is woodblock, which just now [1930] has the public eye."[53] But Weitenkampf's assessment in "American Lithography of the Present Day" was not an up-to-date report and his assertion that ". . . one hesitates to say that it [lithography]

3.33
Rockwell Kent
The Angel
Wood-engraving (1926) 4¹³⁄₁₆ × 6⁵⁄₁₆
Some impressions of this print served as
"GREETINGS FROM THE HOUSE OF
WEYHE MCMXXVI / *Woodcut by Rockwell
Kent, printed from the original block."*
*Elvehjem Museum of Art. Brittingham
Fund.*

To Carl. 1930 *Rockwell Kent.*

3.34
Rockwell Kent
Northern Night (N by E)
Wood-engraving, with a linoleum tint-
block printed in light gray (1930)

5⁹⁄₁₆ × 8⅛
*Philadelphia Museum of Art. Lola Downin
Peck Fund purchase from the Carl and
Laura Zigrosser Collection.*

has definitely 'arrived' here . . ." suggests that conservative preferences led him to ignore the progressive lithographs of Jan Matulka (fig. 3.37), Albert William Heckman, Charles Sheeler (fig. 3.38), Wanda Gág, Birger Sandzen, Abraham Walkowitz, and Louis Lozowick. A more liberal view would have discerned that the growing diversity in printmaking was continuing and artists were choosing any of the intaglio, planographic, or relief media that proved technically compatible with their conceptions. Weitenkamp, however, correctly implied that etching was the most popular medium, especially for the greater number of printmakers whose styles

in the 1920s were elaborations of a graphic vision well tested by the conservative tradition. In the far West, Roi Partridge was etching the mountains and valleys surrounding San Francisco. George Elbert Burr, while in Denver, depicted nearby *Bear Creek Canyon* (1922) and later, from Phoenix, set forth to etch the missions and landscapes of the Arizona and California deserts. Ernest Haskell roamed in search of landscapes from Maine to the mountainous West where he created *The Mirror of the Goddess* (fig. 3.39) and *The Sentinels of North Creek*, the latter selected for the *New Republic* portfolio in 1924. Among etchers in the East, Frank W. Benson had his

wildlife prints hung in almost every comprehensive exhibition of living printmakers. And Childe Hassam, who began etching in earnest with the advice of Kerr Eby in 1915, became an eminent exponent of luminous impressionism in prints. His views of the picturesque village of Cos Cob, Connecticut, and the ephemeral shadows and lights with which he dissolved the domestic architecture were a delight to the eye, as was his print of 1922, *House on Main Street, Easthampton* (fig. 3.40). This etching was selected a quarter of a century later for the retrospective exhibition called American Printmaking: 1913–1947 assembled by the American Institute of

Graphic Arts. Moreover, the conservatives, old or young, continued to organize or join etching societies across the country as leagues which were most successful in the promotion of exhibitions.

There were several technical virtuosi among the etchers, including Kerr Eby and John Taylor Arms, who were friends with neighboring studios near Fairfield, Connecticut. Eby etched the lovely New England countryside in all seasons, and also subjects rare among our printmakers —combat in war-torn Europe, recomposed from his eyewitness drawings. A memorable etching dramatized the first independent action of Americans led by General "Black

Jack" Pershing, an assault against a German salient in the Meuse Valley. *September 13, 1919—St. Mihiel* (fig. 3.41) was the second day of the grim battle with mired, horse-drawn artillery and an endless line of infantrymen slogging toward the front that lay beyond an oppressive sky and mutilated landscape.

John Taylor Arms had been trained as an architectural draftsman. But following wartime duty as an officer in the navy he turned to printmaking and, from 1919 on, received awards that honored him as America's premier architectural etcher. Arms emulated the example of Joseph Pennell by searching Europe for great cathedrals and pictur-

3.35
Rockwell Kent
Bowsprit
Wood-engraving (1930) 5⁷⁄₁₆ × 6³¹⁄₃₂
Created for the American Car and
Foundry Company.
Cleveland Museum of Art. Charles W.
Harkness Endowment Fund.

3.36
Design by Charles Burchfield/wood-engraving by J. J. Lankes.
Carolina Village
Wood-engraving (1923) 4¼ × 8³⁄₁₆
Shown in the traveling exhibition, Fifty Prints, sponsored by the American Institute of Graphic Arts (1926).
Cleveland Museum of Art. Gift of The Print Club of Cleveland.

esque buildings. He also collaborated with his author-wife Dorothy Noyes, in a manner akin to both Pennells, by publishing travel volumes, including the handsome *Hill Towns and Cities of Northern Italy* which was illustrated with etchings, aquatints, and drawings held in the portfolios of his dealer, Kennedy & Company.[54] He lavished his considerable skills on the details of Gothic architecture, of which he was especially enamored as in *Notre Dame de Laon* (fig. 3.42), sometimes using the fine points of sewing needles to score the etching ground with precise draftsmanship, or rendering delicate linear shadings with the aid of a magnifying glass.[55]

In the early twenties Arms created a few prints of New York. He etched Cass Gilbert's "Gothic" Woolworth Building as *An American Cathedral*. *The Gates of the City* (fig. 3.43)

monumentalized an upper section of Brooklyn Bridge, an engineering wonder of the nineteenth century whose span was designed by the Roeblings with piers sheathed to feign the stonework of a Gothic portal. Although it was the most simple and powerful of his prints of American architecture, the geometric patterns that are suggestive of modern compositional taste were less the consequence of a formal preference than Arms's architecturally trained eyes which were responsive to tectonic structures and the illusion of a "Gothic" complex in stones and cables.

Arms's images were handsome elaborations of an older tradition rendered with impressive technical mastery. Those constant features sustained his reputation on both sides of the Atlantic which was buttressed by the knowledgeable praise

of Campbell Dodgson, historian of the art and Keeper of Prints at the British Museum, and by the joint publishing of his etchings by Colnaghi & Company in London—dealers in prints since the eighteenth century—and by Kennedy & Company in New York. Arms was not an inflexible conservative, however, and accepted progressive features or innovations in the prints of others. He served for years on the committee of awards for contemporary American prints to be purchased with monies from the Pennell Fund for the Library of Congress and, on one occasion, wrote to Katherine Ely Ingraham, "[I] agree with you that Joe Pennell would certainly turn in his grave at the idea of a color etching being included in his sanctified collection, but, if that is true, then the old man is doing a veritable flip-flop these past years because of my being

one of those to spend his money on prints!"[56]

In 1931 the Brooklyn Society of Etchers, after sixteen years of existence, was reorganized into the national Society of American Etchers. John Taylor Arms served as President and spokesman for many years and, against conservative resistance, struggled to fill the society's exhibitions with the best of American etchings. Harry Wickey, one of the outspoken younger printmakers, acknowledged that, "Arms was doing his utmost to present exhibitions that were truly representative . . . and [I] am grateful to him for the immense energy he has expended in behalf of . . . printmaking in America."[57] The Society's exhibitions presented prints by the traditionalists Herman Webster, Douglas Shaw Maclaughlan, Ernest D. Roth, Frank W. Benson, Thomas W.

3.37
Jan Matulka
New York
Lithograph (1925) 12¼ × 17¹¹⁄₁₆
Shown in the traveling exhibition, Fifty Prints, sponsored by the American Institute of Graphic Arts (1926), and the retrospective exhibition, The Print in the United States from the Eighteenth Century to the Present, at the National Museum of American Art (1981).
University Art Museum, University of New Mexico. Collection of the Tamarind Institute.

3.39
Ernest Haskell
The Mirror of the Goddess
Etching/engraving (1920) 8⁵/₁₆ × 11¹³/₁₆
Elvehjem Museum of Art. Mark and
Katherine Ingraham Fund.

3.40
Childe Hassam
House on Main Street, Easthampton
Etching (1922) 6¹/₁₆ × 12¹³/₁₆
Shown in the retrospective exhibition,
American Printmaking: 1913–1947, at
the Brooklyn Museum (1947).
Achenbach Foundation for Graphic Arts,
the Fine Arts Museums of San Francisco.
Gift of Osgood Hooker.

3.38
Charles Sheeler
Delmonico Building
Lithograph (1926) 9³/₄ × 6³/₄
Printed by George Miller.

Shown in the retrospective exhibitions,
American Printmaking: 1913–1947, at
the Brooklyn Museum (1947), and The
Print in the United States from the Eigh-
teenth Century to the Present, at the Na-

tional Museum of American Art (1981).
Art Institute of Chicago. Gift of Robert
Allerton.

3.41
Kerr Eby
September 13, 1918—St. Mihiel
Etching/aquatint (1934) 10¼ × 15¹⁵⁄₁₆
Published by F. Keppel & Company.
Awarded the Henry F. Noyes Prize at the
20th Annual Exhibition of the Society of
American Etchers (National Arts Club,
New York, 1935) and an Honorable Men-
tion in the 12th Annual Exhibition of
Northwest Printmakers (Seattle, 1940).
College of Wooster. John Taylor Arms
Collection.

3.42
John Taylor Arms
Notre Dame de Laon
Etching (1929) 14 × 9⅝
Shown in the retrospective exhibition, John
Taylor Arms: American Etcher, at the
Elvehjem Museum of Art (1975).
Elvehjem Museum of Art. Mark and
Katherine Ingraham Fund.

Nason, Kerr Eby, and Arms, as well as works by the progressives John Sloan, Eugene Higgins, Gifford Beal, Edward Hopper, and Martin Lewis, and intaglios by such younger etchers of American landscape and life as Harry Wickey, Reginald Marsh, and Peggy Bacon.

During the preceding decade, drypoints by Peggy Bacon had offered delighting antidotes to the tiring multitude of etched landscapes and architecture which dominated the annual displays of the Chicago Society of Etchers, the Brooklyn Society of Etchers, and the Print Makers Society of California, as well as less prestigious regional exhibitions. Her sly and pricking wit marked her prints as well as her creations in drawing and rhyme. Bacon's ability to inflict a venomous sting was apparent in *Funerealities*, a small volume of her poems and drawings with an original drypoint, *The Widow and the*

Grass Widow (fig. 3.44), inserted as the frontispiece for each copy of the limited edition of 250. And her skills as a telling caricaturist were displayed in 1931 when seventeen of her pastels were exhibited. They were devastating characterizations of prominent personalities including the art critics Royal Cortissoz, Forbes Watson, and Henry McBride—who expressed astonishment that she would ". . . bite the hands . . ." that helped her prosper—and of dealers who sold her art, E. Weyhe and Edith Halpert, Director of the Downtown Galleries where the caricatures confirmed Bacon's searching eyes and clever hand.[58]

In 1921, the Joseph Brummer Gallery presented an early exhibition of Peggy Bacon's drypoints and drawings. Filled with amused interpretations of American life, they must have alerted critics and viewers to Bacon's singularity of wit among

Notre Dame de Laon

Arms. 1909

3.43
John Taylor Arms
The Gates of the City
Etching/aquatint (1922) 9 × 8⅝
*Shown in the retrospective exhibitions, John
Taylor Arms: American Etcher, at the
Elvehjem Museum of Art (1975), and The
Print in the United States from the Eigh-* *teenth Century to the Present, at the Na-
tional Museum of American Art (1981).
Elvehjem Museum of Art. Mark and
Katherine Ingraham Fund.*

printmakers of the time.[59] Three years later the choice of *Promenade Deck*, as one of the six original prints published by the *New Republic*, lent a sprightliness and variety to the portfolio. Helen Fagg, in writing a résumé of "Etchers in America," advised the British that, "With her ironical, wholly feminine sense of humor, Miss Peggy Bacon, the Rose Macaulay of etchers [contemporary English satirical novelist], had drawn the *Frenzied Effort* of a group of earnest strivers."[60] *Frenzied Effort* (fig. 3.45), probably composed by Bacon during one of the weekly life-drawing sessions at the Whitney Studio Club—of which she and other young professionals were members—was, by analogy, a droll commentary on crowded evening classes for studying the nude figure. At the time, almost every art school provided one or more open-enrollment sessions for an odd lot of spinsters, housewives, shopkeepers, and assorted other eccentric amateurs—or voyeurs—with a sprinkling of professional artists and diligent students who dropped by to keep their "hands in." The frenzied effort implied an anguish of ineptitude, the struggle to cope with the subtleties of the female figure as the most difficult of hallowed drawing exercises. Peggy Bacon's prints reminded us repeatedly that the petty irritations or minor crises of life can be the stuff of satire in any kind of society, just as she incised, light-heartedly, an amusing vocal confrontation of the streets between *Rival Ragmen* (fig. 4.14) and the tinkling bells of their pushcarts in a New York slum.

Carl Zigrosser possessed two of the sharpest eyes on the lookout for rising printmakers such as Peggy Bacon and Harry Wickey. He encouraged the collecting of their prints and became a friend, as well as the dealer, for many of them. Wickey wrote appreciatively that, "Zigrosser did much for my work over the years. [He] was the first

person to accept my etchings in his [Weyhe] gallery . . . It was he who sold several of my early drypoints to the Metropolitan Museum. I have always counted him as a good friend."[61]

Shortly after Wickey adopted drypoint and etching in 1919, he began to describe incidents of New York City life in a robust manner, generally following the kinds of subject choices that had been favored by Sloan and Bellows.[62] Among his early prints was *Snug Harbor* (fig. 3.46) which suggests that Wickey, roving the city like Sloan, was privy to the action at an isolated nook on Riverside Drive where sailors on shore leave sought and enjoyed feminine companionship. During the next few years his abilities were appreciated more fully by his fellow artists than by critics and collectors. From juries of his peers he received the Logan Prize in Chicago and the Shaw Award at the Salmagundi Club in New York. Mahonri Young and John Steuart Curry—who ad-

3.44
Peggy Bacon
The Widow and the Grass Widow
Drypoint (1925) 3⁵⁄₁₆ × 3
An original impression served as a frontispiece for each copy of Funerealities, *a limited edition of Bacon's poems and drawings published by the Aldergate Press (1925). Kohler Art Library, University of Wisconsin-Madison.*

3.45
Peggy Bacon
Frenzied Effort
Etching/drypoint (1925) 5⅞ × 9
Published by the Weyhe Gallery.
Shown in the retrospective exhibition,
Americans at Home and Abroad: Graphic
Arts, 1855–1975, at the Elvehjem Mu-
seum of Art (1976).
Elvehjem Museum of Art.

3.46
Harry Wickey
Snug Harbor
Drypoint (1922) 7½ × 10⅜
Shown in the annual exhibition of the Chi-
cago Society of Etchers at the Art Institute
of Chicago (1926) and the exhibition,
Harry Wickey and His Work, at the Weyhe
Gallery (1938).
Collection of David and Eleanor
Whitehead, Arlington, Virginia.

mired especially *Railroad Cut* (fig. 3.47)—purchased several etchings from Wickey for their personal enjoyment.[63]

Leonard Clayton, who ran a small gallery in connection with his picture-framing shop, sold a few prints for Wickey but his etchings and drypoints were hardly visible in the art markets.[64] Then, in the spring of 1929, Harry Hering, an artist friend, showed a group of Wickey's prints in his New York studio. They were seen by Lloyd Goodrich, then a critic for the *New York Times* and soon to become Curator at the Whitney Museum of American Art, who reported, "Mr. Wickey's prints are not often seen in the dealers' galleries, which is too bad, for he is one of the most origi-nal of our etchers, with a strongly marked individuality. Perhaps one reason that his work is not more fre-quently seen is that there is nothing ingratiating about it. He does not go in for the rather overdone refine-ments of the famous 'etcher's line' or the elaborate cuisine with which so many practitioners of the art hide the fact that they have nothing to say."[65]

In December 1929, the paucity of exposure was corrected partially by Wickey's first, but very small, one-man show at the Civic Club in New York. Still, a comprehensive exhibi-tion was not sponsored until Zi-grosser organized one at the Weyhe Gallery in 1938. Seventy-nine prints were displayed including all of the handsome landscapes that Wickey

3.47
Harry Wickey
Railroad Cut
Etching (1932) 8 × 11⅞
An impression of this print was purchased by the artist John Steuart Curry when Wickey tried a sales plan, the "Harry Wickey Print Club."
Robert Hull Fleming Museum, University of Vermont. Gift of Henry Schnakenberg.

3.48
Harry Wickey
Trees by Moonlight
Etching (1931) 9 × 10⅞
Shown in the exhibition, Harry Wickey and His Work, at the Weyhe Gallery (1938).
Courtesy of Ralph E. Sandler, Madison, Wisconsin.

had been etching after his move up the Hudson River to Cornwall Landing in 1929. *Trees by Moonlight* (fig. 3.48) was among them, demonstrating, beyond the rugged manner with which he handled the etching needle and the deep biting of the plates, that Wickey was creating some of the most vigorous landscapes of any American etcher up to that time. *Storm Sweeping the Hudson* (fig. 3.49) and the companion views of the Hudson River Valley, Storm King, and other mountains, were dramatic prints, filled with strong compositional structures, rich contrasts of atmospheric lights and shadows, and a quickening of life etched into each segment of the

valley landscape whether or not it recorded an animate or inanimate feature of nature. In 1935, when Wickey was displaying his greatest power as a printmaker, the fumes of nitric acid used for biting the copperplates affected his eyes seriously and forced an abandonment of the medium. It was a grave loss for American printmaking.

During the quarter of a century that followed John Sloan's creation of the *New York City Life* series, printmaking became an art of widened choices in subject matter, diversities in interpretive content, with a compounded array of styles ranging from the conventionally pictorial to the extremely abstract. There had

3.49
Harry Wickey
Storm Sweeping the Hudson
Etching (1933) 8⁵⁄₁₆ × 10³⁄₄
Awarded the Henry F. Noyes Prize at the 19th Annual Exhibition of the Society of American Etchers (National Arts Club, New York, 1934). Shown in the exhibition, Harry Wickey and His Work, at the Weyhe Gallery (1938).
Courtesy of Ralph E. Sandler, Madison, Wisconsin.

been constant technical improvements. The art of lithography, abetted by the advice and skills of master-printers, attracted increasing numbers of printmakers during the 1920s. Among them was Louis Lozowick who adopted the medium in 1920 at the start of a four-year stay in Europe, mainly in Berlin. The severe, geometrically composed lithographs—Lozowick's conversions of visual recollections of urban America, though created abroad—characterized the early *Cities* series and reflected his encounter with a facet of artistic ferment, the "machine aesthetics" advocated by German and Russian artists-in-exile during the 1920s.[66] They were antecedent to Lozowick's less austere lithographs of American cities and factories that in 1931 received the first two of many major awards—the remarkable $1,000 Brewster Prize of the international printmaking exhibition at the Cleveland Museum of Art for *City on a Rock* and the Collins Prize for his version of the *Brooklyn Bridge* (fig. 3.50) entered in the third annual exhibition of American lithographs sponsored by The Print Club of Philadelphia.

Technical virtuosity in etching was typified by the refined, microscopic needle work of John Taylor Arms in *Venetian Filigree* (fig. 3.51), a print that was a tour de force of linear and textural details and illu-

3.50
Louis Lozowick
Brooklyn Bridge
Lithograph (1930) 13 × 7⅞
Published by the Weyhe Gallery.
Awarded the Collins Prize at the third an-
nual exhibition of American lithographs
sponsored by The Print Club of Phila-
delphia (1931).
Art Institute of Chicago.

3.51
John Taylor Arms
Venetian Filigree (the Ca d'Oro, Venice)
Etching (1931) 10¾ × 11
Published by Kennedy & Company.
Received the award for the best print by a
member of the Chicago Society of Etchers in
the 1st Annual International Exhibition of
Etching and Engraving at the Art Insti-
tute of Chicago (1931). Shown in the ret-
rospective exhibition, John Taylor Arms:
American Etcher, at the Elvehjem Museum
of Art (1975).
Courtesy of Ben Bassham, Kent, Ohio.

3.52
Thomas W. Nason
Lyme Farm (Connecticut)
Wood-engraving (1929) 4¹³⁄₁₆ × 9¹⁄₁₆
Shown in the International Exhibition of Lithographs and Wood-Engravings, at the Art Institute of Chicago (1930).
Boston Public Library, Print Department.

sions of light and shadow. And as for relief prints, superb mastery was revealed in the wood-engravings of Thomas W. Nason. His graphic synopses of hamlets and farms in the township of Lyme, Connecticut (fig. 3.52), or poetic transcriptions of New England's pastoral views were cut with a finesse that had been summoned rarely since the years of the New School of American Wood-Engraving, a skill which Nason extended further when he added the exquisite craft of engraving on copper to his technical repertoire in 1933.[67]

During the two-and-a-half decades there had been recurring temptations to categorize prints by labels of "conservative" or "progressive"— most obviously with the divisions of "academic" and "modern" for *Fifty Prints*, the several national displays sponsored by the American Institute of Graphic Arts. During the jury selections and before the annual exhibitions were sent on tours of the country, the oversimplistic assignment of each of the fifty prints to one division or the other was an awkward and arbitrary accommodation to printmakers who were demanding recognition, and equity, as adherents of either "academic" or "modern" artistic inclinations. Meanwhile, Carl Zigrosser declared that prints by "progressives" were more important to the state of the art when he published assessments in 1929 and 1931. He applauded the growing acceptance of lithography and relief printing, praised the unconventional etchings of Marin and Davies which had been ignored or ridiculed by the public, and expressed dismay that as late as the twenties there were persistent reservations about the prints of Sloan, Bellows, and Eugene Higgins. Zigrosser's list of others who had infused a new vitality into prints of American life, landscape, and legend included Hopper, Martin Lewis, Bacon, Wickey, Gifford Beal, Lozowick, Reginald Marsh, and Thomas Hart Benton. They were selections which supported his opinion that,

"In this affirmation of creative impulse, in this imaginative depiction of life and human relations, in this pride of surroundings, I see the beginning of a national American consciousness."[68]

There was no reason to dispute Zigrosser's observation that his favorite printmakers displayed a growing interest in indigenous themes. Furthermore, many of the "academic" etchers whose works still reflected the pictorial conventions of their forerunners were staying home and recording the architecture and views of great cities from Boston to San Francisco. Then, in the 1930s, the incidence of perceptions and images of America became more frequent. They appeared, in no small measure, because of the new self-concerns of a troubled nation, a rising social and political sensitivity of artists during the years of the Great Depression, and the urging to record facets of the "American Scene"—the preferred themes for works created under the aegis of the several federally funded art projects during the era of Franklin D. Roosevelt's New Deal.

4

The Years of the Great Depression

All artists contend with two needs in seeking an ample fulfillment of their creative careers—a freedom from want which comes with a modest subsistence and a plentitude of time that may be expended liberally on self-selected artistic projects. The requisites were rarely assured to most American artists and, with few exceptions during the first three decades of the century, printmakers were compelled to divert coveted time and energy to magazine illustration, commercial art, and teaching in order to supplement frugal incomes from infrequent sales. Each faced the hazardous competitions that all artists confront in the profession. There were the struggles for artistic visibility and the quest for reputation which came with successes in exhibiting or the honors of prizes. Each artist's career was affected by the acceptance or rejection by dealers and galleries which were crucial for promotion and marketing, the capricious chances of complimentary or damaging reviews— or silence—by influential critics, and the good fortune or failure to gain patronage from private collectors or by museum acquisition. Upon entering the profession, the painter, printmaker, or sculptor discovered the reality of those kinds of uncertainties.

The hurdles to be cleared by an artist in order to attain a simple livelihood, to reap the benefits of time freed for sustained creative endeavors, and then to display and sell the art with just rewards were raised severely by the devastating economic, social, and cultural dislocations of the Great Depression. The grim conditions began to affect everyone in the nation and by the early 1930s the ominous portents had become alarming to all artists, including those who had gained excellent reputations and whose works were handled by well-established galleries. John Steuart Curry, one of the "Regionalists" who had received an exceptionally good press, wrote in dismay to his friend Harry Wickey, "Things look bad as far as selling anything and I can't do it even with the million dollars of publicity that I have gotten."[1] And Wickey, in an effort to make ends meet, started his Harry Wickey Print Club with the offer of etchings at $5.00 to anyone who would subscribe for them in advance.[2] During the following three years, the few prints Wickey sold were to sympathetic friends, fellow artists, and former students. The art market declined year after year. The wood-engraver Lynd Ward published the depressing news that "1938 has been considered among print dealers as the worst of all as far as sales are concerned."[3]

There had been attempts to blunt the effects of the Depression and, in 1932, the Society of Independent Artists adopted a barter plan for its annual exhibition. The *New York Times* reported that, "It was not a matter of new business that the distress of the artists was introduced for discussion [by the Board of Directors], for the matter is as old as art itelf. This year, however, it is more acute. When asked yesterday [14 March] about the matter, John Sloan, president of the Society . . . said: 'Artists are always on the bread line, but this year they are in even worse straits than usual'"[4] Although clothiers, dentists, lawyers, and landlords offered their services or goods in exchange for art, the Society's barter plan turned out to be a minor palliative.

During 1932–1933 the plight of artists led the College Art Association to assess the situation and propose a means of support. Mrs. Audrey McMahon, editor of the society's journal, *Parnassus*, initiated a census of needy artists in the New York area who were not on the general relief rolls of the unemployed; 1,400 were identified. The College Art Association then petitioned the Emergency Work and Relief Bureau—whose monies were donations from private sources—to plan

a program of hiring artists to create works for nonprofit institutions. About 100 were assigned to projects ranging from poster designing to mural painting. The pay was minimal and akin to that of trade-labor artisans working in nonunion shops: $18 a week if the artist were single, $25 if married. The program terminated on 1 August 1933 with several of its features prefiguring the kinds of aid and activities when, four months later, the federal Public Works of Art Project was launched on 8 December.[5]

The Public Works of Art Project (PWAP) was an unprecedented action of the national government, a crash program directed from Washington by Edward Bruce, who was both an artist and a gentleman of influence with experience in the federal service, and by Forbes Watson, author, critic, and art editor, who was appointed Technical Director. Over $1,300,000 was funneled into the project before it ended on 30 June 1934; most of the funds were spent for weekly wages to over 3,700 artists across the country. At the outset, speed and expediency were urgent in order to get the PWAP underway. Washington sought experienced administrative talents for the sixteen regional headquarters. The predictably difficult post of administrator in New York was accepted by Mrs. Juliana Force, Director of the new Whitney Museum of American Art. Her dual roles immediately created a situation that was both disturbing and ironic. The Whitney Museum was supported by Gertrude Vanderbilt Whitney, sculptor and patron, whose long-standing generosity to American artists included the underwriting of the deficits of the exhibitions of the Society of Independent Artists for over fifteen years and her quiet benefactions by monthly personal checks to many deserving artists.[6] Nonetheless, the PWAP was hardly operational in mid-December when criticism of the procedures for

selecting artists arose. John Sloan, as President of the Society of Independent Artists, defended the choice of Mrs. Force as administrator, and the committee members (who included Mrs. Whitney) by stating to the *New York Times* that they had "long experience in giving help to artists and in finding where help was needed," and then declaring that "the trouble is the natural result of throwing corn in the chicken coop. There are bound to be feathers flying."[7]

The protests took a more serious turn soon thereafter when artists met at the Russell Sage Foundation to plan a demonstration at the Whitney on 9 January 1934. Led by members of an Unemployed Artists Group—who bore banners proclaiming ART FOR NEEDY ARTISTS OR IMMEDIATE CASH RELIEF—the protesters broke through a line of police and entered the Whitney Museum. Mrs. Force agreed to meet with a delegation of five, among them a spokesman who stated the grievances as favoritism and unfairness in hiring.[8] In reponse, Mrs. Force quoted directives from Washington which advised administrators to inform "the artists whom you employ that they are not on relief, and that, while we are employing them because they need work, they are employed to do work which the government regards worthy of their hire. . . . we ought all to remember that we are putting *artists* to work. The success of the project is going to be judged by the results the artists produce."[9] The protesters were especially aggravated by the appointments of a few well-known professionals among the many artists hired. The *Art Digest* reported that "a great scandal was made out of the fact that such artists as William Zorach, Joseph Pollet, Hayley Lever, A. Stirling Calder, Arthur Lee, and John Sloan have been on the P.W.A.P. payroll."[10] Although works by each applicant were screened, hiring by Mrs. Force's committee, or at other regional

headquarters, was not an easy task since selections had to be made from among many kinds of artists, young and promising, older and better known, accomplished or merely competent. The confrontations in New York dragged on as a simmering standoff throughout the winter of 1933–1934 with the Whitney Museum becoming a victim when it was forced to abandon its exhibition season and lock its doors on 27 March 1934.

Between 1934 and the first years of the 1940s a successor to the PWAP, the Federal Art Project (Works Progress Administration [WPA]), employed artists in a time when the economic and social ravages of the Great Depression were the paramount concern of the nation and the economic theory of "pump priming" through public expenditures held, as one of its premises, that the federal hiring of people for useful purposes—even artists—increased the flow of dollars as a stimulus to a recovering economy. The government's funding of art projects was substantial until the country was stunned by the bombing of Pearl Harbor. The energies and resources of the United States were then diverted to waging World War II. The art projects phased down to their termination by 1943.

Throughout the terrible years of the Depression, the national government's art programs had been unable to accommodate all artists who applied for support and so discontent and protest demonstrations occurred, especially when funding was short and artists were dismissed temporarily or permanently. But for those on the Federal Art Project in New York who had urged greater opportunities to create prints, 1935 turned out to be a reassuring year. In June, Audrey McMahon, whose earlier efforts on behalf of unemployed artists had led to an administrative post with the FAP, reported on one of the ambitious proposals: "An American school of colored

lithography to compete with the German and French lithographs can be built up and a very talented and eager group of young people is anxiously waiting to have this opportunity. They are so eager that they offer to buy lithographers presses from their own salaries, and a most stimulating project is now on my desk submitted by them." [11]

A proposal for a printmaking workshop became a reality several months later, and Hyman Warsager recalled that "the establishment of the graphic division of the WPA/FAP in that memorable fall of 1935 injected new hope in the artist and a new life into the print." [12] Mrs. McMahon quickly assembled a knowledgeable staff. Gustave von Groschwitz, who later was to become a well-known print curator, was appointed supervisor and several artist-printmakers received assignments as technical associates. Russell Limbach, an experienced lithographer, was given the responsibility of organizing the print shop and named technical advisor. Frank Nankivell, the respected etcher and master-printer of an earlier generation, worked with artists inexperienced in the intaglio media, and Isaac Sanger (fig. 4.1) assisted those who created woodcuts and wood-engravings. [13]

By April 1936 a sufficient number of prints had been created to warrant an exhibition at the gallery of the Federal Art Project. The ebullient mayor of New York, Fiorello LaGuardia, honored the opening with his presence and Edward Alden Jewell, critic for the *New York Times*, reported that the quality of the prints was "very good," citing Yasuo Kuniyoshi's *Tight-Rope Performer* (fig. 4.2), an ephemeral vision of a young and graceful acrobat saluting her audience from the high-wire platform draped with star-spangled bunting. [14] A more ambitious display was organized for the International Art Center in January 1937 when prints by the New York group, and

a few created by project artists from Philadelphia, Cleveland, San Francisco, Massachusetts, and New Mexico, were exhibited in Prints for the People. [15] John Taylor Arms was invited to give the address at the opening ceremonies, surely because of his reputation as a fine etcher and in appreciation of his many efforts in the cause of American printmaking. His presence lent an aura of commendation for federal support of the arts which was compounded by his declaration that "the works shown are deeply and sincerely felt and honestly and, in many cases, beautifully executed." [16] Prints for the People displayed 212 impressions. Among the 116 artists represented there were many who were well known or whose names would become honored: Adolf Dehn, Emil Ganso, Fritz Eichenberg, Mable Dwight, Yasuo Kuniyoshi, Fred Becker, Raphael Soyer, and Will Barnet. The catalogue announced that prints were "available for allocation to tax-supported institutions . . . on the basis of a ninety-nine year loan." [17]

In late March 1937, another exhibition—limited to prints created for the Graphic Arts Division in New York City—was staged at the Federal Art Gallery (fig. 4.3). Holger Cahill, critic, essayist, and, by then, the national director of the FAP, came from Washington to open and salute the exhibition. He introduced the venerable John Taylor Arms who, once again, presented an opening-day address and also wrote for the catalogue: "This exhibition reflects serious study, technical skill and, above all, artistic power." Moreover, for the express purpose of assuring the public that there was value in employing printmakers and to counter the criticisms of "boondoggling artists" supported by federal taxes, the remarks of both Cahill and Arms were broadcast by radio station WHN, New York. [18]

Easily identifiable American subject matter was favored for works

produced on all of the federally funded art projects. Indigenous images improved the chances of congenial receptions by those in charge of public buildings who were not always eager or willing to display art on the walls of facilities under their supervision. *Afternoon in Central Park* (fig. 4.4) by Adolf Dehn—with its sunset, local landmarks, leisurely strollers, and lovers—satisfied the preference in subject matter readily enough. Though controversies plagued the project art, more often than not the administrators urged liberal attitudes toward artistic freedom. Thus, prints were created in a diversity of styles, especially those that were published by the New York workshop. *Alice and Pinkline* (fig. 4.5) by Will Barnet, a charming and affectionately etched vision of a sleepy child and her beloved stuffed rabbit, was created with a genre and style that differed radically from Fred Becker's wood-engraving of a jittery *Jam Session* (fig. 4.6) with its symbolic distortions and visual counterparts to jazz improvisations. And Fritz Eichenberg, an accomplished wood-engraver before he immigrated, via Latin America, from Germany to New York in the early 1930s, received project publication of a print of sociopolitical satire, *Military Escort* (fig. 4.7), although the subject was not drawn from the preferred "American scene." With equal freedom, Louis Schanker composed a highly abstracted *Aerial Act* (fig. 4.8), reconstituting the acrobatics under the "big top" with modern synoptic symbolizations of the performers and an allusion to circus pageantry in patterns of vivid colors.

The project artists were eager to explore color printing, which Audrey McMahon had mentioned to her superiors in 1935. Three years later she informed Washington that lithographs in four and five colors had been created with "signal success" and that the developments in color woodcuts were encouraging. [19]

4.1
Isaac J. Sanger
Near Franconia, New Hampshire
Wood-engraving (1937) 7⅞ × 10
Published by the Federal Art Project.
Courtesy of the artist.

4.2
Yasuo Kuniyoshi
Tight-Rope Performer
Lithograph (1936) 12¹⁵⁄₁₆ × 9
Published by the Federal Art Project.
Shown in the first print exhibition of the
Graphic Arts Division, Federal Art Project
(New York, 1936).
Library of Congress, Prints and
Photographs Division

Russell Limbach served as the technical consultant for the successful ventures into "the neglected field of color lithography. He more than anyone else [was] responsible for the amazing developments in the creative use of this complicated technical medium."[20] Louis Schanker became the leader in exploring the artistic possibilities of color printing with wood blocks.[21]

Printmaking: A New Tradition was chosen as the title for the exhibition of 1938 at the project's Federal Art Gallery, by then located amidst the many art dealers' shops on West Fifty-seventh Street in New York City. The Foreword for the catalogue was written by Zigrosser and an essay of "explanation" was presented by von Groschwitz, who soon was to become Curator of Prints at Wesleyan University.[22] Although the title of the exhibition may have been a bit presumptuous in declaring a "new tradition"— there were twenty-three color lithographs by sixteen artists on display—still, the prints were among the forecasts of new explorations, conceptually and technically, in American printmaking. Fritz Eichenberg conjectured later that, "perhaps printmaking as an independent art received its first powerful impetus during the Great Depression of the 1930s, with the creation of the Federal Arts Project . . . [and] fine artists such as Stuart Davis, Arshile Gorky, and Louis Schanker pro-

4.3
Raphael Soyer
Working Girls Going Home
Lithograph (1937) 11¼ × 9⅜
Published by the Federal Art Project.

Shown in the exhibition of prints at the
Federal Art Gallery (New York,
March–April 1937).
Philadelphia Museum of Art. Gift of E. M.
Benson.

4.4
Adolf Dehn
Afternoon in Central Park
Lithograph (ca. 1937) 9⅞ × 13¼
*Published by the Federal Art Project.
University Gallery, University of
Minnesota, Minneapolis.*

duced prints which heralded new art forms, under government patronage."[23] (fig. 4.9.) Jacob Kainen, one of the project's artist-printmakers (fig. 4.10) and later Curator of Prints and Drawings at the National Collection of Fine Arts, reminded us in 1972 that, "we should not overlook the importance of the WPA graphic arts division in providing the initial impetus [to modern printmaking in the United States after World War II]. The project artists bridged the gap between the old moribund etching societies and the unprecedented flowering of graphic arts that has taken place during the past two decades. When Stanley William Hayter came to this country in 1940 to open his experimental arts studio, Atelier 17, he found the artists ready."[24]

The Graphic Arts Division of the FAP, and a very few artists working independently, were to make another contribution of consequence to the future of modern American printmaking—the adoption of the commercial process of screenprinting and adaptations of it to the needs of artist-printmakers. Screenprinting, or silkscreen as it soon would be frequently called, was a stencil-planographic method of producing multiple copies of typography, designs, or images. During the early decades of the twentieth century, technical improvements of the process had been made by craftsmen who sought economical and expeditious ways of color printing placards, pennants, bottle labels, billboards, and designs on a miscellany of consumer products. De-

4.5
Will Barnet
Alice and Pinkline
Etching (1936) 8⅞ × 5¾
Published by the Federal Art Project.
Courtesy of Associated American Artists.

printing had been developed in commercial shops by 1932—cutout paper stencils that were attached to the frame and under the screen; shellac or lacquer stencils that were painted, or ironed, on to the cloth, blocking the pores of the silkscreen in the negative areas; liquid glue-blockout or tusche-and-glue wash-out methods; and photo-stencils, the last a process that was to encourage a plethora of Pop Art prints in the 1960s and 1970s.[25]

By 1940, the growing acceptance of the commercial craft of screen-printing by artist-printmakers brought forth analogies to the much-earlier technical adaptations in the history of European printmaking—the superb woodcuts whose craft had been derived from the printing of late medieval designs, symbols, or images on textiles, playing cards, or religious prints with relief-cut wood blocks; the fifteenth-century engravings of images on copper that had evolved from the incising of ornamental designs with pointed gravers by goldsmiths and other artisans working with metals; the more subtle pictorial illusions in prints of subsequent centuries aided by the techniques of etching which had antecedents in the acid-resist methods of decorating iron in the armorers' shops; and the handsome lithographs of the nineteenth century that were created after artists adopted Senefelder's invention—a planographic method of "chemical" or lithographic printing from stone—for reproducing musical scores on paper and designs on textiles. There was another kind of analogy that was applicable to the new silkscreen prints. Historically, few masterpieces of printmaking had been created by artists in the years immediately following the adoption of an extant craft medium unfamiliar to them. And correspondingly for silkscreen, a few years of exploratory trials had to pass, often with awkward results, before the medium was sensitively used with a splendid coalescence of

scribed simply, a finely woven silk cloth was stretched on a supporting wooden frame, forming a taut, porous fabric surface to which a stencil was applied. The stencil openings allowed paints to be pressed through the exposed areas of the silk mesh, thereby replicating designs, images, or lettering on paper, cloth, wood, glass, metals, or other materials. All of the basic methods of screen-

artistic conceptions and craft.

By the early 1940s there were in some quarters enthusiastic advocates of silkscreen as a new fine art medium. The critic Elizabeth McCausland used exuberant rhetoric when writing about three early exhibitions of silkscreen prints presented in 1940—at the Springfield Museum and the ACA and Weyhe galleries in New York. She proclaimed to the readers of *Parnassus* magazine that "there is exciting historical portent in the speed with which the silk screen color print has captured the fancy of contemporary graphic artists. It is as exciting as if in 1800, two years after Alois Senefelder had discovered lithography, the French Academy—amid the throes of Na-

poleonic politics—had held a large group exhibition of lithographs.[26]

Guy Maccoy, a young artist from the Midwest, had been one of the first to adopt screen-printing as a fine-art medium. In 1932, Maccoy was hired by a company in Hoboken to assist Geno Pettit in decorating candy-box covers. To complete a rush order they turned to screen-printing as an expeditious method of speeding up the piecework. Maccoy purchased the necessary equipment from the Colonial Silkscreen Supply Company in New York. Soon thereafter, the Hoboken firm failed and Maccoy, left with the materials and a personal debt for their purchase, set forth to produce and sell silkscreen prints in an effort to

4.6
Fred Becker
Jam Session
Wood-engraving (ca. 1937) 7¾ × 9⅞
Published by the Federal Art Project.
Shown in the retrospective exhibition,
American Prints from Wood, organized by
the Smithsonian Institution (1975).
Wisconsin Union, University of Wisconsin-
Madison.

4.7
Fritz Eichenberg
Military Escort
Wood-engraving (ca. 1936) 7¾ × 10
Published by the Federal Art Project.
Shown in the retrospective exhibitions,
American Prints from Wood (1975) and
WPA/FAP (1976), exhibitions organized
by the Smithsonian Institution.
Library of Congress, Prints and
Photographs Division.

help himself survive as an artist.[27] Before the year passed Maccoy had created two silkscreen prints, *Abstraction No. 1* ("Woman Holding a Cat") and *Still Life*. The latter, screened with nine colors, had features of modern abstract art and, as Maccoy informed Zigrosser, was stimulated by the exhibition of pochoirs—hand-brushed stencil works—by Picasso, Braque, and other French artists at the Weyhe Gallery.[28]

Maccoy's ventures led to the first one-man show of silkscreen prints in 1938, sponsored by the Contemporary Arts Gallery. The catalogue, *Guy Maccoy's Color Prints: Silkscreen Process*, listed sixteen small prints, including *Abstraction No. 2* (fig. 4.11),

printed in editions of ten to twenty impressions. The following year, with his artist wife Geno Pettit, Maccoy bought a trailer and hit the road. Living as an itinerant artist, he presented demonstrations and produced silkscreens in the trailer, each of which was sold for a pittance from his continually replenished stocks. Maccoy's prints became more and more complex in the multiplicity of color screenings, overprintings, and pastose layers of silkscreen paints as he sought greater pictorial illusions. Eventually, the compositions feigned effects usually created in paintings, such as those in *Three Trees and a Low Sky* (color fig. 1), one of the first prints in the silkscreen medium to receive a Pennell

4.8
Louis Schanker
Aerial Act
Color woodcut (1940) 12⅟₁₆ × 14⅟₁₆
Published by the Federal Art Project.
Shown in Prints for the People—Selections
from New Deal Graphics Projects, at the
National Museum of American Art
(1979).
National Museum of American Art
(formerly National Collection of Fine
Arts), Smithsonian Institution. Museum
Purchase.

4.9
Stuart Davis
Shape of Landscape Space
Color lithograph (ca. 1938) 12⅞ × 10
Published by the Federal Art Project.
Wisconsin Union, University of Wisconsin-
Madison.

4.10
Jacob Kainen
Cafeteria
Color lithograph (1936) 12 × 16¼
Published by the Federal Art Project.
Shown in the exhibition, Jacob Kainen:
Prints, a Retrospective, at the National
Museum of American Art (1976).
National Museum of American Art
(formerly National Collection of Fine
Arts), Smithsonian Institution. Gift of the
artist.

4.11
Guy Maccoy
Abstraction No. 2
Color silkscreen (by 1938) 5⅜ × 7⅛
Shown in the first one-man show of silk-
screen prints at the Contemporary Arts
Gallery (New York, 1938).
University Gallery, University of
Minnesota, Minneapolis. Gift of the artist.

purchase award (1943) and enter the collection of the Library of Congress.

The inclination to seek "painterly" effects was not unique to Maccoy's prints. Similar allurements seemed irresistible to other artists who adopted silkscreen by the end of the 1930s. Hyman Warsager, Harry Gottlieb, and Leonard Pytlak often chose to ignore a graphic aesthetic and seized the opportunity to use many screens, colors, and complex printings in order to simulate the nuances and illusions that usually had been reserved for watercolors and oils.

Shortly after Maccoy had the first one-man show of screen-prints in 1938, a silkscreen unit was launched within the Graphic Arts Division of the New York FAP. The venture had been urged by two members of the Poster Division, Richard Floethe, the director, and Anthony Velonis who had been trained in commercial screen-printing shops. Velonis was persistent in his arguments that silkscreen would be a medium of merit for printmakers and the experimental unit was initiated under his supervision.[29] Six artists were enlisted: Elizabeth Olds, Harry Gottlieb, Ruth Chaney, Louis Lozowick, Eugene Morley, and Hyman Warsager. Other artists were added gradually while some, who found silkscreen unsuitable to their graphic tastes, left the unit. Although the early prints now seem modest in quality, the level of successes encouraged similar ventures in silkscreen printing at other federal projects across the country.

The mounting interest in printmaking with silkscreen was affirmed by several other events that occurred around the turn of the decade. In March 1940, the ACA (American Contemporary Art) gallery sponsored the second one-man show of silkscreens, a display of prints by Harry Gottlieb. Among the twelve works was *Winter on the Creek* (color fig. 2), elaborately printed

with eleven colors that projected a picturesque scene of ice skaters in a seasonal American landscape. It was dependent upon painting for its conceptual characteristics, but the screen-printing process fell within the definition of an original print and, in 1942, Gottlieb's work received the Eyre Medal for the best print in the 40th Annual Exhibition of Watercolors and Prints at the Pennsylvania Academy of the Fine Arts.

Also in March 1940, Elizabeth McCausland had assembled the large exhibition of silkscreens for the Springfield Museum with many prints by the artists who had worked on the Federal Art Project in New York. All of the first six enlistees for the Silkscreen Unit were represented along with others who had joined later—Chet La More, Leonard Pytlak, Mervin Jules, and Edward Landon. Also on exhibition were prints by Sylvia Wald who would become one of the most sensitive makers of silkscreens, creatively and technically, during the fifties. Wald was among those who had set up a silkscreen workshop on East Tenth Street in the fall of 1939. The venture was independent of the FAP although some of the artists who joined the workshop had been introduced to the medium on the federal project or stimulated by the successes of the Silkscreen Unit. By May 1940, their commitments led them to organize as the Silk Screen Group, "composed and controlled by artists whose aim is the development of the silkscreen print as a graphic arts medium."[30] Four years later, the Silk Screen Group reorganized and became the National Serigraph Society with Doris Meltzer as the Director and with ambitious plans for exhibitions, a sales gallery, classes, and a lecture bureau.[31]

Serigraphy, a term for screen-printing as a fine art, was newly coined and introduced to the public in 1940. It was concoted when Carl

Zigrosser was collaborating on an exhibition for the Weyhe Gallery. As Anthony Velonis, Hyman Warsager, and Zigrosser were planning the display, a wish was expressed that a new technical title might be found which would suggest distinctions of quality between "creative and commercial" silkscreens. Zigrosser recalled that "I had discovered another Greek root related to silk beside the one he [Velonis] mentioned, namely, *ser*. What did he think of the term serigraph, silk-drawing, by analogy to lithograph, stone-drawing? He approved instantly, and so the name was born."[32] Furthermore, the planners chose to print, as the cover for the exhibition catalogue, a design that displayed a flying stork from whose beak dangled a swaddling cloth bearing a framed serigraph—coupled with the pronouncement of an "Exhibition of New Color Prints in a New Creative Medium." The cover's themes symbolized the spreading assumptions that the twentieth century was witnessing the birth in America of a new process of printmaking. And not long thereafter, the scholarly term *incunabula* was assigned to the silkscreens of the late 1930s and early 1940s, implying a historical analogy to the earliest fine-art prints created in Europe during the fifteenth century. Despite such pretensions, the art form was still experiencing an uncertain infancy.

The small serigraphs exhibited at the Weyhe Gallery in 1940 had been printed in unlimited editions and were minimally priced at $1.00 each in order to attract purchasers who were not affluent collectors.[33] But then, during the preceding years of the Depression, most prints in dealers' portfolios yielded low prices, such as those of Thomas Nason consigned to the Kleemann Galleries which advertised his intricate wood-engravings at $8.00 each and the exceptional copper-engraving, *Farm Lane*, for a top price of $12.[34] And because marketing by dealers offered

4.12
Charles Locke
City Wharves
Lithograph (1934) 8¼ × 11⁷⁄₁₆
Printed by George Miller. Published by the Contemporary Print Group in the second portfolio of The American Scene.
Shown in the exhibition, Art for All: American Print Publishing Between the Wars, at the National Museum of American Art (1980).
Milwaukee Art Museum. George B. Ferry Memorial Fund.

artists scant income, in 1933 a Contemporary Print Group had been formed to sell works by mail order. Adolf Dehn, Charles Locke, Reginald Marsh, Mabel Dwight, Thomas Hart Benton, and John Steuart Curry were among the artists. The group announced that the printmakers would "comment on the social scene and express contemporary life," and that a subscription of $15 would reserve a set of six prints comprising *The American Scene, Series I*. Marsh's lithograph of unemployed clustered below the towering equestrian statue *In Union Square* was the first to be published. After *Series II* was issued—to which Charles Locke contributed *City Wharves* (fig. 4.12), one of his favored subjects of Brooklyn docks and stevedores—the enterprise

failed, another victim of the depressed economy.

The mail-order solicitation of the Contemporary Print Group was tried again with more business acumen when, in mid-1934, Reeves Lewenthal initiated the Associated American Artists. In addition to handling the works of active printmakers, many artists who had been painters by preference were urged to try printmaking or to direct more of their efforts toward prints. Artists were offered flat fees of $200 for each edition with additional increments if more than ten impressions were sold by the AAA's aggressive promotions across the country. Unlike the earlier advertisings of prints as premiums in order to attract subscribers to the [old] *Masses* and the *New Republic*, the AAA adopted

4.13
Advertisement by Associated American Artists published on the back cover of *Art Digest* (1 January 1935).

ecdotal street incident of lower New York City selected for reproduction in *Fine Prints of the Year*, a book annual published in London with choice works created in England, western Europe, and America. The AAA issued many lively etchings and lithographs, but its course was cautious. Prints by Americans who were inclined toward abstract art were omitted in favor of works steeped in narrative or pictorial subject matter.

All art dealers, by the nature of their profession, must be promoters in one way or another. The publishing of handsome brochures of their wares or advertisements in appropriate journals have been standard practices. Lewenthal and the Associated American Artists followed the same patterns except that in issuing brochures or writing mail-order advertisements they introduced the rhetoric of hard-sell promotion. In 1941, the AAA announced that some of the prints had been purchased by the Metropolitan, the Art Institute of Chicago and other important museums. The offerings, therefore, were, "INCREDIBLE, BUT TRUE! ONLY $5 FOR A SIGNED ORIGINAL BY GRANT WOOD, THOMAS BENTON OR 65 OTHER GREAT ARTISTS . . . IF YOU ACT PROMPTLY!"[36] Both the banner of the advertisement and the reproduction of *Planting* (fig. 4.15), a lithograph by Benton, suggested that the AAA had discovered that the works of the Regionalists were very attractive to its clientele and should be issued with steady frequency. The print was typical of one type of Benton's regional subjects—a severe landscape of a small, marginal farm in southern Arkansas, with a barefoot black man guiding a mule-drawn plow and the woman casting seeds

mass-marketing techniques with displays in department stores of many cities, exhibitions at universities and women's clubs, and sales by mail order. A full-page advertisement in *Art Digest* for 1 January 1935 (fig. 4.13) announced the availability of forty original "etchings," signed by the artists, at $5.00 each. The success of the sales campaign encouraged further publishing and, in 1936, Edwin Alden Jewell reported in the *New York Times* that "finan-

cially the program has yielded large returns" and that the AAA had moved to new headquarters, with spacious sales galleries, on Madison Avenue.[35] Works by Dehn, Nankivell, Ernest Fiene, Gordon Grant, Luigi Lucioni, and other experienced hands were published in the late 1930s, usually in editions of 250 impressions with each advertised at the customary $5.00 price. Such was the offer of Peggy Bacon's *The Rival Ragmen* (fig. 4.14), an an-

4.14
Peggy Bacon
The Rival Ragmen
Etching (1938) 5⅞ × 8⅞

Published by Associated American Artists.
Achenbach Foundation for Graphic Arts,
the Fine Arts Museums of San Francisco.

by hand into the turned furrows of a leached land.

Benton, Wood, and John Steuart Curry had grown up in agrarian outlands—Missouri, Iowa, and Kansas—and their preferred images were drawn from the legends and life of an older rural culture that was changing rapidly. They advocated an art that was "thoroughly American," identifiable by local or regional themes rendered in pictorial narratives. Moreover, they wrote and spoke out against the "alien" forms, influences, and encroachments of modern European artistic movements. Their art and their statements, especially those of Benton, evoked both opposition and support

from critics. Thomas Craven, a long-time friend of Benton, took the supportive stance and became a self-appointed publicist for the art of the "American scene," generally, and of the Regionalists which, for him, included some works by Charles Burchfield and Reginald Marsh. At times, Craven's exaggerations of the virtues of those kinds of American art and artists bordered on embarrassing puffery. And with scant foresight, or hindsight, he advised in his introduction to *A Treasury of American Prints* that "the succession of fancy cults emanating from the studios of Paris is dead and, for the most part, forgotten; and the abortions of surrealism—the culmi-

nating rot of European gadget makers—have found their proper level as eccentric window dressing for department stores. Never before [the current emergence of painters and printmakers who create local and regional images] has anything remotely approximating a popular movement been seen in America."[37] Craven's misjudgments, written in 1939, were not only misleading art history but they turned out to be flawed prophecy in view of the mounting influences of European avant-garde ideas on American printmaking, conceptually and technically, during and after World War II. But in the late 1930s and early 1940s, the purchasers of modestly

priced impressions issued by the Associated American Artists—especially those created by the Regionalists—hardly had need of any opinions by critics to reinforce their favorable inclinations toward prints that were filled with storytelling images and composed in simple pictorial renderings.

For many viewers, the works of Thomas Hart Benton seemed to be fresh revelations of folkways discovered in the bypassed recesses of the old Border States. In prints, as in his paintings, he recreated an array of local and regional realities and myths—poor sharecroppers bound to unfertile fields, migrant threshers, roustabouts of the oil-boom towns,

cowhands, picturesque transformations of ballads sung in the hill country, or dramatizations of legends such as the verses that recalled the tragic tale of the lovers *Frankie and Johnnie* (fig. 4.16).[38] Frequently, the nostalgic themes were derived from regions that had been culturally centripetal, as were the Missouri Ozarks of Benton's youth and whose isolations, he acknowledged, were fast being penetrated during his lifetime. In 1939, 20th-Century-Fox, as a promotional ploy for its filming of John Steinbeck's *The Grapes of Wrath*, sought to match artist with author by commissioning Benton to create six lithographs—with reproduction rights to bill-

4.15
Thomas Hart Benton
Planting
Lithograph (1939) $9\frac{7}{8} \times 12\frac{5}{8}$
Published by Associated American Artists. Shown in the retrospective exhibition, Americans at Home and Abroad: Graphic Arts, 1855–1975, at the Elvehjem Museum of Art (1976).
Elvehjem Museum of Art. Gift of Mr. and Mrs. Willard Hurst.

4.16
Thomas Hart Benton
Frankie and Johnnie
Lithograph (1936) 16¼ × 22¼
Shown at the Associated American Artists gallery (1937) along with Huck Finn *and* Jesse James*, all lithographs whose compositions were prefigured in the Benton murals for the Missouri Capitol.*
Seattle Art Museum. Eugene Fuller Memorial Collection.

board size—one of which was the melancholy synopsis of destitute, migrant "Okies" in *The Departure of the Joads* (fig. 4.17) from drought-stricken Oklahoma. Two years later, the still-considerable popularity of Benton's regional images drew a record crowd of 60,000 to his exhibition at the AAA galleries. The closing date was twice postponed and the success of the display was confirmed by the sale of half the paintings, seventy-five of the $5.00 lithographs, and twelve larger prints.[39]

Curry, more constantly than Benton, chose to recreate in lithographs the themes that he had rehearsed in his paintings. They were dramatized illustrations of boyhood experiences or the often-retold tales of animals and settlers of the Great Plains—

coyotes stealing pigs, tornados, a barnyard baptism, animals and humans as flood survivors, hogs killing rattlesnakes—or episodic landscapes, such as *The Line Storm* (fig. 4.18) with its men, mules, and hayrack in a race for shelter before the swift advance of a lightning-charged tempest of the prairies. Curry's pictorializations of the people of the sparsely settled wheatlands, the natural disasters occurring on the rivers and plains, and the brutal acts of survival by animals of the region appeared at a time when there was a flurry of interest in American folkways and legends, larger-than-life folk figures, and fading customs of regional cultures. This interest was hailed as a rediscovery of the American heritage and welcomed as a contribution of long-neglected motifs

for the music, literature, and art of the nation. Curry's most-sought-after lithograph was—and still is—the flamboyant figure of *John Brown* (fig. 4.19), the legend-surrounded and violent abolitionist who had incited slaves to rebellion.[40] The print of Brown, with a symbolic cyclone in the background, was otherwise a compositional segment of the full-length figure of the pre–Civil War fanatic, arms akimbo with rifle and Bible, which dominated *The Tragic Prelude*, Curry's mural in the state capitol at Topeka. Despite the popularity of the print of Brown as a folk figure in American history, elevated to epic stature, it was atypical of Curry's work. He usually presented interpretations of his own observed realities of life on the prairies or the retelling of the tales of Kansas. Such incidents were often singular or injected with emotive dramatizations by the artist.

Curry and Benton had tentatively tried their hands at lithography in the late twenties, the former under the guidance of Charles Locke at the Art Students League. Grant Wood did not work in the medium until 1937 when all three were creating lithographs for the AAA; the impressions were pulled at George Miller's workshop. Wood's lithographs were conceived with none of the boisterousness, bravado, or exaggerated actions of Benton's compositions which were often realities revised by his flair for showmanship. And unlike Curry's topics and interpretations, Wood rarely suggested drama or melodrama of humans or animals reacting to the uncertainties

4.17
Thomas Hart Benton
The Departure of the Joads
Lithograph (1939) 12⅜ × 18¼
Commissioned by 20th Century–Fox as promotion for the film based on John Steinbeck's The Grapes of Wrath.
Shown in the retrospective exhibition, American Prints, 1870–1950, *at the Baltimore Museum of Art (1976).*
Art Institute of Chicago. Gift of Mrs. H. S. Perkins.

4.18
John Steuart Curry
Line Storm
Lithograph (1935) 9¾ × 13⅞
*Published by Associated American Artists.
Shown in the retrospective exhibition, The
Print in the United States from the Eigh-
teenth Century to the Present, at the Na-
tional Museum of American Art (1981).
National Museum of American Art
(formerly National Collection of Fine
Arts), Smithsonian Institution. Gift of
Maltby Sykes.*

of elemental forces of the natural en-
vironment or the physical violence
of bestial conflicts. Wood's litho-
graphs, with a few exceptions such
as *Midnight Alarm* (fig. 4.20), bore
the utter quietude of his paintings
that projected an Iowa of silent peo-
ple and of prairie landscapes with-
out ambient atmosphere or hints of
nature's inevitable changes. They al-
luded to an austere and culturally
rigid society of ceaseless labor or
prescribed good deeds, whether it
was the conscientious tending of the
land with its well-groomed fields or
an observance of ritual tradition by
a *Tree-Planting Group* (fig. 4.21) on
the annual Arbor Day of the Great
Plains. Unlike Curry's tale of the ter-
ror of flight before a *Tornado Over
Kansas* or the sudden and threaten-
ing transformation of the benign
countryside by *The Line Storm* (fig.

4.18), Wood's prairies and people
were constructed like models and
manikins with a severe ordering of
disorderly natural forms and by a
technique of carefully hatched
strokes of the lithographic crayon
that permitted no signs of hidden
disarray in a settled landscape and
circumscribed life.

On rare occasions, Wood di-
gressed from his sober recitations of
the labor, landscape, and life of
farms or small towns and satirized,
in an amused manner, traditional or-
ganizations and their members as in
*Daughters of the American Revolu-
tion, Shriners' Quartet,* or a cere-
monial *Honorary Degree* in which he
drew his own likeness as the circum-
spect and dumpy recipient of a doc-
toral hood. But those spoofs were
caricatures doggedly done without
the witty conceptions and sprightly

4.19
John Steuart Curry
John Brown
Lithograph (1939) 14¾ × 10⅞
Printed by George Miller. Published by
Associated American Artists.
Shown in the retrospective exhibition,
American Printmaking: 1913–1947, at
the Brooklyn Museum (1947).
Madison Art Center. Langer Collection.

draftsmanship of satirical prints by Peggy Bacon or the liveliness of etched commentaries on the frailties of human behavior which John Sloan had observed at every glance.

Benton, Curry, and Wood contributed their full share to a broadening of the market, especially through the appeal their prints had to individuals who theretofore were untutored in collecting. The continuity of their lithographic projects and successful sales was supported by the well-publicized prominence the Regionalists enjoyed as painters of indigenous themes, the popularity of similar subjects in the lithographs, and the modest prices which the Associated American Artists had set for its nationwide promotions. On the other hand, few claims of innovation in the art of printmaking may be made for the three and they gave little dedication to the apprenticeship that is requisite for technical knowledge and then printmaking mastery. The latter qualities, which arouse the admiration of fellow printmakers and connoisseurs, were displayed more often in the prints of Dehn, Bacon, Eugene Higgins, and Fiene—also published by the AAA—or of other contemporaries with constant commitments to the art such as Harry Sternberg, Raphael Soyer, Reginald Marsh, Armin Landeck, and Stow Wengenroth.

During the decade, a few printmakers displayed abstract conceptions and an interest in color printing, only hints of the radical directions that so many would take in the 1940s. The majority described the "American scene" with established techniques or adaptations of silkscreen that were compatible with representational imagery.

Charles Locke, who had learned lithography at the Mechanics Ohio Institute in Cincinnati, was chosen by Joseph Pennell to take over the classes in the medium at the Art Students League in 1923.[41] Locke compounded the prints of realists by recreating the life on New York streets or the docks of nearby Brooklyn, as in *City Wharves* (fig. 4.12). Sternberg, who began printmaking with similar glimpses of city life, later turned to laborers and industrial complexes, subjects forecast by *The Vanishing Giant* (fig. 4.22). This theme of railroads, which had appeared in several prints by Hopper, was also intriguing to Marsh who began to etch engines and railroad yards repeatedly as digressions from his better-known prints of bums, burlesques, and carnivals.

Armin Landeck, trained as an architect at Columbia University, had

4.21
Grant Wood
Tree-Planting Group
Lithograph (1937) 8½ × 10¾
The first lithograph by Wood. Published by Associated American Artists.
Milwaukee Art Museum. Gift of Lindsay Hoben.

4.20
Grant Wood
Midnight Alarm
Lithograph (1939) 11¹⁵⁄₁₆ × 7
Published by Associated American Artists.
Shown in the retrospective exhibition, Americans at Home and Abroad: Graphic Arts, 1855–1975, at the Elvehjem Museum of Art (1976).
Elvehjem Museum of Art.

his first successes by etching European landmarks in renderings reminiscent of those by an earlier generation of American printmakers. Upon his return to the United States in 1930, a lack of architectural employment during a deepening Depression persuaded Landeck to follow printmaking as a profession. His architectural training, his admiration for Hopper's urban images, and his friendship with Martin Lewis who had etched neighborhood life between the tenements and brownstone residences all encouraged Landeck in his creation of many views of New York City. One of them, *Housetops, 14th Street* (fig. 4.23), was a composition he saw through the workshop window of George Miller, friend and also

printer of all of Landeck's lithographs. The close associations of Miller, Landeck, and Lewis and the financial stringencies of the times led the three to organize the School for Printmakers with classes in Miller's shop at 6 East Fourteenth Street. Despite reasonable tuitions, after a few months in the winter of 1934–1935, the venture foundered as another casualty of the Depression.[42]

Two decades earlier, Raphael Soyer, a gifted young émigré from Russia, had set up a table-model etching press in one of his parents' tenement rooms. Soyer began his career as an etcher and lithographer, somewhat prophetically, by incising the first of the muted motifs that were to characterize his prints of a silent working class by the like-

4.22
Harry Sternberg
The Vanishing Giant (or Locomotive)
Etching (1930) 9⅞ × 13⅞
Grunwald Center for the Graphic Arts,
University of California, Los Angeles.

4.23
Armin Landeck
Housetops, 14th Street
Drypoint (1937) 8³⁄₁₆ × 11³⁄₁₆
Published by Kennedy & Company.
Ulrich Museum of Art, Wichita State
University.

nesses etched of his immigrant father, mother, and brother Isaac.[43] The glamour and gaiety of city life or the impressive vistas and mighty skyscrapers that had been attractive subjects for New York painters and printmakers were ignored by Soyer as he turned toward other kinds of realities and created his compassionate images of less fortunate people who, with resignation, lived out their lives in the joyless privations imposed upon much of urban humanity by an ungenerous society and city. Tenement-dwelling neighbors, lonely shopgirls, or idle drifters were shown helpless, motionless, and soundless in the seclusive darknesses of their cheaply rented rooms, or on the grimy streets and sidewalk benches of an alienating outside world. Soyer's poignant prints of the poor, or the unemployed of the De-

pression, described the wretched and hungry—men with handouts of bread and coffee from welfare kitchens and storefront missions, or taking their meager meals in loneliness at shabby cafeterias (fig. 4.24). Soyer's sympathetic portrayals of the misfortunate and indigent were untouched by the doctrinaire or harsh commentaries of some of his artist friends. In paintings, or drawings for left-wing journals, some artists broadcast clamorously their commitments to social and political ideologies and activism during those troubling years.

Among Soyer's prints, the lightest in spirit—although never joyous or ebullient—were the many lithographs and intaglios of young girl dancers. Never presented in dazzling public performances but always *Back Stage* (fig. 4.25) where they were si-

4.24
Raphael Soyer
Cafeteria
Etching/drypoint (1937) $6^{15}/_{16} \times 9^{7}/_{8}$
*Published by the Federal Art Project.
Shown in Prints for the People—Selections from New Deal Graphics Projects (1979) and the retrospective exhibition, The Print in the United States from the Eighteenth Century to the Present (1981), both presented by the National Museum of American Art.
National Museum of American Art (formerly National Collection of Fine Arts), Smithsonian Institution. Transfer from the District of Columbia Public Library.*

4.25
Raphael Soyer
Back Stage
Drypoint/roulette work (1937)
8⅜ × 6⅞

Published by the Federal Art Project.
Shown in the retrospective exhibitions,
Americans at Home and Abroad: Graphic
Arts, 1855–1975, at the Elvehjem Mu-
seum of Art (1976), and Prints for the

People—Selections from New Deal Graphics
Projects, at the National Museum of
American Art (1979).
Elvehjem Museum of Art.

lently and unselfconsciously dressing, resting, smoking, or awaiting their cues, with the artist inviting the viewer into the presence of unaffected human beings in the simplest of surroundings. Soyer's young performers evoked responses that were very different than those evoked by the delicate acrobats in Kuniyoshi's visions—so graceful and poised on high wires in nebulous spaces—and the brazen females of chorus lines or the teasing "strippers" pandering to male spectators' lust in noisy bedlams of nightclubs and burlesque theaters as etched by Reginald Marsh.

Marsh reinforced the artistic continuity of direct observations of life—in the manner of Sloan and Bellows before him—by identifying places and personalities of New York. But his etchings and copper-engravings of the late twenties and thirties, with the human derelicts of the Bowery or the bawdy doffings at burlesque houses, erased the ingenuous wonder that lingered in the responses to city life of Bellows and Sloan. Marsh described the harsh facts of the *Bread Line*, of *Smoke Hounds*, and the *East 10th Street Jungle*. He also recreated the blatancy or sleaziness of places and persons in *Speakeasy—Julius' Annex*, *Texas Guinan*, *Fan Dance at Jimmy Kelley's*, the *Gaiety Burlesk*, and *Minsky's New Gotham Chorus* (fig. 4.26).

The sham architectural opulence of burlesque theaters with their ornate boxes filled to overflowing with males leering at the fulsome bodies on stage made crowded compositions. And the carnival carousels of the *Merry-Go-Round* prints and *Steeplechase Swings* (fig. 4.27)—jammed with adults rather than children—or Marsh's several versions of *Coney Island Beach* with endless clusters of bodies displayed a baroque mobility and complexity in masses of humanity at places of play or lustful entertainment.

In later copper-engravings, Marsh turned away from the brashest genre and toward articulated compositions. Unlike the strutting females in earlier etchings, *Battery* (Belle) (fig. 4.28) depicted a hearty young woman—prostitute or not—striding briskly into the fresh breezes of Battery Park, past ships in the harbor and the Statue of Liberty. And Marsh's acceptance of the burin's demands seemed consonant with the linear and lyrical conceptions of his two later versions of *Merry-Go-Round* (fig. 4.29).

At the turn of the decade the metal-engravings of Marsh and Nason antedated a fascination with the medium that arose after Stanley William Hayter transferred his innovative workshop, Atelier 17, from Paris to New York during the wartime occupation of France. For a few months in the early forties, Marsh randomly attended Hayter's sessions—probably out of curiosity more than otherwise. By that time Marsh was an engraver sufficiently accomplished for his artistic inclinations to have had little cause for involvement with the experimental ventures into techniques and materials at Atelier 17 or the avant-garde attitudes of its mentor. Although Marsh was conscientious in developing his skills in metal-engraving—even seeking the advice of a plate engraver who had worked for the United States Mint—he was unusually casual about his editions of prints, sometimes pulling minimal and odd numbers of impressions on his own press or leaving the tasks of printing larger editions, also of random numbers, to Charles White or Peter Platt.[44]

Marsh was less involved with master-printers than some of his fellow artists who respected profoundly the crucial collaborations. Some sought out George Miller to master nuances or enhance lush blacks during the printing of lithographic stones. On several occasions Stow Wengenroth acknowledged his indebtedness to "George Miller [who] had a combination of great technical skill, love of the craft, and infinite patience in the practice of it." And shortly after Miller's death in 1966, Lynd Ward composed a tribute that spoke for scores who had made lithographs in modes as varied as those of Peggy Bacon, Ralston Crawford, Childe Hassam, Raphael Soyer, William Gropper, and Grant Wood, "[George Miller] had a great respect for the creative artist and a rare capacity to understand what it was that the artist was after. He was ready to bend all the resources of [the lithographic] technique to achieve that goal."[45] Miller printed Wengenroth's editions from the early thirties until 1960 when the master-printer retired.[46] He always translated the muted luminosities and darkling tones of landscape which Wengenroth had veiled with subtle textures, reflecting the artist's aesthetic and technical sensitivity to the delicate grain of a finely ground lithographic stone.

Wengenroth created his first lithographs in 1931. The crises of the Depression were looming everywhere and Albert Reese of Kennedy & Company wrote in recollection: "It was in the thirties of doleful memory—1931 to be precise—when artists were many and purchasers were few. Hardly a time and place for an unknown [Wengenroth] to cut his artistic teeth."[47] Nonetheless, within a declining market Wengenroth's lithographs gained as high a priority for purchase as prints by any contemporary because the seeming timelessness of the fishing villages, lighthouses, harbors, and promontories of New England's shores were images that evoked irresistible nostalgia. They called forth sentiments similar to those surrounding a disappearing America painted by Andrew Wyeth who, not surprisingly, declared that Wengenroth was "the greatest black-and-white artist alive today."[48] His lithographs had received instant attention from dealers and in December 1931 an exhibition was organized by Mar-

4.26
Reginald Marsh
Minsky's New Gotham Chorus
Etching (1936) 9 × 12
Achenbach Foundation for Graphic Arts,
the Fine Arts Museums of San Francisco.

garet Sullivan at the Macbeth Galleries. The following March, Wengenroth created *Black Weather* [Eastport, Maine] (fig. 4.30), a lithograph that was to provide an early award at the National Arts Club and, as well, a promise that his visions of weathered settlements and rough escarpments along the Northeast coast, resistant to violent gales and scouring seas, would be prints favored over those of other artists by juries and the public alike.

Wengenroth's reputation as a leading lithographer, built during the thirties, was maintained for decades by his impeccable craftsmanship and the lush tonalities that laid dark cloaks of texture and luminous atmospherics over simply structured landscapes as in *Moonlight* [Inner

Harbor, Rockport] (fig. 4.31). New England's littoral was a constant theme, though in a later print that claimed a prize he cast a stormy shroud around an *Untamed* (fig. 4.32) wild where rookeries of ravens lay hidden in untrammeled woods—a barely inland relic of the Eastern Wilderness that, long before, had lent a similar drama to the paintings of his nineteenth-century predecessors.

Despite discouragements which all of the arts endured in the years of the Great Depression, accomplished printmaking was done whether or not individual artists were the beneficiaries of federal support. Moreover, there were countless new recruits when printmaking options were offered at Project workshops.

4.27
Reginald Marsh
Steeplechase Swings
Etching (1935) 8⅞ × 12⅞
*Library of Congress, Prints and
Photographs Division.*

4.28
Reginald Marsh
Battery (Belle)
Etching/engraving (1938) 9 × 12
*Munson-Williams-Proctor Institute, Utica,
New York. Gift of Edward W. Root.*

4.29
Reginald Marsh
Merry-Go-Round IV
Engraving (1940) 8 × 12
Library of Congress, Prints and Photographs Division.

4.30
Stow Wengenroth
Black Weather (Eastport, Maine)
Lithograph (1932) 6⁷⁄₁₆ × 14¹⁄₁₆
Printed by George Miller.
Received an award at the National Arts Club (New York, 1933).
Boston Public Library, Print Department.

And from those programs a multitude of prints were published and assigned to public buildings, or lay undistributed—with many lost through gross neglect—until, by chance and often long after the termination of the Project, a residue found safety in museums and colleges. It was an odd lot of fine and inferior prints which, regardless of the differing merits, confirmed a nurturing of the art and a dispelling of the American timidity toward color printing.

By 1940, the progress of the years before seemed to assure the art of printmaking a future. However, the confidence of artists, dealers, and critics was circumscribed by the modesty of expectations for printmaking, not unlike some earlier assessments of its state. Consequently, neither printmakers nor others familiar with the art foresaw the energies to be unleashed in technical experimentation and creative exploration in the forties. Furthermore, no one could foresee the influences on printmaking that would flow—during World War II and after—from the presence in America of avant-garde artists who were visitors or émigrés from Europe and elsewhere.

4.31
Stow Wengenroth
Moonlight (Inner Harbor, Rockport, Massachusetts)
Lithograph (1937) 11 1/16 × 16
Printed by George Miller. Published by Kennedy & Company.
Boston Public Library, Print Department.

4.32
Stow Wengenroth
Untamed (near Gull Rock, Monhegan Island, Maine)
Lithograph (1947) 12 15/16 × 18 1/16
Printed by George Miller.
Received the Print Award at the National Academy of Design (1947). Shown in the retrospective exhibition, 30 Years of American Printmaking, at the Brooklyn Museum (1977).
Boston Public Library, Print Department.

5

The Years of World War II and the Late 1940s

The optimistic, though modest, expectations for the future of American printmaking that had been published in the past were expressed again as the thirties ended and the forties began. And if any artists, dealers, curators, or critics perceived that new and radical initiatives would soon have far-reaching consequences, their discernments were unpublished and, thus, lost in obscurity.

The influence of Stanley William Hayter's Atelier 17 is a case in point. During the thirties, a scatter of Americans had joined the covey of artists in Paris who discovered that Hayter's workshop was a center of experiments in novel variations of old intaglio processes. Then, after he arrived in this country in 1940, more of our artists were lured onto new paths of printmaking when they attended his New York studio, which Hayter envisioned as becoming an "American Atelier 17."[1] During the first few years of Hayter's stay, the New York Atelier 17 and the kinds of prints that reflected testings of unorthodox methods in concert with artistic conceptions and styles that seemed radical in America but were *au courant* among artists who had worked at the Paris atelier received only short, indifferent notices from newspaper critics and a paucity of reports in art journals.

It would be unfair, however, to fault severely a scanty reporting of the innovative activities at the New York Atelier 17. Those years bore the grave distractions of threats to art following the European outbreak of World War II in 1939, the flight of foreign artists to America, and the pall of uncertainties that descended over the United States after the bombing of Pearl Harbor and the declaration of hostilities in early December 1941. As the life and commitments of the nation were affected by the mounting fury of land and sea battles, the priorities of a country mobilized for war gave diminished importance to the arts, notwithstanding a few art assignments in the armed forces and other wartime services, or frequent reminders that the humane nature of the arts could share in nourishing a healthy morale on the home front. The press reported and editorialized about the devastating disruption of art abroad and expressed uncertainty and fearfulness for its welfare at home. Otherwise, while the demands of war drafted the nation's energies, the art press did what it could to report on well-established events that were continued doggedly, including the annual exhibitions of the several societies of printmakers. When opportunities arose, the press joined in publicizing unusual wartime displays, exemplified by the Artists for Victory exhibition of December 1942, which was staged with fanfare at the Metropolitan Museum of Art and mounted in the galleries of the museum as an exception to its policy restricting displays by living American artists.

All segments of American society, including the thirty-four art associations that organized the exhibition, demonstrated their solidarity for the war effort in one way or another. The sponsors who chose the catchy, but ambiguous, slogan of Artists for Victory may have been unable to cast a current theme into a simple exhibition title. In those years of political, ideological, and racial repression their conviction may have been that one among many causes justifying a war against fascism was the right of artists to create with untrammeled freedom. Nonetheless, the exhibition succeeded both as a morale-building spectacular for American artists and as a reminder to the public that many painters, sculptors, and printmakers were creatively active in wartime. Moreover, in the dark days of 1942, it would have been tempting, as it was

for A. Hyatt Mayor—then the Metropolitan's Associate Curator of Prints and a member of the Jury of Awards—to cloak Artists for Victory in a mantle of history and patriotism: "This vast exhibition comes aptly at a time that stirs our country more deeply than it has been stirred since the Civil War. Then, as during the Revolution, Americans knew that what they were doing was history, and this knowledge gave force to our art. Today, in another such hour that seems to show the shape of victory to come, the vitality of this exhibition gives us one more affirmation of the strength that we are throwing into man's far-flung struggle."[2]

It was, indeed, a vast display of nearly 1,500 works chosen from 14,000 submitted by artists from across the country. The Jury of Admissions selected 585 graphics for exhibition. The Jury of Awards, comprising museum directors and curators, skirted controversy; prints honored by prizes were chosen with cautious conservatism. John Sloan was given the $500 First Prize for his recent etching of 1941 although it was a visual souvenir of *Fifth Avenue, 1909* (fig. 5.1), recollecting the congestion of pedestrians, automobiles, and horse-drawn carriages on the avenue that led toward the famous old Flatiron Building. Two second prizes, of $250 each, were awarded to prints by Stow Wengenroth and William Gropper, the latter an artist of liberal leanings whose drawings and prints had been reproduced frequently in journals of opinion. *The Speaker* of the House of Representatives was another jibe at the political establishment whose members were targets of Gropper's satirical cartoons. The third prizes were given to Leonard Pytlack and Grace Albee. Pytlack, an alumnus of the FAP silkscreen shop, received the award for *Night Skaters*, a bit of genre in Central Park that affirmed the subject appeal of the "American

scene." Albee's wood-engravings had been ornaments of print-club exhibitions and the award for *Junked* (fig. 5.2) was undoubtedly in admiration of her excellent craftsmanship and the appealing array of artifacts from an earlier time—the horse-drawn plow, buggy, and sleigh.

The jury of prominent museum officials, in its selection of award winners, gave no hint that there were new directions being explored in unpublicized quarters of print-making.[3] Their judgments, which were satisfied by a modest progress in the art, had counterparts elsewhere. In 1940, Lynd Ward wrote of an American "Woodcut Renaissance," but the examples he cited were relief prints by Allen Lewis, Rudolph Ruzicka, and Howard Cook, all impressions pulled in the early 1930s.[4] Two years later, the Silk Screen Group, soon to become the National Serigraph Society, was exhibiting ingratiating, though bland, prints by its members. The promotions were highly visible, however; there were displays at seventy places around the country and the Museum of Modern Art circulated prints at army camps. *Newsweek* drew attention to these activities in an article, "Touché With Tusche." The serigraphers were optimistic about the future and Doris Meltzer, vice-chairman, expressed confidence that the headquarters of the Silk Screen Group would soon move from an apartment in Greenwich Village to a more favorable location for sales amidst the art galleries of midtown Manhattan.[5] In 1943, the Library of Congress organized its First National Exhibition of Prints, demonstrating at the start a conservative preference in Pennell Fund purchases by selecting, as prints of the First Class, Armin Landeck's *Delmonico's Roof* and Thomas Nason's *Silo*.[6] In the same year, the *New York Times* stated pointedly that ". . . 'modernism' has made few inroads . . ." at the 28th Annual Ex-

hibition of the Society of American Etchers, an organization which was to continue its exclusion of lithographs and relief prints for another four years.[7]

During the early 1940s, little notice was taken of the challenging ideas embodied in the prints of artists who were working with Hayter. After abandoning his Paris Atelier 17 the day after war was declared in September 1939, Hayter spent less than a year in his native England, and then sailed for New York in the spring of 1940. In October, the *Art Digest* noted Hayter's presence in the United States with no more than a brief, laconic comment that he had joined the staff of the New School for Social Research ". . . where he will re-establish his famous Atelier."[8] The "course" listing in the catalogue of the New School carried the rubric "Atelier 17" and Hayter personally selected experienced artists to work with him; this was his first move toward the revival of the Paris workshop in America. Hayter later recalled the circumstances surrounding the first several years of his stay in the United States, "I assure you this was a time when you could not give away what we called a modern print and yet four years later you had a tremendous amount of support when we went [with an exhibition of prints by artists associated with Atelier 17] all over the country."[9]

Leaders on the cutting edge of modern art had been attracted to Atelier 17 in Paris because of the experimental spirit, freedom from pedagogical proscriptions, fruitful interactions between artists, and, not least, the dynamic personality of Hayter. Miró, Max Ernst, Yves Tanguy, and Alberto Giacometti were among the artists of many nations—along with possibly a dozen Americans—whose printmaking thrived in the stimulating atmosphere of the workshop. Then, at the New York Atelier 17, artists who had fled to

5.1
John Sloan
Fifth Avenue, 1909

Etching (1941) 8 × 6
Awarded the First Prize for prints in the exhibition, Artists for Victory, at the Met-

ropolitan Museum of Art (1942). Delaware Art Museum. John Sloan Collection.

5.2
Grace Albee
Junked
Wood-engraving (1940) 7½ × 9¹/₁₆
Awarded one of two Third Prizes for prints in the exhibition, Artists for Victory, at the Metropolitan Museum of Art (1942). College of Wooster. John Taylor Arms Collection.

the United States—Chagall, Dali, André Masson, Miró, Jacques Lipchitz, and others—worked side by side with a larger and continually changing cluster of Americans.[10]

A foretaste of the kinds of prints that would be created at the New York atelier was offered in an exhibition of Hayter's prints and paintings at the Willard Gallery in 1941. Amidst the selection of his earlier intaglios was *Combat* (fig. 5.3), a symbolic translation—by the fervor of the engraved lines—of the violence of human hostilities. Hayter had created *Combat*, presciently, a few days before the beginning of the brutal and disastrous Spanish Civil War in 1936. Rosamund Frost's review of the exhibition, "The Chemically Pure in Art: W. Hayter, B.Sc., Surrealist," alluded to his education as a scientist and employment as an oil chemist in the Persian Gulf region before he became an artist, settled in Paris, and joined the vanguard of modern art.[11] Frost was intrigued by the characteristics of his paintings but described some of the engraved and etched prints, with

puzzlement, as "plasters." The *Art Digest*, however, was frankly disenchanted with the ". . . copper engravings which [Hayter] prints on plaster plaques, gouged out in curving hollows to make something akin to a relief. Many of [the engravings] do reach paper and are often far more effective than the plaster stunts. Especially when he goes so far as to color the plasters, masking the one prowess he holds—that of line."[12]

The plaster prints derived from experiments at the Paris workshop, as exemplified in *Composition* (fig. 5.4) by the American painter John Ferren. Metal plates were incised by one or more of the intaglio processes and inked, as was usual for printing on paper, but instead, the plates were surrounded by molding frames into which plaster of Paris was poured. The plaster castings, by then bearing the transferred images in ink, were made three-dimensional by carving and hand-tooling. If colors were desired, they were applied by hand as final effects.[13]

During the early years of Hayter's

mentorship at the New School for Social Research, he declined invitations for group showings of works produced at the reviving Atelier 17 because he was dissatisfied with the quality of the prints. On the other hand, Hayter and his fellow printmakers were beginning to receive token acceptance in a few major exhibitions, among them the Artists for Victory show of 1942. Doris Brian, in her review in *Art News* of the print section of the exhibition, lamented the decline in technical finesse that blighted works by American printmakers, although she complimented the craftsmanship in Wengenroth's *Meeting House*, Grace Albee's *Junked* (fig. 5.2) and Wanda Gág's *Lamplight*. She commended the skillful lithographs of Adolf Dehn and was also delighted by *The Great God Pan* (fig. 5.5), the work of another of the few Americans who satirized society in subjects real or imagined. But Brian noted that the Jury of Selection, made up of seven conservative printmakers, had chosen—from the 6,000 graphics submitted—few prints that bore

5.3
Stanley William Hayter
Combat (or *Battle*)
Engraving/etching (1936) 15⅞ × 19¾
Shown at the Willard Gallery (1941).
University Gallery, University of
Minnesota, Minneapolis.

5.4
John Ferren
Composition
Intaglio and colored plaster (1937)
11⅞ × 9⅛
Museum of Modern Art, New York. Gift of
the Advisory Committee.

5.5
Adolf Dehn
The Great God Pan
Lithograph (1940) 9⅝ × 13⅝
*Shown in the exhibition, Artists for Victory,
at the Metropolitan Museum of Art
(1942).*
*Elvehjem Museum of Art. Brittingham
Fund.*

characteristics of ". . . twentieth-century styles." Brian then singled out prints by five artists who had worked with Hayter in Paris or New York: Karl Schrag, Cathal O'Toole, Ian Hugo, Louise Bourgeois, and Theodore Brenson.[14]

Although the Atelier 17's provocative printmaking ventures under the aegis of Hayter had received little attention during its first three years in New York, visibility was assured when the Museum of Modern Art sponsored a group showing in 1944. New Directions in Gravure was mounted, with Hayter's advice, by Monroe Wheeler, then the Director of Exhibitions. The experimental aspects of the workshop's printmaking were emphasized by supplemental displays of original copperplates, an uninked plaster print by Hayter, and Ian Hugo's relief-printed engravings which adorned a privately printed book written by Anaïs Nin.[15] The title of the exhibition and its sponsorship by a major museum devoted to twentieth-century art announced with authority the "new directions" in which Atelier 17 was leading American

printmaking. The influence of the prints was extended beyond New York because New Directions in Gravure was sent on tour of the United States during the next two years. Another exhibitor was Sue Fuller, whose etching, *The Sailor's Dream* (fig. 5.6), was a visual metaphor produced by pressing muslin, ribbons, and cord into the malleable wax used for soft-ground etching. In 1945 Fuller used similar methods in *Hen* (fig. 5.7), for which a collage was made from a decorative lace collar pressed into the wax ground, then removed, and the plate etched before her engraver's burin incised the completed form of the fanciful fowl. *Hen* became her most admired exhibition piece for several years thereafter; it was awarded First Prize—at the Village Art Center in St. Johns-in-the-Village—by an impressive panel of jurors: John Taylor Arms, Will Barnet, A. Hyatt Mayor of the Metropolitan, Karl Kup, the Curator of Prints at the New York Public Library, and Una Johnson of the Brooklyn Museum.[16]

In addition to the novel experiments initiated at Atelier 17, Hayter

and his colleagues honored and re-evaluated the intaglio techniques of Europe's old-master printmakers. Sue Fuller's pressing of fabrics into a soft ground had historical precedents, notably in the work of Käthe Kollwitz, the great German printmaker who had adopted it for subtle textural illusion in *The Outbreak*, surely the most dramatic print of her *Peasant War* series. Hayter often mentioned his interest in historical antecedents; he demonstrated this interest when he cut finely woven cloth for the etched patterns that gave tonal and flamboyantly kinetic counterparts to the fluidly engraved lines of the wildly dancing figure in *Tarantelle* (fig. 5.8), another of the prints he chose for New Directions in Gravure.

Twentieth-century European art, in various kinds of abstractionism, expressionism, and surrealism, had generated powerful ripple effects around the world. Some American artists had been responsive to those modern artistic modes as the decades passed. Abraham Rattner, who had joined the ranks of modern masters in Paris and later created in-

5.6
Sue Fuller
The Sailor's Dream
Soft-ground etching (1944) 8¹³⁄₁₆ × 5⁷⁄₈
Shown in the exhibition, New Directions in Gravure, at the Museum of Modern Art (1944).
University Gallery, University of Minnesota, Minneapolis. Gift of Ione Walker.

taglio prints at Hayter's New York workshop, was represented in New Directions in Gravure by *And Among Those Who Stood There . . .* (fig. 5.9), his densely designed, expressionistic, and rather Byzantine print version of the Old Testament prophecy by Samuel which revealed the Lord's will that Saul should become the first king of Israel. Alexander Calder, sculptor and master of mobiles, lent other features of contemporary art to the display in the abstract and symbolic shapes of *The Big I* (fig. 5.10). The loosely assembled forms in the etching complemented, in a kinship of artistic style, Miró's prints in the exhibition, while revealing a hint of Calder's exuberance, often found in his sculptures, in the outrageous pun in print and title.

During the war years, the presence of distinguished émigrés intensified the influence of modern European artistic conceptions on younger Americans. The prints of Ian Hugo, for example, reflected features of surrealism that Hayter, and his colleagues Miró, Chagall, and Masson, had espoused first in Paris and then New York. In 1944 Anaïs Nin purchased an old press and, with the assistance of Gonzalo More, privately printed a limited edition of her short writings, some

5.7
Sue Fuller
Hen
Soft-ground etching/engraving (1945)
14⅞ × 11¾
*Awarded First Prize at the Village Art
Center in St. Johns-in-the-Village (1945)
and a Purchase Prize at the 18th Annual
Exhibition of Northwest Printmakers (Seattle, 1946). Shown in the exhibition, Master
Prints (1949), which celebrated the inaugural of the Abby Aldrich Rockefeller Print
Room at the Museum of Modern Art, and
in Technical Processes in Contemporary
Printmaking (1949), at the University
Gallery, University of Minnesota,
Minneapolis.
College of Wooster. John Taylor Arms
Collection.*

poetic and dream-filled, in the volume *Under a Glass Bell*. Original intaglios (fig. 5.11) by her husband, Ian Hugo (Hugh Guiler)—a banker by vocation—served as surrealistic illustrations for the book. In March 1944 the volumes of Hugo's prints and Nin's exotic-erotic writing were placed on sale at the Wakefield Gallery. Collectors quickly bought up the 300 copies of the edition with its unusual illustrations, the sales encouraged, one may presume, by the complimentary remarks of the well-known literary critic Edmund Wilson.[17] In August *Under a Glass Bell*, with its engraved and etched surrealistic fantasies, was a technical and artistic supplement to the exhibition New Directions in Gravure. Some of Hugo's plates were printed in the usual intaglio process; others were printed in a relief method by inking the raised surfaces. The latter were testimony to the probing trials of older techniques at Atelier 17, soon to be repeated when Hayter and Miró studied a fragment of an etched plate that the English poet-artist William Blake had printed in relief.[18] In 1947 Miró created a combination of images and poetry in the print *Illustrated Poem by Ruthven Todd*. The verses, written by Todd in 1937 and dedicated to Miró, recreated the gentle and magi-

5.8
Stanley William Hayter
Tarantelle
Soft-ground etching/engraving (1943)
21¾ × 13⅟16
Published by the Curt Valentin Gallery.
Shown in the exhibition, New Directions in
Gravure, at the Museum of Modern Art
(1944).
Art Institute of Chicago. Joseph Brooks Fair
Collection.

cal worlds that the artist had drawn
from dreams, only to have them
shattered, symbolically, by the ruth-
less bombings of Miró's native
Spain. The composition turned out
to be an unusual color etching,
printed in relief, and, as well, a col-
laborative "poem-print" (1947). The
technical testing and experimenta-
tion at the workshop led many re-
viewers to overemphasize those
kinds of activities when writing of
the growing reputation of Atelier
17. Hayter advocated repeatedly,
however, the artistic necessity of in-
tegrity and synthesis in content,
style, and technique.

Young printmakers were attracted
to the workshop by its freedom
from pedantry and the opportunity
it afforded for individual expression
as much as they were by the reciproci-
ties of technical advice that members
of the group offered to each other
under the liberal guidance of Hay-
ter. On the other hand, Atelier 17
gave young artist-printmakers no ex-
emption from the influences of ma-
jor artistic elders. Reflections of all
modern artistic movements ap-
peared in their prints and some of
the young artists were affected by
the awesome creations of Picasso,
especially the works that restated the
infinite kinds of human and ani-
malistic violence in his savagely dis-
torted and anguished images. André
Racz and Mauricio Lasansky worked
their way through such transitional
stages until Picasso's influence on
them waned and their prints dis-
played the highly personal and ma-

ture characteristics that made them,
in turn, influential printmakers.

In the mid-1940s, however, Racz,
a young Romanian-American émi-
gré, created a harsh interpretation of
the ancient legend of *Perseus Behead-
ing Medusa VIII* (fig. 5.12), expres-
sive and shocking, but not yet free

of influences from Picasso and Hay-
ter. Racz took liberties in his visual
transcription of the myth of Me-
dusa, the only mortally vulnerable of
the three sister Gorgons. The head
of Perseus simulates the helmet, lent
to him by Pluto for his violent mis-
sion. And Medusa's head, blood

1
Guy Maccoy
Three Trees and a Low Sky
Color silkscreen (1943) 11 × 14³⁄₁₆
One of the first prints created in the silk-screen medium to receive a Pennell Purchase Prize and enter the collection of the Library of Congress.
Madison Art Center. Langer Collection.

2
Harry Gottlieb
Winter on the Creek
Color silkscreen (1940) 14^{11}/$_{16}$ × 19^{3}/$_{4}$
*In 1940 the print was displayed in the sec-
ond one-man show of silkscreen prints at the
ACA gallery and in the first group exhibi-
tion of prints in the medium at the Spring-
field Museum of Art (Massachusetts).
Awarded the Eyre Medal for the best print
in the 40th Annual Exhibition of Water-
colors and Prints, at the Pennsylvania
Academy of the Fine Arts (1942).
Madison Art Center. Langer Collection.*

3
Stanley William Hayter
Cinque Personnages
Color intaglio/silkscreen (1946)
14⁵⁄₁₆ × 23⁷⁄₈
*Shown in the 1st National Print Annual
Exhibition, at the Brooklyn Museum
(1947).*
*Elvehjem Museum of Art. Gift of Mark
and Helen Hooper.*

4
Alfred Sessler
Thorny Crown
Color woodcut (1958) 21⅛ × 15½
Elvehjem Museum of Art. Gift of Mrs.
Alfred Sessler.

5
Dean Meeker
Don Quixote
Color silkscreen (1951) 12 × 17¼
Received the Marion Osborne Cun-
ningham Memorial Prize of the San
Francisco Art Association (1952) and a
Purchase Prize in the 1st National Print
Exhibition of the Dallas Print Society, at
the Dallas Art Museum (1953). Shown in
the 6th National Print Annual Exhibition,
at the Brooklyn Museum (1952), and the
Quarter Century International Exhibition
(25th annual) of the Northwest Print-
makers, at the Seattle Art Museum
(1953).
Elvehjem Museum of Art.

6
Worden Day
Arcana III
Color woodcut (1954) 32$\frac{1}{16}$ × 14$\frac{9}{16}$
Shown in the 8th National Print Annual
Exhibition, at the Brooklyn Museum
(1954), and in the exhibition, 14 Painter-
Printmakers, at the Kraushaar Galleries
(1954).
University Gallery, University of
Minnesota, Minneapolis.

7
Carol Summers
Mezzogiorno
Color woodcut (1960) 36 × 35½
Shown in the retrospective exhibition, Carol
Summers Woodcuts, at the ADI Gallery
(San Francisco, 1977).
Courtesy of the artist.

8/20 "In A Moment of Panic" E. Cumella '54

8
Edmund Casarella
Moment of Panic
Color paper relief print (1954)
30¾ × 22¾
Shown in the 9th National Print Annual
Exhibition, at the Brooklyn Museum
(1955), and the 14th National Exhibition
of Prints, at the Library of Congress
(1956).
Elvehjem Museum of Art. Humanistic
Foundation Fund.

9
Alfred Sessler
Larva
Color woodcut (1957) 12¾ × 18¼
Elvehjem Museum of Art. Gift of Mrs.
Alfred Sessler and children.

10
Sister Mary Corita (Kent)
This Beginning of Miracles
Color silkscreen (1953) 15½ × 19½
Published by the International Graphic
Arts Society.
Shown in the 2nd National Print Exhibi-
tion, at the University of Southern Cali-
fornia (1953), and in the retrospective
exhibition, Silkscreen: History of a Me-
dium, at the Philadelphia Museum of Art
(1971).
University Gallery, University of
Minnesota, Minneapolis. Gift of Ione and
Hudson Walker.

11
Dean Meeker
Trojan Horse
Silkscreen on a gold ground (1952)
18$\frac{1}{16}$ × 25$\frac{3}{16}$
*Shown in the exhibition, Young American
Printmakers, at the Museum of Modern
Art (1953). Received a Purchase Prize in
the 26th International Exhibition of the
Northwest Printmakers, at the Seattle Art
Museum (1954).*
Elvehjem Museum of Art. Gift of the artist.

12
Adolph Gottlieb
Untitled
Color lithograph (1969) 22⁵⁄₁₆ × 30¹⁄₁₆
*Elvehjem Museum of Art. Gift of Mark
and Helen Hooper.*

13
Jasper Johns
Fool's House
Color lithograph (1971–1972)
40 11/16 × 20
© Gemini G.E.L.
Shown in the exhibition, Jasper Johns:
Prints 1970–1977, at the Center for the
Arts, Wesleyan University (1978).
Elvehjem Museum of Art. Endowment
Fund Purchase.

14
Jim Dine
Tomato and Pliers
Color lithograph/etching (1973)
23⅞ × 29½
*Printed by Maurice Payne. Published by
the Petersburg Press, London.*
*Shown in the exhibition, Jim Dine Prints:
1970–1977, at the Williams College Mu-
seum of Art (1977).*
*Elvehjem Museum of Art. Charles E.
Merrill Trust Fund.*

15
Jean Charlot
Woman Washing, no. 8 from *Picture Book*
Color lithograph (1933) 8 × 6
Printed by Lynton Kistler. Published by J. Becker, New York.
Elvehjem Museum of Art. Brittingham Fund Purchase.

16
Clinton Adams
Venus in Cíbola I
Color lithograph (1968) 6⅜ × 7½
Printed in collaboration with Jean Milant
at the Tamarind Lithography Workshop.
University Art Museum, University of New
Mexico. Collection of the Tamarind
Institute.

streaming from the severed neck, bears less the locks of writhing serpents—known in legend—than strands of flagellant darts. Her body is swollen, convulsive, half obscured amidst the interpenetrating shapes of legendary beasts.

The emotive force of Racz's print was matched in three engravings that Mauricio Lasansky created in the year following his arrival from the Argentine—*Horses in Heat*, *Horse*, and *Doma* (horsebreaking) (fig. 5.13). *Horse* and *Doma* were chosen for New Directions in Gravure. All three equine prints were filled with frenzied animals, similar in violent features to the maimed, screaming horse that Picasso had evolved for his painting of outrage after the German bombing of the Basque town of *Guernica*, (Picasso's formidable creation of muralesque

proportions was installed at the time in the Museum of Modern Art.) The engraving *Doma* also corresponded to a passage from the nineteenth-century epic poem of Lasansky's native land, *El Gaucho Martín Fierro* by José Hernández. *Martín Fierro* recounts the triumph of the gaucho as a horsebreaker, *el domador*, who, as a man of cunning and with the ". . . craft God gave to him . . ." breaks the wild and flailing animal that seems to be ". . . tearing itself to bits."[19] Lasansky's *Doma* is the subjugation of a terrorized stallion, compounded by a castration which, if not literally shown, is symbolized in the reaching arm and grasping hand of *el domador*. Moreover, implicit in the kneeling, threatening, headless figure that seeks to dominate the half-human, half-stallion is a related theme—a univer-

5.9
Abraham Rattner
And Among Those Who Stood There . . .
Color etching (1944) 6⅞ × 9⅞
Published by the Paul Rosenberg Gallery.
Shown in the exhibition, New Directions in Gravure, at the Museum of Modern Art (1944).
Art Institute of Chicago.

5.10
Alexander Calder
The Big I
Soft-ground etching (1944) 6⅞ × 8⅞
Shown in the exhibition, New Directions in Gravure, at the Museum of Modern Art (1944).
National Museum of American Art (formerly National Collection of Fine Arts), Smithsonian Institution. Museum Purchase.

sal parable of man subjugating man by aggression and brutality.

From our contemporary vantage, it may seem curiously old-fashioned that American artist-printmakers clung tenaciously to a black-and-white tradition for so many decades, or that some were so implacably opposed to the introduction of color into printmaking that they considered it nothing less than an artistic prostitution of the conventions of the art. In the late 1930s, a few American printmakers had been encouraged by their sallies into color lithography, woodcut, and silk-screen, stimulated by the descriptive and aesthetic enrichment that was gained with color. The priority led artists from across the country to found the American Color Print So-

ciety in 1939. The first annual exhibition was presented at The Print Club of Philadelphia in February 1940 with First Prize awarded to Emil Ganso for his color lithograph *Early Snow*. The trend was reinforced by the numerous color impressions coming from Atelier 17, exemplified by Hayter's composition with five figures, one of the most admired color prints that he created in the midforties. *Cinque Personnages* (color fig. 3) was another forecast of subsequent technical complexities in American printmaking; Hayter had engraved and etched the blacks and grays, had parts of the plate cut out to ensure unblemished whites from the unprinted paper, and composed interpenetrating forms by printing, and then over-

5.11
Ian Hugo
Under a Glass Bell
Engraving/soft-ground etching (1944)
10 × 12
Hugo's book-cover intaglio for Anaïs Nin's Under a Glass Bell *was included in the exhibition, New Directions in Gravure, at the Museum of Modern Art (1944) and, earlier in 1944, was shown at the Wakefield Gallery.*
Northwestern University Library, Special Collections Department.

printing, transparent inks and opaque paints with silkscreens.[20]

Color had become a feature crucial to the prints of Fred Becker as he turned from the simple black-and-white wood-engravings of American genre, crisply executed in *Jam Session* (fig. 4.6), to the mixed methods used for *The Cage* (fig. 5.14). The intaglio print was a complex one, both in the techniques and multitude of abstract and decorative forms that reordered birds and cage into a designed fantasy. Furthermore, his basic plate was photoengraved, another harbinger of the many technical exploits of later decades. Photoengraving had an antecedent, a score of years earlier, in the great *Miserere* suite of the French master, Georges Rouault, whose ink-and-gouache drawings had been photoengraved onto plates, then handworked with aquatint, drypoint, and roulette in many states.

Printmakers who shared modern tendencies often sought to exhibit in concert. In 1946 and 1947 three short-lived exhibiting groups were organized. The Vanguard group, which included Schanker, Hayter, Fuller, Drewes, Kurt Seligmann, and later Josef Albers, had their first showing at The Print Club of Philadelphia in 1946. Karl Kup, print curator, wrote that the Vanguard exhibition, ". . . caused somewhat of a breeze in the Quaker City. The show will travel to Chicago later, where it should be given an even breezier reception. Let us hope that more localities will have the good fortune to see what is being done outside the conservative and academic."[21] In July 1946 the Jacques Seligmann Galleries presented The Printmakers, a group of younger artists working in the modern vein whose leader was Seong Moy, a promising creator of color woodcuts who had returned recently from Air Force duty in the China-Burma theater of war. Then in February 1947, the Seligmann Galleries also displayed prints by a new exhibiting group of ten, The Graphic Circle, some of whom were among the members of the Vanguard—Schanker, Drewes, Kurt Seligmann, and Josef Albers. The principal organizer of The Graphic Circle was Boris Margo (fig. 5.15), innovator of cellocuts—celluloid dissolved with acetone—which he often mounted on more rigid supports, each material providing a distinctive effect in the final printing.

Albers had been associated with Walter Gropius's famous Bauhaus in Germany, a center of contemporary design in all of the arts and architecture. His contribution to printmaking was a severe kind of modern abstractionism, typified by the lithograph *Ascension* (fig. 5.16). Albers's interest in the use of mechanical aids and his preoccupation with illusions of spatial effects and movements were phenomena he would study for years in compositions that anticipated the visual legerdemain of Op Art. Aesthetic and technical propositions made by Albers in those years, or later for prints by computerized technologies, were unacceptable to

5.12
André Racz
Perseus Beheading Medusa, VIII
Color engraving/aquatint/soft-ground
etching (1945) 21¾ × 14⅞
*Museum of Modern Art, New York. Gift of
the Spaeth Foundation.*

5.13
Mauricio Lasansky
Doma
Engraving (1944) 19¹³⁄₁₆ × 13⅞
*Shown in the exhibition, New Directions in
Gravure, at the Museum of Modern Art
(1944). In 1945 the engraving received a
Purchase Prize at the 17th Annual Exhibi-
tion of Northwest Printmakers (Seattle)
and a Pennell Purchase Prize in the 3rd
National Exhibition of Prints at the Li-
brary of Congress.*
*Seattle Art Museum. Gift of the Northwest
Printmakers.*

artists of traditional tastes or to con-
temporary printmakers who pre-
ferred surrealistic or expressionistic
content and were unwilling to aban-
don the highly personalized, auto-
graphic characteristics of freehand
draftsmanship. According to Albers,
"[the] ruler and drafting pen [are] a
proper means for graphic expres-
sion. They prove it unjustified to
evaluate and reject lines without
modulation as an unartistic means
for graphic art. In this way they op-
pose a belief that 'hand-made' is bet-
ter than machine or tool made . . .
Each way has its possibilities, and
more emphatically in this time of in-
dustrial evolution."[22]

Rarely did the juries of major
competitive printmaking exhibitions
select or honor the prints of those
who espoused modern tendencies
and unorthodox techniques during
the early years of the forties. It is
probable that the majority of conser-
vative judges, who were the pillars
of etching societies, looked upon
modern or unorthodox works as
transient digressions from the main-
stream of American printmaking.
Nonetheless, admissions and awards
occurred with more frequency from
1944 forward. Hayter received the
Charles M. Lea Prize at The Print
Club of Philadelphia for *Laocoön*,
one of many prints with mythologi-
cal themes that he was creating in a
disquieting style with radical tech-
niques. And in the autumn of 1944,

5.14
Fred Becker
The Cage
Color intaglio/photoengraved plate
(1946) 6⅞ × 4¹⁵⁄₁₆
Awarded a Purchase Prize at the 19th Annual Exhibition of Northwest Printmakers (Seattle, 1947). Shown in the First National Print Annual Exhibition at the Brooklyn Museum (1947).
Seattle Art Museum. Gift of the Northwest Printmakers.

5.15
Boris Margo
The Sea
Color cellocut/wood support (1949)
16⁹⁄₁₆ × 16⁹⁄₁₆
Shown in the exhibition, Master Prints, which celebrated the inaugural of the Abby Aldrich Rockefeller Print Room at the Museum of Modern Art (1949), and in the 3rd National Print Annual Exhibition at the Brooklyn Museum (1949).
Museum of Modern Art, New York. Purchase Fund.

following the display of New Directions in Gravure, several of the Atelier 17 exhibitors had prints accepted for the 29th Annual Exhibition of the Society of American Etchers. Karl Schrag's aquatint, *Solace,* was hung, Sue Fuller displayed *Cock,* which the *New York Times* praised as ". . . a distinguished black-on-red engraving," and Hayter was represented by *Flight.* Ian Hugo was singled out by an Honorable Mention in the Kate W. Arms Memorial Prize for his *Bird of Divinity.*[23]

By 1945, the prints of Mauricio Lasansky were first honored by awards when an impression of his violent engraving, *Doma* (fig. 5.13) received a prize at the 17th Annual Exhibition of Northwest Printmakers and another was acquired by the Library of Congress during the 3rd National Exhibition of Prints, although the choice was an odd and surprising contrast to the usual conservative purchases made with Pennell Fund monies. Fuller's *Hen* (fig. 5.7) was awarded a Purchase Prize in 1946 at the 18th Annual Exhibi-

tion of Northwest Printmakers in Seattle and, in New York, Fuller and Hayter were two of the several appointed members of the Jury of Admissions for the 31st Annual Exhibition of the Society of American Etchers. However, their counterparts, on the Jury of Awards, were unwilling to approve prizes for any of the vanguard printmakers. Nonetheless, changes of one kind or another could not be resisted indefinitely and in 1947, with the 32nd Annual Exhibition of the Society of American Etchers, accommodations

were made, finally, to the importance of media other than intaglio when the organization was reincorporated as the Society of American Etchers, Gravers, Lithographers, and Woodcutters, prompting queries, however, about the continuing exclusion of serigraphers. The change in name did not herald a sudden liberalization of admissions and awards,

although modest progress was suggested when Fuller won the John Taylor Arms Prize for her etching *Bat* and Lasansky received the Treasurer's Award for his color engraving *My Wife*. However, neither print was outrageously controversial.

Another event of 1947 that bore the prospect of a more liberal forum for modern American printmakers

was the First National Print Annual Exhibition organized by Una Johnson, the Curator of Prints at the Brooklyn Museum. It initiated a long succession of prestigious annual and biennial exhibitions of contemporary prints. A Purchase Prize was awarded to one of Robert Gwathmey's many images of the life of southern blacks, *Singing and*

5.16
Josef Albers
Ascension, from the *Graphic Tectonic Series*
Lithograph (1942) 17³/₁₆ × 8⅛
Printed by Reinhard Schumann.
Museum of Modern Art, New York. Gift of the artist.

5.17
Robert Gwathmey
Singing and Mending
Color silkscreen (1946) 12 × 14⅛
Awarded a Purchase Prize in the First National Print Annual Exhibition and shown in the retrospective exhibition, American Printmaking: 1913–1947, both held at the Brooklyn Museum (1947).
Achenbach Foundation for Graphic Arts, the Fine Arts Museums of San Francisco. Gift of George Hopper Fitch.

Mending (fig. 5.17). Moderately modern in its semiabstract, poster-like manner and unusually bold color choices of silkscreen paints, the print clung to a regional reference and had been singled out for special notice once before, in a display of the National Serigraph Society in December 1946.[24] Another Purchase Prize for the Brooklyn Museum collection, and a print more closely allied to the "new directions," was the engraving *Battle of the Sexes* (fig. 5.18) by Ernest Freed, who had worked with Lasansky. Although it reflected some Italianate mannerisms of a much earlier art-historical period, the characteris-

tics of the print were clearly in concord with the allegorical themes and vigorous, though more abstract, figure engravings of Hayter.

Both *Singing and Mending* and *Battle of the Sexes* were lent for display in another exhibition held at the Brooklyn Museum, when the American Institute of Graphic Arts sponsored American Printmaking: 1913–1947. Although it was a retrospective rather than a competitive exhibition for active printmakers, the modern section reflected an eagerness to display conceptionally contemporary works. The visual review began with prints of Joseph Pennell and Childe Hassam, fol-

lowed by examples of the progressive printmakers who had reported on American life during the succeeding decades. Then came a group of recent works by Albee, Landeck, Robert Riggs, and Wengenroth, but none was radical in artistic characteristics. As addenda, however, there were surprising and odd assortments of prints by modern American and avant-garde European artists.

The Committee of Selection was composed of four members. Una Johnson, Curator at the Brooklyn Museum, served as Chairman, and Jean Charlot—printmaker and fresco painter associated with the modern Mexican mural movement—wrote

5.18
Ernest Freed
Battle of the Sexes
Intaglio (1946) 17¾ × 28⅜
Awarded a Purchase Prize at the 1st National Print Annual Exhibition and included in the retrospective exhibition, American Printmaking: 1913–1947, both held at the Brooklyn Museum (1947). Shown in A New Direction in Intaglio, at the Walker Art Center (Minneapolis, 1949), and the retrospective exhibition, 30 Years of American Printmaking, at the Brooklyn Museum (1976). Brooklyn Museum. Museum Collection Fund.

the catalogue essay. A decade later Johnson ascribed the selections for the American retrospective to Charlot, but it is likely that Johnson's liberal inclinations supported Charlot's in the committee's choices of prints by Stuart Davis, Calder, Rattner, Ben Shahn, Fuller, and Freed.[25] As a historical survey of American printmaking, the liberality of selections was even more striking in the works of émigrés or transients such as Alexander Archipenko, Albers, Margo, Hayter, and the *Composition* by Max Ernst from one of the *Brunidor* portfolios of surrealistic and fantastic art printed at Atelier 17. American visitors to the galleries must have been astonished further when they encountered a *Rotorelief* in color by a leader of Dada, Marcel Duchamp, printed in Paris a decade earlier by offset lithography—a record-shaped object to be rotated on a phonograph turntable, thereby creating an optical illusion of spatial depth as it whirled.

Jean Charlot's essay for the exhibition catalogue proposed an overview: "If this [American] retrospective collection has succeeded in being truly representative of the trends of the span involved, it should suggest the unlacing of the stays of academic tradition, the ensuing gambol in the pastures of modern [progressive] art, and, on the edge of the [present] era, a revulsion of younger artists against the once-young moderns"[26] Few of the prints were by very young Americans, however, and the artistic opposition to the work of the "once-young moderns," such as Charles Sheeler and Edward Hopper, was represented more prominently by the works of the recent émigrés from Europe or mature Americans, such as Stuart Davis, Rattner, and Weber. Still, the exhibition had a good dose of the contemporary when compared to selections by the majority of print juries that, in those years, continued to

favor the traditional, thereby assuring exhibitions whose conservative ramparts were rarely breached.

The yearly competitions of the National Exhibition of Prints sponsored by the Library of Congress admitted or rewarded only a scatter of modern prints. A new venture, tied to the marketplace, compounded the conservative preferences. In 1946 the Associated American Artists promoted a First Annual National Print Competition Exhibition, offering prizes far more substantial than those that lured printmakers to submit works to other shows. After the prints had been chosen, it was reported that both the ". . . prizes and the show as a whole are rather middle-of-the-road, with more deflection to the right than to the left."[27] Two of the four jury positions for the First Annual had been granted to the printmaker John Taylor Arms and to Carl Zigrosser, who was by then a curator. Although the judgments had been moderate, all jury posts for the Second Annual were assigned to staff members of the Associated American Artists, assuring "in-house" choices. Three first prizes of $1,000 each were awarded and, in return, the dealership reserved the right to publish and sell editions of the prizewinning prints. Luigi Lucioni, who always was skillfully precise in the execution of handsome pictorial etchings, received one of the top awards for *The Big Haystack* (fig. 5.19), a print typical of his consistently calm and gracious New England landscapes. The other $1,000 prizes went to Stephen Csoka for a solidly conservative etching of a mother and child victimized by war, entitled *Fatherless*, and to one of Ivan Le Lorraine Albright's knaggy and unflattering likenesses, a lithographic version of the *Self-Portrait* that he had painted in oils a dozen years earlier.[28]

A current of conservatism continued on its persistent course in Philadelphia when the Eyre Medal was awarded to Carl Schultheiss for *Pastoral I* in the 45th Annual Exhibition of Watercolors and Prints at the Pennsylvania Academy of the Fine Arts.[29] Then, his *Pastoral II* (fig. 5.20), handsomely engraved but displaying an eclectic affinity for Renaissance devices and effects, was published by the Chicago Society of Etchers as its prize print of 1947 with presentation impressions given to all of the nonprofessional associate members of the Society.[30] C. J. Bulliet, critic for the Chicago *Daily News*, described the traditional characteristics of the 37th Annual Exhibition of the etchers in Chicago, then remarked that "there is one dare devil, Ernest Freed, who dares to show a color etching, . . . 'Black Magic,' . . . which is startling in its surroundings."[31] Meanwhile, if the printmakers who were striking out in new directions were receiving fewer honors than conservatives at major competitive exhibitions, there were compensations such as group and one-man shows sponsored by dealers who were sympathetic to avant-garde art at the Willard, Seligmann, Hugo, Kleemann, Laurel, and Ashby galleries.

When World War II ended with the cessation of hostilities in the Pacific in 1945, many veterans of the Armed Forces used subventions of the GI Bill of Rights to enroll in all kinds of educational institutions during the next several years. Enrollments in art schools and the art departments of universities and colleges swelled. The young artists whose careers had been interrupted by service in the far-flung theaters of war had been mustered out with little awareness of the challenging innovations that had jolted the steady but largely complacent progress in American printmaking. Some quickly gravitated toward the few stimulating print programs during their years of catching up on postponed studies in the arts. Atelier 17 was by then a readily identifiable center of experimental practices, Mauricio Lasansky had launched the seminal program and group enterprise in intaglio printmaking at the University of Iowa, and the print workshop at the University of Wisconsin was in its formative stage under the mentorship of Alfred Sessler.

Hayter returned to France in 1946 to survey the prospects for reestablishing his workshop, but four more years passed before the Paris Atelier 17 was revived. Meanwhile, whenever Hayter took extended leaves abroad, the New York workshop continued under a succession of directors, including Karl Schrag, James Kleege, Leo Katz, and Peter Grippe. Joann Moser has identified over 135 émigrés, mature American printmakers, and younger artists who worked at Atelier 17 during the fifteen years of its existence in New York, and is confident that there were others whom she has been unable to trace.[32] The direct impact and rippling influence on printmaking had been far-reaching, but the magnetism of the workshop diminished gradually—in part because of the prolonged absences of Hayter—until 1955 when Atelier 17 in New York was abandoned.

Mauricio Lasansky had been a prominent young printmaker in the Argentine before he received a Guggenheim Fellowship and came to the United States in 1943. The international mixture of artists who worked at Atelier 17 lent encouragement to new characteristics in his conceptions and a stimulus to extended explorations of intaglio methods, including color printing. The Whyte Gallery in Washington sponsored a one-man show in 1944 and in 1945 Lasansky won an award for *Doma* (fig. 5.13) at the 17th Annual Exhibition of Northwest Printmakers and received the Charles M. Lea Prize at The Print Club of Philadelphia for *Sol y Luna*. Then, with admirable foresight, Professor Les-

5.19
Luigi Lucioni
The Big Haystack
Etching (1947) 8 × 11⅞
Awarded a $1,000 First Prize at the 2nd Annual National Print Competition Exhibition, sponsored by Associated American Artists (1947).
Courtesy of Associated American Artists.

ter Longman invited Lasansky to the University of Iowa. The felicitous developments that derived from his presence led to a printmaking center of such influence that it became the prototype for programs and workshops at many colleges and universities after his students fanned out across America to teach intaglio.

Complex features began to emerge in Lasansky's prints as his art turned from the starkly engraved simplicity of *Doma* toward multiple processes and frightful apparitions in four versions of *For an Eye an Eye* (fig. 5.21). Those several visions of violence—grotesque humans, naked and threatening, brandishing crude, makeshift weapons—all bore similar titles, alluding to the Biblical law (in Exodus and Deuteronomy) of retribution without mercy: "And thine eye shall not pity, but life shall go for life, eye for eye, hand for hand. . . ."

The prints were conceived in the years when mindless brutalities were being exposed to the world with numbing shocks, one after another, especially the ghastly horrors of the Nazi concentration camps which Lasansky evoked, though more abstractly, in *Dachau*. Those and other works, however, were transitional in the artistic evolvement that led to richly tonal and highly evocative prints of a decade later, most splendidly in an unusually large intaglio that Lasansky created after a stay in Spain. *España* (fig. 5.22)—with a gigantic, apparitional rider who soars as a furtive, tainted specter above his immobile mount, and a malformed infant prostrate before a weeping peasant woman—seemed to enact a metaphoric nightmare of a tragic land and people under the Franco dictatorship, a vision in a dreadful dream which Lasansky con-

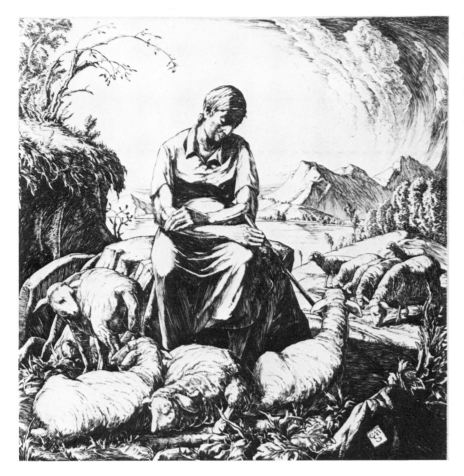

5.20
Carl Schultheiss
Pastoral II
Engraving (1947) 9¾ × 9
Chosen as the presentation print of the Chicago Society of Etchers (1947).
College of Wooster. John Taylor Arms Collection.

jured into view as a contemporary counterpart of the haunting series of *Sueños* or *Disparates* [*Dreams or Strange Things*] that the deafened Goya had etched late in life.

Soon after Lasansky arrived in the Midwest, an Iowa Print Group was formed under his leadership. In January 1949 prints by the members were shown at the Walker Art Center in Minneapolis. The exhibition, entitled A New Direction in Intaglio, had a pedagogical purpose; copperplates were displayed next to original impressions.[33] The exhibition served as a review of Lasansky's prints from 1936 to 1948 and also as a foretaste of the accomplishments of students who later were printmakers at universities across the country Ernest Freed, Malcolm Myers, John Paul Jones, Lee Chesney, Glen Alps, Ray French, and James Steg. Several had by that time

been exhibitors in the national print annuals at the Brooklyn Museum, and Freed displayed, once again, *Battle of the Sexes* (fig. 5.18), the Purchase Prize engraving acquired by the museum a year and a half earlier. One of three intaglios exhibited by Malcolm Myers was *St. Anthony* (fig. 5.23), a print purchased with Pennell Fund monies for the Library of Congress. Myers's conception of the ancient and apocryphal legend, and the frightful visions endured by St. Anthony, was cloaked in a dark, enveloping chiaroscuro from which the fantastic and threatening beasts of the legions of Satan emerged to assault the holy hermit.

Those prints, and others exhibited in A New Direction in Intaglio, revealed that the themes preferred by the Iowa Print Group were allegories, mythologies, visions, and ab-

stractions rather than portrayals of familiar American life and landscape. Moreover, the analogous exhibition titles of the Iowa Print Group and Atelier 17—A New Direction in Intaglio and New Directions in Gravure—along with a quickening frequency of articles about the successes at the two workshops, created a transitory and mistaken consensus that intaglio printmaking was the only area blessed with exciting ideas and vital advances.

A second timely printmaking center in the Midwest, also forecasting the rise of many university programs and workshops, was initiated two years after Alfred Sessler joined the faculty at the University of Wisconsin in 1944. In contrast to the exclusive advocacy of intaglio processes by Lasansky at Iowa, Sessler encouraged students to seek creative and

5.21
Mauricio Lasansky
For an Eye an Eye, III
Etching/soft-ground/aquatint/electric
stippler (1946–1948) 27 × 21½
*Shown in the exhibition, A New Direction
in Intaglio, at the Walker Art Center,
Minneapolis (1949).*
*University of Iowa Museum of Art. Gift of
Mr. and Mrs. Webster B. Gelman.*

5.22
Mauricio Lasansky
España
Etching/soft-ground/aquatint/engraving
(1956) 31⅞ × 20¾
*Shown in the 152nd Annual Exhibition of
Watercolors, Prints and Drawings, at the
Pennsylvania Academy of the Fine Arts
(Philadelphia, 1957) and the 7th Annual
Mid-America Exhibition, at the William
Rockhill Nelson Gallery (Kansas City,
1957). Received the José Guadaloupe
Posada Award at the Primera Exposition
Bienal Interamericana de Pintura y
Grabado (Mexico City, 1958).*
*University of Iowa Museum of Art. Gift of
Mr. and Mrs. Webster B. Gelman.*

technical success in several major
media. He had learned etching from
Elsa Ulbricht and other funda-
mentals of printmaking on the Fed-
eral Art Project in Milwaukee and
through his personal association
with Robert von Neumann, a su-
perb teacher and German-trained li-
thographer, woodcutter, and etcher.
Von Neumann was the recipient of

frequent honors in national compet-
itive exhibitions for prints, such as
Trapnet Fishing on the Great Lakes
(fig. 5.24), filled with indigenous
and vigorous images of the fisher-
men and fleets that sailed out of
western Lake Michigan ports from
the Door Peninsula southward.
 Printmaking had been an occa-
sional or minor offering at most art

schools and was too often ineptly
taught. Wisconsin was no exception
before 1946, the year Sessler began
instruction in three basic media:
lithography, etching, and woodcut.
His own printmaking at the time
was primarily in lithography and
differed markedly from the "new di-
rections" in intaglio and the accom-
panying modern conceptions and

5.23
Malcolm Myers
St. Anthony
Intaglio (1946) 15 × 24
Embossed, lower right, "Print Group University of Iowa."
Awarded a Purchase Prize in the 17th Annual Exhibition of Northwest Printmakers (Seattle, 1947). Shown in the First National Print Annual Exhibition, at the Brooklyn Museum (1947), and the exhibition, A New Direction in Intaglio, at the Walker Art Center, Minneapolis (1949). Seattle Art Museum. Gift of the Northwest Printmakers.

styles that were spreading beyond New York. Sessler's themes usually reflected the social genre that he experienced and observed during his youth and young adulthood in Milwaukee, although at times he digressed to create prints revealing a strong distaste for the brutality of *Night Riders*, of hate organizations, and the sometimes abusive forces of the law. More frequently, his prints revealed a deep compassion for the little people and their lot, the waifs and wanderers of poorer city neighborhoods. The drab realities were simple or amusing, as in the gaggle of gossiping women at an old Milwaukee market in *Morning Forum* (fig. 5.25). During the forties and early fifties, Sessler's works bore witness to the subtle and unyielding persistence of sadness or absurdity

that blights the human condition. Recurring compositions were filled with the sorrow-ravaged faces of aging male and female derelicts, or wandering ragwomen ludicrously self-bedecked with the found treasures of shabby finery in castaway ribbons, bows, and bonnets. As a surprising exception to those kinds of themes, in 1949 Sessler created *Tomah Rock* (fig. 5.26), a landscape lithograph which prefigured the many forms of nature he transcribed as symbolic metaphors in later, and strikingly colorful, woodcuts. In actuality, Tomah Rock was one of the many ancient, obdurate, landlocked "islands" that had resisted the relentless forces of wind and water in the unglaciated Driftless Region of western Wisconsin. The expressive and organic shapes, incipient in the

lithograph, later burst forth in a series of tense, multicolored woodcut compositions, based on fragments of nature but carrying wider connotations through allusions and analogies as in *Thorny Crown* (color fig. 4). In turn, the dynamic color woodcut was the genesis of several print rehearsals for Sessler's last painting, in creation at the time of his sudden death in 1963, wherein the thickets of thorny shapes formed a crucifixion symbol, affirmed by the title, *Until the Ninth Hour*, which echoed St. Mark who recounted that ". . . there was darkness over the whole land until the ninth hour. And . . . Jesus cried out with a loud voice . . . My God, my God, why hast thou forsaken me?"

The printmaking workshop that Sessler had envisioned for Wiscon-

sin added another dimension shortly after Dean Meeker joined the faculty. While attending the School of the Art Institute of Chicago, Meeker had supported himself by working at commercial silkscreen companies. In 1948, students at Wisconsin responded so favorably to an informal course in serigraphy that it became a permanent offering of the printmaking program two years later. By 1951, Meeker, who for years would be intrigued by legendary, historical, and literary themes, had created his ephemeral vision of *Don Quixote* (color fig. 5) in a color silkscreen. Soon thereafter, the print received the Marion Osborne Cunningham Memorial Prize in San Francisco, an award that honored the memory of an early serigrapher and generous patron of the Western Serigraph So-

5.24
Robert von Neumann
Trapnet Fishing on the Great Lakes
Lithograph (1943) 10⅝ × 14¹³⁄₁₆
Awarded Third Prize in the 2nd National Exhibition of Prints, at the Library of Congress (1944), and an Honorable Mention at The Print Club of Philadelphia (1944).
Library of Congress, Prints and Photographs Division.

5.25
Alfred Sessler
Morning Forum
Lithograph (1951) 6¾ × 2⅞
Elvehjem Museum of Art. Gift of Mrs.
Alfred Sessler.

ciety, an organization that Guy Maccoy had helped to promote after he settled in California in 1947. Printmaking at Wisconsin received further stimulation from the appointments of Warrington Colescott and Robert Marx, both of whom were showing silkscreens in the early fifties at the National Print Annual Exhibitions of the Brooklyn Museum, and later with the arrivals of Raymond Gloeckler, William Weege, and Jack Damer plus a parade of visiting printmakers, all of whom gave enrichment and diversity to the offerings.

Other collegiate programs, which emerged rapidly in the 1950s, varied from the self-imposed limitations set by Lasansky's intaglio center at Iowa to the wide array of media that Wisconsin printmakers preferred to present. Although universities and colleges were responsible for the training of the greater share of younger printmakers who joined the multiplying ranks of practitioners in the fifties, a growing interest in printmaking emerged in the professional art schools as well, marked most notably by the establishment of the Pratt-Contemporaries Graphic Art Center in 1956 and favored by a $50,000 grant from the Rockefeller Foundation. Under the guidance of codirectors Margaret Lowengrund and Fritz Eichenberg, and with a starting staff of Arthur Deshaies, Seong Moy, Walter Rogalski, and Arnold Singer, the Pratt Center initiated a program which grew in strength, over the years, by its excellent training, print exhibitions, and publications on contemporary and historical printmaking, filled with technical reviews, essays, biographies, and documentation.[34]

Meanwhile, by chance in 1949, several publicized opinions and printmaking exhibitions created a timely recapitulation of the forties. Una Johnson, Curator at the Brooklyn Museum and the guiding spirit of its displays of contemporary prints, wrote in the Foreword to the catalogue of the Third National Print Annual Exhibition, "Rarely, I believe, have individual jurors been more sympathetic and more concerned about the contemporary artist and his work. The modern print has come out of its precious portfolio and onto the wall where it holds its own with other works of art. . . . it is well suited to capture and record the tempo and mood of our time."[35] Her commentary confirmed that modern prints were more welcome than before in major exhibitions and implied that they reflected a new temper in the art and culture of America. Johnson mentioned almost casually that the modern print on a gallery wall could hold ". . . its own with other works of art." She was surely alluding to the recent developments that had moved contemporary printmaking into closer competition with painting—in largeness of scale, boldness of color, richness of texture, and subtlety of visual illusions. Perhaps her observation implied a perceptive forecast of greater competition in the future.

Two other exhibitions, also staged in 1949, were reviews, each in its own way, of developments during the decade—Master Prints at the Museum of Modern Art and Technical Processes in Contemporary Printmaking at the University of Minnesota Gallery.

Mrs. John D. Rockefeller, Jr., was a founder of the Museum of Modern Art and an officer of the institution on several occasions. An avid collector and benefactor, in 1940 she had presented a splendid gift of 1,600 etchings, lithographs, and woodcuts to the museum. Suitable space for a print collection was finally arranged in 1949 and dedicated as the Abby Aldrich Rockefeller Print Room, with William S. Lieberman as the Associate Curator in charge. Master Prints, the exhibition of celebration, was an impressive display of works from the permanent collection by outstanding

5.26
Alfred Sessler
Tomah Rock
Lithograph (1949) $10 \times 7\frac{3}{4}$
*Elvehjem Museum of Art. Gift of Mrs.
Alfred Sessler.*

European printmakers from the late-nineteenth to the mid-twentieth centuries, supplemented with works by a respectable number of Americans. Printmakers who had been associated with Atelier 17—Lasansky, Raymond Jordan, Boris Margo, Schanker, Peter Grippe, Racz, and Gabor Peterdi—were represented by recent works, along with a few prints by commentators on current American life—Adolf Dehn, Peggy Bacon, and Ben Shahn. The selection of prints that had been created during the 1940s ranged from the technical ventures and vanguard features of Margo's cellocut, *The Sea* (fig. 5.15), to Shahn's silkscreen of simple forms and muted colors that displayed an edited frieze of political figures inscribed with lampooning commentary. His *Three Friends* (fig. 5.27) was a topical satire on a trio of powerful politicians in the Republican Party, Arthur Vandenburg, Thomas Dewey, and Robert Taft; a concocted spoof of three competitors within the GOP, feigning political sodality with dentate smiles for the benefit of press photographers.

5.27
Ben Shahn
Three Friends
Color silkscreen (1941) 15 × 22
Shown in Master Prints, the exhibition of celebration for the inaugural of the Abby Aldrich Rockefeller Print Room at the Museum of Modern Art (1949), and in the retrospective exhibition, Silkscreen: History of a Medium, at the Philadelphia Museum of Art (1971).
National Museum of American Art (formerly National Collection of Fine Arts), Smithsonian Institution. Gift of Mr. and Mrs. Harry Baum in memory of Edith Gregor Halpert.

Modern Prints, aside from a favoring of Europeans, was tilted toward a selection of American works that bore the bench marks of "new directions," suggesting the kinds of contemporary printmaking that were favored in the collecting by the museum.[36]

Earlier in the spring of 1949, Technical Processes in Contemporary Printmaking was organized by the University of Minnesota Gallery and displayed expressly for the annual meeting of the Mid-America College Art Association.[37] Prints by Will Barnet, Adolf Dehn, Sue Fuller, Malcolm Myers, Harry Sternberg, and Mauricio Lasansky were hung next to the woodblocks, copperplates, and photographs of lithographic stones that had been used for one or more of the trial proofs and final impressions exhibited by the artists. Students of

printmaking, artist-teachers, art historians, and curators of the Midwest region had the opportunity to examine the didactic presentations of processes, as in Barnet's woodblock and impression of *At the Sea Shore,* Sue Fuller's lace-collar collage and copper-engraved plate—a beautiful, glistening metal ornament in its own right—hung adjacent to the print of *Hen* (fig. 5.7), thirteen trial states plus the plate of Lasansky's color intaglio, *Bodas de Sangre,* and Malcolm Myers's plate and seven states pulled during the creative evolvement of *Man and World.*

In conjunction with the display, the six exhibitors participated in a panel discussion. The remarks of the majority of the speakers—and the exhibition—offered recapitulations of the current state of printmaking, enthusiastic affirmations of its emerging prominence among the

arts, and a near consensus of liberal attitudes toward and commendations of contemporary tools, materials, and processes. Of the six printmakers, Adolf Dehn was the least sanguine about the promising state of the art. Later in the year he published a short article, "Revolution in Printmaking," derived from his comments at the Minnesota symposium.[38] As a lithographer, Dehn held the opinion that American lithographic printing suffered from widespread ineptitude. His casual recognition of silkscreen as a medium adopted by printmakers in recent years was limited to a lackluster comment that the process allowed color prints to be made and sold at modest cost. And Dehn made no mention of the wood-engravings, woodcuts, and color woodcuts of Misch Kohn, Antonio Frasconi, Barnet, Schanker, Seong Moy, and Adja Yunkers that were, by then, a promise of the power which relief prints would display in the fifties. Thus, Dehn's assertion of a "revolution" turned out to be a diminished acknowledgment that there had been a revitalization of the intaglio media under the aegis of the only two printmakers he named, Hayter and Lasansky.

As the decade ended, Albert Reese, of Kennedy and Company, published *American Prize Prints of the 20th Century*, a historical compendium of 231 prints selected from the award winners of nearly fifty years, beginning with the period of Joseph Pennell. Not surprisingly, the choices Reese made from the works honored by juries during the forties formed a conservative majority, leavened by a few prints with modern features by Margo, Hayter, Ralston Crawford, Fuller, and Lasansky. After surveying five decades of prize prints, Reese concluded that, "In spite of the years of depression, of turmoil, of war, and now of social and economic unrest, the future of American graphic artists is more full of promise than ever."[39]

The forecast by Reese was one of simple optimism and, therefore, comparable to that advanced by Carl Zigrosser two decades earlier—a cheering prediction of modest expectation that was quickly fulfilled. On the other hand, at the end of the forties, the recent group shows, the larger exhibitions that included or emphasized modern trends, and the occasional commendations laced with a bullish optimism about new directions in American printmaking failed to offer firm clues that critics, dealers, curators, or printmakers were prepared for the wrenching changes that soon would beset the art and the assailing of criteria that had long served as determinates of what was, or was not, an original print.

6

Printmaking in the 1950s

Each medium of printmaking has inherent properties and processes that affect the descriptive and aesthetic characteristics of a print when an impression is pulled from a block, stone, plate, or screen. A judicious choice of medium may be crucial, therefore, if the singularity of a printmaker's conception is to be transcribed with artistic integrity. From the 1890s through the 1920s, these kinds of considerations led European artist-printmakers to the discovery that the old craft of woodcut provided transcriptions compatible with the abstract images, expressive symbolizations, and subjective content that characterized much of modern art. The striking results lent a new vitality to woodcut which emanated from the black-and-white or color blocks cut by masters of diverse styles. Among the artist-printmakers responsible for the revival were the Post-Impressionists Paul Gauguin and Félix Vallotton in France, the artists linked with modern Expressionism such as the Norwegian Edvard Munch, the Germans Ernst Barlach and Käthe Kollwitz, artists of the *Brücke* group— Emil Nolde, Ernst Kirchner, Eric Heckel, Karl Schmidt-Rottluff— and the German-American Lyonel Feininger whose taut abstractions of Baltic fleets and Hanseatic cities were aptly transcribed in prints from wood.

During those decades the prevailing conventions of the woodcut art were flouted, conceptually and technically. Munch and the members of the *Brücke* cut harsh images in blocks that transmitted newly conceived revelations of old human degradations, passions, and emotions, exemplified by the graphic distillation of rejection and sorrow in the *Prophet* (fig. 6.1) when Emil Nolde slashed and tore the wood with knife, chisel, and gouge. And among the hundreds of woodcuts that displayed a new concordance between an old craft and modern conceptions was *Christ in Gethsem-*

ane (fig. 6.2)—Ernst Barlach's emotional revision of the gospels of Matthew and Mark which revealed that Christ was withdrawn a stone's cast from his disciples when He prayed alone and with anguished awareness of impending betrayal and death. On the other hand, the New York—born Lyonel Feininger—who served as the director of the print shop at the Bauhaus and was familiar with the art of the Cubists in France and Expressionists in Germany—preferred severe abstractions and spatially reconstituted landscapes and seascapes as in *Hansaflotte* (fig. 6.3) or other panoramas of Baltic ports and ships.[1]

When suitable to their conceptions, the modern European printmakers adopted unorthodox processes by scarring wood surfaces with bits of broken glass or steel wire brushes. And to increase the intensities of expressive connotations or the emphases of symbolic references they printed mordacious colors on sawed-apart sections of the wood, overprinted images with multiple blocks, made impressions on colored papers, added artists' colors with brushes, or combined disparate media as Munch did when printing colors with wood blocks beneath black lithographic images in one of his several accusations of woman as a *Vampire* (fig. 6.4).

A limited circle of European and American collectors and curators venerated the originality of the turn-of-the-century printmakers in their lifetimes and during the decades immediately thereafter. However, American artists printing from wood seemed uninformed or indifferent to the innovative prints for years. In 1949 Carl Schniewind, Curator of Prints and Drawings at the Art Institute of Chicago, assembled an exhibition, The Woodcut Through Six Centuries. The modern section displayed prints by Vallotton, Gauguin, Munch, Nolde, Heckel, and Kirchner. Schniewind vouchsafed to viewers that ". . . the wood-

6.1
Emil Nolde
Prophet
Woodcut (1912) 12¾ × 8⅞
Robert Gore Rifkind Foundation, Beverly Hills.

cut has again become a medium of individual expression." Then he added, "In the United States the woodcut has not yet reached general popularity, but there is every indication that artists are becoming more and more interested in this important graphic medium."[2]

Undoubtedly Schniewind had noticed that a few American printmakers of modern tastes were turn-ing to woodcutting in the forties and, by their willingness to adopt all sorts of methods and chromatic effects, were demonstrating a sensitivity to the precedents initiated earlier by the Europeans. Then, in the 1950s and 1960s, when Americans created a corpus of wood-engravings and woodcuts which brought an improved stature and many exhibition honors to the art, it was clear that the leaders in printing from wood were ignoring whatever conventions seemed inimical to their modern artistic conceptions.

Before American relief printing reached a climax of creative inventiveness in the fifties and sixties some preludes of consequence had preceded the ascent. Young artists served apprenticeships during the years of the Federal Art Project

6.2
Ernst Barlach
Christ at Gethsemane
Woodcut (1919) 8 × 10
Elvehjem Museum of Art. Department of Art History Purchase.

alongside the experienced hands of Isaac Sanger, Asa Cheffetz, Oscar Weissbuch, Lynd Ward, Fritz Eichenberg, and others in New York City or on federal projects elsewhere. Meanwhile, Thomas Nason and Grace Albee were cutting skillful wood-engravings independently of government support. All of those works of the later thirties formed a commendable body of American relief prints, and though most of them were conservative in characteristics, the wood-engravings, woodcuts, and color woodcuts by Fred Becker, Louis Schanker, Werner Drewes, and a few others bore modern features. Then, in the forties, Drewes, Will Barnet, Schanker, and Antonio Frasconi created woodcuts and color

woodcuts of modern styles and unconventional techniques that were even more germane to the ways in which the art would evolve during the decades that followed.

Werner Drewes, for whom woodcut was a major medium, immigrated to the United States in 1930 with an intimate knowledge of the prints of his German predecessors and a passing kinship in his woodcuts to those of Feininger, a former colleague at the Bauhaus. Shortly after Drewes's arrival, he cut a series of abstract views of New York City, was accepted as a "naturalized" American printmaker—later confirmed by the appointment as Supervisor of the Graphic Arts Division of the New York FAP in 1940–

1941[3]—and had *Abstraction* chosen
from one of his several woodcut
portfolios for display in the retro-
spective exhibition of American
Printmaking: 1913–1947. By the
early forties, Drewes was printing
completely nonobjective composi-
tions that served as appropriate cre-
dentials for charter memberships in
the Vanguard and The Graphic Cir-
cle exhibiting groups.[4] Later in the
decade, the extreme abstractions
gave way to more descriptive color
compositions with identifiable
themes, as in *Maine Sunset* (fig. 6.5),
which anticipated features that
would be echoed in woodcuts by
Drewes and other American print-
makers in the fifties and sixties.

Will Barnet was an accomplished
etcher and lithographer; he was in-
structor and the staff lithographic
printer at the Art Students League
by the time he cut his first blocks in
1937.[5] His black-and-white prints of
the following two years were starkly
linear in design and bore modest,
though transient, correspondences
to earlier woodcuts by the German
Expressionists. On the other hand,
Barnet's themes were full of amiable
sentiments in images of small chil-
dren and his family. A print of
1939, based on the bonding affec-
tion of an infant and mother as they
awakened in *Early Morning* (fig.
6.6), was of a modern style rarely
seen in American woodcuts at the
time and rewarded by the Mildred
Boercke Prize at The Print Club of

6.3
Lyonel Feininger
Hansaflotte (Hanseatic Fleet)
Woodcut (1918) 6½ × 8⅝
*Allen Memorial Art Museum, Oberlin
College. Anonymous Gift.*

6.4
Edvard Munch
Vampire
Color woodcut/lithograph
(1895–1902) 15¹⁄₁₆ × 21⅝
Elvehjem Museum of Art.

6.5
Werner Drewes
Maine Sunset
Color woodcut (1949) 12⅜ × 23⅞
Shown in the retrospective exhibition, Werner Drewes: Woodcuts, at the National Museum of American Art (1969). National Museum of American Art (formerly National Collection of Fine Arts), Smithsonian Institution. Gift of the artist.

Philadelphia, a Purchase Prize in the 1st National Print Annual at the Brooklyn Museum, and an award in the 16th Annual Exhibition of Northwest Printmakers. His first two trials with color woodcut were also made in 1939.[6] The following year, Barnet adorned the print of his son *Peter* (fig. 6.7) with a harmony of style, colors and charming con-tent. The cuttings and registry of seven colors were exceptional and the print received Honorable Mention when it was displayed as *Peter and Birdie* in the 3rd Annual Exhibition of the American Color Print Society at The Print Club of Philadelphia.

Although Barnet displayed prints with the Vanguard group and his entries were well received in major exhibitions, in 1943 he forsook printmaking of all kinds for four years and woodcut for even longer.[7] Nonetheless, in 1949 the University of Minnesota invited him to be one of six panelists at the forum on modern printmaking. Concurrently, he was the sole exhibitor of wood-cuts in Technical Processes in Con-

6.6
Will Barnet
Early Morning
Woodcut (1939) 9 × 15⅜
*Awarded the Mildred Boercke Prize in the
16th Annual American Block Print and
Wood Engraving Exhibition, at The Print
Club of Philadelphia (1942), a Purchase
Prize in the 16th Annual Exhibition of
Northwest Printmakers (Seattle, 1944),
and a Purchase Prize in the 1st National
Print Annual Exhibition, at the Brooklyn
Museum (1947).*
*Seattle Art Museum. Gift of the Northwest
Printmakers.*

6.7
Will Barnet
Peter
Color woodcut (1940) 11¼ × 9
*Awarded Honorable Mention in the 3rd
Annual Exhibition of the American Color
Print Society at The Print Club of Phila-
delphia (1942).*
Courtesy of Associated American Artists.

temporary Printmaking assembled by the University Gallery for the Mid-America College Art Association, a display in which two silk-screens, Dehn's six lithographs, and Barnet's four woodcuts were surrounded by an overabundance of intaglio prints and plates.[8] During the forum dialogue a young instructor from the Midwest, who had been influenced by the lore of the forties that the intaglio media were peerless for the creation of contemporary prints, complained that it was difficult to launch graphic programs because of the costs of intaglio presses, copperplates, and tools. Barnet, who by then had created fine prints in four media, responded pithily: "Hell, anyone can start a rewarding printmaking program with a block of wood and a sharp knife."[9]

Louis Schanker made his first woodcuts in 1935 during odd hours of respite from the painting of a mural sponsored by the New York FAP for public radio station WNYC.[10] From then on, as a Supervisor of the Graphic Arts Division and later as a teacher and printmaker, he was one of the most active advocates of color woodcut in the country. Schanker and Hayter, as faculty members at the New School for Social Research, for a time shared the teaching studio where Atelier 17 was being revived.[11] And although both were dedicated leaders in experimental printmaking, Schanker's role was to seek new ways of creating woodcuts. "The possibility of invention, I believe, is one of the most intriguing aspects of woodcut. Traditional tools are no longer sufficient. . . . [and] anything which can be used to 'mar' the surface of the wood is legitimate as a tool. This offers endless possibilities. Ordinary wire screening forced into the wood will, of course, provide a particularly ingratiating texture, almost a patina, as in my woodcut *Carnival*."[12]

Composed in 1945, *Carnival* (fig. 6.8) was a cluster of symbols transcribing Schanker's recollections of

youthful days in a traveling circus. The modern style, a novel network of textures impressed into the wood with wire screening, and the printings of blacks and brilliant colors from five blocks must have led the jury to choose *Carnival* as a specimen of very contemporary color woodcut for the retrospective review of American Printmaking: 1913–1947. In the years before and after, woodcuts by Schanker—with themes reduced to abstract shapes in medleys of gay colors—surely formed an array of exuberant prints along the walls of the Kleemann Galleries in 1944 and gave bold accents of patterns and colors to the exhibitions of the Vanguard and The Graphic Circle printmakers.[13] When the latter group held one of its showings at the Jacques Seligmann Galleries in 1947, *Art News* was prompted to point out that Schanker had proved his skill in printing large woodcuts with no fewer than ten blocks.[14] And in January 1949, notwithstanding an observable trend toward larger prints, the *Art Digest* found it singular that at Schanker's experimental workshop, Studio 74, he was carving a woodcut on a six-foot plank.[15] The huge print, *Dance Macabre*, was finished in time to be selected for the 3rd National Print Annual which opened at the Brooklyn Museum two months later.

Artists from abroad who were sharing in the quest for a contemporary American art of intaglio had counterparts who were accomplished woodcutters before they immigrated to this country. Hence, as Barnet, Schanker, Anne Ryan, Fred Becker, and other Americans began to create prints that had markings of a modern art of wood-engraving and woodcut, the presence of Fritz Eichenberg and Werner Drewes from the early thirties on, and the arrivals of Antonio Frasconi in 1945 and Adja Yunkers in 1947 compounded the talents that were committed to working on wood.

The young Frasconi had been a successful political caricaturist in Montevideo before he began cutting simple black-and-white wood blocks of the *Unemployed*, the *Hunger Children*, and other unfortunates of Uraguay in 1943, woodcuts that were antecedents of political and social commentaries which surfaced periodically in later prints.[16] In 1946, only a year after his arrival in New York with a scholarship to the Art Students League, Frasconi was favored with a one-man show at the Brooklyn Museum. From then on—as if to prove his proposition ". . . that the woodcut by its very nature is a popular form . . . and that the artist must speak to as great an audience as possible,"[17] Frasconi became one of the most peripatetic of American printmakers. He recorded innumerable facets of the landscape and life of California valleys, Vermont farms, the dunes and flocks of migratory birds along Long Island shores, or the labors of farmers, beekeepers, fruit growers, night-shift signalmen with glowing lanterns in railroad yards, fishermen and ketches, or the mongers of New York's Fulton Fish Market. As had Eichenberg, Frasconi became a prominent illustrator—of children's books, limited editions of Cervantes, Garcia Lorca, Whitman, and the fables of Aesop—and, as well, the creator of panoramic landscapes from contiguously printed blocks which became friezes on paper when extended as one would an unfolding screen. Meanwhile, Frasconi's earliest American single-sheet prints had placed him among the pioneers of contemporary color woodcut—a role assured by the *Boy with Cock* (fig. 6.9) which was cut in 1947 with modern idioms of artistic language and printed by a black key block and no fewer than four colors that elaborated on the lively struggle of a youth and raucous fowl. By the end of the following year, Frasconi had been granted a one-man show at the Weyhe Gallery and a Purchase

Prize for the color woodcut of a *Girl with Bird Cage* at the 2nd National Print Annual in Brooklyn. Then, in a group exhibition of 1949 by which the Weyhe Gallery predicted the growing vigor of American woodcuts and wood-engravings, Frasconi shared the walls with his wife Leone Pierce and other young woodcutters, Seong Moy, Worden Day, Misch Kohn, and Leonard Baskin, who were on the threshold of enriching the art and receiving their rewards.[18]

Adja Yunkers was another accomplished printmaker from abroad who lent his talents to the new trends in American woodcuts. Born in Riga, Latvia, later active at several art centers of Europe, his color prints had been handled by the Kleemann Galleries before his Stockholm studio was destroyed by fire and he immigrated in 1947. In the autumn of 1947 Yunkers's color print *Shields* was accepted for the 32nd Annual Exhibition of the Society of Etchers, Gravers, Lithographers and Woodcutters; it received a critic's commendation when Howard Devree of the *New York Times* singled out the woodcut for its richness of colors and likened it to a "reincarnation" of the Ajuntā cave paintings.[19] Through competitive exhibitions Yunkers was soon identified with the printmakers in the forefront of the art of modern American woodcuts, a judgment reinforced in 1950 by the one-man show at the Kleemann Galleries which included *Shields* and an ambitious ten-block color print, *La Mesa Encantada*, created at Alameda,

6.8
Louis Schanker
Carnival
Color woodcut (1945) 14¼ × 21
Shown in the retrospective exhibition, American Printmaking: 1913–1947, at the Brooklyn Museum (1947).
National Museum of American Art (formerly National Collection of Fine Arts), Smithsonian Institution. Museum Purchase.

6.9
Antonio Frasconi
Boy with Cock
Color woodcut (1947) 24³⁄₁₆ × 14⁴⁄₁₆
New York Public Library, Prints Division.

New Mexico, where he was the principal artist of the Rio Grande Workshop.[20]

In 1949 the critic Dorothy Drummond observed that, ". . . the contemporary printmaker is drawing closer and closer in approach—and even technique—to the oil painter and watercolorist."[21] And two years later Carl Zigrosser declared, in an assessment of American Prints Since 1926: A Complete Revolution in the Making, that, "one sees prints becoming larger and larger in size. They are often enormous, competing in color-weight and impressiveness with paintings."[22] The comments referred to prints in all media and served to describe many color woodcuts of the early fifties including the blocks of Yunkers—and of Seong Moy—which evinced, as well as any, the trend toward largeness and painterly conceptions, with even an added illusion of brushwork.

In 1953 Yunkers created *Magnificat* (fig. 6.10), a woodcut of impressive scale, painterly idioms and complexity of color printings that was conceived as a visual canticle in glorification of woman triumphant over the tragic circumstances that beset human existence. It was the central section and forerunner of a polyptych of five parts. Printed in an edition of seven impressions with fifty-six colors from eight blocks, *Magnificat* and the flanking "wings" made up a 14-foot polyptych when they were presented at the Grace Borgenicht Gallery in May.[23]

Experimental ways of composing and treating wood blocks, multi-color printings and expanded di-

6.10
Adja Yunkers
Magnificat
Color woodcut (1953) 44 × 48
Shown as the center section of a woodcut polyptych at the Grace Borgenicht Gallery (1953).
Philadelphia Museum of Art. Lessing J. Rosenwald and museum funds.

mensions had become irresistible to young woodcutters, among them Seong Moy. When The Printmakers group presented its first exhibition at the Jacques Seligmann Galleries in 1947, Moy displayed *Chinese Time Piece* which may have been the color print described with exaggerated rhetoric as ". . . a mural sized woodcut."[24] For textural effects beyond a frank display of grainy patterns from the wood Moy chose to glue onion-sacking on the block in printing *Fish Quartet*, and when ordering the designs for multiblock prints he adopted brush drawing on overlays of transparent celluloid sheets.[25]

At the age of ten, Moy left the province of Canton for St. Paul where he spent the remainder of his boyhood with relatives. Moy's art evolved with influences of his Eastern cultural heritage and contemporary Western painting, the latter through the guidance of the St. Paul artist Cameron Booth and, in 1941,

the Abstract Expressionist Hans Hofmann with whom he studied in New York.

Moy was inducted into the Air Force in 1942 and served in Yunan province of the China-Burma Theater. His ties to Chinese culture were strengthened by his return to China in 1947, his reunion with his mother, and his marriage to Sui Yung.[26] Oriental images pervaded most of his prints in the late forties and fifties as in *Chinese Actor* and *Love on the Yangtze*, two of five Chinese themes in a portfolio published by Rio Grande Graphics in 1952.[27] Earlier, from 1948 to 1950, Moy had tasted experimental methods of intaglio printmaking at Atelier 17 and an etching, *The Hunter and His Wife*, was awarded First Prize at The Print Club of Philadelphia in 1948. Nonetheless, Moy's reputation as a printmaker rested on color woodcuts in which dynamic compositions were laced together with brush-like draftsmanship that seemed both

calligraphic and painterly. Moy recalled that "in China grade school, you draw with brush and pencil . . . [and] style is a way of thinking . . . ,"[28] suggesting requisites for the kinesthetic style and gestural calligraphy of *Classical Horse and Rider* (fig. 6.11), a woodcut which received a Purchase Prize in the 7th National Print Annual at the Brooklyn Museum (1953), and also *Two Circuses in One*, commissioned in 1952 by the International Graphic Arts Society a year after its founding.

Four years earlier, Irvin Haas, author of a monthly column "The Print Collector," informed the readers of *Art News* that, "Just a short time ago, some of us bewailed the fact that few print makers were working in the relief mediums. The situation seems to be the reverse at the present . . . with many artists exploiting the wood's inherent qualities for their expression. A notable fact in this resurgence is the increased use of colored wood

6.11
Seong Moy
Classical Horse and Rider
Color woodcut (1953) 25¼ × 15¼
*Awarded a Purchase Prize at the 7th Na-
tional Print Annual (1953) and shown in
the exhibition, 14 Painter-Printmakers
(1955), both presented by the Brooklyn
Museum.*
*Library of Congress, Prints and
Photographs Division.*

blocks."[29] Not only was the evidence mounting in the color woodcuts of Schanker, Barnet, Drewes, Frasconi, Yunkers, and Moy, but as Haas published his comment Worden Day was displaying similar kinds of prints at the Bertha Schaefer Gallery and advertising a new three-color woodcut which could be purchased from her studio in Rockport, Massachusetts.[30]

Day often introduced *objets trouvés*, found pieces of wood or metal, when printing her woodcuts—an innovative idea, though not unique, with a correspondence to the prints of Rolf Nesch, the German-Norwegian artist, whose color impressions were printed from "assemblages" of copper, zinc, glass, screening, or other materials and exhibited by New York galleries after World War II. The content of Day's color woodcuts suggested a ceaseless morphology of organisms and rocks which she then cloaked with titles that alluded to ancient enigmas of a *Primeval World*, *Runic Traces*, or *Tumuli*. The prints were composed with flowing elements that bore visual analogies to a theme from Goethe which Day later cited in her *Credo*—". . . formation, transformation / Eternal mind's eternal conversation / wreathed with all floating / forms of what may be. . . ."[31]

In 1954 Day created a color woodcut on black paper to evoke ". . . forms of what may be . . ." in the mysteries of *Arcana III* (color fig. 6). By then, the rising prominence of relief prints prompted

Atelier 17 to add instruction in color woodcuts and Day was chosen to initiate the medium at the experimental workshop where, a decade earlier, she had worked as an intaglio printmaker side by side with Hayter.[32]

The enticements of creating prints with color blocks lured a mounting

number of artists to try their hands by the beginning of the 1950s. Nonetheless, the early exhibition pieces of Misch Kohn and Leonard Baskin gave proof that new conceptions of the timeless states of human experiences, the stresses imposed upon man in a contemporary society, or the efficacy of images based

upon great literary sources, could be transcribed incisively within the limitations of black-and-white wood-engraving and woodcut.

Misch Kohn had his first stint of printmaking shortly before the end of his schooling in the spring of 1939 when Max Kahn, the fine lithographer and master-printer from Chicago, was a visiting instructor at the John Herron Art Institute in Indianapolis. Later in the year, after the young Kohn had a short but bitter taste of the Depression-ridden art world of New York, Kahn persuaded him to share his studio in Chicago and join the Federal Art Project. There, Kohn created a woodcut of *John Brown* and sixteen small wood-engravings as vignettes and illustrations for a Project-sponsored history of civil liberties in Illinois, all modest digressions from his lithography.[33] In 1944 his interest in relief prints was rekindled during a stay in Mexico where Kohn created wood-engravings of landscape, bullfights, and peasant women. In the wake of the Revolution, Mexican artists honored a tradition of "prints for the people," especially the thousands of topical prints and broadsides that José Guadalupe Posada (1857–1913) had engraved on wood. Kohn became acquainted with the revolutionary muralists and the printmakers who were seeking to revive an art of prints for the people at the *Taller de Grafica Popular*, the workshop organized as an artists' collective where in 1943 Leopoldo Mendez had completed the violently antifascist wood-engravings for *El Libro del Terror Nazi en Europa*.[34] Kohn's experiences surely encouraged a virtuosity of cutting and the flair for graphic style that began with his Mexican prints and, in the 1950s, brought nineteen awards to his wood-engravings.

In 1949 Kohn engraved the first six of his large exhibition pieces. One of them, *Death Rides a Dark Horse* (fig. 6.12), was exhibited at the Renaissance Society of Chicago in February 1950 along with other Contemporary American Prints Selected by Five Printmakers (Sloan, Arms, Hayter, Kahn, and Beatrice Levy) and, shortly thereafter, received a Purchase Prize in the 4th National Print Annual at the Brooklyn Museum. *Death Rides a Dark Horse* was Kohn's revision of an apocalyptic rider from *The Revelation of St. John*, a headless figure borne on the black mount of Pestilence which preceded the pale horse of Death as ". . . Hell followed with him." Its saturnine spirit pervaded other prints of the early fifties when Kohn symbolized the universality of torments that man will suffer in images of a self-inflicted *Season in Hell*, through an outcry of anguish from the *Head of a Contemporary*, or by the hostile landscape behind a wounding agony and death to which Kohn gave the metaphoric title *Sleeping Soldier* (fig. 6.13).

The sharp black-and-white contrasts of Kohn's compositional structures were moderated with skeins of looping lines and fluid shadings, the latter by his mastery of the tint tool, a multiple-pointed graver. Kohn chose to print his large end-grain blocks unorthodoxly with a lithographic press and also elected to apply exceptional pressures which lent embossments to the brilliant whites.[35] Although two blocks of 1949, *Tiger* and *Prisoners*, split in printing before the completion of the editions, he accepted the risks many times and in 1957 printed *The City*, a wood-engraving 31 inches long.

After 1954, Kohn's crisp expositions on threats to the living were replaced by wood-engravings with crepuscular settings and ornamental images, visions cloaked in a *chiaroscuro* of ambient, softening blacks. Thus, by 1956, a Renaissance city with its *Florentine Figure* (fig. 6.14), bedecked in motley, had become ephemera educed by his masterful handling of the graver and, concurrently, the signs of a transformation in artistic conception that soon led Kohn to abandon wood-engraving and adopt the less restrictive techniques of etching and sugar-lift aquatint.

During the years when Abstract Expressionism was flourishing as the avant-garde art of American painting, Leonard Baskin, the sculptor-printmaker, was more than willing to express his opposition and defend "The Necessity for the Image" as a great heritage from the art of the past and an imperative for a meaningful art of the present.[36] His grave figures of men—flaccidly bloated, atrophied, or seemingly stripped of skin—were images of human frailty, despair, or torment and at the same time, of contemporary and timeless connotations. From 1949 through the next few years, as his prints from wood began to be featured at the Weyhe Gallery and in major exhibitions, Baskin declined to follow the trend toward lavishly colored woodcuts, notwithstanding a few prints with supplemental blocks of red, and rendered incisively his somber subjects in black-and-white cuttings. On the other hand, Baskin matched the huge prints by other artists when he created *Man of Peace* in 1952 on a block nearly 60 inches high. Two years later he cut the life-size specter of *Hydrogen Man*.

With propositions, written, spoken, and illustrated by his single-figure prints and sculptures, Baskin insisted that the image of the human body was the richest artery of communication and expression in art. "Our human frame, our gutted mansion, our enveloping sack of beef and ash is yet a glory. Glorious in defining our universal sodality and glorious in defining our utter uniqueness."[37] And more often than not the fragility of hopes and the presence of tragedies marked the images of men which conveyed the theme of universal fellowship.

Baskin also believed that "artists have ever turned to the print for the expression of specific ideas, impelled

6.12
Misch Kohn
Death Rides a Dark Horse
Wood-engraving (1949) 21⅞ × 15¾
Awarded a Purchase Prize in the 4th Na-
tional Print Annual Exhibition, at the
Brooklyn Museum (1950).
Achenbach Foundation for Graphic Arts,
the Fine Arts Museums of San Francisco.

6.13
Misch Kohn
Sleeping Soldier
Wood-engraving (1951) 17⅝ × 23⅝
Awarded the Pauline Palmer Prize in the
Chicago and Vicinity Show, at the Art
Institute of Chicago (1951), and an
Honorable Mention in the 24th Annual
Exhibition of Wood Engravings, Woodcuts
and Block Prints, at The Print Club of
Philadelphia (1952).
Art Institute of Chicago.

by an immediacy of purpose. . . ."[38] He wrote in homage to earlier masters whose prints revealed the savage realities of war, exposed the corruption of political and religious institutions, or ridiculed absurdities of social customs and, on occasion, followed the examples of Callot, Kollwitz, Rouault, Dix, and especially Goya. *Mantegna at Eremitani* (fig. 6.15) was both Baskin's vision of a cry of anguish from the great Renaissance painter-engraver and a commentary on the desecration of war—an epitaph cut in wood that the viewer understands fully only upon remembering the tragic destruction of Mantegna's murals during the chance bombing of the Eremitani Chapel by American planes.

No woodcut of the fifties was reproduced more frequently in art journals and mass periodicals than Baskin's *Man of Peace* (fig. 6.16), the nearly full-scale figure that received a Purchase Prize at the 7th National Print Annual of the Brooklyn Museum in 1953. The title, the appearance and gesture of the man, and the disquieting symbols of barbed wire and dead bird were unexplained by Baskin or the critics,

leaving the viewer to speculate on the meaning of the print. There may have been clues, however, deriving from ideological controversies during the Cold War and testy arguments about the political inclinations of Picasso at the turn of the decade. In late 1949, the Spaniard's lithograph, *Dove*, was awarded the Pennell Memorial Prize in the 47th Annual Exhibition of Watercolors, Drawings and Prints at the Pennsylvania Academy.[39] It was the same *Dove* that had been printed, in reverse, the preceding April as the centerpiece for the first Picasso "peace poster," publicizing the CONGRÈS MONDIAL DES PARTISANS DE LA PAIX in Paris. His association with the left-wing organization and the refusal of the State Department to grant a visa to Picasso triggered a public dispute about his proposed visit to America. Under an ironic editorial caption, "Picasso for Peace," the publisher of the *Art Digest*, Peyton Boswell, Jr., charged that "as a leader of the phony 'World Congress of Peace Partisans,' he should be barred [from the United States] for the same reasons as any other enemy propagandist."[40] And George Biddle, the respected

artist and frequent spokesman for artistic causes, entered the public debate with an "Open Letter," stating that ". . . it should also stand on the record that Picasso did not propose to come here to meet fellow artists, but as an avowed Communist. . . ."[41] Subsequently Picasso designed additional posters for the communist-front organization, the *Second World Congress of Partisans of Peace* (London, 1950) and the *Congress of the People for Peace* (Vienna, 1952), both with variations on the *Dove*, by then celebrated or notorious.

In the year Picasso designed the third "peace poster" Baskin created *Man of Peace*. The figure, with a facial resemblance and the casual garb of the aging artist, holds a dead *Dove*, plucked from ensnarement or lifeless from abuse behind the barbed wire of a concentration camp. In those years of ideological contentiousness, the possibility that Baskin was mocking the ingenuousness of Picasso's political alliances and adding irony by the title of the woodcut was left in doubt by the artist who, when queried, neither confirmed such a commentary nor offered another for the print which

received exceptional visibility in the fifties and later.[42]

Baskin rejected the role of prints as portfolio pieces when he created the enormous exhibition woodcut of *Hydrogen Man* (fig. 6.17), symbolizing "the bomb" as a threat to all mankind. The shattered skull of Death teeters on a human frame, grotesque with genetic distortion, mangled arm, and atrophy of the leg as it descends to a foot with talons, the ultimate signature of man's satanic power of self-destruction.

The universality of Man, blemished, was a constant theme in the art of Baskin. As an essayist he was no more charitable to contemporary Man ". . . [who] has charred the earth and befouled the heavens more wantonly than ever before. He has made of Arden a landscape of Death. In this landscape we dwell and with these images we must live."[43] Such somber views were not shared by Carol Summers, who mused that "Out of my hands roll surprises, histories, enigmas—images known and unknown. They have seeped up through my feet from Mother Earth, or down through fathers and mothers—the compost that connects us to the original creation."[44]

Scarcely two years after Summers had studied printmaking with Schanker at Bard College, an early abstraction, *Bridge No. 1*, was selected for a Purchase Prize at the 5th National Print Annual at the Brooklyn Museum (1951); his work was also included in the exhibition of American woodcuts at the Museum of Modern Art (1952). In a review of the latter display Dore Ashton singled out ". . . one newcomer, Carol Summers, [who] achieves a great luminosity in his inking. . . ."[45] Several months thereafter, Irvin Haas hailed him as ". . . one of our most promising young artists . . ." after leafing through woodcuts by Summers at Margaret Lowengrund's gallery and print workshop, The Contemporaries.[46]

6.14
Misch Kohn
Florentine Figure
Wood-engraving (1956) 15¼ × 8½

Elvehjem Museum of Art. Humanistic Foundation Fund.

Color woodcuts of *Vesuvio* erupting or the mountainous *Mezzogiorno*, the *Dream of Constantine* or a *Rainy Mountain Starfall* were compositions conjured from ancient landmarks, visions, or earthly marvels and printed by Summers as boldly bannered landscapes, stained with colors that transcend the chromatic realities of nature. All were abstract images of landscape suspended in an ambience of drifting colors, effects that Summers sought in the late fifties when he adopted unconventional printing methods. Rather than inking the raised surfaces of the wood before printing, Summers chose to lay the paper over a dry block and then roll out a "positive" impression with a lightly inked brayer. "After inking is completed, the print is sprayed with mineral spirits, . . . [and] the degree of dissolution of the ink, or running, is controlled by the quantity of the spray. The 'bleeding' or 'blur-ring' of sharp edges and the undulating color field are qualities I seek."[47]

By 1958 Summers had perfected the process and created the floating stains of the *Dark Vision of Xerxes* (fig. 6.18). The "bleeding" bands of color compose the uplands threatened by a tempestuous cloud, its core an "undulating color field" above the deckled cells of turbulence spinning free to lash the land. A vision of the Persian king emerges in the tempest as if an ancient omen were portending the invasion that ravaged Greece.

Twice Summers received grants to study in Italy, in 1954 from the Italian government and in 1961 as a Fulbright Fellow. And for more than a decade the themes of ancient cities, temples, and places—Siena, Segesta, Aetna, the Mezzogiorno, and other landmarks of the Mediterranean region—recurred in his printmaking while he was evolv-

6.15
Leonard Baskin
Mantegna at Eremitani
Woodcut (1952) 14 × 23⅝
Philadelphia Museum of Art. Print Club Permanent Collection.

6.16
Leonard Baskin
Man of Peace
Woodcut (1952) 59½ × 30⅞
Awarded a Purchase Prize in the 7th National Print Annual (1953) and shown in Ten Years of American Prints: 1947–1956, both exhibitions sponsored by the Brooklyn Museum.
Cleveland Museum of Art. Gift of The Print Club of Cleveland.

ing the distillation of landscape forms that often projected symbolic meanings.

Mezzogiorno (color fig. 7) was the sere and timeless region of the south. Summers traced the ancient mountains—eroded, or terraced to hold a hill-town church—with peaks that thrust above a ribboned road which spared them isolation. They reach the purple veiling of a darkened sun—four times in declination—in respite from the "midday" fury that justified the region's name.

By 1955, the prominence of woodcuts and color woodcuts led William Lieberman to affirm that "today, curiously, it is American rather than European artists who continue the vigorous tradition of the modern woodcut."[48] Two years later a similar judgment could be made when an international exhibition of color woodcuts by artists from twenty-five countries, of which the largest number were Americans, was organized by the Victoria and Albert Museum in London.[49] Meanwhile, artists committed to the woodcut medium were introducing more technical innovations, including sallies into relief printing with materials other than wood.

Relief prints from paper had become acceptable counterparts of woodcuts when, in 1952, Lieberman chose one by James Forsberg for the American exhibition at the Salzburg Festival and his cardboard print, *Temple* was commissioned by the International Graphic Arts So-

6.17
Leonard Baskin
Hydrogen Man
Woodcut (1954) 71½ × 41
*Shown in the exhibition of contemporary
American and European prints at the
Grace Borgenicht Gallery (1955).
Elvehjem Museum of Art. Humanistic
Foundation Fund.*

ciety in 1957. Edmund Casarella
was experimenting with paper relief
prints as early as 1950 and by the
mid-fifties had displayed several at
the print annuals of the Brooklyn
Museum. *Moment of Panic* (color
fig. 8) was typical of his nonobjec-
tive compositions filled with ten-
sions when Casarella cut and pasted
up as many as eight blocks from
laminated cardboards. Textures were
punched into the surfaces of the
cardboards with the points of nails
or an ice pick and up to sixty colors
with opaque and transparent inks
were applied during Casarella's
printings.[50]

"If you can ink it, you can print
it" was an open-ended assumption
attributed to Casarella.[51] This axiom
seemed timely for additive processes
which were the reverse of the sub-
tractive method of cutting wood
blocks. Occasionally in the forties
woodcuts had received supplemen-
tary textures from the printing of an
odd lot of materials. From the fifties
forward even more miscellaneous
materials, in substance, shape, and
texture, were glued to a variety of
supports to build the "plates" or
"blocks" that were printed with ink-
ings as relief or intaglio impressions,
or as inkless embossments. They
were printmaking adaptations of *col-
lage*, the gluing of paper, wood, or
other disparate materials to canvas,
which had been a frequent feature
of twentieth-century avant-garde
painting. "Collagraphy" was a term
coined in 1956 by Glen Alps for his
experiments with additive "plates";

6.18
Carol Summers
Dark Vision of Xerxes
Color woodcut (1958) 37 × 25
Shown in the retrospective exhibition, Carol
Summers Woodcuts, at the ADI Gallery
(San Francisco, 1977).
National Museum of American Art
(formerly National Collection of Fine
Arts), Smithsonian Institution. Gift of the
Woodward Foundation.

Alps cited it as a printmaking medium when he exhibited *Collagraph No. 12* in the 1958 print annual at the Brooklyn Museum.[52]

Throughout the 1940s and 1950s woodcutters tested their skills in color printing from multiple blocks and random treatments of surfaces—or supplements of materials other than wood—in order to effect a variety of textures. Alfred Sessler's woodcut of 1957 typified the trend when he chose the brilliant colors and subtle texturings that lent luster to the feigned immensity of a microscopic *Larva* (color fig. 9) and its hollowed home. Sessler selected four blocks—three of pine and one of masonite—and complemented the textures of the woody grains with others by shaving, scraping, and scratching with razor blades or by stipplings with a burin point and dressmaker's roulette.[53] In the fifties, Sessler and Charles William Smith experimented with multicolored prints from only two blocks, a key block for the basic design and a second for colors. Sessler called the subtractive cuttings and sequential printings of colors a "reduction block" method. Smith used the second block as a support for an additive process when he glued cardboard shapes to the uncut surface, printed a given color, then removed the cardboards and repeated the procedure.[54]

The experiments with "blocks" other than wood were exemplified by the paper prints, collagraphs, and adoptions of lucite for either relief or intaglio printings by Josef Albers and by Harold Paris in his *Buchenwald* themes which were displayed at the Argent Gallery in April 1951. By 1954 Arthur Deshaies was discontented with the end-grain blocks of wood-engraving because of their limitations in size and the risks of cracking during printing. "I then began working in lucite (clear plastic), and experienced the excitement of discovering a means of expanding [the dimensions of] a print. Drawings could be placed beneath the transparent block and remain clearly visible . . . [and upon inking] . . . one could hold the plate to the light and determine the degree of density of the ink layer. All of this was totally impossible with the end-grained block."[55] Deshaies also sought freedom from the rigidities of wood-engraving techniques and later adopted untraditional tools,

some power driven. The experiments augmented his expressive conceptions and complex compositions which were consummated, by the end of the decade, in early impressions of the *Cycle of a Small Sea* series and by an emotive print, *The Death That Came for Albert Camus* (fig. 6.19), created in 1960 soon after the French author died from an auto accident in Provence.

The mounting exhibition successes of black-and-white or color relief prints—some of astonishingly large dimensions—came as printmakers expanded the range of resources that wood-engraving, woodcut, or media akin to them offered in consonance with modern artistic conceptions. Nonetheless, the probings by relief printmakers were judged to be less extreme than the manipulations of intaglio printers who were accused of feasting on exploits while starving their art. The

technical exhibitionism that would become a plague among printmakers provoked misgivings as early as 1951 when Carl Zigrosser wrote, "Many printmakers seem to have an almost excessive interest in technique. Is it because they have little to say, or is it because they, like society as a whole, are assailed by confusion and doubt in these turbulent times?"[56]

In 1952 Dore Ashton, then the most conscientious reviewer of print exhibitions and a perceptive commentator on trends in the art, also was uneasy about technical tricks after viewing New Expressions in Fine Printmaking: Ideas, Methods, Materials—the exhibition assembled by Una Johnson at the Brooklyn Museum. Ashton acknowledged that the display was a revealing survey of contemporary prints and methods which ". . . gives us a chance to evaluate the extensive experiments of

6.19
Arthur Deshaies
The Death That Came for Albert Camus
Lucite engraving (1960) 19½ × 31½
Shown in the 8th Annual Bradley University National Exhibition of Prints (1962). Achenbach Foundation for Graphic Arts, the Fine Arts Museums of San Francisco.

the past 10 years of American printmaking and to reflect on the question: do complicated or novel means serve creative ends? In this exhibition, all the cards are on the table. Each spectator can also learn—through the work of a dozen artists represented—that technical gambits alone are insufficient, that the rare, truly creative product makes technique secondary. In the intaglio section—probably the most controversial—one finds that methodology frequently encumbers expression."[57] Then, in 1953, Ashton published notes on the 7th National Print Annual Exhibition which ended tersely, "no one is satisfied with technical novelty any longer."[58] Two months before, when Lawrence Campbell reviewed the 37th Annual Exhibition of the Society of American Graphic Artists—on display at the galleries of Kennedy and Company—Campbell criticized both conservative and modern printmakers for an infatuation with technique. "Most printmakers continue to be obsessed with craftsmanship. One can take this from John Taylor Arms who has more craft than anyone else, but has something to say. It is hard to take from most of the others, who, modern or conservative, appear alike absorbed with tricks and utterly meaningless if mystifying effects."[59]

In the latter half of the fifties the major art journals reduced their coverage of American printmaking, favoring international news and lengthy articles on the flamboyant and subjective features of Abstract Expressionist painting or large nonobjective constructions in sculpture. *Arts* summarized the gradual decline of editorial interest in printmaking in 1959: "Although the modern tradition has been rich with achievements in the art of printmaking, lately there has been a certain falling off of interest—a lowering of aesthetic temperature . . . Some notable personalities in the field have defected entirely, turning to other

means for their expressive vehicle, while others seem to have fallen into a kind of lassitude which keeps their art—and our interest in it—in a state of rest. . . . gradually the art of printmaking in this country seems to have removed itself from the center of interest to the margins."[60]

The judgment of the journals was not shared by those who were actively involved with printmaking. New national and international exhibitions, annuals and biennials, were being launched at universities and cities across the country, offering invitational or competitive opportunities to printmakers that supplemented those of well-established exhibitions sponsored by museums and print societies in Brooklyn, New York, Philadelphia, Chicago, Washington, Wichita, Seattle, and San Francisco.[61]

Until *Art News* dropped "The Print Collector" as a monthly feature in 1957, Irvin Haas constantly reviewed current exhibitions and listed newly available prints by Americans. Moreover, Haas had commended the graphic workshop which Margaret Lowengrund promoted in conjunction with The Contemporaries gallery, praised the Creative Graphic Workshop guided by the lithographer and printer Robert Blackburn and, as early as 1950, had called for more workshops with subventions from museums, libraries, art schools, or colleges.[62] And throughout the fifties many new printmaking programs and workshops were initiated at universities and art schools, especially from north to south in mid-America and along the Pacific Coast.

In 1951 the International Graphic Arts Society was formed as "a nonprofit membership organization for the creation and distribution of international contemporary works of graphic art. . . ." The Print Council of America was incorporated in 1956 with a mission of "fostering the creation, dissemination, and appreciation of fine prints, new and

old." Although exceptional influence on the creative printmaking of the time should not be ascribed to those organizations, nonetheless, their activities in support of exhibitions and sales and concerns with the general welfare of the art contributed to the evidence that American printmaking was hardly "in a state of rest."

Many New York galleries, old and new, became eager handlers of prints by "big name" Europeans, and the dealers' promotions identified a flood of imports created by Redon, Toulouse-Lautrec, Gauguin, and other late-nineteenth-century French printmakers, as well as Munch, Kollwitz, and most of the German Expressionists, the contemporaries Miró, Nesch, and, above all, Picasso prints in abundance. On the other hand, the Weyhe, Kennedy, Grace Borgenicht, Bertha Schaefer, and National Serigraph Society-Meltzer galleries continued to be faithful sponsors of contemporary American printmaking, while a scatter of others offered one-man or group shows from time to time. The Contemporaries gallery, new and limited in resources, was opened by the lithographer Margaret Lowengrund in 1951. From then until 1956 when an alliance was made with the Pratt Institute to form the Pratt-Contemporaries Graphic Art Center, Lowengrund dedicated her gallery to the exhibiting of recent American prints. Some were by printmakers who had become well publicized by the early fifties or in the decade before—Albers, Barnet, Baskin, Minna Citron, Day, Drewes, Eichenberg, Fuller, Margo, Moy, Gabor Peterdi, Racz, Schanker, Schrag, Seligmann, John von Wicht, and Yunkers. Others, soon to gain national recognition, were Casarella, Colescott, Sister Mary Corita (Kent), Lee Chesney, Michael Ponce de Leon, Deshaies, Leonard Edmondson, Meeker, Danny Pierce, Summers, Peter Takal, Sylvia Wald, and June Wayne.

Loose alliances of printmakers

continued in the fifties and some of the participants in the exhibiting groups of the forties—The Graphic Circle, Vanguard, and The Printmakers—became members of the 14 Painter-Printmakers. Barnet, Drewes, Fuller, Margo, Moy, Schanker, and Seligmann were joined by Citron, Day, Perle Fine, Jan Gelb, Alice Trumbull Mason, Schrag, von Wicht, and Peterdi when the fourteen exhibited prints and paintings at the Stable Gallery in 1953 and the Kraushaar Galleries in 1954 and 1957. Meanwhile, in 1955, the Brooklyn Museum sponsored them in an exhibition, 14 Painter-Printmakers, which prompted the curators to declare that the tradition of *peintre-graveur* was still strong in France and followed willingly by contemporary American artists.[63]

In the exhibition of 14 Painter-Printmakers at the Brooklyn Museum Peterdi displayed *Apocalypse* (1952—fig. 6.20) and *Germination I* (1951—fig. 6.21), two among his many images on themes of *The Fight for Survival* and *The Triumph of Life*. Shortly after their creation—when the Grace Borgenicht Gallery staged a one-man show in 1952—Peterdi recalled that, "The uncertainties of our century forced me to express them [the prevalence of irrational violences] as they burst into futile and horrible action. But I believe in life, and it is this faith which now compels me to express the creative force of nature as a symbol of the triumph of life over destruction."[64] *Apocalypse* bore residual elements of the surrealistic visions, stark and terrifying, that were recurring conceptions in his work from the time of his introduction to printmaking at Hayter's Paris Atelier 17 in 1933 to the *Black Bull* portfolio published in 1939 by Jeanne

6.20
Gabor Peterdi
Apocalypse
Engraving/etching/soft-ground (1952)
23¼ × 35
Shown in the exhibition, 14 Painter-Printmakers, at the Brooklyn Museum (1955).
Art Institute of Chicago. Gift of Mr. and Mrs. Henry C. Woods.

6.21
Gabor Peterdi
Germination I
Etching/aquatint/engraving/stenciled
colors (1951) 19⅞ × 23⅞
*Shown in the retrospective exhibition, Gabor
Peterdi: Forty-Five Years of Printmaking,
at the National Museum of American Art
(1979).*
Courtesy of Associated American Artists.

Bucher Editions shortly before
Peterdi followed other artist-émigrés
to America.

Peterdi's *Germination I* was
among the prints that comprised
The Triumph of Life series and a con-
ceptual countertype to *Apocalypse*. A
patterned cross section of laminated
soils where seeds burst open with
eccentric shapes to pierce the earth
above, it was a prototype for *Spawn-
ing II* commissioned by the Interna-
tional Graphic Arts Society (1952).
Akin in composition and symbolic
meaning—and as an intaglio with
stenciled colors—*Spawning II* de-
scribed the genesis of life in a liquid
microcosm. Birth, growth, death,
and resurrection were stimulating

ideas for Peterdi and visions of na-
ture in fragments or landscapes,
with latent or dynamic forces of
rocks, plants, forests, seas, and the
drama of seasons, permeated his
prints and sometimes were assigned
metaphoric titles. The landscape *Ca-
thedral* (fig. 6.22) was chosen for
American Prints Today / 1959, the
first exhibition assembled by the
Print Council of America; this ex-
hibition was displayed, almost si-
multaneously from coast to coast, in
sixteen major museums.[65]

In late 1959 Peterdi received
other rewards which had connota-
tions beyond his personal successes.
At the time, most museums did not
chance one-man shows of contem-

6.23
Armin Landeck
Stairway Hall
Engraving/drypoint (1950) 11⅞ × 14½
Shown in the 5th National Print Annual Exhibition, at the Brooklyn Museum (1951). Awarded the John Taylor Arms Memorial Prize at the 39th Annual Exhibition of the Society of American Graphic Artists (1955).
Elvehjem Museum of Art. Mark and Katherine Ingraham Fund.

Opposite:
6.22
Gabor Peterdi
Cathedral
Etching/engraving (1958)
31⁷⁄₁₆ × 22¹¹⁄₁₆
Shown in American Prints Today/1959, the exhibition sponsored by the Print Council of America and displayed at sixteen major museums, and Prints and Drawings by Gabor Peterdi, at the Cleveland Museum of Art (1962).
National Museum of American Art (formerly National Collection of Fine Arts), Smithsonian Institution. Lent by the artist.

Page 198:
6.24
Moishe Smith
The Four Seasons—Winter
Intaglio (1958) 24 × 34½
Shown in American Prints Today/1959, the exhibition sponsored by the Print Council of America and displayed at sixteen major museums.
Elvehjem Museum of Art. Gift of the Class of 1966.

6.25
Rudy Pozzatti
Grasshopper
Woodcut (1954) 16½ × 36
Awarded a Purchase Prize at the 27th International Exhibition of Northwest Printmakers (Seattle, 1955) and an Honorable Mention in the 152nd Annual Exhibition of Watercolors, Drawings and Prints, at the Pennsylvania Academy of the Fine Arts (Philadelphia, 1957).
Seattle Art Museum. Gift of the Northwest Printmakers.

to younger printmakers who, in turn, shared the inheritance. Among the recipients of the legacies were Lee Chesney and John Paul Jones who then became donors of new ideas and methods as printmaker-teachers at the University of Illinois and the University of California, Los Angeles. In 1949 Jones had been an exhibitor with Lasansky in A New Direction in Intaglio and chose as his display two variations on an abstraction, *Still Life No. 2*, in which dark, muted shapes in an aquatint background served as foils for a bright overlay of geometric and interpenetrating patterns. The intaglio complexities and conceptual features of the prints prefigured *Boundary* (fig. 6.27) of 1951, for which Jones received awards at the annual exhibitions of the Brooklyn Museum, Bradley University, and the Northwest Printmakers. Although his skillful ordering of non-objective forms exemplified another kind of stylistic taste that expanded the variety current at the time, Jones soon concluded that ". . . these things became sterile . . ." despite

their artistic finesse, and ". . . didn't seem to fulfill anything any more."[70] After 1954 he turned to the creation of ephemeral images of the human figure in visions that seemed to bear a kinship to the revelations of the invisible in the lithographic suites of Odilon Redon. *Annunciation* (1959—fig. 6.28), wherein a disengaged head floats beside the enthroned figure and an aquatic beast emerges from the black shadow near her feet, were among the invocations of strange imagery that marked his later works. In an exhibition of 1963, the Brooklyn Museum, with a grant from the Ford Foundation, chose the work of Jones for another of its retrospectives of modern American printmakers in midcareer.[71]

Lee Chesney was another fledgling printmaker who must have been exhilarated by participation with Lasansky in A New Direction in Intaglio in 1949 and the acceptance of his prints by the Brooklyn Museum for display in its national print annuals at the turn of the decade. Unlike the early preference of Jones for

"The Grasshopper" 7/10 Rudy S. Pozzatti '54

17
Garo Antreasian
Fragments
A suite of twelve lithographs plus title
page and colophon (1960–1961).
Title Page
Color lithograph (1961) 18¼ × 15⅛
Fragment (B)
Lithograph (1960) 17⅞ × 14¾
Colophon
Color lithograph (1961) 18⅛ × 14¹⁵⁄₁₆
"*FRAGMENTS, a suite of twelve litho-
graphs plus title page and colophon, was
handprinted by the artist at Tamarind
Lithography Workshop, Los Angeles. The
edition consists of twelve numbered impres-
sions on Rives BFK paper. Some Trial, Art-
ist and State Proofs exist and are recorded
at Tamarind. All stones and zinc plates
have been effaced.*
*The binding is by Schuberth Bindery, San
Francisco.*
This is number 6.
s/ Garo Z. Antreasian '61"
Elvehjem Museum of Art

18
Sam Francis
Untitled
Color lithograph (1963) 22 × 30
Printed by Irwin Hollander at the
Tamarind Lithography Workshop.
Shown in the exhibition, American Graphic
Workshops: 1968, at the Cincinnati Art
Museum (1968).
University Art Museum, University of New
Mexico. Collection of the Tamarind
Institute.

19
June Wayne
At Last a Thousand III
Color lithograph (1965) 25 × 35
*Printed by Jurgen Fischer at the Tamarind
Lithography Workshop.*
*Shown in the exhibition, Tamarind:
Homage to Lithography, at the Museum of
Modern Art (1969), and the retrospective
exhibition, Los Angeles Prints: 1883–
1980, at the Los Angeles County Museum
of Art (1980).*
*University Art Museum, University of New
Mexico. Collection of the Tamarind
Institute.*

20
Nathan Oliveira
Acoma Hawk I
Color lithograph (1975) 30⅛ × 22⅛
Printed by Harry Westlund and Richard
Shore at the Tamarind Institute.
Shown in the exhibition, Tamarind—Suite
Fifteen, at the University Art Museum,
University of New Mexico (1977), and in
Nathan Oliveira Print Retrospective:
1949–1980, at the Art Museum and Gal-
leries, California State University (Long
Beach, 1980).
University Art Museum, University of New
Mexico. Collection of the Tamarind
Institute.

21
Roy Lichtenstein
Cathedral # 4
Color lithograph (1969) 48½ × 32½
© Gemini G.E.L.
Shown in the exhibition, Technics and Cre-
ativity II *Gemini G.E.L., at the Museum*
of Modern Art (1971), and in the retro-
spective exhibition, American Prints
1960–1980, at the Milwaukee Art Mu-
seum (1982).
Elvehjem Museum of Art. Anonymous
Fund.

22
Claes Oldenberg
Profile Airflow—Test Mold, Front End
Color silkscreen/cast polyurethane/
Plexiglas/welded aluminum frame
(1968–1972) 15⅝ × 18⅜
© Gemini G.E.L.
Shown in the exhibition, Claes Oldenberg
Recent Prints, at M. Knoedler & Com-
pany (1973).
Elvehjem Museum of Art. Charles E.
Merrill Trust Fund.

23
Robert Rauschenberg
Cardbird, II
Silkscreen-printed "dimensional object"
(1971) 54½ × 33½
© Gemini G.E.L.
Shown at Castelli Graphics (1971) and in
the retrospective exhibition, American
Prints 1960–1980, at the Milwaukee Art
Museum (1982).
Milwaukee Art Museum. Gertrude
Nunnemacher Schuchardt Fund.

24
Roy Lichtenstein
CRAK! NOW, MES PETITS . . . POUR
LA FRANCE!
Color lithograph (1964) 18⅝ × 26¾
Printed by Total Color, New York.
Published by the Leo Castelli Gallery.
Shown in the retrospective exhibition,
American Prints 1960–1980, at the Mil-
waukee Art Museum (1982).
Milwaukee Art Museum. Gift of Quad/
Graphics, Inc., with National Endowment
for the Arts Matching Funds.

25
Andy Warhol
Marilyn Monroe
Color silkscreen (1967) 36 × 36
Printed by Factory Editions. Published by
Brooke Alexander, Inc.
Elvehjem Museum of Art. Robert Gale
Doyon Fund and Harold F. Bishop Fund.

26
Tom Wesselmann
Great American Nude
Color silkscreen (1969) 16⅞ × 23
Printed by the Chiron Screen Print
Company, New York.
Shown in the retrospective exhibition,
Americans at Home and Abroad: Graphic
Arts, 1855–1975, at the Elvehjem Mu-
seum of Art (1976).
Elvehjem Museum of Art.

27
Edward Ruscha
Mocha Standard
Color silkscreen (1969) 19⁹⁄₁₆ × 37
Printed and published by Cirrus Editions,
Los Angeles.
Shown in the retrospective exhibition, Silk-
screen: History of a Medium, at the Phila-
delphia Museum of Art (1971).
Elvehjem Museum of Art. Anonymous
Fund Purchase.

28
Allan D'Arcangelo
Landscape No. 3
Color silkscreen (1965) 39¾ × 29¹³⁄₁₆
Published in the portfolio, 11 Pop Artists,
III, by Original Editions, New York.
Shown in the touring exhibition, POP and
OP, assembled by the American Federation
of Arts (1966), and the retrospective ex-
hibition, American Prints 1960–1980, at
the Milwaukee Art Museum (1982).
Milwaukee Art Museum. Gift of Dr. and
Mrs. Christopher Graf.

29
James Rosenquist
Cold Light
Color lithograph (1971) 22½ × 30⅛
*Printed by Charles Ringness at the
Graphicstudio, University of South Florida,
Tampa. Published by Castelli Graphics.
Shown in the exhibition, James Rosenquist,
at the Whitney Museum of American Art
(1972), and in the retrospective exhibition,
30 Years of American Printmaking, at the
Brooklyn Museum (1976).
Elvehjem Museum of Art. Charles E.
Merrill Trust Fund.*

30
Clayton Pond
The Kitchen in My Studio on Broome Street
Color silkscreen (1971) 38 × 28¹/₁₆
*Shown in the exhibition, Clayton Pond /
Prints, at the Madison Art Center (1972).
Elvehjem Museum of Art. Edna G. Dyar
Fund.*

31
Richard Anuszkiewicz
Eternity, from the *Inward Eye* suite
Color silkscreen (1970) 25½ × 19⁹/₁₆
*Printed by Domberger KG, Bonlanden bei
Stuttgart. Published, as a livre d'artiste
with words by William Blake, by the
Aquarius Press of the Ferdinand Roten
Galleries, Baltimore.
Shown in the exhibition, Anuszkiewicz
Prints, at the University Art Galleries,
Florida State University (Tallahassee,
1981).
Elvehjem Museum of Art. Gift of David C.
Ruttenberg.*

32
Robert Cottingham
Fox
Color lithograph (1973) 20⅞ × 20¹⁵⁄₁₆
Printed and published by Landfall Press.
Elvehjem Museum of Art. Anonymous
Fund Purchase.

6.26
Rudy Pozzatti
Venetian Domes
Engraving (1955) 19½ × 15¾
Shown in the exhibition, Work of Rudy Pozzatti, at the Cleveland Museum of Art (1955), and in the 3rd Biennial Invitational Exhibition of Recent American Prints, at the University of Illinois, Champaign (1958).
Art Institute of Chicago. Gift of Dr. Harold Joachim.

geometric abstractions, Chesney conjured up a surrealistic blend of contexture and images when he composed *Pierced and Beset* (fig. 6.29) in 1952. The color intaglio enjoyed the widest exposure of any impression by a young printmaker in 1952 and 1953. Awards came from the third annual at Bradley University and the 2nd National Print Exhibition at the University of Southern California. Chesney also received the top prize in the 13th Annual Exhibition of Etching at The Print Club of Philadelphia from a distinguished jury composed of the curator Carl Zigrosser, the critic Dore Ashton, and the artist Theodore Brenson, an "alumnus" of the New York Atelier

17.[72] Meanwhile, *Pierced and Beset* was chosen for American Watercolors, Drawings and Prints at the Metropolitan Museum of Art in 1952 and shown in the timely résumé of works by Young American Printmakers at the Museum of Modern Art in 1953.

As the younger printmakers swarmed from the new workshops in search of professional standing through exhibitions and awards, their immediate predecessors as contemporary "old masters"—Hayter, Lasansky, Peterdi, and colleagues— were displaying recent works in competitive, invitational, or one-man shows. Some who had worked with Hayter joined former or current printmakers at Atelier 17 in an

6.27
John Paul Jones
Boundary
Etching/engraving/soft-ground/aquatint
(1951) 28½ × 22¼
Awarded a Purchase Prize at the 23rd Annual Exhibition of Northwest Printmakers (Seattle, 1951) and awards at the 2nd Annual Bradley University National Exhibition of Prints (1951) and the 5th National Print Annual Exhibition, at the Brooklyn Museum (1951). Shown in the retrospective exhibition, John Paul Jones: Prints and Drawings 1948–1963, at the Brooklyn Museum (1963).
Seattle Art Museum. Gift of the Northwest Printmakers.

6.28
John Paul Jones
Annunciation
Etching/soft-ground (1959)
27⅞ × 24⅞
Shown in the retrospective exhibition, John Paul Jones: Prints and Drawings 1948–1963, at the Brooklyn Museum (1963).
Los Angeles County Museum of Art. Art Museum Council Fund.

exhibition at the Grace Borgenicht Gallery in 1951 where prints by Hayter, Racz, Schrag, Becker, Moy, Letterio Calapai, and Peter Grippe were on view.[73]

About the same time, Peter Grippe, one of the several directors of the New York Atelier 17 when Hayter was in France reviving the Paris workshop, initiated an ambitious printmaking project by artists and poets similar to the earlier collaboration of Miró and Ruthven Todd in 1947. Its consummation demanded nine long years of Grippe's ". . . extraordinary tenacity and devotion." In 1958 the Morris Gallery, whose proprietor-poet was Morris Weisenthal, advertised *Twenty-One*

Etchings and Poems with an introduction by James Johnson Sweeney, Director of the Guggenheim Museum. There were delays, however, and the portfolio was published in 1960.[74] Among the pairs of collaborators who etched their images and handscripts in the same plates were the artists and poets Adja Yunkers and Theodore Roethke; Letterio Calapai and William Carlos Williams; Jacques Lipchitz and Hans Sahl; Peter Grippe and Dylan Thomas; and Willem de Kooning and the art critic Harold Rosenberg.[75]

Some ventures into the diversity of intaglio prints that marked the fifties were overlooked by inattentive collectors or received only a few sen-

tences from the press. Louise Nevelson was a skillful sculptor before she first ventured into printmaking between 1953 and 1955. Her themes were fanciful and, in part, stimulated by Mayan art and architecture following her two visits to Yucatan in 1950.[76] Magical images in a mysterious realm of gods, kings, queens, gardens, and forests, as *In the Land Where the Trees Talk* (fig. 6.30), were proofed at Atelier 17 from plates that combined etching, drypoint, and netting pressed into soft-ground. The prints were given various titles and described no further than as exotic proofs when *Magic Forest* and a few others were hung in the studio of the photographer

Pierced and Beset ⁷/₁₅ Lee Chesney

6.29
Lee Chesney
Pierced and Beset
Color intaglio (1952) 15¹³/₁₆ × 23¾
*Received awards in the 3rd Annual
Bradley University National Exhibition of
Prints (1952), the 2nd National Print Ex-
hibition at the University of Southern Cali-
fornia (1953), and the 13th Annual
Exhibition of Etchings, at The Print Club
of Philadelphia (1953).*
*Philadelphia Museum of Art. The Print
Club of Philadelphia.*

Lotte Jacobi in 1954 and prints of
Ancient Figures served as adjuncts to
Nevelson's exhibition of sculpture at
the galleries of Grand Central Mod-
erns the following year.[77] In 1958
the intaglios received more visi-
bility—but evoked scant attention
from the press—when the Esther
Stuttman Galerie covered the walls
with about thirty prints, and half
again as many varied impressions, of
kings, queens, and inhabitants of a
Moon Garden.[78] Nonetheless, they
were the beginnings to be followed
by Nevelson's novel printmaking of
the sixties and seventies when she
turned to nonobjective composi-
tions, with close correspondences
to her dark or black monumental
sculptures, in etching-collage, li-
thography, and less conventional
media such as intaglios on lead lami-
nated to papers or multiples in low
sculptural relief editioned in plastics
or cast in black paper pulp.

In January 1952, the nonprofit
International Graphic Arts Society
(IGAS) issued an illustrated *Bul-
letin*—the first of 101 during the
next twenty years—announcing that
seven prints that made up *Series
No. I* were available for purchase
by members. The original prints,
signed by the artists and published
in editions of no more than 200 to
210 impressions, were distributed
from the IGAS headquarters and
gallery on West 56th Street under
the direction of Theodore Gusten.
Members joined the Society by pay-
ment of a $10 fee and were required
to purchase no fewer than three
prints annually at prices ranging
from $4.50 to $8.50 (fig. 6.31). In
the beginning, the commissions to
American printmakers were recom-
mended by a panel of well-known
curators—Una Johnson, Carl Zi-
grosser, Karl Kup, William S.
Lieberman, A. Hyatt Mayor, Carl

Schniewind, Elizabeth Mongan (of the National Gallery)—and the painter-printmaker Ben Shahn. Three *Series* of prints were published in 1952 and members had the option to purchase three or more impressions by artists who represented various facets of contemporary printmaking in America, such as Hayter, Dehn, Schanker, Moy, Lowengrund, Margo, Federico Cas-

tellon, Rogalski, Yunkers, Landeck, and Peterdi.

This Beginning of Miracles (color fig. 10) by Sister Mary Corita (Kent), a serigrapher from the West Coast, was the first of the few silkscreens commissioned by the IGAS. The print was published in April 1953 as one of *Series No. IV* while, almost simultaneously, an impression of the elaborate silkscreen in

6.30
Louise Nevelson
In the Land Where the Trees Talk
Etching/drypoint/soft-ground (ca. 1953) 18¾ × 18½
Brooklyn Museum. Gift in Memory of Theodore Haseltine.

6.31
Leonard Baskin, Frightened Boy and His Dog *(1954), a color woodcut in black and red, published by the International Graphic Arts Society; as advertised in* Art Digest *(15 February 1955).*

twenty-three colors had been accepted for display in the 2nd National Print Exhibition at the University of Southern California. *This Beginning of Miracles* was a spritely interpretation of St. John's report that Christ converted water into wine during the feast of the Marriage at Cana (John 2:1–11), an event which Sister Mary laced with modern revisions in the iconography of the oft-painted New Testament tale. She surrounded the enormous figures of Christ and His mother, holding goblets, with a welter of episodes during the marriage feast. Some miniature scenes were bounded by structural-steel supports of twentieth-century architecture with one beam, high above the throng, bearing a television antenna. Among the invited guests were the disciples of Christ, clustered around a candlelit banquet table where they were assigned seats that feigned the famous modern chairs designed by Charles Eames. Meanwhile, the "governor" of the feast was depicted several times as he discharged his duties, the last revealing the moment of amazement when he tasted the contents from the elaborately decorated ". . . six waterpots of stone . . ." that had become, miraculously, many firkins of wine.

Silkscreen, despite prophecies of its flourishing future made by printmakers experimenting with the medium during the years of the Federal Art Project, and notwithstanding the mounting numbers of color-laden prints publicized and sent on tours by the National Serigraph Society in the 1940s, was rarely cited as progressive or among the finest creations in contemporary American printmaking by the critics. Thus, compliments for the accomplishments of Pytlack, Bernard Steffen, Edward Landon, and other leading practitioners were limited to those that came from their fellows in the league of serigraphers, by the one-man shows, or the awards received in the annual exhibitions sponsored at the National Serigraph Society's gallery. However, after the Brooklyn Museum initiated its National Print Annual in 1947 a few silkscreens of modern design were admitted, and honored occasionally with awards. Sylvia Wald's *City Lot on Sunday* was accepted and *Singing and Mending* by Robert Gwathmey (fig. 5.17) received a Purchase Prize at the first Brooklyn annual. Then, at the second annual, a San Francisco serigrapher was given a similar award when

Dorr Bothwell submitted *Memory Machine* (fig. 6.32), her print of a heart, surrealistically rendered, whose shadowed interior sheltered the vision of a young girl in a garden, holding a nosegay of flowers. Soon thereafter, the juries for the Brooklyn exhibitions were further attracted to the fresh talents among serigraphers. In the five annuals of 1950 through 1954 Sylvia Wald was represented in all exhibitions, silkscreens by Dean Meeker and Warrington Colescott—young printmakers at the University of Wisconsin—were displayed in 1951 to 1954, and in the exhibitions of 1953 and 1954 Sister Mary Corita (Kent)'s *Seat of Wisdom* and *At Cana of Galilee* were accepted by the jurors.

The abstract compositions and subjective content of silkscreens by Sylvia Wald were well characterized in *Dark Wings* (fig. 6.33) with its fragments of color which coalesced into ambiguous images. The print was awarded Second Prize in the 15th Annual Exhibition of the National Serigraph Society (1954) and Dore Ashton commended *Dark Wings* as ". . . an atmospheric print with delicate textures suggesting wings, and life beneath damp forest leaves." As an introduction for her review of the Society's annual Ashton stated:

The serigraph, which originated as a commercial medium, has had a hard time coming of age as an expressive graphic vehicle. Until recently, one rarely saw an experimental serigraph.

6.32
Dorr Bothwell
Memory Machine
Color silkscreen (1947) 9⅛ × 12⅛
Awarded a Purchase Prize in the 2nd National Print Annual Exhibition, at the Brooklyn Museum (1948), and First Prize in the 9th Annual Exhibition of the National Serigraph Society (1948). Shown in the retrospective exhibition, 30 Years of American Printmaking, at the Brooklyn Museum (1977).
Achenbach Foundation for Graphic Arts, the Fine Arts Museums of San Francisco.

6.33
Sylvia Wald
Dark Wings
Color silkscreen (1953–1954)
18½ × 23½
Awarded a Second Prize in the 15th Annual Exhibition of the National Serigraph Society (1954).
Brooklyn Museum.

Conventional flat patterning and mat colors prevailed. And for some reason, the medium for a long time attracted only the most pedestrian artists working in representational manners.

But things are different these days . . . enlivened by predominantly experimental and abstract work. It is the first annual which strikes me as provoking and the first in which fresh trends are clearly marked. A new refinement achieved by manipulation of overprinting with transparencies and a new concentration on varied textures are encouraging departures from convention.[79]

Less than a month later Ashton was heartened further by the silkscreens in the 8th National Print Annual at the Brooklyn Museum. "For the first time in the annual's history the serigraphs included are on an esthetic level with the other media. Not only did three serigraphs take purchase prizes, but at least a half-dozen others are far above average. Among those I found original and effective were Robert Marx's fluent abstraction [*Migrant*], rich in both line and tone; Warrington Colescott's ornately colored abstraction [*Magdalenian I*], and Sylvia Wald's symbolic print [*Sun Caught in Rock*], which, however, depends too much on its elegant textures."[80]

The experiments with silkscreen that Ashton had hailed included those of Dean Meeker who explained in 1957 that, ". . . I have worked primarily with the serigraph print because I am able to get intensity and transparency of color, a va-

riety of textures and surfaces that is possible in no other medium. I can use a whole gamut of printing materials such as vinyl plastics, lacquers, enamels and encaustic emulsions. I feel the medium has yet many facets unexplored both in technique and as a vehicle of expression."[81] The year before, Meeker had created a serigraph of astonishing dimensions (12½ feet by 24½ feet)—a mural on canvas at the Blue Cross–Blue Shield headquarters in Milwaukee— for which he devised special equipment and techniques, including the screening of symbolic designs with gilder's size as the necessary adhesive for laying gold leaf.[82] His forecast that the medium had many unexplored facets was to be borne out during the sixties by his embossed, lush color prints created in a serigraph-polymer intaglio process.

Meanwhile, in the early fifties, Meeker's *Don Quixote* (color fig. 5) had received the visibility of awards from the 14th Annual Exhibition of Milwaukee Printmakers (1951) and the Cunningham Memorial Prize in San Francisco (1952). Then, in 1952, Meeker printed another experimental silkscreen on a gilded paper. Deep umber silhouettes diagramed a *Trojan Horse* (color fig. 11) concealing Greek warriors— armed and waiting—on its interior decks, the stealthy host becoming visible only when reflected lights shimmered on the metallic surface of the gold ground of the print. Ashton singled out the silkscreen as among the ". . . indications of new trends in the medium . . ." when it was displayed in the exhibition of Young American Printmakers at the Museum of Modern Art (1953).[83] The serigraph was honored later by a Purchase Prize at the 26th Annual International Exhibition of Northwest Printmakers (1954), and Jules Langsner, in a review of the 3rd National Exhibition of Prints at the University of Southern California, cited "a most unusual print, which this critic kept returning to, is Dean

Meeker's serigraph in black ink on gold paper, *Trojan Horse*."[84]

Nonetheless, silkscreens did not enjoy hearty acceptance. A serigraph by Meeker was selected by a jury of the National Academy of Design and the artist congratulated, only to have the print withdrawn from the exhibition when it was found to be a silkscreen.[85] And compliments were not freely given although now and then critics would praise an individual serigraph by Wald, Bothwell, Sister Mary Corita (Kent), Meeker, or Colescott as if the merits were exceptional. The annual exhibitions of the National Serigraph Society and the one-man or small group showings for members in the gallery of the Society were the principal displays of silkscreens with the exception that new serigraphers received showings at The Contemporaries when Margaret Lowengrund sponsored exhibitions by Meeker (1955), Colescott (1956), and Sister Mary Corita (Kent) (1957). Among prominent printmakers in other media, silkscreens were rare diversions or screenings were adopted occasionally as color supplements in their intaglio or relief prints.

Despite the new print exhibitions, the many workshop programs, and the founding of the International Graphic Arts Society and the Print Council of America there were murmurs of discontent or misgiving about some aspects of printmaking.

In January 1959 Lee Chesney presented a paper on "Printmaking Today" at the annual meeting of the College Art Association in Cleveland. He lamented the limited opportunities that active printmakers had for display of their creations.

Among the many handsome prints created today . . . far too few make their way to gallery walls for public appraisal and consumption. Granted that public museums provide the major patronage in this day and granted further that these same museums have shown interest in the contemporary graphic production, their support of printmaking has not

been altogether outstanding. The Museum of Modern Art, for example, to whom contemporary artists look for support sponsored one lone national competitive exhibition of prints about five years ago and has been noticeably silent otherwise. There have been numerous 'First Annual National Exhibition of Prints' sponsored by Universities and print groups, but few second annuals ever materialized and, quite rarely a third or fourth. The Brooklyn Museum has furnished enthusiastic leadership in its lively annuals open to all artists of the United States but after ten consecutive and sparkling yearly exhibitions has decided to change to a biennial arrangement instead. The Library of Congress through the Pennell Fund has continued a lasting support for nearly twenty-five years and it is to be hoped that the interest of this major institution will continue indefinitely.

In any event the opportunity to show in large exhibitions is somewhat limited. Insofar as commercial galleries are concerned the opportunities are virtually nil. The untimely death [November 1957] of the director of The Contemporaries, Margaret Lowengrund, and the subsequent change in policy of the gallery removed *one-half* of the opportunity from New York City, the hub of the exhibition world! The Weyhe Gallery remains the only exclusively print exhibition place of stature in the city. Only a very few of 57th Street's finest galleries show prints and they must be the second offering of a stable artist. No outsiders need apply. Thus the artist whose major creative efforts are in printmaking finds few opportunities for showing in New York and almost no chance for one-man exhibitions.[86]

Not only were opportunities for display limited, but judgments about the art of lithography failed to form a heartening consensus. In 1950 Gustave von Groschwitz, then Senior Curator of Prints at the Cincinnati Art Museum, organized the first International Biennial of Contemporary Color Lithography and declared that "the quality and quantity of the color lithographs in the American section will come as a surprise to all. It is perhaps too soon to explain this sudden popularity of the

medium in America."[87] However, late in 1949 at the Minnesota symposium, the lithographer Adolf Dehn lodged the complaint that American lithographic printing was inept. In subsequent years there were other disparities. On the one hand, Robert Blackburn at his Creative Graphic Workshop, Margaret Lowengrund at The Contemporaries, and Will Barnet at the Art Students League were active lithographers who also coached artists in the craft or offered their skills as printers. Moreover, fine lithographs were being created by Wengenroth, Lozowick, Barnet, John von Wicht, and other established artists while younger printmakers—Nathan Oliveira, Andrew Stasik, June Wayne, Clinton Adams, and Garo Antreasian—were beginning their careers as leaders in lithography. By 1959 Lee Chesney claimed that the Cincinnati biennial was ". . . one of the finest of its kind and has done more for the medium than any other single exhibition."[88] It was a timely compliment after five lithographic biennials, but Chesney had no way of knowing that the exhibitions would be terminated in the following year when a new Biennial of Prints was initiated, based on von Groschwitz's rationale that, "since the Biennials of Color Lithography had accomplished their purpose and, also, because of the emergence of remarkable talents in other fields of printmaking, the next logical step was to organize an exhibition of prints that would include all types."[89]

But there was no consensus about the stature of American lithography in the fifties. June Wayne, as one of the jurors for the 2nd National Print Annual at the University of Southern California (1953), had expressed regrets that there were few experimental lithographs, and, in fact, lithographs of any kind, submitted.[90] And Dore Ashton, after viewing The 1954 International Biennial of Contemporary Color Lithography

at Cincinnati and commending a dozen artists' prints, wrote comfortlessly, "Finally, the U.S. is represented with just about everyone making color lithographs here—150 printmakers. I found that the section was crowded with amateurish work, overstocked with conservative work, and on the whole, less impressive than [foreign] counterparts. The fact remains . . . that we still cannot match the brilliant work in European countries where the tradition of *peintregraveur* prevails."[91] Wayne recalled her gloominess about the state of craftsmanship; she asserted that "by 1959, only one printer still pulled stones for artists in this country, and, unfortunately, his technical skills were irrelevant to the then dominant aesthetic of Abstract Expressionism."[92] In 1959 Wayne was so concerned about the paucity of master lithographic printers and a flagging of the art that she submitted to the Ford Foundation a proposal for a workshop ". . . to help stimulate development of the lithograph and restore it as a creative medium for American artists."[93] The request received an initial subvention of $135,000 and in 1960 the Tamarind Lithography Workshop was launched in Los Angeles. Thus, Tamarind on the West Coast and Universal Limited Art Editions on Long Island—the latter a venture begun in 1957 by Tatyana Grosman—became centers of influence that bolstered the art of lithography in the 1960s.

For more than a century dealers, collectors, curators, scholars, and artists had been unable to reach a consensus on definitions by which printed images would be judged unfailingly as either "originals" or "facsimiles." Nonetheless, general guidelines were an imperative because an attribution of "original" by connoisseurs or dealers heightened the value of a print in the marketplace. A consensus seemed even more remote when modern printmakers complicated matters by

adopting new tools and materials, unconventional methods, and the improved technologies of photomechanical processes that had been developed, one after another, for the printing industry. Still, the pesky problem was less alarming than dubious or fraudulent practices of some artists, printers, and dealers. Photomechanical reproductions of paintings and drawings, or copies of them handmade on printing plates, were misrepresented as "originals." Furthermore, unwary purchasers were artfully misled when dealers offered facsimiles to the public as "limited editions" or "prints signed by the artist"—as indeed the reproductions sometimes were—in order to claim values higher than warranted.

In the fifties and early sixties attempts were made to alert the public to the problems by presenting disclosures of misguided or unscrupulous practices. Dore Ashton informed readers of *Arts* magazine of "The Situation in Printmaking: 1955" with a caption stating that "dubious practices in France threaten the international market and militate against efforts of American printmakers to reassert the concept of 'authentic'." The article was a comprehensive review of the long history of the "vexing problem of authenticity" which had continued into the twentieth century when Braque and other prominent artists signed reproductions and Jacques Villon produced counterparts of art works by modern masters as prints bearing the signatures of both engraver and artist. Then Ashton relayed Villon's alarm at the spread of such questionable enterprises, "I am partly guilty myself . . . [and] I would like to say that it is not honest for any artist to sign the work of another, above all a reproduction of his work in another medium. The public must be warned." Citing several contemporary deceptions, Ashton deplored "prints" by well-known French moderns that were

being marketed in competition with authentic works by American printmakers whose hands had created the images on the plates or stones, who printed their own impressions or supervised the editions pulled by master printers. She shared with readers the criticisms by von Groschwitz that identified famous artists who autographed reproductions of compositions in other media and recounted Zigrosser's dismay with those who inscribed their signatures on sheafs of blank papers and then supplied craftsmen with maquettes of compositions to be copied and printed.[94]

In an effort to lessen the vexations, the Print Council of America published *What Is an Original Print?* in 1961, and revised editions in 1964 and 1967. Members of the Board of Directors were curators and a few collectors who sought counsel from an Advisory Committee of Dealers as they became involved with ". . . the problem of originality in prints in order to protect the public from sharp practices. . . . The prestige acquired by original prints and the difficulty of defining them has enabled unscrupulous dealers and auction houses to pass off photomechanical and other reproductions of old and new works as original prints. To discourage or to take legal action against such fraud and misrepresentation, it is useful to have a valid definition of the original print in order that it may be distinguished from its counterfeit." The booklet sought to be educational with its essay on "The Historical Background" by Carl Zigrosser, a section on "Processes and Techniques of Modern Printmaking," another defining "Reproductions," and guidelines for "The Artist" formulated by Frasconi, Kohn, Lasansky, Peterdi, and Benton Spruance. As "standards and guides for artists, dealers, publishers, collectors, and the general public" the Council proposed that:

An *original print* is a work of art, the general requirements of which are:
1. The artist alone has created the master image in or upon the plate, stone, wood block or other material, for the purpose of creating the print.
2. The print is made from the said materials, by the artist or pursuant to his direction.
3. The finished print is approved by the artist.[95]

Although the standards proposed by the Print Council were commended by reputable dealers and received the concurrence of the prominent printmakers who drafted the recommendations for "The Artist," they were unenforceable in the marketplace and unacceptable to many printmakers.

Among those who found the guidelines of the Print Council unnecessarily traditional and restrictive were printmakers who were exploring new conceptions and experimenting with novel technologies and materials. In 1966 Fritz Eichenberg, the venerable wood-engraver and editor of *Artist's Proof*, cited the tenor of a symposium on new directions in printmaking—sponsored by the Pratt Graphic Art Center—during which ". . . it became quite clear to the participants that new definitions must be found for the contemporary print; the old ones are becoming increasingly obsolete. The word 'print' no longer exclusively implies the depositing of ink on a piece of paper." Eichenberg judged the call for new definitions to be a recurrence of ". . . the ever existing gap between generations: the rear-garde and the avant-garde, the way-in and the way-out, the traditional and experimental."[96]

In the same issue of *Artist's Proof* (1966) Luis Camnitzer, a codirector of the New York Graphic Workshop, published "A Redefinition of the Print."[97] He criticized the Print Council's certification of plate, stone, wood block, or other material as a "liberal although limited" definition

that subscribed to traditional, two-dimensional, image-producing surfaces that are ". . . thought to require ink and to print on paper." Opposing the Council's limitation, he urged the acceptance of any technology of image-producing and of any kind of material as an "image receptor," including three-dimensional structures. Camnitzer rationalized his radical proposals by asserting that "we move into a realm of almost absolute freedom—the sole limitation being the printing of an edition, and the sole responsibility being to reveal an image." It was one of several redefinitions of open-ended practices in printmaking and the creation of "multiples" during the sixties and seventies.

Meanwhile, because of and despite such unorthodoxies, diverse kinds of prints were sold in a market that prospered as never before. By the midsixties, old and new dealers, publishers, directors of workshops, and principals of other entrepreneurial ventures scrambled for advantage during the booming exchange in contemporary prints. An increasing number of American artists joined the printmaking enterprise, often with the urging of their dealers who knew that unique paintings were too dear for clients of modest means, but prints were affordable works of art for less affluent "collectors." Thus, during the next decade and a half, the marketing of prints multiplied, accompanied by aggressive advertising and promotion which often bore blandishments about impressions of "museum quality" and the value of prints as art investments.

7

Print Workshops Coast to Coast and the Print Boom in the Marketplace, 1960–1980

After 1960, the establishment of many workshops, coast to coast, provided new resources for American printmaking. Their growing corps of master-printers advised artists and printed the editions sought by publishers and dealers who were eager to meet the demand of a booming print market. Artists whose print compositions relayed the latest styles in painting and sculpture were attracted especially to the workshops that offered collaborations in lithography and silkscreen.

When relief and intaglio printings had been in ascendancy during the forties and fifties, the leaders of an abstract kind of expressionism in painting—heterogeneous in manifestation but nonetheless cited as a "New York School" by critics—rarely engaged in printmaking. Jackson Pollock, before developing his "drip" or "action" manner of painting, pulled trial proofs of seven prints created at Atelier 17 in 1944–1945, intaglios with surrealistic idioms akin to those of Arshile Gorky. They were neglected until eleven years after Pollock's death when, in 1967, his estate commissioned Emiliano Sorini to print editions of fifty and the plates were sealed and deposited at the Museum of Modern Art.[1]

Art International, in a note on the 5th International Biennial of Contemporary Color Lithography (Cincinnati, 1958), mentioned that it was "curious, and unfortunate, that American vanguard artists have till now shown little interest in lithography. The medium would seem a 'natural' for such painters as Kline, Motherwell, Gottlieb, Newman, Ferren and Rothko, for instance."[2]

Soon thereafter, Robert Motherwell, Adolph Gottlieb, Willem de Kooning, and Barnett Newman discovered that subjective content and abstract styles in their art could be transcribed to lithography effectively when they collaborated with the new master-printers. The powerful chromatic notes in Gottlieb's theme paintings of "imaginary landscapes" and "bursts" were prototypes for *Untitled* (color fig. 12), a color lithograph composed in 1969. In 1960, de Kooning had created two flamboyantly gestural lithographs (untitled) at Berkeley with the assistance of George Miyasaki and Nathan Oliveira, artist-lithographers on the West Coast, whose prints by then had brought them awards and fellowships. But de Kooning's interest flagged until another decade passed and a series of lithographs were printed at the workshop of Irwin Hollander in 1970–1971.

Robert Motherwell turned to printmaking more frequently. In the early forties he had tried intaglios in the studio of Kurt Seligmann and at Atelier 17, and a revival of interest in printmaking emerged in the 1960s with his creation of lithographs at the workshops of Tatyana Grosman and Irwin Hollander, some of them displaying a calligraphy born of dynamic brushwork as in *Automatism A* (fig. 7.1).

Elsewhere, amidst a growing throng of printmakers who worked in collaboration with printers at silkscreen and lithographic workshops, Andy Warhol, Roy Lichtenstein, Edward Ruscha, Robert Indiana, and other proponents of "Pop Art" reiterated the images and content of their paintings—the totems and trivia of mass media and commerce in mid-twentieth-century America. In addition, Jasper Johns, Robert Rauschenberg, Jim Dine, and Warhol clipped and transferred to their prints "pop" images and other kinds of reproductions which had been published as magazine illustrations, advertisements, and newspaper photographs. For those purposes, the artists favored the technologies of modern commercial art and the printing trades—silkscreen, photo-silkscreen, photolithography, offset lithography, and combinations.

By the midsixties, those sallies into printmaking received substan-

7.1
Robert Motherwell
Automatism A
Lithograph (1965) 19½ × 14½
Printed by Irwin Hollander.
Shown in the 15th National Print Exhibition at the Brooklyn Museum (1968).
Achenbach Foundation for Graphic Arts, the Fine Arts Museums of San Francisco.

tial coverage in the press in contrast to a scarcity of reporting on printmaking by the art periodicals after the midfifties. The omissions had hardly been redressed in 1962 when *Art News* featured two articles, each with the same headline—"Is there an American print revival?" The editors' captions—burdening the reports by Jules Langsner of Los Angeles and James Schuyler, poet and friend of artists working with Tatyana Grosman—wrongly implied to readers that printmaking had waned. Answers to the query, "Is there an American print revival?", surely were not contemplated as the task when each correspondent wrote

a brief on one of a pair of workshops fostering the art of lithography—the Tamarind Lithography Workshop in Los Angeles where a program of fellowships for visiting artists and the training of master-printers was well underway with the guidance of June Wayne, Clinton Adams, and Garo Antreasian, and the printing and publishing by Grosman's Universal Limited Art Editions (ULAE) at West Islip, Long Island.[3]

Tatyana Grosman's earlier trials in publishing had been replications of works by Max Weber and the sculptors Mary Callery and Jacques Lipchitz. They were translated into

silkscreens by her husband, the artist Maurice Grosman, who had learned the process at commercial firms when he sought supplemental income after their flight from Occupied France to New York in 1943.[4] The curators William Lieberman and Carl Zigrosser advised her to publish original prints of record and thus, in 1957, she purchased a secondhand lithographic press, named her venture Universal Limited Art Editions, and soon induced Robert Blackburn to travel from his workshop in New York as the master-printer.

Young painters of the "second generation" of the "New York

7.2
Helen Frankenthaler
First Stone
Color lithograph (1961) 22 × 30
Printed by Robert Blackburn. Published by Universal Limited Art Editions.
Shown in the exhibition, Helen Frankenthaler Prints: 1961–1979, at the Sterling and Francine Clark Art Institute (Williamstown, 1980).
Art Institute of Chicago. Purchased from Universal Limited Art Editions.

School" were the very first and, subsequently, most frequent participants at ULAE after 1957 when Grosman began to recruit Larry Rivers, Sam Francis, Grace Hartigan, Johns, Helen Frankenthaler, Rauschenberg, and Dine, although by the midsixties Motherwell and Barnett Newman were among "senior" contemporary artists who created print portfolios there.

The preferences of the painters turned printmakers ranged from the concise formalism of Newman's color lithographs for *XVIII Cantos* (1963–1964), or the loose calligraphy and floating stains of color in Frankenthaler's *First Stone* (fig. 7.2), to compositions with freely combined emblems, signs, images, or fragments of commonplace objects. When images feigned objects—

by inking and pressing them onto the stones as in Johns's *Skin with O'Hara Poem* (fig. 7.3), by drawing or painting with tusche, by collage or photographic transfer—and singular stones received inscriptions by both poets and painters, the prints published by ULAE confirmed that lithography responded readily to transcriptions of spontaneous, autographic, capriciously combined, or chance effects.

In 1957, Grosman's visit to Larry Rivers's studio in nearby Southhampton—and the chance presence of the poet Frank O'Hara—had led to the first lithographic project at ULAE, *Stones* (fig. 7.4), a suite of twelve prints with images and poems scribed as if they were guileless graffiti. The portfolio was not completed until 1959, and soon

7.3
Jasper Johns
Skin with O'Hara Poem
Lithograph (1963–1965) 20⅞ × 32⅜
Printed by Zigmunds Priede. Published by Universal Limited Art Editions.
Shown in the exhibition, New American Expressions in Fine Printmaking, at the Royal Library of Belgium (Brussels, 1968). Courtesy of Universal Limited Art Editions.
In 1963 the images of Skin *were made by inking parts of Johns's body. The typescript of the poem by Frank O'Hara was added to the stone, and signed by the poet, in 1965.*

The clouds go soft
 change color and so many kinds
 puff up, disperse
 sink into the sea
the heavens go out of kilter
 an insane remark greets
 the monkey on the moon
 in a season of wit
 it is all demolished
or made fragrant
 sputnik is only the word for "traveling companion"
here on earth
 at 16 you weigh 145 pounds and at 36
 the shirts change, endless procession
 but they are all neck 14 sleeve 33
 and holes appear and are filled
the same holes anonymous filler
 no more conversation, no more conversation
 the sand inevitably seeks the eye
 and it is the same eye.

7.4
Larry Rivers and Frank O'Hara
Stones
Plate *E 12* from the suite of twelve
lithographs (1957–1959) 14 × 17⅞
*Printed by Robert Blackburn. Published by
Universal Limited Art Editions.
Shown at the Tibor de Nagy Gallery
(1959) and in the group exhibition, The
Fine Art of Lithography: Lithographs Pub-
lished by Universal Limited Art Editions,
at the Kornblee Penthouse Gallery (1961).
Art Institute of Chicago. Purchased from
Universal Limited Art Editions.*

O'Hara's lines inscribed by the poet:

```
                        Pittsburgh
                        Carnegie
will we ever   get to the  Internation-
                        al Stuff

Al rents a car   Grace says
              yes!!        →  ←
                          this way
  it snows    Diana cries
will there be anything to eat?
  who will be there?

  Lionello Venturi?
  André Masson?
  Thomas B Hess?
```

thereafter was advertised by the gal-
lery of Tibor de Nagy, the dealer
who had published O'Hara's first
book of poems in 1952 and cur-
rently handled the paintings of
Rivers, Hartigan, and Franken-
thaler.[5] Grosman's energetic place-
ment of prints continued in the
following year with impressions by
Johns, Rivers, and Hartigan at the
Barone Gallery and lithographs by
Johns with Leo Castelli, a promi-
nent dealer in avant-garde art. Then,
in 1961, the prospering workshop
at West Islip reinforced its identity
with a group exhibition at the
Kornblee Penthouse Gallery—The
Fine Art of Lithography: Litho-
graphs Published by Universal Lim-
ited Art Editions.

Grosman preferred to publish portfolios, although many single-sheet prints were created at ULAE. One such print was the second lithograph by Johns, *Coat Hanger I*, cited as an "archetypical example of the artist's unexpected use of a common object" by Richard S. Field, an Assistant Curator at the Philadelphia Museum of Art, when he mounted a comprehensive exhibition, Jasper Johns Prints 1960–1970.[6] *Coat Hanger I* (fig. 7.5)—selected for the traveling show sponsored by the Print Council, American Prints Today / 1962—was one of few prints published by ULAE to be entered in the kind of exhibition that presented a broad array of American prints.

During the sixties, Johns was one of the more prolific printmakers published by ULAE and Kenneth Tyler's workshop in Los Angeles, Gemini G.E.L. (Graphic Editions Limited). Many of the prints were recreations of themes prominent in his paintings—numerals 0 to 9, alphabets, words or letters in the guise of stencilings, American flags and maps of the contiguous forty-eight states—and the widely publicized sculpture painted to feign two cans of Ballantine's Ale which Johns revised in *Ale Cans* (1964), a color lithograph printed, in part, with metallic ink. Johns converted commonplace objects, signs, and symbols into emblematic compositions that harbored ideas and messages which viewers were free subjectively to educe as they wished.

In a lithographic revision of *Souvenir*, a painting of 1964, Johns interspersed an assortment of "memory-images," explaining that "thinking anything could be a souvenir of something else. . . ."[7] The title was inscribed on the back of a stacked canvas, painted or unpainted, as it might be in his studio or that of artist-friends. A flashlight hangs below a bicycle mirror. Johns's likeness, which was transferred to the lithographic stone

from an earlier photosilkscreen, was enframed as a counterpart of Japanese souvenir dinner plates with photographs of wrestlers and baseball players that the artist had seen in a Tokyo shopwindow—here encircled by the "stenciled" words for primary colors, BLUE, RED, and YELLOW. *Souvenir* (fig. 7.6), the lithograph, was produced at ULAE expressly for the opening of Johns's print exhibition at the Philadelphia Museum of Art in 1970.[8]

The painters recruited by Grosman often tested the skills and ingenuity of printers. Johns's *Souvenir*, for example, was editioned with eleven colors from nine complexly designed stones including photosilkscreen transfers. Nonetheless,

7.5
Jasper Johns
Coat Hanger I
Lithograph (1960) 25½ × 21
Printed by Robert Blackburn. Published by Universal Limited Art Editions.
Shown in American Prints Today / 1962, an exhibition sponsored by the Print Council of America.
Courtesy of Universal Limited Art Editions.

7.6
Jasper Johns
Souvenir
Color lithograph (1970) 23⅝ × 17½
Printed by Zigmunds Priede, Dan Socha,
Frank Akers, and John Butkiewicz.
Published by Universal Limited Art
Editions.
Shown in the exhibition, Jasper Johns Prints
1960–1970, at the Philadelphia Museum
of Art (1970).
Philadelphia Museum of Art. Gift of the
Artist.

new master-printers responded enthusiastically to unexpected challenges. When Johns worked at Gemini (color fig. 13), Kenneth Tyler was exuberant: "Let's face it, he's one of the greatest lithographers of all time—and one of the hardest to print. His stones yield the last ounce of blood lithography has to yield."[9]

The preference of some modern artists for disparate combinations of themes, images, and materials had been invading the art of the Western world during most of the earlier decades of the century, creating disjunctures in contrast to the traditional visual and tactile unities of pictorial illusion or of physical property in painting and sculpture. The rebellion against conventions in all forms of art—never more insistent than in the promulgations and contrivances of the Dadaists—was reflected once again in the chance juxtaposition of movements, sounds, and objects that became factors of happenstance in the choreography of Merce Cunningham, the musical compositions of John Cage, the art of Rauschenberg, and the performances in which all three were collaborators. "Happenings," in which they and Jim Dine were principals or participants, were being espoused by Allan Kaprow who proposed that the events should be "planned" though performed without rehearsal or repetition, thus laying claim for happenings as art forms but intensified as experiences by chance occurrences and sensations that were more true of "life." It was inevitable that the disjunctive features found in the works by Johns, Rauschenberg, and Dine would be relayed into their prints and "multiples" of the sixties.

When Dine arrived in New York in 1958, fresh out of art school, he became a committed creator of happenings under the influence of Kaprow who, as the artist recalled, "made us feel important, in a creative and revolutionary way."[10] Dine produced a few prints at the Pratt Graphic Arts Center,[11] the most dramatic a series of six that were transmutations into lithography of *Car Crash*, a happening he had staged at the Reuben Gallery in 1960.[12] Each print bore jet-black signs and symbols—expressionistic abstractions of destructive impacts, of violent letterings repeating CRASH among the ranks of graveyard crosses with a terminal blood-red cross symbolizing *The End of the Crash*. By 1961 his developing doubts about happenings—their links to the theater

and his role as creator and performer—led Dine to conclude that he "couldn't go on just making happenings, acting in skits, and pouring paint on myself. I wanted to do other things . . . to make paintings."[13] In the summer of 1962, Johns took Dine to the workshop at West Islip where, in the years thereafter, he created innumerable prints while his admiration for the proprietor flourished. "Working with Tanya Grosman at Universal Limited Art Editions on Long Island has been the catalyst for everything. She is the only person I have ever met with standards for everything from coffee and babka to violet litho ink. She has made me aware of paper."[14]

The violence of *Car Crash* disappeared from Dine's prints created at ULAE and other workshops. More often than not his images were of commonplace objects which lay quietly on the printed paper surfaces, defined further by diagrams, emblems, symbols, and words. Depictions of hardware that appeared repeatedly were ascribed to recollections of the tools his father—and grandfather—sold in Cincinnati shops. C-clamps, pliers, wrenches, scissors, awls, and chisels were lithographed and etched as an inventory of "icons," or silkscreened in the suite *A Tool Box* where they and hammers, vises, drills, and hoists were clustered with unlikely images of kids and Donald Duck (1966). Dine's familiar objects were chosen for portfolios, such as *11 Pop Artists* (1965) where *Awl* bore erotic hints—as in other of his prints— by photoreplications of models' legs and bodies assembled as a montage surrounding "macho" symbols of a red pack of Marlboro smokes touched by the pricking point of an awl that lent the humdrum title. Bathrooms, toothbrushes, pastes, and *Bathrobe(s)* with no figures— though a score and more were called *Self Portrait*—engrossed Dine, as did symbolic hearts by which he cast metaphoric allusions to emo-

tional experiences. Images of commonplace kitchen vegetables were clipped from magazines and replicated by offset lithography— correctly or erroneously labeled by his handscripts—and sometimes juxtaposed with random objects such as the pliers in *Tomato and Pliers* (color fig. 14).

By the 1970s, eroticism was flagrant in Dine's prints of privy parts or *Four Kinds of Pubic Hair* (1971), transmogrified by drypoint strokes to form a hairy row in *Five Paint Brushes* (fig. 7.7) or the waving cilia which edged the hammers, wrenches, roulettes, and punches that became Dine's private fantasies of *Thirty-Bones of My Body* (1972). Dine etched portraits of the literary symbolists of nineteenth-century France—Rimbaud, and Flaubert whose *The Temptation of St. Anthony* had inspired fantastic beasts in Redon lithographs. Dine also etched innumerable self-likenesses, intense with introspection as was *Positive Self Portrait* or, from the same copperplate, *Self Portrait as a Negative* (fig. 7.8).

Continuing the challenges to the conventions of printmaking, Grosman urged Rauschenberg to create a "book" in 1964.[15] Instead, he chose to print lithographs on Plexiglas. The six plastic sheets, entitled *Shades*, were assembled as "multiples" or, as the edition was defined in the colophon, "24 numbered lithographic objects." Each unit or translucent "page" was inserted into a three-dimensional aluminum frame constructed with six slots. The "title page" was fixed in position, but the five other "prints" were reversible, could be rotated, or were interchangeable for an infinite number of arrangements, not unlike the pages of unbound "nonnovels" of the time which were shuffled randomly and read and reread in chance sequences. The tusche scumblings and dissimilar letterings were from the hand of Rauschenberg, but most of the images were transferred to the stones by inking photomechanical halftone

engravings which he had obtained from the morgue of the *New York Times*—a mélange of baseball scoreboards and a stadium, the "floor" of the New York Stock Exchange, jockeys, horses and harness-racing sulkies, a cat and a crossword puzzle —with signs and symbols that composed the fragmented "collage" of contemporary Americana. *Shades* (fig. 7.9) provided another transitory effect if a flashing light bulb on an extension cord (included with purchase) was dropped behind the "title page." The "lithographic object" was announced in an illustrated advertisement by the Leo Castelli Gallery in December 1965.[16]

Two-dimensional prints by Rauschenberg also reflected earlier features of his art, the assemblages of "found" and dissimilar objects, sometimes brushed with paints— "combines," as the artist chose to call the groupings. Those prints were complex "combines," too—images transposed from inked objects, photoreplications of reproductions clipped from periodicals and other printings or their transfer to the stones by soaking with solvents, and scumblings with a greasy crayon— lithographs that mirrored his dismissal of printmaking conventions.

Sometimes Rauschenberg made use of happenstance to create coded titles for his prints. In 1962, at ULAE, a stone was fractured during its proofing by Robert Blackburn. In 1963 Rauschenberg chose to ink and pile the fragments at the bottom of the gaping fissure, edition the stone, and commemorate the circumstances by the title *Accident*. The lithograph, a curiosity and a tour de force of printing by Zigmunds Priede, received the *Grand Prix* of the International Print Exhibition V at Ljubljana, Yugoslavia, in 1963.[17]

Rauschenberg's *Breakthrough II* (fig. 7.10) received its title in 1965 after a hairline crack widened during the proofing of one of the four stones used to produce the print. At

7.7
Jim Dine
Five Paint Brushes
Etching/drypoint/roulette work (1972)
23⅝ × 35⁷⁄₁₆
Printed at the Petersburg Press, London.
Shown in the exhibition, American Prints:
1960–1980, at the Milwaukee Art Museum (1982).
Milwaukee Art Museum. G. P. Foundation Fund.

the upper terminus of the fracture Rauschenberg added a truncated head of the Statute of Liberty upside down. It was an addendum to the miscellany of images in the composition—reproductions (in reverse) of *The Toilet of Venus* by Velázquez and Houdon's statue of *George Washington* in the Virginia state capitol; photographic facsimiles of an extension cord jack and keys; scumblings; and traces of an eye chart that had been printed from one of the four lithographic stones on an earlier occasion.

Rauschenberg assembled *Booster* (fig. 7.11) with fragments from earlier prints—chairs, arrows, drill heads, athletes in action, and scumblings with lithographic tusche and crayon—floating them beneath an astronomy chart inscribed with the 1967 orbital paths of Jupiter and Saturn and flanking full-scale X-ray films of the artist's body, naked ex-

cept for hobnail boots. Printed in two contiguous sections at Gemini G.E.L. in 1967, the lithograph/ silkscreen matched the huge dimensions of Leonard Baskin's largest woodcut figures and, as a tour de force, became the most-publicized piece of Rauschenberg's series *Booster and 7 Studies.*

Rauschenberg spurned conventions of printmaking in his choice and manipulation of media when creating prints. He designed *Shades* as a "lithographic object" and concocted *Revolver* (1967), a power-driven construction more complex than Marcel Duchamp's *Rotorelief* of the thirties. The metal base of *Revolver* held in an upright position five transparent Plexiglas disks—silkscreened in color with a hurry-scurry of words, diagrams, and images, including *Le bain Turc* by Ingres—each of which could be revolved forward or backward. Surely,

the many excursions into lithographic printing had dispelled Rauschenberg's doubts of 1962 "that the second half of the 20th century was no time to start drawing on rocks." [18] Moreover, if there had been similar skepticism about printmaking among other painters and sculptors who were publicized in art and mass periodicals as generating new artistic tides in America, they were frequently suppressed. Artists and dealers alike found that collaborations with master-printers at the new workshops and the incremental values of prints in the marketplace were irresistible. Johns's color lithograph of *Ale Cans*, for example, issued in 1964, commanded an asking price six years later of $3,500 for one impression from the edition of thirty-eight. [19]

Grosman considered herself a publisher primarily, although she lent advice, a shop, and master-printers to the score of artists she invited to ULAE in West Islip during the sixties. The Tamarind Lithography Workshop was a different kind of printmaking enterprise. Tamarind was envisioned as a center of research and education, [20] a place where the testing of artistic and technical resources could affect the welfare of the art far beyond the walls of the workshop. Thus, in a manner akin to many other problem-solving projects supported by the Ford Foundation, Tamarind became involved in assessment of the tools, materials, and processes of lithography—old and new—establishing long-overdue standards of documentation for prints and editions, issuing books and pamphlets on the concerns of printmakers and workshops, and, in 1971, publishing a landmark volume by Antreasian and Adams, *The Tamarind Book of Lithography: Art and Techniques*. [21] Furthermore, Tamarind became a workshop of new opportunities through the training of three score master-printers, by its welcoming of guest artists, and the granting of

two-month residencies with honoraria of $1,000 and expenses to each of nearly 100 artist-fellows recommended by a selection panel composed of printmakers, museum directors, curators, art critics, and editors. [22] Consequently, during the decade of the workshop's tenure and thereafter, the Tamarind projects had far-reaching influence on American lithography, both directly and through infinite rippling effects.

Tamarind flourished because of the determined enterprise of the painter-printmaker June Wayne who launched it in 1960. Twelve years earlier, Wayne had perceived that li-

7.8
Jim Dine
Self Portrait as a Negative
Etching (1975) 9¾ × 6⅞
Printed by Zigmunds Priede. Published by Universal Limited Art Editions.
Shown in the retrospective exhibition, Jim Dine Prints: 1970–1977, at the Williams College Museum of Art (1977), and in Artist and Printer: Six American Print Studios, at the Walker Art Center, Minneapolis (1980).
Elvehjem Museum of Art.

7.9
Robert Rauschenberg
Shades
Lithographic object (1964)
15 × 14 × 12
Printed by Zigmunds Priede. Published by
Universal Limited Art Editions.
Shown at the Leo Castelli Gallery (1965),
in American Graphic Workshops: 1968, at
the Cincinnati Art Museum (1968), and
in the retrospective exhibition, Robert
Rauschenberg Prints: 1948/1970, at the
Minneapolis Institute of Arts (1970).
Courtesy of Universal Limited Art
Editions.

thography was a medium sympathetic to her artistic conceptions.[23] Many of her subjects were evoked by the writings of Franz Kafka and John Donne, from whose words Wayne extracted ephemeral visions laden with images and metaphoric symbols of human emotions. Her prints soon brought awards at shows in southern California and, by 1952, were being displayed at The Contemporaries gallery in New York and chosen by the Art Institute of Chicago for one of its exhibitions of works by printmakers in early or midcareers.[24] In 1953 Wayne's lithographs began to receive honors in the East. From the 35th Annual Exhibition of the Society of American Graphic Artists, hung in the galleries of Kennedy and Company, she received the Knobloch Prize and at the Library of Congress a Purchase Prize was awarded by the jury of the Pennell Fund. Both awards were for impressions of *The Witnesses* (1952), a theme stimulated by Kafka's *The Trial*.[25] At the same time in 1953, a "retrospective exhibition" of Wayne's five years of experimental lithography was presented by Margaret Lowengrund at The Contemporaries gallery.

Wayne's impressions had been printed from stones in collaboration with Lynton Kistler, a leading West Coast lithographer who as early as 1933 had printed lithographs in color for Jean Charlot (color fig. 15).[26] In 1953 Kistler began to suffer allergic reactions to the acids used in hand-printing.[27] Thus, in 1955 with Kistler, Wayne turned to offset lithography on high-speed commercial presses for a series of six "fable" prints—the zinc plates "stopped-out" by sand, pebbles, twigs, beans, and other organic materials for simulation of textures when she sprayed lithographic tusche from an airbrush. The series—a venture enkindled by the hope, unfulfilled, that the tales and prints might be published as a *livre de luxe*—bore Wayne's liberal visual-

7.10
Robert Rauschenberg
Breakthrough II
Color lithograph (1965) 48½ × 34
Published by Universal Limited Art Editions.
Shown in the retrospective exhibition, Robert Rauschenberg Prints: 1948/1970, at the Minneapolis Institute of Arts (1970), and Contemporary American Prints from Universal Limited Art Editions / the Rapp Collection, at the Art Gallery of Ontario (Toronto, 1979).
Achenbach Foundation for Graphic Arts, the Fine Arts Museums of San Francisco.

7.11
Robert Rauschenberg
Booster
Color lithograph/silkscreen (1967)
71¹⁵⁄₁₆ × 35⅜
© Gemini G.E.L.
Shown at the Leo Castelli Gallery (1967)
and in the exhibition, Technics and Cre-
ativity Ⅱ Gemini G.E.L., at the Museum
of Modern Art (1971).
Henry Art Gallery, University of
Washington. Gift of Anne Gerber.

7.12
June Wayne
Tower of Babel A
Lithograph (1955) 26⅞ × 19¼
Printed by Lynton Kistler.
Achenbach Foundation for Graphic Arts,
the Fine Arts Museums of San Francisco.

7.13
June Wayne
Shine here to us and thou art everywhere
Lithograph (1956) 18⅝ × 24⅝
Printed by Lynton Kistler.
Achenbach Foundation for Graphic Arts,
the Fine Arts Museums of San Francisco.

THE RISING SUN.

Busy old fool, unruly Sun,
Why dost thou thus,
Through windows, and through curtains, call on us?
Must to thy motions lovers' seasons run?

Thou, sun, art half as happy as we,
. . . and since thy duties be
To warm the world, that's done in warming us.
Shine here to us, and thou art everywhere;
This bed thy centre is, these walls, thy sphere.

(Selected lines from "The Rising Sun," *The
Songs and Sonnets of John Donne*. Introduction
and explanatory notes by Theodore Redpath.
[London: Methuen, 1956].)

izations of fables written by Abraham Kaplan. *Tower of Babel A* (fig. 7.12) was composed with images alluding to Kaplan's *The Root of Misunderstanding* in which the builders of the tower, a high priest, and the many peoples who climbed toward heaven found "a nothingness," with the "confusion of tongues" no more than a gabble of returned travelers' tales.[28]

The visual imagery of Wayne's prints often created anew themes from literature. Those that transcribed love lyrics by John Donne (1572–1631) coincided with the midcentury revival of admiration for the metaphysical poet. *Shine here to us and thou art everywhere* (fig. 7.13) comes from the last two lines of Donne's sonnet which begins with a scolding of "The Rising Sun." Wayne transformed the words into a visual *ambiance* of sun, planets, and clouds which yield a heavenly couch for lovers in warm embrace, modifying Donne's metaphor in which the bed of love within four walls has become the shining center of an orbiting sun that warms the lovers, and likewise the world.

Subsequent compositions and a search for a fine printer led Wayne to Paris in 1957 and the shop of Marcel Durassier. The collaboration was exhilarating and the prospect of a *livre de luxe* took her to Paris again in 1958 where Durassier printed the lithographs for *John Donne, Songs and Sonets, Lithographs by June Wayne*—some of them her earliest impressions in color. The experience strengthened her conviction that there was an imperative need for a program that would improve the quality of lithography in the United States.

Upon setting forth and returning on her second journey to Paris in 1958–1959, Wayne stopped in New York to call on W. McNeil Lowry of the Ford Foundation. Her persuasive argument that ways should be found to "revive" the art of lithography prompted the encouragement of a project proposal. The prospectus for a lithography workshop and six goals for its programs[29] was drafted by Wayne with helpful counsel from Clinton Adams.[30] The proposals received approval by the Ford Foundation in late 1959 and an accompanying monetary grant allowed Tamarind to open in 1960. During the first year Adams and Antreasian, as staff members and artists experienced in lithography, lent their organizational skills and creative minds to the development of Tamarind's physical resources, research, and programs. Visiting artist-fellows were stimulated to create single editions as well as the numerous suites of prints that, by 1962, were especially endorsed by Wayne.[31]

While teaching painting and printmaking at the University of California, Los Angeles, Clinton Adams had begun to work in lithography in 1948 at Lynton Kistler's shop where he met June Wayne in 1949.[32] Both shared an interest in lithography; they also had similar exhibiting histories. By the early fifties, Adams was well represented in the exhibitions of southern California and Margaret Lowengrund had displayed his prints at The Contemporaries gallery in New York. In 1954, Adams's *Second Hand Store II* was chosen for the exhibition of Young American Printmakers at the Museum of Modern Art and *The Cabinet* received a Purchase Prize in the 26th International Exhibition of Northwest Printmakers at Seattle. Both prints were marked by the subtle control with which Adams handled the lithographic crayon in sublimating the realism of still-life depictions. Both his interest in lithography which continued to parallel that of Wayne and his administrative experiences at the universities of Kentucky and Florida made Adams a logical choice as the first Associate Director of Tamarind in July 1960.

An intaglio, *Window II* (1959), purchased by the Pennell Fund for the Library of Congress, forecast a theme Adams transformed into the abstractions of the *Window Series*, one of the first suites created at Tamarind in 1960. *Plate III* (fig. 7.14) from the series of ten was selected for the résumé of prints produced at the workshop when the Museum of Modern Art presented Tamarind: Homage to Lithography in 1969. In those ten years the complexities of design and execution in the *Window* prints were modified by simpler abstractions which appeared in the ten lithographs that composed the "*Venus in Cíbola*" suite, created in 1968–1969 when Adams—on leave from the University of New Mexico—returned to Tamarind as an artist-fellow.[33] The chaste design and color of *Venus in Cíbola I* (color fig. 16) lent an elegance to the erotic symbolism that Adams evoked for an imaginary alliance of the goddess and the legendary golden cities sought by Coronado in the Southwest.

Garo Antreasian, largely self-taught in lithography, became an active exhibitor in the fifties. He exhibited work at the Esther Gentle Gallery (1952), in several of the competitive print annuals at the Brooklyn Museum, and as an invited artist for the American section of von Groschwitz's 1960 International Exhibition of Prints at the Cincinnati Art Museum. Antreasian displayed a lithograph in color, *Lime, Leaves and Flowers*, at the Cincinnati exhibition; for its catalogue, he wrote, "my purpose is to restore lithography to its rightful place as a *major* print medium dedicated to ambitious concepts."[34] When American Prints Today / 1959 was shown in October at the Los Angeles County Museum of Art, Wayne admired his color lithograph of *Fruit* and wrote to Antreasian who, meanwhile, had been asked by the Ford Foundation for his opinion of the Tamarind proposal.[35] Shortly thereafter, Antreasian was invited to

7.14
Clinton Adams
Plate III, from the *Window Series*
Color lithograph (1960) 14⁷⁄₁₆ × 11
*Printed by Garo Antreasian and Joe Funk
at the Tamarind Lithography Workshop.
Shown in the one-man show at the Felix
Landau Gallery (Los Angeles, 1961) and
in the exhibition, Tamarind: Homage to
Lithography, at the Museum of Modern
Art (1969).
University Art Museum, University of New
Mexico. Collection of the Tamarind
Institute.*

7.15
Antonio Frasconi
Franco I
Lithograph (1962) 30⅛ × 22¼
*Printed by Bohuslav Horak at the
Tamarind Lithography Workshop.
Shown in the exhibition, Tamarind:
Homage to Lithography, at the Museum of
Modern Art (1969).
University Art Museum, University of New
Mexico. Collection of the Tamarind
Institute.*

serve as Technical Director during the start-up of Tamarind and asked for a leave of absence from his teaching at the John Herron Art Institute in Indianapolis.

In 1960–1961 Antreasian created two suites, *Fragments* and *Tokens*. The former was composed of twelve prints—lithographs, color lithographs, and collage-lithographs—designed in an array of "fragments" that bore allusions to geologic masses or residual markings of fossilized microorganisms. Thus, *Fragments* (color fig. 17) and Adams's *Window Series* were projects by orig-

inal staff members that were precedents for the many lithographic suites produced during the next ten years of Tamarind at Los Angeles. The roster of more than a hundred artist-fellows whose creations complemented the diversity of contemporary art reflected the mixture of artistic preferences of the committee members and staff who nominated and selected artists for grants. The fifty guest artists who requested to work at Tamarind without the financial support of fellowships were similarly diverse.[36]

Frasconi, Kohn, and Yunkers

were among the early artist-fellows, printmakers from wood who responded to lithography by adjustments in design. The critical commentaries on the modern world that appeared in starkly simple woodcuts by Frasconi were themes treated more elaborately in the sixteen lithographs of his portfolio *Oda a Lorca* (1962). *Franco I* (fig. 7.15)—a shadowed portrait, encased in horned and mitered armor of the Spanish state and church rising menacingly above a ruined land and people—was chosen from the portfolio for the workshop retrospective,

Tamarind: Homage to Lithography. And Kohn, who had turned to intaglio for freedoms never possible in wood-engraving, further exercised the option in lithography at Tamarind when he created, in current idioms of "monster art," the pitted torso of a grotesque *Giant* (fig. 7.16)—which toured the country in American Prints Today / 1962, and was displayed in the Illinois biennial of prints, drawings, and watercolors at the Art Institute of Chicago (1962).

Yunkers's artistic tendency toward painterly expressionism—suppressed to some degree by the woodcut medium despite the use of multicolor blocks—soared in *Skies of Venice* (fig. 7.17), a series of nine lithographs. Painterly in conception, although monochromatic, Yunkers recalled, "I was chiefly concerned with the 'grays' in a print, difficult to preserve when printing an edition. Thanks to the master printer [Bohuslav] Horak who printed my stones we succeeded in producing grays light as a whisper."[37]

Nominating and selecting artist-fellows was bound to be risky and von Groschwitz, a committee member, judged that some of the prints produced at Tamarind were less than splendid.[38] Nonetheless, American lithography was stimulated by the prints of excellent quality created by more than a majority of the grantees. Their artistic generation, conceptual preference, and geographic origin were all varied. Artists came to Tamarind from the East, Midwest, and the West Coast. Three were from California during the early years of Tamarind—Rico Lebrun, Nathan Oliveira, and Sam Francis.

Rico Lebrun, who was past sixty when he was an artist-fellow at Tamarind, was admired for superb drawings and the draftsmanship of lithographs he created in the forties at the shop of Lynton Kistler. Human tragedies and religious themes, quintessential in his muralesque painting of a *Crucifixion* in 1950, were preludes to the expressionistic intensity of his subject treatment when he turned once more to lithography at Tamarind. He paid homage to the late-Medieval German master of the Isenheim Altar with a *Grünewald Study* (fig. 7.18) of the agonies of Christ and the mourners below the cross.

Nathan Oliveira was a young printmaker of twenty-three when his reputation began to reach beyond the West Coast by the selection of *Arena*, a print of the bullring, for the 2nd International Biennial of Contemporary Color Lithography—the first of four lithographs in color to be displayed sequentially in the exhibitions that von Groschwitz presented until 1958 at the Cincinnati Art Museum. Oliveira's commitment to lithography in those years led him to acquire stones and a press for his studio in Oakland and to develop his printing skills. As an artist-printmaker, he converted subjective single figures—man, woman, or animal—into visionary and somber images.

Oliveira's first collaboration with master-printers was in 1963 at Tamarind when he created *Homage to Carrière* (fig. 7.19). The print of tribute—a symbolic face, nimbus of a sacred personage, and the inscription of Carrière's name—was more an icon than a likeness of the late-nineteenth-century French painter-printmaker. The sublimated features of a whitened visage emerging from the blackness, however, transcribed an admiration of the chiaroscuro that cloaked with mystery the images by Eugène Carrière, prominently so in two heads of 1885—a *Self Portrait* in oil and the lithographic vision of his daughter, *Tête de femme*, published in *L'Estampe originale*—the latter a print possessed by Oliveira.[39]

Upon completion of *Homage to Carrière*, Irwin Hollander—then manager of the Tamarind shop—suggested that the image be printed in reverse. This led to a redrawing of the lower part of the stone and the printing of *Black Christ I*, the inking of a purple background for *Black Christ II*, and finally in the sequence a printing of dark blue and red with a reversal of the face back to white. As the last version was being proofed, the report of the assassination of President Kennedy came over the workshop radio and, thus, the print was given a commemorative title, *November 22, 1963*.[40]

Unlike the preferences of Lebrun and Oliveira for defined themes and discernible images, the prints of Sam Francis were laden with the visual idioms of a completely abstract "expressionism." More often than not Francis assigned *Untitled* (color fig. 18) to the lithographs. Nonetheless, a viewer's response was tilted toward unencumbered aesthetic pleasure by the floating free forms and dotted trajectories lavishly imbued with brilliant colors. Although Tatyana Grosman had persuaded Francis to work at ULAE in 1959, the stones were not printed until 1968. In the meantime, fifteen color lithographs were printed for the artist in 1960 by Emil Matthieu in Paris[41] and, three years later as an artist-fellow, Francis created nearly 100 prints at Tamarind. The ease with which lithographic tusche allowed Francis to create fluid, colorful prints akin to his paintings

7.16
Misch Kohn
Giant
Lithograph (1961) 41¼ × 29¾
Printed by Bohuslav Horak at the Tamarind Lithography Workshop. Shown in the exhibition, American Prints Today / 1962, sponsored by the Print Council of America, and in the Illinois Biennial, at the Art Institute of Chicago (1962).
University Art Museum, University of New Mexico. Collection of the Tamarind Institute.

embossing stamp, or chop (⛭)—the alchemist's symbol for stone. *A Definitive List of Chops used on Tamarind Lithographs for the Ten Years July 1, 1960 to July 1, 1970* illustrated the personal chops of the sixty-six printer-fellows, among them eighteen certified as "Tamarind Master Printers."[44] Upon leaving Tamarind some printer-fellows established or directed new shops as did Ernest de Soto (Collector's Press) in San Francisco, Jean Milant (Cirrus Editions) and Kenneth Tyler (Gemini Ltd., later Gemini G.E.L.) in Los Angeles, Jack Lemon (Landfall Press) in Chicago, Irwin Hollander (Hollander's Workshop) in New York, and Herbert Fox (Fox Graphics—Editions Ltd.) in Boston. As a group, the more than three score trainees contributed to the flourishing of the art when they became printers at those and other workshops or served as instructors in lithography at universities and art schools throughout the United States and Canada.

By 1970 Tamarind's subventions from the Ford Foundation were being phased down and planning began for a transition from the Tamarind Lithography Workshop in Los Angeles to a modified enterprise, the Tamarind Institute in Albuquerque, New Mexico. Adams and Antreasian, as early officers of Tamarind and later as consultants, had

7.18
Rico Lebrun
Grünewald Study
Lithograph (1961) 25⁹⁄₁₆ × 30⁷⁄₁₆
Printed by Bohuslav Horak at the Tamarind Lithography Workshop.
Shown in the exhibition, Tamarind: Homage to Lithography, at the Museum of Modern Art (1969).
University Art Museum, University of New Mexico. Collection of the Tamarind Institute.

sustained their interest over the years and in 1965 initiated a program of pretraining for printer-candidates at the University of New Mexico before they moved on to the Los Angeles workshop. A logical development, therefore, was the alliance of the Tamarind Institute with the College of Fine Arts on the Albuquerque campus.[45] In 1970 Tamarind's equipment and archives were moved from Los Angeles and in the years that followed the Institute served the University in its printmaking program, as an informational enterprise through the publication of the *Tamarind Technical Papers*—later issued as the *Tamarind Papers*—and as a workshop for custom printing that became self-supporting through the sale of lithographs after editions were split fifty-fifty with the visiting artists.

The prints created in the sixties at the Tamarind Lithography Workshop had provided one corpus of evidence that contemporary American printmaking bore a multitude of conceptual riches. Essayists for art journals, however, wrote principally about the prints of younger painters of the "New York School" and "Pop Art" which were favored by publishers and dealers in New York. Such oversight in the periodicals

7.19
Nathan Oliveira
Homage to Carrière
Lithograph (1963) 30⅛ × 22⅜
Printed by Aris Koutroulis at the Tamarind Lithography Workshop.
Shown in New Dimensions in Lithography: Tamarind Lithography Workshop, at the University of California, Los Angeles (1964), in the retrospective exhibition, [Nathan Oliveira] Ten Years of Printmaking, at the Stanford University Museum and the San Francisco Museum of Art (1965), and an exhibition of prints from Tamarind at the Felix Landau Gallery (Los Angeles, 1966).
University Art Museum, University of New Mexico. Collection of the Tamarind Institute.

continued well into the seventies despite the diversity and excellence of prints displayed in national exhibitions or in the extensive Tamarind Institute editions, printed in Albuquerque,[46] of seventy-five artists from all over the country. Jack Tworkow, a prominent "elder" of Abstract Expressionism, displayed a preference late in his career for abstract color fields behind geometrically intersecting linear compositions, untitled except for the citations TL (Tamarind Lithograph) and the numberings of his eight editions (1977–1978). Tworkow's conceptions were echoed in etchings subsequently printed at Jack Lemon's Landfall Press.

The images of human anguish and violence that had permeated earlier woodcuts by Jacob Landau (fig. 7.20) were revealed, once again, in lithographs of the *Divine Comedy*. These were conceived initially in the unfulfilled prospect that they would serve as illustrations accompanying a publication of John Ciardi's new translation, published in 1977, of the journey of Dante and Vergil through Hell.[47]

To mark the decade and a half of Tamarind, fifteen artists were invited in 1975 to create four lithographs each.[48] The sixty prints were completed in 1977 and, with the title *Tamarind—Suite Fifteen*, first exhibited at the Art Museum, University of New Mexico. Wayne, Adams, and Antreasian were represented as early principals of the workshop in Los Angeles. Among the other twelve was Fritz Scholder, who by then had created more than 100 lithographs at Albuquerque. The four prints embodied his personal perceptions (he himself was one-quarter American Indian) of Native Americans, their heritage, and current cultures—images that had evolved from the insights of his youth in the Dakotas and adulthood in the Southwest.[49] *Indian with Butterfly* (fig. 7.21)—is an evocative portrayal with a dark silhouette

shadowing the brooding face below the Indian's black hat on which are pinned the fragile remains of a Monarch. In the judgment of Gustave von Groschwitz it is a "lithograph which stirs mixed feelings of admiration and pity . . . one of the most memorable prints in the exhibition."[50]

Elaine de Kooning created twenty editions at the Tamarind Institute in 1973. She returned in 1977 to produce eight thematic variations of the *Jardin du Luxembourg* (fig. 7.22) of which four were exhibited in Tamarind—Suite Fifteen. Pastel shades and vernal lights shimmered in the Parisian garden—dissolving to formlessness the sculptured revelries of Bacchus, Satyr, and bacchants—when de Kooning cloaked a leafy bower with the scintillating brushwork of a latter-day "impressionism."

Nathan Oliveira conveyed in four succinct compositions the silent watchfulness of raptors and the immutable poise granted all birds of prey. Each lithograph of *Acoma Hawk* (color fig. 20)—by a singular image and deep chiaroscuro—possessed the essence of a lonely hunter scanning mesas near Acoma, an ancient pueblo of New Mexico.

Suite Fifteen was a celebration of Tamarind lithography. It was also a précis of the eclectic array of content and style in current printmaking; *Untitled* color abstractions by David Hare were hung near the atmospheric pictorial of landscape and cyclone in James McGarrell's *Quotation with Twister* (fig. 7.23). The expressionistic distortions of colors and human form in George McNeil's monstrous *Philadelphia Woman* were displayed alongside the conceptual opposite of *Words-as-Art*—au courant supplements to the pictorial communication of painting—in Edward Ruscha's yellow, blue, and black "placard" with boldface letters bearing the platitude THERE'S NO JOB TOO SMALL. Suite Fifteen demonstrated that the re-

7.20
Jacob Landau
The Violent Against Themselves. Circle VII, Canto XIII
Lithograph (1975) 23 × 17
Printed by Richard Shore at the Tamarind Institute.
University Art Museum, University of New Mexico. Collection of the Tamarind Institute.

A man may lay violent hands upon his own
 person and substance; so in that second round
 eternally in vain repentance moan

the suicides and all who gamble away
 and waste the good and substance of their lives
 and weep in that time when they should be gay.

(Dante Alighieri, *The Divine Comedy,* translated by John Ciardi [W. W. Norton, New York, 1977]).

7.21
Fritz Scholder
Indian with Butterfly
Color lithograph (1975) 40 × 20
Printed by Richard Shore and David Salgado at the Tamarind Institute.
Shown in the exhibition, Tamarind—Suite Fifteen, at the University Art Museum, University of New Mexico (1977).
University Art Museum, University of New Mexico. Collection of the Tamarind Institute.

sources of a workshop and the collaborations in printing could accommodate artists of very diverse tastes.

Both Atelier 17 and the Iowa Group had enjoyed substantial recognition following their didactic exhibitions, New Directions in Gravure (1944) and A New Direction in Intaglio (1949). But new workshops received only a scatter of notices until the early sixties when *Artist's Proof* published briefs about George Lockwood's Impressions Workshop (Boston), the Intaglio Workshop of Letterio Calapai and Robert Blackburn's Creative Graphic Workshop (New York), and slightly longer summaries by printmaking directors—Malcolm Myers on the University of Minnesota, Jules Heller about the workshop at the University of Southern California, and June Wayne on the first two years of Tamarind.[51]

The growing importance of workshops led the Associate Curator of Prints at the Cincinnati Art Museum, Mary Welsh Baskett, to state as the rationale for mounting an exhibition of American Graphic Workshops: 1968, "Over the last twenty-five years, this country has seen a phenomenal expansion in creative printmaking focused on graphic workshops . . . [and] the workshops are essential to the continuation of the art."[52]

The prints assembled at Cincinnati came from the Hollander Workshop, Tamarind, Universal Limited Art Editions, and six workshops allied with art schools and universities—the Pratt Center for Contemporary Printmaking, Tyler School of Art (Temple), and the universities of Indiana, Iowa, Wisconsin, and Yale. The exhibition was a synoptic slice of current printmaking with at one extreme, *Shades*, the "lithographic object" in three dimensions by Rauschenberg (fig. 7.9), and at the other, a tour de force of conventional wood-engraving in Fritz Eichenberg's sa-

tirical jab at the mores of modern youth, *Bestiarium Juvenile* (fig. 7.24).

Lithography became a major medium in the sixties, served by a growing corps of printers—many trained at Tamarind—who signed on with one or another of the new workshops that were emerging everywhere.[53] Nonetheless, other media had not suffered at the universities and there were private workshops providing printing in woodcut, intaglio, and silkscreen. In 1959, George Lockwood had founded Impressions in Boston with

7.22
Elaine de Kooning
Jardin du Luxembourg I
Color lithograph (1977) 30 × 20
Printed by John Sommers and Marlys Dietrick at the Tamarind Institute. Shown in the exhibition, Tamarind—Suite Fifteen, at the University Art Museum, University of New Mexico (1977). University Art Museum, University of New Mexico. Collection of the Tamarind Institute.

7.23
James McGarrell
Quotation with Twister
Color lithograph (1975) 30 × 20
Printed by Stephen Britko at the Tamarind Institute.
Shown in the exhibition, Tamarind—Suite Fifteen, at the University Art Museum, University of New Mexico (1977), and the National Invitational Printmaking Exhibition, at the University of South Dakota (1978).
University Art Museum, University of New Mexico. Collection of the Tamarind Institute.

lithographic equipment from a defunct music publishing firm. Soon thereafter, he stated that, "my shop is devoted to lithography."[54] Intaglio and relief were also printed at Impressions; Lockwood was an accomplished wood-engraver. After Lockwood left the enterprise in 1967, the Impressions Workshop, under the direction of Stephen Andrus, expanded its publishing of prints and its sales gallery.[55] Impressions Workshop often printed intaglios for well-known artists of diverse visions, such as Harold Altman in whose work people and parks are transitory

impressions curtained by veils of etched strokes printed in subdued colors, or Michael Mazur's disturbing images of inmates confined in closed wards of mental hospitals, or Peter Milton's recollections as fantasies, "magically combined, to produce an unknown magical end."[56]

Milton had been turning time into suspended states of memory when, in 1968, he created a "metaphor for mnemonic machinery"[57] in *Julia Passing* (fig. 7.25), a vision prompted by the recent death of his grandmother with her memories of ninety years of life. Its Victorian setting—spatially parsed by wrought-iron fencings near brownstone flats of Baltimore—was abruptly pierced by modern urban structures and stairs up which the artist's children ran. *Julia Passing* was a major composition among Milton's etchings of the sixties; it was chosen to represent Yale in American Graphic Workshops: 1968, although Milton had left the university six years before.

Milton read widely on the history of photography and, in 1967, assembled rough collages—laced with photographic excerpts—as designs for hand-drawn etchings. Two years later, he contact-printed ink drawings on transparent Mylar onto light-sensitive etching grounds as phototransfers.[58] Both procedures were used extensively in twenty-one original etchings—printed by Gretchen Ewert and Robert Townsend at Impressions Workshop—for a limited-edition portfolio of *The Jolly Corner* by Henry James, published by the Aquarius Press of the Ferdinand Roten Galleries in 1971. James had told the tale of Spencer Brydon, who, after thirty-three years in Europe, returned to the empty mansion of his childhood. Nightly, and with trepidation, he roamed the darkened rooms to search for "what he might have been." The elusive presence of his alter ego stalked the haunted home and, at last, was seen—a terrifying vision of his

7.24
Fritz Eichenberg
Bestiarium Juvenile
Color wood-engraving (1965)
23⅛ × 15¹¹⁄₁₆
*Shown in the exhibition, American Graphic
Workshops: 1968, at the Cincinnati Art
Museum.*
*Cincinnati Art Museum. Albert P.
Strietmann Collection.*

other self. Milton traced the story freely in untitled prints, evoking an ambiguity of time and constructing Victorian spaces in which the artist staged magical visions, replete with floating figures, stags, bulls, beautiful women, and photo-feigning likenesses of Renoir, Verdi, and Mallarmé.

Daylilies (fig. 7.26), Milton explained,[59] was a print with images and symbols "borrowed" from a treasury of memories. They dwell within the hush of remembrances— boyhood recollections and the pleasures of his children, masterworks of painting, prints, and photography, and artifacts, the "cultural relics from the public domain." The mirror that reflects a montage of the "past" and a gentleman of the "present" who stands before a fireplace mantel were prefigured by images in *The Jolly Corner* suite. Milton's symbols of past and present, however, were free of true chronology. In *Daylilies* the portrait of the "present" was redrawn by the artist from a photograph which the late-nineteenth-century painter Thomas Eakins had taken of his friend Frank Cushing; the cat was redrawn from an Eakins photograph of the painter's pet.

A commitment to printing books of poetry with original etchings

led Kathan Brown to establish the Crown Point Press in the Bay area in 1962.[60] "When I started . . . I was printing for myself and my friends. It didn't occur to me, for years, that it was a business. I thought it was a way of making art, and that if I earned something from it to cover my costs, fine, it meant I could keep going."[61]

Brown's workshop, one of many that started up in or near San Francisco during the sixties, was not "open" to intaglio printmakers upon random requests. Sol LeWitt, Brice Marden, Claes Oldenburg, Wayne Thiebaud, Richard Diebenkorn, Chuck Close, and other artists were either invited to create prints published by the Crown Point Press or sent to Oakland by New York pub-

lishers, among them Richard Solomon of Pace Editions, Marian Goodman of Multiples, and the Parasol Press whose director, Robert Feldman, was a constant contractual patron.[62]

Although Kathan Brown printed over fifty unpublished intaglios for Richard Diebenkorn in 1963, Crown Point Press printed and published a portfolio, *41 Etchings and Drypoints* (1965),[63] that bore traces of his representational images as a leader among the "California figurative painters." In prints of the late seventies, however, Diebenkorn eliminated pictorial references in favor of spare, abstract compositions whose graphic aesthetic resided in aquatint tonalities and etched or drypoint linearisms, as in the suite

7.25
Peter Milton
Julia Passing
Etching/engraving (1967) 18 × 24
Awarded a Purchase Prize in the 1968 National Print Exhibition, at the New York State University College (Potsdam). Shown in American Graphic Workshops. 1968, at the Cincinnati Art Museum, and the 2nd Annual National Print and Drawing Competition, at Northern Illinois University (1969).
Cincinnati Art Museum. Albert P. Strietmann Collection.

7.26
Peter Milton
Daylilies
Etching/engraving/direct photographic
transfer (1975) 20 × 32
*Printed by Robert Townsend at Impressions
Workshop. Copublished by the artist and
Impressions Workshop.*
*Shown in the retrospective exhibition, 30
Years of American Printmaking, at the
Brooklyn Museum (1977).*
*Library of Congress, Prints and
Photographs Division.*

7.27
Richard Diebenkorn
Untitled # 4, from *Six Soft-Ground
Etchings*
Etching (1978) 29⅞ × 21¾
*Printed by Lilah Toland and David Kelso.
Published by Crown Point Press.
Shown in the retrospective exhibition,
Richard Diebenkorn: Intaglio Prints
1961–1978, at the University of Califor-
nia, Santa Barbara, Art Museum (1978),
and in American Prints 1960–1980, at
the Milwaukee Art Museum.
Milwaukee Art Museum.*

Six Soft-Ground Etchings (fig. 7.27).
Kathan Brown, an accomplished
etcher, printer, and workshop direc-
tor, honored the intaglio traditions
of Rembrandt and other great print-
makers of the past while she and
master-printers at Crown Point
Press respected the individual needs
of contemporary artists. Chuck
Close exclaimed, "It's an abso-
lutely terrific place. They're flexible
enough to accept that the place is
now going to be Chuck Close's stu-
dio for a while, and so next week
it'll be Sol LeWitt's. They are won-
derful, and they give you just the
right amount of guidance, sugges-
tions, and criticism without [prints]
having a [workshop] 'look.'"[64]

Close photographed heads and
shoulders before converting por-
traits of his friends into enormous
paintings. And, despite dabs and
hatchings from artist's brushes, he
retained a "photographic" factual-
ism, as in the nine-foot head of
Keith (1970). His first print was a

mezzotint in 1972, the face of *Keith*
oversize by three times. When it was
learned that Parasol Press was send-
ing Close to Oakland, a larger etch-
ing press was purchased. Kathan
Brown recalled, ". . . [in mezzo-
tint] the artist works from dark to
light on a plate that will print black.
We [had] never made a traditional
mezzotint . . . in the sense that the
plate was hand-rocked, simply be-
cause it's too time-consuming. For
Keith, the plate [was] almost 3 × 4
feet and it was impossible to hand-
rock a plate that size. We put the
black on the field with the photo-
graphic imprint of a very fine half-
tone screen with 200 dots to the lin-
ear inch—that's actually finer than
the traditional mezzotint rocker.
Chuck scraped and burnished the
plate [to create the image] in the
usual [mezzotint] way."[65]

The plate for *Keith* was also
etched with grids, a system used by
Close to scale paintings from his
photographs. Later, in two self-

14/35
RD+P

7.28
Chuck Close
Self-Portrait
Etching/aquatint (1977) 44¼ × 35½
Printed by Patrick Foy at Crown Point
Press. Published by the artist and
distributed by Pace Editions.
Shown in the exhibition, Close Portraits, at
the Walker Art Center (Minneapolis,
1980), and in American Prints 1960–
1980, at the Milwaukee Art Museum
(1982).
Milwaukee Art Museum. Gift of the
Friends of Art with National Endowment
for the Arts Matching Funds.

portraits, etched strokes, bound by each of the gridded squares, wove sampler effects throughout the factual likenesses of the artist's face. The *Self-Portrait* (fig. 7.28) of 1977 was etched at Crown Point Press for printing black ink on white paper. The second plate, of 1978, was etched for printing white ink on a black ground.

The reputation of Crown Point Press rested on its fine intaglio printing but other workshops were not so committed to only one or another medium. Even ULAE ventured beyond lithography in 1967 with Grosman's encouragement of artists to create etchings because of the presence of master-printer Donn

Steward, once a student of intaglio with Lasansky at Iowa as well as a printer-trainee at Tamarind. For several years thereafter, Steward was the printer of etchings at West Islip for Frankenthaler, Motherwell, Johns, Cy Twombly, and the sculptor Lee Bontecou (fig. 7.29).

No workshop would equal the technical exploits of Gemini G.E.L. Its immediate predecessor, Gemini Ltd., had been initiated in July 1965 by Kenneth Tyler, shop director at Tamarind in 1964–1965, his wife Kay Tyler, and Bernard Bleha, a former Tamarind printer. The enterprise soon faced difficulties in making ends meet[66] and, in 1966, was reorganized as Gemini G.E.L.

by three partners, Tyler and the businessmen—art collectors Sidney Felsen (an accountant) and Stanley Grinstein (a manufacturer).

Gemini, a "closed" shop which both printed and published, sought contracts with artists who were consistently featured in New York galleries. Its early issues were lithographs and, within a year, Gemini was creating its image as a successful enterprise through full-page advertisements in *Art in America*—each, in turn, reproducing in full color Albers's *White Line Squares*, Frank Stella's *Star of Persia I* (fig. 7.31), Rauschenberg's *Booster* (fig. 7.11), and announcements of their availability at the Leo Castelli Gallery in

7.29
Lee Bontecou
Etching One
Etching/aquatint (1967) 17¾ × 11⅞
Printed by Donn Steward. Published by
Universal Limited Art Editions.
Shown in the exhibition, Recent American
Etching, at the Davison Art Center,
Wesleyan University (1975).
Philadelphia Museum of Art.

New York and a dozen other dealers from Boston to Seattle. Not long thereafter, Gemini began producing embossments and fabricating three-dimensional multiples with synthetic materials and innovative procedures, utilizing the technology and crafts-manship of the motion-picture and aerospace industries in the Los An-geles area.[67] Thus, in 1967, Tyler stated, "We at Gemini do not pay credence to whether something has been done before or not. We see if what the artist requires of us is pos-sible . . . and attempt to come up with . . . the best technical means we can deliver. We like to think of ourselves as technicians when we are printing."[68]

In 1971 the Museum of Modern Art reviewed five years of prints and multiples produced at the workshop by the exhibition Technics and Cre-ativity �II Gemini G.E.L. The title of the show and the touches of indus-trial terminology in the catalogue essay by Riva Castleman, Curator, implied that "the very foundation of Gemini [was] research, development and collaboration."[69]

But Gemini had needed time, equipment, and experimentation be-fore the technological innovations would flourish and, thus, early pub-lications were traditional printings skillfully done. Tyler had printed

7.30
Josef Albers
W.E.G., I
White embossing/gray silkscreen (1971)
26⅛ × 20⅛
© Gemini G.E.L.
Shown in the exhibition, Technics and Creativity ⊔ Gemini G.E.L., at the Museum of Modern Art (1971).
Elvehjem Museum of Art. Gift of Bruce E. and Serene Wise Cohan.

two suites for Josef Albers at Tamarind, *Night and Day*, and *Midnight and Noon*[70] which perhaps led to the contract for the first suite of prints issued by Gemini, Albers's sixteen color lithographs entitled *White Line Squares* (1966). Later, a sequence of conventionally printed lithographs and silkscreens by Alan D'Arcangelo, Man Ray, Sam Francis, and Ben Shahn were published before Rauschenberg and Tyler collaborated on *Booster* (fig. 7.11) in

1967, a tour de force of silkscreen and lithography that required contiguous stones and exceptionally large paper for the six-foot image.

Embossed prints—inked or inkless from customary intaglio plates and etching presses—had been created by several printmakers, including those of Josef Albers in the 1950s.[71] However, in 1969, Gemini turned to modern technology when preparing and printing a suite by Albers, *Embossed Linear Constructions*. The precisely measured lines were ruled on graph paper by Albers in New Haven and forwarded to Los Angeles. An engineer programmed the patterns on digital tape which controlled the movements of an electronically automated milling machine as it engraved the plates. The uninked designs were embossed on the white papers with a hydraulic forming press. Tyler, after conferring with Albers in New Haven once again, followed similar procedures for the ten embossed prints of 1971, *W.E.G., I* (fig. 7.30) [*White Embossing on Gray*], thus, confirming Albers's proposition of a quarter of a century before, "that 'hand-made' is [no] better than machine or tool made . . . in this time of industrial evolution."

The works chosen for the display at the Museum of Modern Art were translations into prints and multiples of current conceptions of the abstract, of expressionism, "hard-edge" painting, "minimal" sculpture, photocollage, and Pop images. Pieces by Albers and Rauschenberg, who had early contracts with Gemini, were exhibited along with those by artists who had collaborated within the next few years—Ellsworth Kelly, John Chamberlain, Don Judd, Jasper Johns, Roy Lichtenstein, Claes Oldenburg, Edward Kienholz, and Frank Stella.

Gemini published Stella's first lithographs—miniature simulations of his "shaped" canvases whose contours paralleled the color stripes of Stella's minimal, hard-edged paint-

ings—with multicolored chevron designs and exotic titles such as *Star of Persia I* (fig. 7.31) and *Quath-lamba II*. Variety was lent to the exhibition by the Pop painter, Roy Lichtenstein (color fig. 21), whose paintings had lampooned the banal art and episodes of comic books with their cheaply photoengraved linecuts and benday dots. Florid replications of master paintings in mass periodicals and coffee-table books had become popular with publishers and Lichtenstein's Gemini prints unflatteringly feigned the reproductive degradations of the serial versions of a *Haystack* and *Rouen Cathedral* in which Claude Monet, with his painterly impres-sionism, dwelt on the mutable nature of atmospheric lights and colors.

Most of the works shown at the Museum of Modern Art were readily acceptable as prints. Rauschen-berg and Johns displayed over twenty-five lithographs along with those of other artists. Further techniques of Gemini were marked in the multiples that crossed the threshold of printmaking into Pop or minimal sculpture. In 1969, Johns and Tyler collaborated on "lead-reliefs," in editions of sixty.[72] A bare light bulb dangling from a cord was chosen for the exhibition, while a slice of bread, a flag—commonplace objects that had appeared

7.31
Frank Stella
Star of Persia I
Color lithograph (1967) 22⅜ × 25¹⁵⁄₁₆
© Gemini G.E.L.
Shown in the exhibition, Technics and Creativity �II *Gemini G.E.L., at the Museum of Modern Art (1971) and in the retrospective exhibition, 30 Years of American Printmaking, at the Brooklyn Museum (1976).*
Cleveland Museum of Art. Gift of Agnes and Albrecht Saalfield in memory of Frances Hurley.

7.32
Jasper Johns
High School Days
Lead-relief multiple (1969) 23 × 17
© Gemini G.E.L.
*Shown in the retrospective exhibition, Jasper Johns Prints 1960–1970, at the Philadelphia Museum of Art (1970).
Courtesy of Gemini G.E.L.*

in paintings and prints by Johns—also were converted into low reliefs. A lead toothbrush bore a wry and topical title, *The Critic Smiles*. *High School Days* (fig. 7.32)[73]—a lead shoe with a mirror attached to the toe—alluded to novelties, advertised in "pulps" such as *Captain Billy's Whiz Bang*, with which adolescent males could titillate their peers and rout blushing girls.

Claes Oldenburg displayed several multiples in the exhibition. A yellow nylon *Ice Bag—Scale B* (1970) with a wooden stopper was akin to his "soft sculptures" of gigantic ham-

burgers, Popsicles, and typewriters that were stitched and stuffed with kapok. Also on display was a version of *Profile Airflow* (1970) (color fig. 22)—fabricated as a print covered by a transparent polyurethane relief memorializing the daring design of Chrysler sedans in the thirties. Shortly before and during the exhibition, Gemini bought full-page advertisements in *Studio International* to announce Oldenburg's *Mickey Mouse—Scale C* and to advise that the workshop was the "Producers of Prints and Dimensional Objects,"[74] the latter providing an alternative to "multiples" in the imprecise lexicon of contemporary arts. The black, anodized aluminum sections of *Mickey Mouse* could be assembled by the purchaser and—as the exhibition catalogue noted—parts were movable, thus allowing multiple moods for Mickey's face.

The exhibition also introduced *Cardboard Door*, a multiple by Rauschenberg, which anticipated seven "dimensional objects," with printings, assembled at Gemini between December 1970 and October 1971. *Cardbirds* (color fig. 23), the caption for the series, possibly was intended as a wordplay on the corrugated cardboards which were silkscreened with the letterings common to shipping cartons for foods, phonograph records, and hardwares and the warnings FRAGILE, GLASS—HANDLE WITH CARE, and THIS SIDE UP. The cardboard sheets and segmented cartons, in a scatter of laminations, were assembled with staples, tape, and glue, and sealed with a transparent acrylic to make the Pop multiple less fugitive.

Gemini was a successful enterprise throughout the seventies, although by 1977 a commitment to multiples and the space needed for manufacturing—such as the edition of Edward Kienholz's *TV sets*—required intrusion into the studio spaces that had accommodated silkscreen and intaglio printing.[75] Meanwhile, Tyler had left Gemini in 1974 for

33
Jack Beal
Oysters with White Wine and Lemon
Color lithograph (1974) 12⅙ × 16
Printed by Paul Narkiewicz.
Shown in the exhibition, Jack Beal: Prints
and Related Drawings, at the Madison Art
Center (1977).
Elvehjem Museum of Art. Charles E.
Merrill Trust Fund.

34
Philip Pearlstein
Girl on Orange and Black Mexican Rug
Color lithograph (1973) 24½ × 34
Printed and published at Landfall Press.
Shown in the retrospective exhibition, The
Print in the United States from the Eigh-
teenth Century to the Present, at the Na-
tional Museum of American Art (1981).
Elvehjem Museum of Art. Charles E.
Merrill Trust Fund.

35
Richard Lindner
Miss American Indian, from *After Noon*,
a suite of eight prints
Color lithograph (1974) 28 × 21½
Published by Shorewood Publishers.
Elvehjem Museum of Art. Gift of
William J. Stiefel.

36
Mauricio Lasansky
Quetzalcoatl
Color intaglio (1972) 75¹¹⁄₁₆ × 33½
Shown in the retrospective exhibition, 30
Years of American Printmaking, at the
Brooklyn Museum (1976).
University of Iowa Museum of Art.
Extended loan of Stephanie Bishop.

37
Helen Frankenthaler
Savage Breeze
Color woodcut (1974) 29½ × 24⅞
*Printed by Bill Goldston and Juda
Rosenberg. Published by Universal Limited
Art Editions.*
*Shown in the retrospective exhibition, 30
Years of American Printmaking, at the
Brooklyn Museum (1976).*
University of Iowa Museum of Art.

38
Wayne Thiebaud
Boston Cremes
Color linocut (1970) 13⁹⁄₁₆ × 20³⁄₈
Published by the Parasol Press, Ltd.
Shown in the traveling exhibition, Wayne
Thiebaud Graphics: 1964–1971, assembled
by the Parasol Press, Ltd. (1972), and in
the retrospective exhibition, Americans at
Home and Abroad: Graphic Arts, 1855–
1975, at the Elvehjem Museum of Art
(1976). Elvehjem Museum of Art. Endow-
ment Fund Purchase.

39
Raymond Gloeckler
Hornblower
Chiaroscuro woodcut (1980) 7⅝ × 18
The edition of Hornblower *was commis-
sioned by the Wisconsin Foundation for the
Arts as presentation prints for the recipients
of the Governor's Awards for the Support of
the Arts (1980).*
*Courtesy of Frank R. Horlbeck, Madison,
Wisconsin.*

40
Arthur Thrall
Document
Color intaglio (1962) 22¾ × 17¹⁵⁄₁₆
Awarded the Vogel Award in the exhibition,
Drawings and Prints by Wisconsin Artists,
at the Milwaukee Art Museum (1962).
Elvehjem Museum of Art. Gift of the Class
of 1964.

41
Warrington Colescott
The Triumph of St. Valentine
Color intaglio (1963) 17⅞ × 23¾
*The print was purchased by the Pennell
Fund for the Library of Congress (1963)
and shown in the exhibitions, Warrington
Colescott: Prints and Drawings, at the
Minneapolis Institute of Arts (1968), and
in Warrington Colescott: Graphics, at the
Milwaukee Art Museum (1968).
Elvehjem Museum of Art. Gift of the Class
of 1964.*

42
Warrington Colescott
Attack and Defense at Little Bohemia
Color intaglio (1966) 20¼ × 21⅞
Shown in the exhibitions, Warrington Cole-
scott: Prints and Drawings, at the Min-
neapolis Institute of Arts (1968), and
Warrington Colescott: Graphics, at the
Milwaukee Art Museum (1968).
Elvehjem Museum of Art. Gift of Mark
and Helen Hooper.

43
Warrington Colescott
S. W. Hayter Discovers Viscosity Printing
Color intaglio (1976) 21⅞ × 27½
*Received an award at the 35th National
Exhibition of the American Color Print So-
ciety, at the Philadelphia Art Alliance
(1976). Shown in the retrospective exhibi-
tion, 30 Years of American Printmaking,
at the Brooklyn Museum (1976).*
*Elvehjem Museum of Art. Friends of the
Elvehjem Museum of Art Purchase.*

44
Robert Burkert
December Woods
Color silkscreen (1962) 20¼ × 31¼
*One of eight silkscreen prints presented as a
portfolio display in the 15th Annual Ex-
hibition of Boston Printmakers at the Mu-
seum of Fine Arts (1962). Shown in New
Talent in Printmaking: 1966, at Associ-
ated American Artists.*
*Elvehjem Museum of Art. Gift of the Class
of 1964.*

45
Frances Myers
Taliesin West
Color aquatint/soft-ground (1979)
20 × 24
Published by the Perimeter Press.
Shown in the exhibition, Contemporary
Printmaking: Intaglio, at the Allen R.
Hite Art Institute, University of Louisville
(1981), and in Frances Myers—Aqua-
tints: The Frank Lloyd Wright Portfolio, at
the Madison Art Center (1981).
Elvehjem Museum of Art. Catherine
Cleary Fund.

46
Michael Ponce de Leon
Omen
Color bas-relief print (1963)
24⅝ × 18¼
Shown in the exhibition, Michael Ponce de
Leon, at the Corcoran Gallery of Art
(1966).
Elvehjem Museum of Art.

47
Alan Shields
Houston Oil
Color mixed media (1974) 8½ × 6¾
Created at the Upper U.S. Paper Mill and
Jones Road Print Shop. Published by Wil-
liam Weege's Shenanigan Press.
Shown at the Paula Cooper Gallery (1974)
and in the traveling exhibition, Jones Road
Print Shop, organized by the Madison Art
Center and first shown at the Milwaukee
Art Museum (1982).
Courtesy of the Jones Road Print Shop.

48
William Weege
Record Trout
Silkscreen/flocking/glitter on acetate
phonograph records (1976) 16 × 36
Printed at the Jones Road Print Shop.
Shown in the traveling exhibition, Jones
Road Print Shop, organized by the Madi-
son Art Center and first shown at the Mil-
waukee Art Museum (1982).
Elvehjem Museum of Art. Gift of the
Artist.

Bedford Village in Westchester County, New York, and, thereafter, at Tyler Graphics, Ltd., he became a printer and publisher of editions by Stella, Motherwell, Lichtenstein, and Frankenthaler.

Printmaking workshops and master-printers were crucial for many painters who became new recruits to printmaking in the sixties. However, the workshops were not limited to ULAE, Tamarind, Crown Point, Gemini, and others which were receiving publicity in the art journals as the primary centers for the improving of printmaking as a fine art. Artists, publishers, and dealers also found that their needs were satisfied by establishments that offered skills derived from experience in commercial printing. That was so at workshops where the sundry techniques of the printing trades —offset lithography, photolithography, silkscreen and photosilkscreen —congenially served the conceptions in Pop prints.

Pop was an art of impersonalized content with which an artist characterized the ubiquitous images of American popular culture. Pop Art was the slangy label adopted by critics and dealers for vernacular likenesses of personages and products— Jackie, Jack, Superman, Elvis, Liz, Marilyn, astronauts, athletes, panties, foods, Coca-Cola, headlines, billboards, signs, and slogans— images rendered in facsimiles, ceaselessly, by the mass media of television, films, the daily press, periodicals, comic books, and advertising. This kind of Americana was scattered into prints by Dine, Rivers, and Rauschenberg and became the primary subject of lithographs and silkscreens by Robert Indiana, Andy Warhol, Tom Wesselmann, Edward Ruscha, and Roy Lichtenstein.

The woodcuts and etchings of Lichtenstein antedated by more than a decade the printmaking ventures of other Pop artists. In 1951 he had received a Purchase Prize for a woodcut displayed in the fifth print annual at the Brooklyn Museum. *To Battle* (fig. 7.33), a fanciful joust filled with whimsy akin to that of Paul Klee, was reviewed by *Art News* as a "joyous composition whose floating toy trumpeters are a delightful blend of sophistication and naïvete."[76] Later, divertissements in the art of Lichtenstein had other forerunners, such as the color woodcut of an early *Heavier-Than-Air-Machine* displayed at the Heller Gallery in 1953.[77]

In the sixties, in spoofs of comics, Lichtenstein created parodies of both the melodramas splattered with lettering that mimicked sounds, and the stark line drawings with coarse shadings that were photoengraved as zinc "linecuts." VAROOM, BRATATAT, POW!, and WHAAM! were blasts of violence while "cool" ripostes were limned for heroes, or for the heroine of freedom fighters in CRAK! *NOW, MES PETITS . . . POUR* LA FRANCE! (Color fig. 24).

Lichtenstein once avowed, "I want my painting to look as if it had been programed. I want to hide the record of my hand."[78] If those were true intentions, he succeeded as well or better in lithography and silkscreen when producing his representations that likened the representations of other arts published in facsimiles by photomechanical processes—the impressionism of Monet in the *Rouen Cathedral* series (color fig. 21), of expressionism in a doleful *Moonscape* printed on metallic-coated plastic sheets (1965), the geometric designs of Art Deco with a paraphrasing of corporate advertising in *Peace Through Chemistry* (1970), and Action Painting with the feigning of a slashing *Brushstroke* (1967).

The pleasure of parody was rendered opaquely in Warhol's vacuous images. With expressionless guile he transcribed the printing on Campbell's soup cans or S & H green stamps. He clipped photographs from the daily press to be further processed as modern "realities" several times removed from one's actual experiences—first as news shots of people and events, developed, photoengraved and printed, then clipped, rephotographed, and enlarged as positives on photosensitive silkscreens for printing once again. Warhol's films led to "serial" compositions, each with rows of high-contrast likenesses of *Liz*, *Jackie*, or *Chairman Mao*, silkscreened on canvases or converted to prints. And cubes of wood, silkscreened as cartons with BRILLO labels, were stacked in galleries like supermarket displays.

In a deadpan manner, Warhol also hid his "hand" as a selector of images to be photosilkscreened by craftsmen and as the juror of color proofs submitted by silkscreen shops. The crude registry of distorted colors that had been abominations of printing in Sunday supplements were effects patently chosen by Warhol for the *Marilyn Monroe* (color fig. 25) portfolio of 1967—ten-color silkscreens "in memoriam" of Everyman's sex symbol who, five years before, had committed suicide.

Likenesses of *Marilyn*, *Liz*, and *Jackie* were transcribed as Pop goddesses of love and beauty in scores of prints by Warhol and others. Tom Wesselmann, however, impersonalized other sex symbols in so many paintings, three-dimensional collages, and prints that they were numbered as nudes and occasionally, with tongue in cheek, granted apotheosis as the *Great American Nude*. The print of one recumbent female, thus "glorified," received a smoothness of shading from the use of an airbrush gun and the printing of twenty-three color separations from fine nylon screens.[79] Wesselmann, by the vacant face and pneumatic bosom, rouged lips and plastic nipples of the *Great American Nude* (color fig. 26), twitted the art of the billboard importuning with sex.

Billboards, traffic signs, and temporary structures had cluttered the

7.33
Roy Lichtenstein
To Battle
Woodcut printed on brown wrapping
paper (1951) 11⅛ × 23⅜
*Awarded a Purchase Prize in the 5th Na-
tional Print Annual Exhibition, at the
Brooklyn Museum (1951).
Brooklyn Museum.*

landscape and crowded the roads of
America for years. Edward Ruscha
and Allan D'Arcangelo extracted de-
tails of the visual disorder in severely
designed compositions. A gas sta-
tion, sketched near San Antonio in
1962, prefigured two versions of
Ruscha's best-known print subject—
Standard Station (1966) and *Mocha
Standard* (1969—color fig. 27)—
silkscreens printed from stencils
hand-cut by the artist. Both prints
were chosen for a unique exhibition,
Silkscreen: History of a Medium,
assembled by Richard Field at the
Philadelphia Museum of Art in
1971. Critics cited the Standard sta-
tions as a West Coast brand of Pop.
The billboard letters HOLLYWOOD,
erected along a treeless California
ridge, were recomposed by Ruscha
during the late sixties and early
seventies in several editions—one
silkscreened at Cirrus Editions
with grape and apricot jams and
Dutch-chocolate Metrecal. Another,
published by Multiples, Inc., was
printed with a sky of pink from
Pepto-Bismol and the dun-colored
hills surrounding Hollywood with
Romanoff caviar.[80] In 1970 Editions
Alecto (London) printed and pub-
lished *NEWS, MEWS, PEWS,
BREWS, STEWS, & DEWS*, a port-
folio of *Six Organic Screenprints* with
fugitive colors as substitutes for
inks—extracts from red raspberries,
canned baked beans, red and black
caviar, daffodil and tulip stalks.[81]
Ruscha's subjects were less typically
Pop, as were the swarms of flys,
ants, and cockroaches silkscreened
actual scale for the portfolio *Insects*
(fig. 7.34).

The artistic preferences of many
printmakers for either subjective ab-
stractions or the disjunctures of
words and images in complex col-
lages were unsuitable for conveying
the likeness of modern placards with
their declarative commands. On the
other hand, Allan D'Arcangelo ex-
tracted stark directional signs from
his highway art for *Landscape No. 3*
(color fig. 28), published in the
portfolio *11 Pop Artists, III* and sent
on tour in an exhibition, POP and
OP, assembled by the American
Federation of Arts from the collec-
tion of Philip Morris, Inc. Robert
Indiana transcribed some of his
posteresque paintings of the sixties
into ten silkscreens for the portfolio
Decade, published by Multiples, Inc.

One of them was a version of $^{LO}_{VE}$ — plagiarized again and again as a logo of the rebellious young in those years and popularized on a U.S. postage stamp. Other silkscreens in *Decade* bore ironic commentaries. The print *Mississippi* targeted racial violence by a map of the state, twice encircled with stenciled letterings ☆ *JUST AS IN THE ANAT-OMY OF MAN EVERY NATION MUST HAVE IT'S HIND PART* ☆. And *THE AMERICAN DREAM* (fig. 7.35) was mocked in four star-studded decorations from a pinball machine and the admonishments TILT and TAKE ALL.

James Rosenquist's prints and paintings often contained the para-phernalia of Pop Art, which justified the selection of *For Love* as a silk-screen in the portfolio *11 Pop Artists, III* (1965). However, Rosen-quist combined logos, words, and images of Pop with improvisations and evocative meanings, notably so in *Cold Light* (color fig. 29), a land-scape with turbulent blue clouds surrounding a stark white moon.[82] Only a photographic positive for offset lithography—supported by posts as a curious canopy—bears a remote kinship to a commonplace object. Moonlight projects through the transparent parts of the film to replicate on the foreground the Sun-rise Edition of the Tampa *Tribune* for Wednesday, 31 March 1971.

7.34
Edward Ruscha
Flys, from the portfolio *Insects*
Color silkscreen on wood veneer laminated to paper (1972)
20¹/₁₆ × 26¹⁵/₁₆
Printed by Adolph Reischner at Styria Studio, New York. Published by Multiples, Inc.
Shown in the exhibition of 12 years of publishing by Multiples, Inc., at the Multiple/Goodman Galleries (1977), and in the retrospective exhibition, American Prints 1960–1980, at the Milwaukee Art Museum (1982).
Milwaukee Art Museum. Gertrude Nunnemacher Schuchardt Fund.

7.35
Robert Indiana
The American Dream
Color silkscreen (1971) 39 × 22
Printed by Domberger KG, Bonlanden bei
Stuttgart. No. 1 of ten prints in the
portfolio DECADE published by Multiples,
Inc.
Metropolitan Museum of Art. John B.
Turner Fund (1971).

Compounding the theme of recent moon-space-earth connections, the cold light is transformed into prismatic colors—by split-fountain inking of the print—to replicate the front page of the *Tribune*, once again, which reports that RED CHINESE FREE JET and FOUR AMERICANS RETURN UNHARMED upon the landing of a hijacked Philippine airliner at Hong Kong.

In 1971 the exhibition Silkscreen: History of a Medium was presented at the Philadelphia Museum of Art. Richard Field, curator, wrote, "Unexpectedly, the more one studies [the] past history [of the screen print], that is, its commercial beginnings and subsequent development, the more one understands the factors that have made silkscreen such a meaningful medium for the present. Specifically, the processes, attitudes, images, and structural (formal) conventions of commercial printing forge common links between the art of the 1960s and the strictly use-oriented, industrial product."[83] Consequently, artists whose silkscreens bore Pop images were well represented. As a historical exhibition, however, it was composed of three didactic displays. There was a survey of several centuries of stencil printings and twentieth-century commercial silkscreens. Another section was devoted to the new printmaking art of serigraphy from 1930 to 1960 with works by Guy Maccoy, Anthony Velonis, Hyman Warsager, Leonard Pytlack, Ben Shahn, Robert Gwathmey, Sylvia Wald, Dorr Bothwell, Sister Mary Corita [Kent], and others. The résumé concluded with an array of screen prints created between 1960 and 1970 by artists of several nations. America was represented by Dine, Indiana, Johns, Lichtenstein, Rauschenberg, Rosenquist, Ruscha, Warhol, and Wesselmann. Modern conceptual differences were as marked as Clayton Pond pictorials of the interior and still life in his studio on Broome Street in New York (color fig. 30) —printed with thick, glistening enamel paints that seemed as hard and reflecting as the ceramic and metal surfaces of stove, sink, tiles, pipes, and pans—and nonpictorial chromatic designs with optical illusions in silkscreens by Albers or the dizzying effects of color juxtapositions in the Op Art of his former pupil, Richard Anuszkiewicz (color fig. 31).

The exhibition Silkscreen: History of a Medium opened in 1971, too soon to mark the abundance of screen prints by the painter-printmakers of late-twentieth-century factualism. Nonetheless, it presented clues to those kinds of images in printmaking by Ruscha's *Mocha Standard* (color fig. 27) and *Coffee Shop at the Chicago Art Institute* (1971) by Kenneth Price. During the following year Ruscha painstakingly delineated swarms of *Flys* and other pests for the portfolio *Insects* and Richard Estes created the cold composites of his *Urban Landscape* series, typified by the austere design of Mies van der Rohe's *Seagram Building* (fig. 7.36) with its steel and glass reflecting, from across the street, the heavy masonry of an earlier architectural monument.

The kinds of factualism that marked the trend evoked from critics and dealers diverse labels, such as "New Realism," "Radical Realism," "Photorealism," "Artificial Realism," "Superrealism," and simply "Figurative" painting. The works were hailed as a reaction to preceding styles, as fresh artistic visions for the seventies, and, not surprisingly, well-established workshops, publishers, and dealers quickly issued editions of silkscreens and lithographs for the market.

The prints of Estes simulated the gloss of photographic factualism. Robert Cottingham overstated actualities selectively as with the signboard facade and neon tubes of *Fox* (color fig. 32) the forward features of a movie palace. They were conceptions—however varied from artist to artist—that hardly made up a "radical realism" but rather effected enlargements as of close-focused details, and natural enframings with images cropped. Jack Beal lent an effect of the factual to *Oysters with White Wine and Lemon* (color fig. 33) by pervasive details and elaborate emphases on lights, shadows, textures, and decorations. The nudes of Philip Pearlstein (color fig. 34) were also claimed for the New Realism of the seventies. Nonetheless, they were in the tradition of undraped figures and studio properties, although the bodies, as realistic records of individual models, now seemed overly enlarged within the crowded formats of cropped nudes and segments of patterned rugs.

In the sixties and seventies, dealers, publishers, and major workshops competed aggressively for a share of the booming market. Older dealerships, such as Associated American Artists and Ferdinand Roten Galleries, increased the announcements of their wares in art journals. Newer dealers and publishers, including Multiples, Brooke Alexander, Pace Editions, and Parasol Press, advertised continually. Some art galleries expanded their dealings in prints by establishing separate divisions—Castelli Graphics, Kennedy Graphics, Marlborough Graphics, and Martha Jackson Graphics—and sought markets outside New York by advertising galleries coast to coast that were authorized to sell the prints and portfolios in other cities. Well-known workshops that printed and published—among them Landfall Press, Tyler Graphics, Pratt Graphic Center, and Hollander's Workshop—repeatedly bought space in the journals to announce their latest editions. And the advertisements of Gemini G.E.L., Collector's Press, ULAE, and Impressions Workshop were often embellished by full-color reproductions of recently published prints and suites.

7.36
Richard Estes
Seagram Building
Color silkscreen (1972) 19⅝ × 27½
Published by the Parasol Press, Ltd.
Shown in the retrospective exhibition,
American Prints 1960–1980, at the Mil-
waukee Art Museum (1982).
Courtesy of Parasol Press, Ltd.

The print enterprise had its hazards, however. In 1974, *Print Collector's Newsletter* assembled a panel to discuss the "mystifying" determinates of current print prices. The participants were Sylvan Cole, Jr., of Associated American Artists, Marian Goodman of Multiples, printer and publisher Kenneth Tyler, dealer and publisher René Block, John Loring, printmaker published by Pace Editions, and, as moderator of the panel, Jo Miller, curator at the Brooklyn Museum. They agreed that the market was booming. However, there were differing opinions about the gambles of financing production costs of new editions, the chanciness of judging the market relative to the numbers of an edition, and the price that would ensure sales and profits.

During the panel discussion Cole spoke of the flourishing print market as a "phenomenon that can only happen when the economy allows it to happen. The print hardly exists in bad times. Our print history in the '30s was . . . rather dismal . . . As the painting market gets farther out of sight, prints will fill the void. [The prices of prints] will fluctuate as the economy fluctuates [and] only in a highly volatile, inflationary economy will prints like a Peter Milton sell for $650 or a Jasper Johns' *Coat Hanger* go for $9,000."[84] Cole's observation was confirmed, in some measure, as the economy began to flounder and a recession arrived in the early eighties. Art objects, including prints, were less attractive as investments or as a hedge against inflation. The exchange of prints in the marketplace declined. And across the country workshops with marginal resources struggled to survive; some failed.

8

Assessments of the State of the Art and a Flourishing of National Print Exhibitions

Assessing the state of American printmaking has never been a simple task. The diverse kinds and enormous numbers of prints created in the sixties and seventies compounded the problems of making judgments without the influence of predetermined assumptions. The proposition that a print "Establishment" and printmaking "revivals" had emerged during those two decades was influenced by an assumption that important prints were rarely created by artists committed to printmaking. A corollary assumption was that the superior prints of the time were created by painters and sculptors prominent in the New York art scene who had ventured into printmaking in collaboration with the proprietors and master-printers of professional workshops.

Judgments about the state of printmaking had been published in each decade, including the seventies. In July 1973 Judith Goldman, editor of *Print Collector's Newsletter*, wrote, "Prints became worldly, noisy and public in the 1960s, when the lithographic presses never stopped. Anything seemed editionable, marketable and salable. What most distinguishes the graphic output of the last decade is the emergence of major publishing workshops."[1] Those were judgments with which Goldman introduced "The Print Establishment," two sequential articles for *Art in America*. She described the "Establishment" as composed of prominent painters and sculptors who had turned to printmaking and the workshops which collaborated in printing and publishing their prints, citing Gemini, Tamarind, Cirrus, Landfall, Hollander's Workshop, Petersburg Press, Editions Press, Impressions Workshop, and Lakeside Studio. Goldman singled out for a special compliment the book-publishing tour de force of ULAE, *A la Pintura* with intaglios by Motherwell illuminating the poem by Rafael Alberti.

Also in mid-1973, *Art in America* published "The Graphic Revival" by Diane Kelder, art historian and editor of the College Art Association's *Art Journal*. She remarked that "the creation of a large responsive print market was, in part the result of the enormous demand for works by Warhol, Lichtenstein, Rauschenberg, Johns, Stella and others." Kelder also stressed the crucial role of workshops. She expanded Goldman's listings by adding Crown Point Press, Graphicstudio, Styria Studio, and Tanglewood Press, and added that publishers had contributed to the "revival," mentioning Multiples, Brooke Alexander, the Parasol Press, and Martha Jackson Graphics.[2]

Richard Field and Philip Larson added their assessments of an intaglio printmaking "revival." Field proposed that "the American etching revival of the late 1960s was not a rediscovery but a reinterpretation of etching"[3] and ascribed the initiatives to the collaborations, after 1967, of Donn Steward, master-printer, and artists active at Grosman's ULAE—Johns, Bontecou, Motherwell, Frankenthaler, Newman, and Cy Twombly. As curator at the Davison Art Center, Field in 1975 organized Recent American Etching, an exhibition to identify the "revival" with works by the artists mentioned and other prominent painters and sculptors who were creating intaglio prints in the early seventies, among them Alex Katz, Pearlstein, Close, Sol LeWitt, Rosenquist, and Oldenberg. In 1977 Philip Larson wrote for *Print Collector's Newsletter* that "by the mid-1960s everyone knew Johns and Rauschenberg had brought lithography back from the dead. Now, by the mid-70s, it's evident that aquatint has also come back. Black and white have never been richer. The recent aquatint revival starts with black and white, with Jasper Johns, and with Universal Limited Art Editions."[4]

Curiously, propositions of printmaking "revivals" often included

gratuitous criticism of the larger group of American printmakers. Judith Goldman stated that "unlike today's major printmakers, who are painters and sculptors first," from the universities where Lasansky, Peterdi, and Baskin taught "came a second generation whose work is competent but academic, dominated by Hayter's burin line and viscosity technique, Lasansky's rendition of it, or by Peterdi's cut plates."[5]

Diane Kelder recalled that "printmaking was largely an academic affair in the fifties." She was less severe, however, in speculating that "in the college art departments and museum art schools, the exposure of a generation of younger artists to a variety of graphics techniques may well have made the multifaceted art of the print possible," adding—despite the overwhelming number of active printmakers who printed in their own studios—that the professional workshops had moved printmaking "from the groves of academe and cottage industry."[6]

Larson described earlier aquatints as "the moribund exercises of Lasansky, Peterdi, and other university printmakers."[7] Field acknowledged that "since 1945, etching has flourished in America, mostly under the leadership of Mauricio Lasansky, Leonard Baskin, and Gabor Peterdi." Nevertheless, he implied that it was an impairment that "these men and their contemporaries were devoted to etching, usually to the exclusion of other media," naming among a younger group Altman, Chesney, Colescott, Deshaies, Leonard Edmondson, Meeker, Malcolm Myers, Ponce de Leon, Pozzatti, and Peter Takal.[8]

In 1979, judgments that the finest contemporary prints were created by artists who first had made their names as painters in New York were reflected, once again, in the opinions of six publishers, dealers, curators, and a painter-printmaker during a panel discussion on "New Prints of Worth: A Question of Taste."[9] Brooke Alexander, the publisher, remarked that "it's unusual to encounter an artist first in prints," and the painter-printmaker Alex Katz concurred: "I think most [artists] start to make prints about five years after they pull themselves together. They're like 40-year-old people." Kathryn Markel, dealer in prints, lamented early printmaking apprenticeships. "I agree—I think we all agree—that a kid who goes to school and wants to learn to be an artist and learns printmaking is working at a disadvantage . . . I'm also comparing [artists] who graduate from college with their basic printmaking degrees, having been in printmaking, with those having been in painting or something else. And one out of a thousand in painting will make it when they're 30, and none, or so few I can't think of any, of the printmakers will." Richard Field, curator, was more generous to some who were admired primarily as printmakers when he posed a query: "If prints follow innovations in painting, either by school or specific artist, what about those printmakers we've always had like Bellange, who really wasn't much of a painter, or Bresdin, and hosts of others, maybe even, though I shudder to say it, Peter Milton? You know these people have their niches, and they're basically printmakers, and we don't want to throw them out totally." To which Alex Katz replied, "They're like lovely minor artists."

Thus unwittingly or not, the reports and opinions published in the art journals fostered an impression that the vitality of current printmaking lay only in prints by prominent painters and sculptors. Although workshops and prints issued by publishers were important in the sixties and seventies, printmaking had other vital signs, such as the national exhibitions, invitational and competitive, that were held in every region of the country. They were showcases for a thriving art where older and seasoned printmakers presented recent developments in their prints and a host of younger artists exhibited new conceptions and technical innovations.

Gene Baro, art critic and guest curator, upon assembling 30 Years of American Printmaking in conjunction with the 20th National Print Exhibition at the Brooklyn Museum, wrote in 1976, "It's fine to see painters and sculptors of seriousness and capability expressing themselves in the print mediums. This involvement, which became obvious during the 1960s, persists and grows in the present decade. It is good, too, to discover individualists, themselves brilliant technicians, who bring sound artistic insight to their work in the print field. Finally, it is heartening to see that contemporary printmaking is not a phenomenon solely of New York or Los Angeles, and certainly not of the workshops alone, but of many individuals all over this nation, graphic artists who have qualities that would command widespread respect and admiration were they better known."[10]

The combination of recent and "retrospective" prints—the latter shown once before at the Brooklyn Museum—honored the nineteen national print exhibitions presented between 1947 and 1974 under the aegis of the former curators, Una Johnson and Jo Miller. The selections confirmed Baro's statement in its synoptic overview of contemporary American printmaking and also demonstrated that older artists were still lending diversity and richness to the art. Members of a generation born before the turn of the century displayed prints created in the sixties and seventies. There were one or more wood-engravings by Albee and Eichenberg; abstract silkscreens or intaglios by Josef and Anni Albers; a prizewinning, stenciled abstraction, *Black and White* (1960), by the late John von Wicht; and the octogenarian Mark Tobey was represented by aquatints and litho-

graphs of the seventies—akin in their liveliness and modern manner to *Untitled* (1970—fig. 8.1).

Within the chronology of prints and printmakers, the abstractions created in the seventies by Jacob Kainen and Jack Tworkov, or Richard Lindner's *NYC*, emblematic of a grotesque, obscene *Fun City* (fig. 8.2) (1971) and his caustic satire in a carnival distortion of *Miss American Indian* (color fig. 35) (1974), bore no residual conservatism as one might expect from elders born in the first decade of the century. And prints by members of the following generation (from 1910–1919) displayed still-evolving conceptions in the color intaglios of Lasansky's monumental *Quetzalcoatl* (color fig. 36) (1972), Misch Kohn's *Disappearing 8* (1976), the two vinylcuts printed on fabrics by Romas Viesulas, and Motherwell's *Bastos* (1975), a tusche drawing combined with a photolithographic replication of a frayed package of French cigarettes.

On the other hand, prints created before the seventies by their contemporaries, Barnet, Frasconi, and Peterdi—or by members of older generations, such as Albright, Milton Avery, Bothwell, Lozowick, Hayter, Nevelson, and Yunkers—identified printmakers who had been exhibitors or prizewinners in one or another of the nineteen Brooklyn shows and gave "retrospective" signatures to the exhibi-

8.1
Mark Tobey
Untitled
Lithograph (1970) 17⅞ × 22⅛
Henry Art Gallery, University of Washington. Gift of Wesley Wehr in memory of Zoe Dusanne.

8.2
Richard Lindner
Fun City
Color lithograph (1971) 26¾ × 39⅝
Printed at the Shorewood Graphic Workshop. Published by Shorewood Publishers.
Shown in the retrospective exhibition, 30 Years of American Printmaking, at the Brooklyn Museum (1976).
Brooklyn Museum. Gift of Mr. and Mrs. Samuel Dorsky.

tion. Along with the Motherwell, a fourth of the prints were lent by workshops and publishers, probably to ensure proper representation for the printmakers of Abstract Expressionism, Pop Art, Minimal Art, and Superrealism. Scattered throughout the exhibition were prints by less-publicized printmakers of several generations, some as young as twenty-four years old, among whom Baro found his gifted "individualists."

The exhibition—limited to 330 prints—presented a commendable synopsis of the richness and complexity of American printmaking. However, it was beyond the realm of reason to suppose that the Brooklyn show—or any exhibition— could include all equally eligible printmakers and pay tribute to the multitude of prints as fine in their aesthetic and topical content or

technical finesse. There were other showcases for prints, however, such as the collections of major museums, the annual printmaking exhibitions, one-man shows at national and regional art centers, and the galleries of dealers across the country.

At Brooklyn barely a score of woodcuts and wood-engravings were shown. Most were "retrospective" prints by Yunkers, Frasconi, Barnet, Anne Ryan, Avery, and Kainen with supplements from a few young artists and *Savage Breeze* (color fig. 37), a woodcut with eight color blocks by Helen Frankenthaler—selected, perhaps, as an example of her very recent venturing into the medium and as one of the first woodcuts printed and published by ULAE.[11]

Woodcut and wood-engraving had thrived in the fifties, but in the sixties and seventies the media were

less attractive to most printmakers and certainly to artists who sought counterparts of their paintings and the collaboration of master-printers at silkscreen and lithographic workshops. "Where have all the woodcuts gone?" was one topic for discussion by a panel at the meeting of the College Art Association in 1973.[12] Jacob Landau, once a very active creator of woodcuts, blamed the paucity on the ease of lithography and photolithography. Amy Baker, of Martha Jackson Graphics, remarked that she encountered "original woodcuts [but] of very un-original ideas." Jo Miller, curator of the Brooklyn Museum, commented in 1972 that woodcut was in "a moribund state" when none were selected for the 18th National Print Exhibition at the Brooklyn Museum (1972).[13] A few years later, Karin L. Breuer, in a study of fourteen national exhibitions between 1966 and 1975, confirmed that few woodcuts were seen in juried exhibitions.[14]

However, relief printing was neither dead nor dismal. In the sixties, the elders, Fritz Eichenberg, Jacques Hnizdovsky, and Lynd Ward were creating woodcuts and wood-engravings that were equal in quality to their earlier prints. Hnizdovsky displayed his mastery in delicate silhouettes of leafless *Pinoak Trees* (fig. 8.3), and Ward, venerated for years as a wood-engraver of book illustrations, exhibited the virtuosity of his hand in *Two Men* (fig. 8.4). Drewes, Frasconi, Landau, and Summers were unwilling to abandon woodcut. Baskin was exploring chiaroscuro woodcuts in green, black, and white, as in *Icarus* (1967), and color abstractions were being created by Robert Conover, Ansei Uchima, and Will Barnet, whose *Singular Image* (fig. 8.5) was chosen for display in 30 Years of American Printmaking. Wayne Thiebaud, a California realist whose serial images of mass-produced pies, cakes and candied apples has Pop characteristics, chose linocut for his

color relief print of *Boston Cremes* (color fig. 38) (1970).

Spare as the numbers were, woodcuts and wood-engravings could be seen in the sixties and seventies at the national print exhibitions sponsored by the Northwest Printmakers, the Boston Printmakers, and the Society of American Graphic Artists which for years had printmakers working from wood among its members—Robert Blackburn, Sidney Chafetz, Eichenberg, Hnizdovsky, Landau, Moy, Clare

8.3
Jacques Hnizdovsky
Pinoak Trees
Woodcut (1963) 23⅝ × 15⅜
Shown in the 16th Annual Print Exhibition of Boston Printmakers, at the Museum of Fine Arts (1964), and in the retrospective exhibition, American Prints from Wood, a traveling exhibition organized by the Smithsonian Institution (1975). Winnipeg Art Gallery. Gift of the artist through Roger L. Selby.

8.4
Lynd Ward
Two Men
Wood-engraving (1960) 16 × 6
Shown in the retrospective exhibition,
American Prints from Wood, a traveling
exhibition organized by the Smithsonian
Institution (1975).
National Museum of American Art
(formerly National Collection of Fine
Arts), Smithsonian Institution. Gift of
John B. Turner.

Romano, Uchima, and Ward. In an-
nual exhibitions elsewhere, Chafetz
and Raymond Gloeckler were fre-
quent exhibitors of satirical wood-
cuts. Man, with his human frailties,
was the basic image for their com-
mentaries. Chafetz explained, "In
another environment, I might want
to concern myself with purely tech-
nical, compositional, or poetic ex-
perimentations. At the moment, I
see too many absurd things around
me to indulge in these luxuries."[15]

So, with the incisive blades of the
woodcutter's tools, Chafetz carved
the grotesque figure of a *Corporate
Image* (1965) and ridiculed his fel-
lows in academia as the halt, lame,
and blind, or worse, a masked im-
postor, foolish with pride in cap and
gown—recalling the old theme of
the illiterate *Fool* and his unread
books, first cut from wood for Se-
bastian Brant's *Narrenschiff* in 1494.
However, Chafetz also transcribed
his reverence for great cultural lead-
ers into woodcut, as in the pene-
trating likeness of Sigmund Freud
(fig. 8.6).

Amidst the proliferous photo-
silkscreens and photolithographs
budding with technical complexi-
ties, a graphic terseness in the wood-
cuts and wood-engravings by Ray-
mond Gloeckler seemed to offer a
welcome option for jurors of in-
numerable national exhibitions. In
an interview, Gloeckler stated his
justification of images from wood
succinctly: "For me, the woodcut
medium provides the opportunity

for a direct, powerful statement. The feel of the wood, its characteristic grain and its resistance to the cutting tools, places certain restrictions upon the artist. In compensation, however, it affords a simplicity and strength difficult to achieve in any other medium. I prefer to confine most of my prints to black and white and to work on a large scale. This increases the inherent strength and impact of the image." [16] Nonetheless, Gloeckler introduced color to buttress his caustic commentaries of the sixties—as in the image of a self-righteous patriot that the artist described (in the same interview) as "the red, white and blue of him," who, through a megaphone, admonished the world that *We Must Act* (1964) or the harsh colors accenting the violent confrontations, racial slurs, and an ironic title, *Gemütlichkeit: Milwaukee* (1967), created after the supposition of a friendly, tolerant "old German" Milwaukee was belied by police brutality during days and nights of the Freedom March.

Gloeckler printed more amiable images in the seventies, typified by *Big Biker* (fig. 8.7)—unusually large for a wood-engraving, and a prize-winning print chosen for invitational and competitive exhibitions from the East Coast to California. Unlike Baskin, who had chosen the rarely used chiaroscuro woodcut process for somber subjects, Gloeckler found the multiple-block medium suitable for outlandish themes, as the *Hornblower* (color fig. 39) whose puff shreds a trumpet's bell. Other caprices—anthropomorphic combinations of beasts and men, some who plagued our national life—filled the pages of *The Horny Goloch* (1978), a book of satirical wood-engravings and verses chosen for the retrospective show, Printmaking in Modern American Illustration, at the Pratt Graphics Center (1979). [17]

Across the country, competitive or invitational print exhibitions were juried by curators and printmakers, with a scatter of museum directors and art critics. Choices of prints, from conservative to contemporary in style, content, and technique, were influenced by personal preference, as can be seen in statements by jurors in the catalogues. Kneeland McNulty, curator at the Philadelphia Museum of Art, commented, after he had selected prints for the Fifth

8.5
Will Barnet
Singular Image
Color woodcut (1964) 32½ × 22
Shown in the retrospective exhibition, 30 Years of American Printmaking, at the Brooklyn Museum (1976).
Courtesy of American Associated Artists.

8.6
Sidney Chafetz
Freud
Woodcut (1963) 22¾ × 22½
Awarded a Purchase Prize in the 4th National Exhibition of Prints and Drawings, at Ohio University (1963).
Library of Congress, Prints and Photographs Division.

Dulin National Print and Drawing Competition (1969), "In no other country does there seem to be such a proliferation of fine printmaking. In choosing this exhibition, technically impeccable images which clearly denoted Hayter and Lasansky alumni were generally discarded in favor of more original technical approaches such as: use of bright colors to produce bold silk-screen prints, embossed paper to create a third dimension, collographs from built-up surfaces, transference of photo images, and the combining of commercially produced materials with traditional drawing and printmaking."[18]

There were also tiltings of tastes between printmaker-jurors. Some had reputations recently gained—Adams, Antreasian, Oliveira, and Andrew Stasik; others had been known from the thirties or before—Csoka, Dehn, Eichenberg, Landeck,

and Wengenroth; or had been prominent since the decades between—Kohn, Landau, Peterdi, and Yunkers. Thus, the competitive and invitational exhibitions of the sixties and seventies displayed a medley of prints by thousands upon thousands whose careers spanned decades and whose reputations were national, regional, or local only—old-timers such as Albee, Roth, Sanger, Asa Cheffetz, and Doel Reed, and their professional juniors, and very young printmakers and students. Frances Myers and Warrington Colescott, as printmaker-jurors, affirmed those facts when they wrote, jointly, "The open, juried exhibition is an American tradition that has strengthened both unique and editioned art on paper by offering exposure to artists purely on the basis of product quality. It matters not their age, sex, experience, gallery affiliation, salability, social status, etc. The tradition has had great benefits for artists who work on paper, for their easily transportable work has been assured of exhibition in all parts of the country, and a public has emerged in answer to the work."[19]

Singular prints in competitive shows received awards again and again from sundry juries, as did Andrew Stasik's abstraction of diverse images in *Still Life/Landscape, No. 5* (1969). Jack Damer's lithographs were chosen for more than a score of invitational exhibitions. A favorite was *Fog Mourn II* (1972, fig. 8.8) based on Martin Schongauer's celebrated copper-engraving *The Death of the Virgin* (ca. 1470) but with the miraculous presence of the Apostles at Mary's bedside transformed into a veiled vision. Other and later lithographs by Damer, derived from his abstract *Xacto Facto* series, were sliced horizontally to create the lattice work for printed three-dimensional objects. Arthur Thrall (color fig. 40) displayed repeatedly, in shows across the country, another kind of abstraction by which copper-engraved calligraphies

8.7
Raymond Gloeckler
Big Biker
Wood-engraving (1971) 12 × 9
*Awarded Purchase Prizes in the 24th An-
nual Print Exhibition of Boston Print-
makers, at the Rose Art Museum, Brandeis
University (1972), and the National Prints
and Drawings Exhibition, at the Mount
Holyoke College Art Museum (1974).
Shown in Raymond Gloeckler: A Retro-
spective, 1955–1979, at the Milwaukee
Art Museum.
Elvehjem Museum of Art. Charles E.
Merrill Trust Fund.*

recalled the elegant handscripts in ceremonial documents and procla-mations of an earlier age.

Narrative prints with waggish airs were favored by the juries, as was *St. Luke Paints the Madonna* (fig. 8.9) by David Driesbach. The artist commented on his enchantment with Early Flemish painting, "this intaglio echoes the memory of a painting by Roger van der Weyden making a silver point drawing of the Virgin" (Museum of Fine Arts, Boston).[20] With that recollection, however, any resemblance ended. Driesbach concoted a puckish pre-sentation of the legend that Luke painted the likeness of Mary, a tale

which led to a role as patron saint for the guild of painters in medieval times. The evangelist-artist is seated in a wheelchair, checking propor-tions of the Virgin and Child with brush and thumb. Within a pillared catacomb, the holy pair float in a draped ark, surrounded by the ox, symbol of St. Luke, sirenlike angels, and a violinist, presumably con-scripted to furnish music during sit-tings, as the portraitist John Singer Sargent preferred.

The grubby and great were sati-rized in the prints of Warrington Colescott. "An area that really grips me is that black zone between trag-edy and high comedy, where with a

little pull or push one way or the other you can transmute screams into laughter, and where the rules are no rules."[21] Thus, Colescott flouted facts in warping the realities of events and personalities, topical or historical, as in *The Triumph of St. Valentine* (color fig. 41). No rules smothered his parody of the *St. Valentine's Day Massacre* when, in the prohibition days of 1929 at a garage on Clark Street in Chicago, Al Capone's hit-men gunned down seven of the "Bugs" Moran gang as they awaited a delivery of booze from Detroit. A motley bunch of mobsters—in coonskin caps, berets, and helmets, flaunting sabers, fenc-

ing swords, and machine guns—attack a row of nudes against the wall beyond three panicked ponies on that "lovers' day." The close-up of a gangster's "moll" in scanty dress and, in the background, a sexy chase within Chicago's Loop recalls the reputation of the city.

Colescott commented in 1962 that, "my graphic work, oriented to satire and lampoon, comes out of current and past events, bits and pieces of which have dug into my mind."[22] This comment anticipated later themes, rooted in realities but embellished by outlandish improvisations. They would be as topical as *The Great Society* of Lyndon Johnson (1966), the upside-down hanging of the dead bodies of Mussolini and his mistress, Carla Petacci—twenty years before—with a mocking title, *Quo Vadis, Baby?* (1967), or past heroes and hapless in a hilarious story of our nation, *Histories: U.S.A* (1973). John Dillinger, a folk figure of banditry in the thirties, triggered Colescott's running tale of the scofflaw and his mobsters. After an escape from the Crown Point, Indiana, jail, which Colescott revised into *The Breakout From the Indiana Pen* (1966), Dillinger left a trail of violence and twelve banks robbed across the Midwest. Cornered in a northern Wisconsin resort, the *Attack and Defense at Little Bohemia* (color fig. 42) ended in a bungled assault by the "Feds" and the bandit's getaway. The siege of "Little Bohemia" had its "shoot-out" from a vintage car racing past a landscape where a bemused nine-point buck watches a farmer swill his hogs; a mobster laughs as he blasts the "Feds" from the rustic lodge, its rooms filled with death, nudes, and lovemaking; and an antique biplane buzzes the hideout at the moment of assault, signaled by a sheriff—in an earlier version, J. Edgar Hoover—with the likeness, and bravado, of Teddy Roosevelt leading his Rough Riders.

The feigning of "histories" con-tinued in Colescott's *A History of Printmaking*, eleven jocular prints created between 1976 and 1978. Among them were *Dürer, at 23, in Venice, in Love, His Bags are Stolen*; an auction in the studio of *Rembrandt Bankrupt* had one bidder whispering to another ". . . prints are a good investment . . ."; the *Lunch with Lautrec* documents the artist-epicure cooking for guests—with likenesses of the café entertainers and demimondaines of his posters and prints; and *Picasso at the Zoo* has the Spanish master sketching a centaur, a minotaur, and other mythical animals of his art, now confined to cages. As for printmaking in America, the *Entry of Mauricio Lasansky into Iowa City* is obscured by a rousing football victory parade, and *Rauschenberg at Tamarind, in Hollywood* is turned into a Busby Berkeley song and dance spectacular—and hoax. A mentor of modern American printmakers was assigned his place in history by *S. W. Hayter Discovers Viscosity Printing* (color fig. 43) at Atelier 17 where Hayter raises a brayer, loaded with red ink, in triumph.[23]

Logic was also disarmed in the prints by Robert Nelson of super birds and bovines despite their realistic renderings. A bespectacled rat—giant flashlight in hand—pursues an unknown quest into the darkness of *Light Load* (fig. 8.10), the punning title of the print belying his heavy backpack bulging with other shining flashlights, hammers, wrenches, augers, awls, and Yankee drills.

Themes descendant from the Bible or from legendary sources—revered throughout the centuries—reappeared in prints by Meeker, Baskin, and others. Meeker, with *Joseph's Coat* (fig. 8.11), recalled the tale in Genesis when envy overcame the elder sons of Jacob. Conspiring against the father's favorite, they sold the youngest brother into slavery, then tore and drenched with blood his splendorous garment and

8.8
Jack Damer
Fog Mourn II
Lithograph (1972) 34½ × 24
Shown in Printmakers: Midwest Invitational at the Walker Art Center, Minneapolis (1973) and the retrospective exhibition, Jack Damer: Prints and Multiples, 1965–1983, at the Elvehjem Museum of Art (1983).
Courtesy of the artist.

proffered it as proof of Joseph's death to the stricken father. In the print, Joseph, the gift of Jacob draped upon his shoulders, postures with a youthful curiosity and pride—the "coat of many colors" lush with richnesses devised by polymer-intaglio/silkscreen printings which Meeker had developed.

Portraits and self-portraits, whether sequestered in episodic themes or composed as single likenesses, were a tradition in printmaking that rarely waned and artists continued to submit them for national exhibitions. Portraits by Lasansky could make up a family album; Gloeckler lampooned his likeness in the resting cyclist of *Big Biker* (fig. 8.7); and Virginia Myers lent intimate characterization to *Self Portrait with Hat* (fig. 8.12).

Among abundant prints pictorially inscribed to lend credence to fanciful tales were the parables by David Becker—partly autobiographical, partly imaginary—which in the prints became, for him, realities.[24] *In a Dark Time* (fig. 8.13), like a morality play, has path and woods as settings for the acts of callous youth, mocking the shrouded dead which lay within the thicket or in a shallow burial case drawn, in silence, by the few who mourn.

Seeming factualities supported other kinds of visions by Bruce Mc-Combs—nostalgic recreations of an early motor age with racy convertibles, driverless, cruising a *Bridge* (fig. 8.14) of bricks that spanned a city with its billboards of the time advertising Republic trucks and Reo

8.9
David Driesbach
St. Luke Paints the Madonna
Intaglio (1958) 18 × 23½
*Shown in the 31st International Exhibition
of Northwest Printmakers (Seattle, 1960),
the 29th Annual American Graphics and
Drawings Exhibition, at the Wichita Art
Association (1960), the 23rd National Ex-
hibition of the Society of Washington Print-
makers, at the National Collection of Fine
Arts (1960), the 34th Annual Ohio Print-
makers Exhibition, at the Dayton Art In-
stitute (1960), and the 5th National Print
Exhibition, at the Hunterdon Art Center
(New Jersey) in 1961.*
*Elvehjem Museum of Art. Brittingham
Fund.*

cars, Pierce-Arrow "style" and the
mighty "Straight-8" Duesenberg.

McCombs created fantasies in un-
populated cities; the human pres-
ence was a fact of urban life for
Gerson Leiber. "[I] had always been
fascinated by people en masse and I
have used this theme a number of
times in my prints"[25]—with *The
Crowd* and *The Rookery* as titles.
However, unlike Marsh who had
smothered Coney Island with sen-
suous human bodies, Leiber as-
signed to *The Beach* (fig. 8.15) a
lure of landscape for people fleeing
the city.

Modern printmakers knew, no
less than their forebears, that land-
scapes were limitless in enduring
forms, visually altered by transitory

effects of light and color. Thus,
conceptions of landscapes were envi-
sioned anew by Drewes, Day, Sum-
mers, and Wald, and revised end-
lessly as award-winning exhibits
in national print shows of recent
decades.

Visions of the changing seasons,
and a *Scorched City*, were the themes
of eight luminous silkscreens (color
fig. 44) displayed by Robert Burkert
when he was honored as the Presen-
tation Artist in the 15th Annual Ex-
hibition of the Boston Printmakers
at the Museum of Fine Arts (1962).
Harold Altman evoked repeatedly
the memories of chance encounters
and quiet conversations on public
paths with subtle shadings that
welded them into benign landscapes,

pleasant parks (fig. 8.16) designed to lend civility to an earlier urban life.

A suite of canyon prints (fig. 8.17) by Clare Romano distilled the landscape of a wonder of the natural world, the Arizona desert scoured to awesome depths by waters of the Colorado. Obdurate walls that flank the chasm and nature's pigments lodged in laminations of descent had mutability only by the changes— day and night—of lights, shadows, and atmospheric colors, all simulated by Romano by the bold designs, textures, and chromatics in her "canyon" collographs.

Architecture of the Old and New Worlds lent matrices for the images and cultural themes of prints by

Pennell, Marin, Lozowick, Arms, their colleagues, and their successors into the 1970s. Cottingham and Estes rendered buildings of glass and Art Deco designs with the visual vocabulary of New Realism (fig. 7.36, color fig. 32). Victorian mansions instilled an illusion of age and magic of place in prints by Peter Milton (fig. 7.26) and Kenneth Kerslake. Shops and homes in villages of Pennsylvania were familiar Americana in the *White House* or *Blue House* (fig. 8.18) by Linda Plotkin. And Keith Achepohl converted ancient Mediterranean architecture to severe geometric abstractions in a sequence of *Mura* prints.

Architecture and landscape were the alternating images in color aqua-

8.10
Robert Nelson
Light Load
Lithograph (1979) 28 × 38
Printed at Impressions Workshop.
Awarded a Purchase Prize in the 31st National Exhibition of Boston Printmakers at the Brockton Art Center (1979). Shown in the one-man show at the Franz Bader Gallery, Washington, D.C. (1980).
Elvehjem Museum of Art. Gift of James Watrous.

8.11
Dean Meeker
Joseph's Coat
Color polymer–intaglio/silkscreen
(1965) 34 × 20
Shown in the print exhibition, Perspectives in Color, at the Madison Art Center (1966).
Courtesy of the artist.

8.12
Virginia Myers
Self Portrait with Hat
Engraving (1960) 34½ × 22
Awarded a Purchase Prize in the 31st National American Graphic Arts and Drawing Exhibition, at the Wichita Art Association (1963). Shown in American Graphic Workshops: 1968, at the Cincinnati Art Museum (1968).
Courtesy of the artist.

Self Portrait with a Hat

8.13
David Becker
In a Dark Time
Intaglio (1973) 16 × 24
Awarded a Gold Medal in the 3rd Biennial of American Graphic Arts at the Museum of Modern Art, Cali, Colombia (1976). Shown in the retrospective exhibition, 30 Years of American Printmaking, at the Brooklyn Museum (1976). Courtesy of the artist.

8.14
Bruce McCombs
Bridge
Intaglio (1973) 28 × 22
Awarded a Purchase Prize in the 15th Annual Bradley University National Exhibition of Prints (1975). Shown in New American Graphics: An Invitational Exhibition, at the Madison Art Center (1975), the 3rd National Print Exhibition of the Los Angeles Printmaking Society, at the University of Southern California (1975), and in the 18th North Dakota Print and Drawing Annual Exhibition, at the University of North Dakota (1975). Courtesy of the artist.

tints of Frances Myers, dramatically combined in *Monte Alban II* (fig. 8.19) where massive pre-Columbian terraces and temples still rise as ruins against the panorama of receding mountain ranges. In 1977 she was commissioned by the Perimeter Press to create a portfolio of landmark buildings designed by Frank Lloyd Wright.[26] Myers, in prints, honored creativity in architecture by envisioning the essences of six Wright designs that spanned half a century from Unity Temple (1906) to the Marin County Civic Center (1959). Among them was the seasonal center of the Taliesin Fellowship—animated structures on an Arizona desert slope—conceived anew by Myers in a medley of forms that induce a graphic metaphor of *Taliesin West* (color fig. 45).

Many national competitive exhibitions had been sponsored resolutely year after year; others failed soon after launching. Whatever their ten-

ure during the sixties and seventies, all were arenas coast to coast where masters from several generations displayed the excellence of their prints and the young gained entry for the testing of their talents. The thousands upon thousands of prints chosen for those kinds of exhibitions, the multitude of works withheld from competitions but promoted by dealers and publishers, and prints honored by invitational and one-man shows were all manifestations of an American printmaking enterprise that was flourishing as never before.

8.15
Gerson Leiber
The Beach
Etching/aquatint/roulette work (1965)
21½ × 27¾
Awarded a Purchase Prize in the 15th National Print Exhibition, at the Brooklyn Museum (1966). Shown in the American Exhibition of Contemporary Sculpture and Prints, at the Whitney Museum of American Art (1966).
Cincinnati Art Museum. Gift of the Cincinnati Print and Drawing Circle.

8.16
Harold Altman
Park with Seven Figures
Intaglio (1969) 11¾ × 19½
Imprimé Georges Leblanc, Paris.
Awarded a Purchase Prize in the 11th Annual National Exhibition of Prints and Drawings, at the Oklahoma Art Center (1969). Shown in the 2nd Annual National Print and Drawing Competition, at Northern Illinois University (1969), and the 22nd Annual Exhibition of Boston Printmakers, at the Rose Museum, Brandeis University (1970).
Courtesy of the artist.

8.17
Clare Romano
Silver Canyon
Collagraph (1977) 22 × 29½
Shown in the 56th National Print Exhibition of the Society of American Graphic Artists, at the Azuma Gallery (1978), and in the National Invitational Printmaking Exhibition, at the University of South Dakota (1978).
Courtesy of Associated American Artists.

8.18
Linda Plotkin
Blue House
Intaglio (1975) 24½ × 32
Received an Award of Merit in the 5th Biennial International Mat-media Exhibition, at Dickinson State College (1975). Shown in the 54th National Print Exhibition of the Society of American Graphic Artists, at the Pratt Graphics Center (1976), and the 10th Dulin National Print and Drawing Competition, at the Dulin Art Gallery (Knoxville, 1976).
Courtesy of Associated American Artists.

8.19
Frances Myers
Monte Alban II
Color aquatint (1976) 21¾ × 27¾
*Shown in the retrospective exhibition, 30
Years of American Printmaking, at the
Brooklyn Museum (1976). Awarded a Pur-
chase Prize in the 3rd Miami Graphics
Biennial International Print Competition,
at the Metropolitan Museum and Art Cen-
ters (Miami, 1977). Shown in New Talent
in Printmaking: 1977, at Associated
American Artists.
Courtesy of the artist.*

9

Controversial Practices and Continuing Innovations

The booming market for prints from the 1950s on was accompanied by artistic innovation as well as continuing controversy over the definition of an original print. Dubious and fraudulent practices in the printmaking enterprise in the 1950s had led to articles of alarm in the art journals and to the publication of *What Is an Original Print?* by the Print Council of America in 1961. As the market for prints grew, the vexatious practices spread. There was no consensus among artists, critics, publishers, dealers, and legal authorities about criteria for "original" prints. By the end of the seventies several states—including California, Maryland, and Hawaii—had enacted legislation for the protection of purchasers of art though none provided model laws. And, in the early eighties, the State of New York proposed disclosures about prints so burdensome or indeterminable that dealers of integrity were compelled to oppose the legislation.[1]

The disputes about what was or was not an "original" print had flared up once again after Donald H. Karshan, print editor of *Art in America*, initiated a print-publishing program for the magazine in July 1968 with the following rationale: "The Larry Rivers color lithograph (*A Hut Can Be a Hairdo*) bound into this issue is as original in its edition of 46,000 as it would be if the edition were fifty impressions—as long as each impression had been printed with sufficient care to fully represent the original intentions of the artist."[2] For the six issues of 1970, color lithographs by Paul Jenkins, Anuszkiewicz, Calder, Peter Dechar, Ray Parker, and Rauschenberg—the last in an "edition" of 65,000—were printed by the Triton Press, folded, and bound into copies of *Art in America*.

In *Studio International* the following year, Karshan elaborated his argument that limiting impressions in editions often was an act of contrived rarity, whereas prints as multiple "originals" could, or should, be printed in whatever unlimited numbers technology and quality of impressions permitted.[3] Also in 1971, Jack Beal, painter-printmaker, wrote of other matters in dispute, citing:

. . . the quasi-immoral situation now pervading the world of printmaking.

Foremost among them is the production and sale of off-set lithographic reproductions of drawings and paintings—works which are being signed by the artist and misrepresented by the sellers.

More private occurrences include gouache drawings by well-known artists being converted to silkscreen prints by the technicians at the print workshop. The tracings are made, stencils cut, colors mixed, and editions run without the artist ever seeing or participating in the process.

Similar practices prevail in litho workshops. Not long ago a drawing arrived, in a graphics workshop, from one of the world's most famous artists. It was photographed and applied to a zinc plate. Several chalk transfers were made onto other plates, and the resident printer (who is clearly a master craftsman) drew and painted on these plates in a superb imitation of the style of the artist. He then mixed the inks and ran the proofs. Since the artist went to Europe just after doing the original drawing, he had signed several hundred sheets of blank paper so that the entire print could be produced and marketed in his absence.[4]

In 1974, such issues led *Print Collector's Newsletter* to publish four articles, each entitled "On Originality," by Gabriel Austin, Richard Field, Hubert Prouté, and June Wayne.[5] Although Wayne was unwilling to define "original" prints because it was "an exercise in futility," and asserted that the best attempts were those of the Print Council of America, she posed the following queries, "Would you collectors, critics, curators, dealers agree to buy *only* those prints that fit the definitions? What about your 'right' to curatorial opinion, critical

judgment, access to mavericks and innovators? Can you be free if artists aren't?

Wayne then rebuked the print-publishing practices of some artists, some dealers, and *Art in America*:

No one knows as much about real money as counterfeiters, and the patois of print connaissance is never more fluent than among pushers of worthless printed pictures. One only has to read the Karshan text that accompanied *Art in America*'s "original lithographs in limited editions of 60,000" to see how the language of expertise can be twisted to "validate" junk. What pyrotechnical linguistics it would have taken to pursue those editions through the courts! Yet how simple to look at the prints themselves, feel the misery of the images suffocating in a prison of inept processing, place the ugly paper in the sun and watch the colors fade. Eyes, sensibility, common sense, knowledge, experience are the best protection against a fake, and my definition of a fake is anything that pretends to be something it isn't.[6]

A year later Judith Goldman, editor of *Print Collector's Newsletter*, called the disputations feckless: "No distinguishing criteria for quality emerged out of the deluge of [recently] printed pictures. Attempts to establish them were often economic, and inevitably reverted to discussions of originality—an issue as boring as it is spurious. Prints, by definition, are reproductive; originality, whatever it may be, lies with the artist, and in the printer's and publisher's integrity."[7]

During the seventies, dealers, collectors, curators, critics, and jurors were confronted by anomalies. Printmaking was conceived as an open-ended art; works that were untraditional or exotic in processes and materials were presented for display in print galleries or regional and national exhibitions. By then, prints by photolithography and photosilkscreen were commonplace. Embossments of paper—some inkless—by Albers, Ezio Martinelli, Angelo Savelli, Boris Margo, and Deshaies were no longer unusual, and the

lead reliefs and sheet-lead embossments by Johns and Nevelson were marketed under a catchall of prints or multiples. The *Hoarfrost* series (1974) by Rauschenberg—printed on silk, chiffon, taffeta, and other textiles—was hung one print behind another as a row of huge, floating veils. Bontecou printed on muslin, Ruscha on linen, and the carrier for William Wiley's *Little Hide: Slake* (1973) was chamois. Plastics—translucent, opaque, or with laminated metallic surfaces—were chosen in lieu of papers for editions by Lichtenstein, Rauschenberg, Rosenquist, Rivers, and Ernest Trova. The composer John Cage created what he called "Plexigrams," silkscreens on Plexiglas sheets which were fitted into slots of a wooden frame similar in construction to Rauschenberg's *Shades* (fig. 7.11). Cage gave the random letters, words, and symbols the title *Not Wanting to Say Anything About Marcel* (1970), which paid oblique homage to Duchamp. The vacuum-forming of thermoplastics for industrial products and free-standing sculpture was adopted with printings in heat-resistant inks for Wesselmann and by John Risseeuw for his innovative illusions, in relief, of figures, symbols, maps, and poetry. "Copy Art"—the duplications of drawings, paintings, collages, and parts of the human body in black and white or colors with the photocopying machines of the Xerox, 3M, and IBM corporations—had advocates whose exuberant claims of a new medium of printmaking were reminiscent of those made for silkscreen in the early forties.[8] Small wonder that those, and other processes and materials, appeared to be a carousel of technical confections from which printmakers and workshops selected whatever was aesthetically appropriate and innovative, or novel enough to attract attention.

Designers of craft arts long had known that all kinds of papers and paper pulps were materials agreeable to infinite artistic manipulations.

On the other hand, the interests of printmakers had been limited by the search for handmade papers of permanence, of differing characteristics that catered to a concordance with one or another printmaking process, and of effectiveness as carriers and foils for printed images. Few handmade papers satisfying the several needs were produced in the United States during the twentieth century until scattered small mills were founded after 1960.[9] Those papermaking ventures made their contributions to a welling-up of enthusiasm for the creation of paper art objects, including prints with handmade paper pulps or papers that were cast, laminated, embossed, folded, torn, and sliced with openings or cut to form protruding flaps.

A broadened awareness of the potentialities of paper beckoned innovative printmakers, among them Michael Ponce de Leon who, in creating *Omen* (color fig. 46) and other prints of the midsixties, cast and welded metal plates as three-dimensional structures, inked each level separately, and with a hydraulic press printed and formed quarter-inch-thick papers—expressly created for him by the papermaker Douglass Howell. Ponce de Leon affirmed that "while constructing this [kind of] bas-relief I feel a closer kinship to the sculptor than the printmaker or painter. . . ."[10]

Innovative trials with papers were carried forth in the studios of individual printmakers or at small experimental workshops. One of the latter was the Jones Road Print Shop near Barneveld, Wisconsin, established by William Weege in 1971.[11] The prospect of prints as objects was explored with pulps and papers as in Sam Gilliam's *Great American Quilt* series (1976) with paper embedments and color stains, and the laminated, woven paper prints by Alan Shields which Weege described as "things with printmaking techniques."[12]

The print objects by Shields

(color fig. 47), at once symbolic and decorative, combined the processes of the craft arts and printmaking. The papers were handmade and laminated by Shields and Joseph Wilfer at the latter's Upper U.S. Paper Mill, south of Madison. In the pulp stage they were embossed by wires with elaborate watermarks to trace designs and, when the papers were dry, silkscreened on both sides, relief-printed with sliced vegetables, cut for interweaving with paper strips, sized for bonding flock or glitter, and pierced, or stitched with colored threads, on a sewing machine.

In the late sixties, Weege's "Veristic" prints were photocollages— barbed broadsides against social injustices, Richard Nixon, the Vietnam War, and Mayor Richard Daley at the 1968 Democratic National Convention surrounded by violent clashes between protesters and police on the streets of Chicago during the "Days of Rage." Jack Beal, painter-printmaker of a New Realist style, described Weege's prints as closer to Life than those of "other painters who use social images . . . because it tickles their fancy, and being bound up in the New York Fag Pop World, do their best to . . . obscure any meaning the original image held."[13]

In 1970, Weege and Jack Damer were sponsored by the International Art Program of the Smithsonian Institution as the two printmakers at an American graphics workshop associated with the *Biennale* in Venice—Weege as the supervisor of the shop and to demonstrate silkscreen, Damer as the instructor in lithography.[14] By then, Weege's prints were moving away from black-and-white political commentaries toward elaborate aesthetic effects from pigments, dyes, flocking, glitter, and stitchings that he, and Shields, explored at the Jones Road Print Shop. Playful lampoons of a sex-saturated American popular culture often lay beneath images and titles,

the latter with outright puns or double meanings, as in the print of a sensual nude, reclining with legs cleft, and linked to another phenomenon of nature on the West Coast by the title *Andreas Fault* (1975).

Weege's *Record of My Work* (1976), an abstraction printed with mixed media on an acetate phonograph record, was alluded to again by *Record Trout* (color fig. 48), a brilliantly pigmented game fish, mounted—as if it were a trophy catch—on three National Public Radio Theater records.

The innovative use of papers had been one quest among others at the Jones Road Print Shop and Weege explored further possibilities in 1977 as a visiting artist at the International Institute of Experimental Printmaking where paper and papermaking were prime concerns. He created works beyond the boundaries of printmaking—frame constructions laced with strings, each laden with pulp as a filament when lifted from the watery vat. The objects were pigmented, detached from the frames, pressed, assembled in layers of webbed designs, and, on occasion, given a waggish title such as *San Francisco String Symphony* (1977).

The International Institute of Experimental Printmaking had been established in 1973 by Garner Tullis in an old lumber mill at Santa Cruz and relocated with expanded equipment for paper and printmaking in a warehouse on the docks of San Francisco three years later. Although Tullis was committed to the idea that there were unexplored potentialities for art on, in, of paper,[15] "Experimental Printmaking" in the title of the Institute suggested ample options for visiting artists, whatever their artistic inclinations. Thus, among the early works created at the shop—and displayed in an exhibition, Pioneering Printmakers, at the Fine Arts Gallery of San Diego (1974)[16]—were Nathan Oliveira's *Woman, Santa Cruz*, an experi-

mental lead-sheet monotype, Jack Zajac's *Moth* from a series of inkless embossments, and *Technical Artifacts*, a series of heads which Tullis had cast with paper pulp and brushed with graphite to simulate the shimmering gray of plumbago. Creations from the Institute gained further visibility in 1976 when Martha Jackson Graphics sponsored an exhibition in New York and a show of the works toured museums and galleries across the country.[17] Vacuum silkscreens by Sam Francis were included in the exhibition. Beyond the threshold of printmaking toward sculpture were the graphite-coated paper castings by Tullis, David Whipple's suites of paper dustpans and shovels, the latter with wooden handles, and the low-relief paper sculptures of Louise Nevelson— *Dawnscape* in white and *Nightscape* in black—made after a sculptured wood "positive" was shipped from New York to the Institute where a latex "negative" was fabricated as the mold for the paper castings.

Atelier Royce, an experimental enterprise open to professional artists, was initiated by Richard Royce at Santa Monica in 1976. The shop concentrated on papermaking and the creation of paper objects, some with woodcut and intaglio printings.[18] Judy Chicago cast her large paper butterfly, *Submerged—Emerged* (1976), from carved wooden molds, with the impressions either paper-pulp white or colored by airbrush, without printings. Claire Falkenstein, however, favored bands of white decorations printed by lift-ground etching before the black papers of *From Point to Cone* (fig. 9.1) were folded into graceful convolutions. Experiments by Royce (fig. 9.2) led to "prints" by hand-pressing paper pulps onto wooden panels which had been incised and inked for the transfer of images. The castings, when removed, were bonded at the edges to construct freestanding sculptural objects with printings.[19]

Printmakers were intrigued by the potentialities of arts created in, on, or of paper and, not surprisingly, as the new mills producing handmade papers flourished, the artists heeded the advice of and welcomed collaborations with master papermakers. By the late seventies, the organizers of symposia on papermaking and paper arts were including as panelists, printmakers, workshop directors, and curators of print collections, notably so at the World Print Council's conference on Paper—Art & Technology, held at the San Francisco Museum of Art in 1978.[20]

The printmakers and workshops that freely exploited new materials and technological innovations frequently adopted conceptions and practices that had been traditionally within the province of other arts and crafts. Some new approaches were mere novelties or were limited by an infatuation with technique that recalled the misgivings of Zigrosser, Ashton, and Campbell about technical exhibitionism in the fifties. Whatever the individual merit of each venture, the exploits became a conspicuous feature of printmaking in the sixties and seventies. And some of those ventures extended the borders of printmaking and offered seminal influences to the art of the early eighties.

9.1
Claire Falkenstein
From Point to Cone
Paper object with sugar-lift etching
(1976) 22 × 16
Printed at Atelier Royce.
Shown at Atelier Royce in one of several exhibitions in the Los Angeles area during 1976 that celebrated Women in the Arts.
Courtesy of Atelier Royce, Ltd.

9.2
Richard Royce
Glyph
Cast paper object with printings (1979)
42 × 26 × 48
Created at Atelier Royce.
Shown in the exhibition of Atelier Royce at the Portland Art Museum (1979) and in Richard Royce: Cast Paper Prints and Objects, at the Contemporary Crafts Gallery (Portland, Oregon, 1979).
Courtesy of Atelier Royce, Ltd.

Epilogue

For many decades American printmaking received less honor than the art deserved. In the sixties and seventies, however, a consensus emerged that recent printmaking in the United States equaled or surpassed in excellence that of any other country in the world. Concurrently, a greater interest in the history of the art arose. Scholarly studies of past and present prints and printmakers multiplied, curators assembled retrospective exhibitions of their works, displays of prints by periods were mounted more frequently, retrospective exhibitions that traced the broader history of the art seemed timely, and art museums established special conservancies for prints from modern workshops.*

American printmaking continues to flourish in the early eighties. The fascination with the history of the art is encouraging further inventories, surveys, and assessments that offer new perceptions of American prints and printmaking. Both the consensus about the creative excellence of recent prints and the canvassing of the history of the art are tacit judgments that American printmaking is now a mature art.

*Conservancies for editions printed at the Tamarind Lithography Workshop and the Tamarind Institute were established in the early seventies at the University Art Museum, University of New Mexico, and in the early eighties for editions from Gemini G.E.L. at the National Gallery of Art and from ULAE at the Art Institute of Chicago.

Notes

Chapter 1

1 *American Art Review* 2 (Boston, 1879–1881): 190, 191. J. R. W. Hitchcock, *Etching in America* (New York, 1886), 29.

2 Janine Bailly-Herzberg, *La Société des Aquafortistes: 1862–1867* 1 (Paris, 1972): 273; preface to the fourth year of the *Société* written by Castagnary.

3 Maxime Lalanne, *A Treatise on Etching*, translated by S. R. Koehler from the second French edition (Boston, 1885): 69 n. 22. Cadart published the first edition of Lalanne's *Traité de la graveur à l'eau-forte* (Paris, 1866); his widow published the second edition (Paris, 1878).

4 *New York Tribune*, 5 May 1877, 5.

5 *American Art Review* 1 (Boston, 1879–1881): 338.

6 *American Art Review* 2 : 46, 137, 271, 363. *The United States Directory and Year-Book* 1 (New York, 1882): 22.

7 The influence of Whistler's prints on American and European printmakers was displayed in the exhibition, The Stamp of Whistler, at the Allen Memorial Art Museum, Oberlin College; Robert H. Getscher and Allen Staley, *The Stamp of Whistler* (Oberlin, Ohio, 1977).

8 Sir Francis Newbolt, *The History of the Royal Society of Painter-Etchers and Engravers 1880–1930* (London, 1930), 9. The society was granted a royal diploma by Victoria in 1888; Newbolt, *History*, 29. Haden was knighted by the queen in 1894.

9 "Duveneck's Boys" included C. A. Corwin, T. M. Wendell, H. Rosenberg, G. E. Hopkins, and Otto H. Bacher; *American Art Review* 2 : 231.

10 Otto Bacher, *With Whistler in Venice* (New York, 1908), 136.

11 The events were described in a letter from Maud Whistler to her husband's ". . . pet pupil Bacher . . . "; Bacher, *With Whistler*, 138–143.

12 *American Art Review* 2 : 44.

13 Newbolt, *History*, 53. *The Year's Art* (London, 1882), 43. *Athenaeum* 2808 (London, 20 August 1881): 249. Seventy-eight etchings were exhibited by the Americans, *Art Journal* (London, May 1881), 157.

14 M. [Mariana] G. [Griswold] van Rensselaer [Mrs. Schyler], "American Etchers," *Century Magazine* 25.4 (New York, 1883): 489. In 1884, Mary Nimmo Moran's *Three-mile Harbor* was published in the *Studio* (New York), an art weekly that issued "Painter-Etchings" on a monthly basis. In 1889, she joined her husband, Thomas, in an exhibition at C. Klackner & Co., New York, where she displayed fifty-eight etchings; *New York Tribune*, 11 March 1889, 7.

15 Some artist-etchers had summer studios in areas where they created landscape etchings: James D. Smillie at Montrose, Susquehanna County, Pennsylvania; R. Swain Gifford at Nonquitt, Massachusetts; J. C. Nicoll at Shrub-Oak near Peekskill, New York; Samuel Colman at Newport, Rhode Island; Thomas and Mary Nimmo Moran at East Hampton, Long Island. Lizzie W. Champney, "The Summer Haunts of American Artists," *Century Magazine* 30.6 (October 1885): 846–858.

16 *Catalogue of Etchings Exhibited at the Museum of Fine Arts (Gray Room) January 1879* (Boston, 1879). Philip Gilbert Hamerton, "Mr. Seymour Haden's Etchings," *Scribner's Monthly* 20.4 (August 1880): 586–600.

17 "Monthly Record of American Art," *Magazine of Art* 5 (London, 1882): xlii.

18 *New York Times*, 12 November 1882, 2. John Elderkin, *A Brief History of the Lotos Club* (New York, 1895).

19 Elizabeth Robins Pennell, *The Life and Letters of Joseph Pennell* 2 (Boston, 1929): 78.

20 *New York Tribune*, 6 February 1883, 2; 9 February 1883, 5.

21 *New York Times*, 3 December 1882, 6. "Monthly Record of American Art," *Magazine of Art* 6 (London, 1883): vi, viii.

22 Bacher, *With Whistler*, 165ff.

23 *New York Sun*, 15 October 1883, 2. "Monthly Record of American Art," *Magazine of Art* 7 (London 1884): 1, xv, xx. *The United States Art Directory and Year-Book* 2 (New York, 1884): 7.

The author is grateful for information about Hermann Wunderlich and his gallery, and the Whistler exhibition, that was recounted in letters from Rudolph G. Wunderlich, grandson and former president of

the Kennedy Galleries (22 March 1979) and Gerold M. Wunderlich, great-grandson and also of the Kennedy Galleries (10 July 1979). Hermann Wunderlich left the employ of Goupil & Co., later Knoedler's, about 1870 and, in 1874, established his own firm. About 1885, E. G. Kennedy, who later published the major *catalogue raisonné* of Whistler's prints, became a partner. In 1910, eighteen years after Wunderlich's death, the dealership became known as Kennedy & Co. In 1959 the firm adopted its current name, Kennedy Galleries, Inc.

Gerold Wunderlich confirmed an amusing aftermath of the Whistler exhibition—an anecdote that told of the celebrated yellow draperies being made over into underclothes for the Wunderlich children who, the story goes, suffered discomfort from the itchy, woolen cloth.

24 *New York Times*, 17 March 1883, 2.

25 Frank Weitenkampf, *American Graphic Art* (New York, 1912), 21.

26 *American Art Review* (Boston, 1879–1881).

27 Koehler's several kinds of involvements with prints are presented in Clifford Ackley, "Sylvester Rosa Koehler and the American Etching Revival," *Art and Commerce: American Prints of the Nineteenth Century* (Charlottesville, Va., 1978).

28 *New York Tribune*, 14 April 1882, 6.

29 *American Art Review* 2:143.

30 Lalanne, *A Treatise on Etching*.

31 *New York Tribune*, 14 December 1883, 6. Koehler worked with an advisory group of artists: Henry Farrer, Swain Gifford, and Frederick Dielman. In 1884, an advertisement indicated that three editions were published: a *Parchment Edition* of only three copies, an *Edition de Luxe* of two hundred, and a *Popular Edition* with the number of copies unspecified; *The United States Art Directory and Year-Book* 2 (New York, 1884).

32 S. R. Koehler, *Etching* (New York, 1885). Among the original prints were Parrish's *Annisquam* (Cape Ann), Farrer's *Sweet is the Hour of Rest*, Smillie's *A Fallow Field* (Susquehanna Valley), Mary Nimmo Moran's *Home of the Muskrat* (Long Island), Thomas Moran's *Twilight in Arizona*, and Charles Platt's *Rue du Mont Cenis*.

33 *New York Tribune*, 12 April 1888, 4. Mariana Griswold van Rensselaer wrote the introduction to the catalogue of the exhibition at the Union League Club (New York) with an acknowledgment to Koehler who had organized the exhibition and written the catalogue essay for the display at the Museum of Fine Arts, Boston.

34 "Monthly Record of American Art," *Magazine of Art* 5 (London, 1882): xxiv. *New York Tribune*, 14 April 1882, 6. *New York Times*, 19 November 1882, 6. *The United States Art Directory and Year-Book* 1 (New York, 1882): 142. Among the original prints were Platt's *Shanties on the Harlem*, Farrer's *Sunset, Maine Coast*, Parrish's *Sunset—Gloucester Harbor*, Thomas Moran's *Three-mile Harbor* (Long Island), J. C. Nicoll's *Burnt Pines*, and Joseph Pennell's *Yard of the Plow Inn* (Philadelphia).

35 *New York Tribune*, 26 May 1884, 6. About 1883, Janentsky & Co., Philadelphia, initiated the *Etchers Folio*, a monthly with three plates and a text for each issue; *The United States Art Directory and Year-Book* 2 (New York, 1884): 48.

36 Frederick Wedmore, *Fine Prints* (London, 1896), 100.

37 Ibid., 118.

38 *New York Times*, 28 February 1887, 3.

39 Frederick Keppel, *The Golden Age of Engraving*, 2nd ed. (New York, 1910), 162.

40 Eleanor A. Sayre and Sue W. Reed, "The Department of Prints and Drawings, Museum of Fine Arts, Boston," *Artist's Proof* 11 (1971): 40.

41 Arline B. Saarinen, *The Proud Possessors* (New York, 1958), 123.

42 Minutes of the meeting of the Board of Trustees, 19 July and 24 August 1909; The Art Institute of Chicago: Archives II, 278A.

43 Willis O. Chapin, *Collection of Prints: The Buffalo Fine Arts Academy* (Buffalo, 1905), 94–119.

44 J. Thomas Sharf and Thompson Wescott, *History of Philadelphia* 2 (Philadelphia, 1884): 1070–1073. Elizabeth Robins Pennell, *Our Philadelphia* (Philadelphia, 1914), 376, 394. William A. Coffin, "Souvenirs of a Veteran Collector," *Century Magazine* 53.2 (December 1896): 231. Joseph Pennell, *The Adventures of an Illustrator* (Boston, 1925), 238.

45 *New York Times*, 25 November 1888, 13. *Illustrated Catalogue No. 10 of Etchings and Engravings Published by Frederick Keppel & Company* (New York, 1895?), 2.

46 *Illustrated Catalogue No. 10 of Etchings and Engravings Published by Frederick Keppel & Company* (New York, 1895?), 2.

47 Elbridge Kingsley, "Memories of Wood-Engraving," *Wood-Engraving: Three Essays* (New York, 1916), 41.

48 Timothy Cole, *Considerations on Engraving* (New York, 1921), 10, 11.

49 Kingsley, "Memories of Wood-Engraving," 43.

50 Philip Gilbert Hamerton, *The Graphic Arts* (New York, 1882), 326.

51 *American Art Review* 2:137, 141. Closson and Juengling were singled out in an article on the prints exhibited at the Salon; J. Biusson, "Le Salon de 1881," *Gazette des Beaux-Arts* 2.24 (Paris, 1881): 141. Juengling received a medal at the Munich International Exhibition in 1883; S. R. Koehler, *Frederick Juengling: A Memoir* (New York, 1890). Closson received a silver medal at the Paris Salon of 1890 and a medal at the Columbian Exposition in Chicago, 1893; *American Painters of the Impressionist Period Rediscovered* (Waterville, Me., 1975).

52 "The Exhibition of American Wood-Engraving," *Century Magazine* 23.4 (February 1882): 621.

53 "Monthly Record of American Art," *Magazine of Art* 5 (London, 1882): i.

54 M. G. van Rensselaer, "Wood-Engraving and the Century Prizes," *Century Magazine* 24.2 (June 1882): 230. The international prestige of the Americans was affirmed in "Wood-Engraving and the 'Scribner' Prizes," *Scribner's Monthly* 21.6 (April 1881): 937: "However critics may differ as to the merits of the so-called 'New School' of wood-engravers in America, it is beyond cavil that to this school is due the present wide-spread foreign reputation of this phase of American art. Ten years ago our blocks were not signally different in kind or quality from English work."

55 *The United States Directory and Year-Book* 1 (New York, 1882): 60. "American Wood-Engravers—Gustav Kruell," *Scribner's Magazine* 17.2 (February 1895): 186. *New York Tribune*, 5 June 1887, 6.

56 William M. Laffan, *Engravings on Wood. By Members of the Society of American Wood-Engravers* (New York, 1887), no pagination.

57 Laffan, *Engravings on Wood.*

58 Theodore L. De Vinne, "The Printing of 'The Century'." *Century Magazine* 41.1 (November 1890): 89. The wood-engravings were proofed from the original blocks. Because their delicacy could not withstand the very long pressruns on power-driven, high-speed presses, wax molds were made from the blocks, then electroplated cuts produced for the printing of the magazine.

59 *The Century Gallery: Selected Proofs from The Century Magazine and St. Nicholas* (New York, 1893). Philip Gilbert Hamerton, *The Art of the American Wood-Engraver*, I [text], II [plates] (New York, 1894).

60 [Félix Buhot]; *New York Tribune*, 5 June 1887, 6. [Paul Gauguin, August 1901], "Wood-engraving for illustrations has become like photogravure, sickening. A drawing by Degas beside a copy of the drawing done by hatchers." *The Letters of Paul Gauguin to Georges Daniel de Monfreid*, translated by Ruth Pielkovo (New York, 1922), 142.

61 Laffan, *Engravings on Wood.*

62 W. J. Linton, *Threescore and Ten Years, 1820–1890: Recollections* (New York, 1894), 153, 205, 221, 228.

63 Ibid., 227.

64 "A Symposium of Wood-Engravers," *Harper's New Monthly Magazine* 60 (357) (February 1880): 448, 449.

65 Henry Wolf, "Concerning Wood-Engraving," *Print Collector's Quarterly* 1.3 (July 1911): 353.

66 Elbridge Kingsley, "Wood-Engraving Direct from Nature," *Century Magazine* 25.1 (November 1882): 49. Kingsley received Gold Medals at the Paris Exposition of 1889 and the Columbian Exposition, Chicago, 1893.

67 *A Brief Guide to the Department of Fine Arts: Panama-Pacific International Exposition* (San Francisco, 1915), 55. "Henry Wolf," *Print Collector's Quarterly* 1.3 (July 1911): 361.

68 William Merritt Chase, the distinguished American painter after whose works Wolf made wood-engravings, painted his portrait with an appreciative inscription, "To my friend Henry Wolf / Wm. M. Chase"; "American Wood-Engravers," *Scribner's Magazine* 17 (January 1895): 20.

69 James Huneker, "Henry Wolf," *New York Sun*, 1 December 1907, 8.

70 Wolf, "Concerning Wood-Engraving," 357.

Chapter 2

1 Organizations founded in the second decade were: the Chicago Society of Etchers, 1910; the California Society of Etchers, 1911; the New York Society of Etchers, 1913; the Association of American Etchers, ca. 1913; the Philadelphia Print Club, 1915; the Brooklyn Society of Etchers, 1915; the Painter-Gravers of America, 1917.

2 In a letter to Dr. Hans W. Singer, Curator of the *Kupferstich-Kabinet* in Dresden, dated 11 November 1920; quoted in Elizabeth Robins Pennell, *The Life and Letters of Joseph Pennell* 2 (Boston, 1929): 229.

3 In 1921, and the publishing of vol. 8, the *Print Collector's Quarterly* moved to London where it was edited by Campbell Dodgson, Keeper of Prints and Drawings at the British Museum.

4 Elizabeth Robins [Pennell]. "A Ramble in Old Philadelphia," *Century Magazine* 23.5 (March 1882): 656.

5 *Official Catalogue of Exhibitors, Department of Art: Universal Exposition*, rev. ed. (St. Louis, 1904), 52–56.

6 Pennell's *The Ponte Vecchio* was replicated in a wood-engraving by R. C. Collins and printed as the frontispiece of the second of two articles by William Dean Howells, both entitled "A Florentine Mosaic," *Century Magazine* 29.6 (April 1885): 805.

7 Elizabeth Robins Pennell, *The Life and Letters of Joseph Pennell* 1 (Boston, 1929): 299.

8 The invitation to Pennell to publish a print in Album 8 of *L'Estampe originale* may have been influenced by Whistler who had been represented in Album 4 by *Danseuse*, a transfer lithograph (1893). Donna M. Stein and Donald H. Karshan, *L'Estampe originale: A Catalogue Raisonné* (New York, 1970).

9 *Official Catalogue of the Department of Fine Arts: Panama-Pacific International Exposition*, John E. D. Trask and J. Nilsen Laurvik, eds. (San Francisco, 1915). Laurvik, art critic and editor, was largely responsible for the international section of the exhibition. In addition to works by Munch, one could view the art of the Viennese Expressionist Oskar Kokoschka, and the sculpture and paintings of the Italian Futurists Boccioni, Balla, Severini, and Carra.

10 "Building the Panama Canal. From eight lithographs drawn for the Century Magazine in the Canal Zone, February, 1912, by Joseph Pennell," *Century Magazine* 84.4 (August 1912): 566–574.

11 Elizabeth Robins Pennell, *Joseph Pennell: A Memorial Exhibition of His Works* (Washington, D.C., 1927), 32.

12 *Will Bradley, His Chap Book* (New York, 1955), 46. Bradley, in his recollections of the exhibitions of posters in the mid-1890s, wrote of the public's excitement in viewing "the gay designs of Chéret and the astounding creations of Lautrec."

13 Joseph and Elizabeth Robins Pennell, *Lithography and Lithographers* (London and New York, 1898).

14 William M. Ivins, Jr., "Joseph Pennell," *Bulletin of the Metropolitan Museum of Art* 21.11 (November 1926): 254.

15 Elizabeth Robins Pennell, *The Life and Letters of Joseph Pennell* 2 (Boston, 1929): 271, 276, 277.

16 Ivins, "Pennell," 252.

Chapter 3

1 Peter Morse, *John Sloan's Prints: A Catalogue Raisonné of the Etchings, Lithographs, and Posters* (New Haven, Conn., 1969), 382.

2 Morse, *Sloan's Prints*, 143.

3 John D. Morse, "John Sloan, 1871–1951," *American Artist* 16 (January 1952): 28, 57, 58.

4 P. Morse, *Sloan's Prints*, 134.

5 Charles W. Barrell, "The Real Drama

of the Slums, As Told in John Sloan's Etchings," *The Craftsman* 15.5 (February 1909): 559–564.

6 J. D. Morse, "Sloan," 57–58.

7 P. Morse, *Sloan's Prints*, 17.

8 Milton W. Brown, *The Story of the Armory Show* (New York, 1963), 291.

9 P. Morse, *Sloan's Prints*, 190.

10 Ibid., 155. W. D. Richmond, *Grammar of Lithography* (2nd ed., London, 1880).

11 P. Morse, *Sloan's Prints*, 155; quoted from a letter, John Sloan to Dolly Sloan, dated 9 August 1905.

12 Frank Weitenkampf, "American Lithography of the Present Day," *International Studio* 97 (December 1930): 40.

13 H. C. Brunner, "American Posters, Past and Present," *The Modern Poster* (New York, 1895), 88–90.

14 Elizabeth Robins Pennell, *The Life and Letters of Joseph Pennell* 2 (Boston, 1929): 111–112.

15 Clinton Adams, *American Lithographers, 1900–1960: The Artists and Their Printers* (Albuquerque, University of New Mexico Press, forthcoming).

16 Ernest W. Watson, "George Miller, Godfather to Lithography," *American Artist* 5 (June 1943): 14. Bolton Brown, "Lithographic Drawing as Distinguished from Lithographic Printing," *The Print Connoisseur* 2 (December 1921): 149.

17 Bellows quoted in Carl O. Schniewind, "George W. Bellows, Lithographer and Draughtsman"; catalogue of the exhibition at the Art Institute of Chicago, *George Bellows: Paintings, Drawings and Prints* (Chicago, 1946), 33.

18 Schniewind, "Bellows," 33.

19 [Bellows], "The Big Idea: George Bellows Talks About Patriotism for Beauty," *Touchstone* 1.3 (July 1917): 270.

20 A study of the relationships between Bellows's illustrations and lithographs is presented in Charlene Stant Engel, "George W. Bellows' Illustrations for the *Masses* and other Magazines and the Sources of His Lithographs of 1916–1917"; unpublished doctoral dissertation (University of Wisconsin-Madison, 1976).

21 Lauris Mason, *The Lithographs of George Bellows: A Catalogue Raisonné*

(Millwood, N.Y., 1977).

22 Lloyd Goodrich, *Edward Hopper* (New York, 1971), 38. Henry McBride wrote that "the Whitney Studio Club, it seems, is ten years old. This is its tenth annual exhibition"; "Modern Art," *Dial* 76.1 (July 1925): 84.

23 Paul McCarron, in the introductory essay of the exhibition catalogue, *Martin Lewis* (New York, Kennedy Galleries, 1973). Malcolm C. Salaman, *Martin Lewis*, no. 26 in the series *Modern Masters of Etching* (New York, 1931). Lewis's work was also presented in the monograph series, *American Etchers* [XI] *Martin Lewis* (New York, 1931).

24 Suzanne Burrey, "Edward Hopper: The Emptying Spaces," *Art Digest* 29.13 (1 April 1955): 10.

25 Goodrich, *Hopper*, 106.

26 *The Complete Graphic Work of Edward Hopper*, with a *Catalogue Raisonné* by Carl Zigrosser (Worcester, Mass., 1963).

27 "It is worth reporting that Hopper does all his own work [etching, biting, printing] from the first to last"; Virgil Barker, "The Etchings of Edward Hopper," *Arts* 5.6 (June 1924): 324.

28 James Huneker, *The Pathos of Distance* (New York, 1913), 111–124. James Huneker, *Unicorns* (New York, 1917), 1–5.

29 Brown, *Armory Show*.

30 Jerome Myers, *Artist in Manhattan* (New York, 1940), 36.

31 A discussion and *catalogue raisonné* of Davies's prints are included in Merrill C. Rueppel, "The Graphic Art of Arthur Bowen Davies and John Sloan"; unpublished doctoral dissertation (University of Wisconsin-Madison, 1955). Frederic Newlin Price, *The Etchings and Lithographs of Arthur B. Davies* (New York, 1929).

32 An exhibition notice in *Arts* 2.2 (November 1921): 170.

33 Janet A. Flint, in the introductory essay of the catalogue of the exhibition at the National Collection of Fine Arts, *George Miller and American Lithography* (Washington, D.C., 1976).

34 Biographical information on Marin and a *catalogue raisonné* of prints are presented in Carl Zigrosser, *The Complete Etchings of John Marin* (Philadelphia, 1969).

35 MacKinley Helm, *John Marin* (Boston, 1948), 13.

36 Charles Saunier, "John Marin: Peintre Graveur," *L'Art Décoratif* (January 1908), 17–25. Impressions of the original etching, "Meaux Cathedral," were bound into the pages of the *Gazette des Beaux Arts* 3.40 (November 1908): 398.

37 H. H. Tolerton, in the commentaries for the *Illustrated Catalogue by American Artists* (Chicago, 1913). This catalogue was published by the Albert Roullier Art Galleries and is referred to as "Roullier II."

38 Marin, as quoted by Alfred Stieglitz, in Dorothy Norman, *Alfred Stieglitz: An American Seer* (New York, 1973), 97.

39 Norman, *Stieglitz*, 99.

40 Zigrosser, *Etchings of John Marin*.

41 Zigrosser, *Etchings of John Marin*.

42 Brown, *Armory Show*.

43 Daryl R. Rubenstein, *Max Weber: Prints and Color Variations*; catalogue for the exhibition at the National Collection of Fine Arts, Smithsonian Institution (Washington, D.C., 1980). A discussion and *catalogue raisonné* of Weber's woodcuts are included in Joann Moser, "Max Weber: The Works on Paper"; unpublished Master of Arts thesis (University of Wisconsin-Madison, 1972).

44 *Broom* 3.1 (August 1922).

45 Henry McBride, "Modern Art," *Dial* 78.4 (April 1925): 347.

46 Una E. Johnson, "The Woodcuts and Lithographs of Max Weber," *Brooklyn Museum Bulletin* 9.4 (1948): 7–12. Weber's lithographs were less innovative, conceptually and technically, than his woodcuts. Most of the lithographic compositions were taken from his paintings and drawings of figures and still lifes. A few were New York cityscapes, including one of Brooklyn Bridge which by then had become a subject chosen repeatedly by New York painters and printmakers. Most of the lithographs were created between 1928 and 1933. Over thirty were displayed in his one-man show of paintings at Edith Halpert's Downtown Gallery in 1928 and some were shown, randomly, in one or another of the print exhibitions of the 1930s.

47 *Woodcuts and Linoleum Blocks by Max Weber* (New York, Weyhe Gallery ex-

hibition catalogue, 1948).

48 Rockwell Kent, *It's Me O Lord: The Autobiography of Rockwell Kent* (New York, 1955), 353.

49 Dan Burne Jones, *The Prints of Rockwell Kent: A Catalogue Raisonné* (Chicago, 1975). Most of the wood-engravings of Kent that were used as illustrations or advertisements were duplicated by making electrotypes after an edition of impressions were printed from the original wood blocks; ibid., xiii. Kent created a great many lithographs, some as illustrations for new editions of literary classics. As a group, their bland silver-gray tonalities, overly controlled modeling, and static posings of the figures combined to diminish the liveliness that resulted from the linear cuttings and crisp black-and-white contrasts of the wood-engravings. For the printing of his lithographs, Kent first turned to Bolton Brown and then, from 1926 onward, to George Miller and his son Burr; ibid., xiv.

50 *Rockwellkentiana: Few words and Many Pictures by R. K. and, by Carl Zigrosser, A Bibliography and List of Prints* (New York, 1933), 36.

51 *New Hampshire / A Poem with Notes / and Grace Notes by / Robert Frost / with Woodcuts / by J. J. Lankes / Published by Henry Holt / & Company: New / York: MCMXXIII.*

52 Ralph Pearson, *Fifty Prints* (New York, 1927).

53 Weitenkampf, "American Lithography," 41.

54 Dorothy Noyes Arms and John Taylor Arms, *Hill Towns and Cities of Northern Italy* (New York, 1932).

55 Ben L. Bassham, *John Taylor Arms: American Etcher* (Madison, Wis., 1975), 28; catalogue and *catalogue raisonné* for the exhibition at the Elvehjem Museum of Art.

56 From a letter written by John Taylor Arms to Katherine Ely Ingraham, dated 16 January 1944, following the purchase for the Library of Congress of the color etching/aquatint by Ingraham, *From the Garden* (1936).

57 From a handscript note written by Harry Wickey as an addendum to his file of correspondence from John Taylor Arms (s.a.), now in the collection of Ralph E. Sandler, Madison, Wis.

58 Henry McBride, "Peggy Bacon," *Arts* 17.8 (May 1931): 583–585. *Art Digest* 5.15 (1 May 1931): 5.

59 The exhibition also presented the paintings of Peggy Bacon's husband, Alexander Brook; *Arts* 2.3 (December 1921): 176.

60 Helen Fagg, "Etchers in America," *Fine Prints of the Year* 4 (London, 1927): 14.

61 From a handscript note written by Harry Wickey as an addendum to his file of correspondence from Carl Zigrosser (s.a.), now in the collection of Ralph E. Sandler, Madison, Wis.

62 Harry Wickey and John Sloan became good friends and Wickey wrote, "Although I have never studied with Sloan his work has influenced my thinking to a very great extent and I believe I could be counted as one of his students"; from a handscript note written by Harry Wickey as an addendum to his file of correspondence from John Sloan (s.a.), now in the collection of Ralph E. Sandler of Madison, Wis.

63 In a letter to Harry Wickey from John Steuart Curry, dated 6 January 1932; now in the collection of Ralph E. Sandler, Madison, Wis.

64 Harry Wickey, *Thus Far* (New York, 1941), 66.

65 Lloyd Goodrich in the *New York Times*, 19 May 1929, X, 22.

66 William C. Lipke, in the exhibition-catalogue essay, "Abstractionism and Realism: 1923–1943; Paintings, Drawings and Lithographs of Louis Lozowick" (Burlington, Vt., 1971).

67 Francis Adams Comstock and William Fletcher, *The Work of Thomas W. Nason, N.A.* (Boston, 1977). John Taylor Arms, "The Engravings of Thomas W. Nason," *Print Collector's Quarterly* 24.2 (April 1937): 199.

68 Carl Zigrosser, "Modern American Etching," *Print Collector's Quarterly* 16.4 (October 1929): 381. Carl Zigrosser, "Modern American Graphic Art," *Creative Art* 9 (November 1931): 369–374.

Chapter 4

1 John Steuart Curry, in a letter to Harry Wickey, dated 13 December 1931; now in the collection of Ralph

E. Sandler, Madison, Wis.

2 Harry Wickey, *Thus Far* (New York, 1941), 96.

3 Lynd Ward, "Printmakers of Tomorrow," *Parnassus* 11.3 (March 1939): 9.

4 *New York Times*, 15 March 1932, 1; 31 March 1932, 29.

5 William F. McDonald, *Federal Relief Administration and the Arts* (Columbus, Ohio, 1969), 19, 350. Audrey McMahon, "May the Artist Live?" *Parnassus* 5.5 (October 1933): 1–4. Forbes Watson, "Art and the Government in 1934," *Parnassus* 6.8 (January 1935): 15.

6 Marchel E. Lundgren, "Dialogue," in *The New Deal Art Projects: An Anthology of Memoirs*, Francis V. O'Connor, ed. (Washington, D.C., 1972), 314.

7 *New York Times*, 14 December 1933, 3.

8 *New York Times*, 6 January 1934, 13; 10 January 1934, 19.

9 *Art Digest* 8.7 (1 January 1934): 3.

10 *Art Digest* 8.13 (1 April 1934): 11.

11 Audrey McMahon, in a letter to Bruce McClure, dated 25 June 1935; quoted in McDonald, *Federal Relief*, 434.

12 Hyman Warsager, "Graphic Techniques in Progress," in *Art for the Millions*, Francis V. O'Connor, ed. (Greenwich, Conn., 1973), 139.

13 Jacob Kainen, "The Graphic Arts Division of the WPA Federal Art Project," in *The New Deal Art Projects: An Anthology of Memoirs*, Francis V. O'Connor, ed. (Washington, D.C., 1972), 157, 158. Warsager, "Graphic Techniques," 139.

14 *New York Times*, 1 May 1936, 17.

15 *Parnassus* 9.2 (February 1937): 39. *Art Digest* 11.7 (1 January 1937): 23.

16 McDonald, *Federal Relief*, 435.

17 *Parnassus* 9.2 (February 1937): 39.

18 *New York Times*, 31 March 1937; 4 April 1937, X, 9.

19 Audrey McMahon, in a report to Holger Cahill, dated 30 November 1938; cited by Kainen, "Graphic Arts of WPA," 170.

20 Ward, "Printmakers," 11.

21 Kainen, "Graphic Arts of WPA," 168.

22 Kainen, "Graphic Arts of WPA," 167.

23 Fritz Eichenberg, *The Art of the*

Print (New York, 1976), 122.

24 Kainen, "Graphic Arts of WPA," 173.

25 The author is grateful to Richard S. Field, Curator, The Davison Art Center, Wesleyan University, for the opportunity to read his unpublished manuscript, "Silkscreen: History of a Medium," which traces the developments in silkscreen technology and artistic application. Another presentation of the history of stencil-printing and silkscreen is to be found in Merrill Clement Rueppel's "An Introduction to the History and Techniques of Stencilling Including the Contemporary Art of Serigraphy"; unpublished M.A. thesis (University of Wisconsin-Madison, 1951).

26 Elizabeth McCausland, "Silk Screen Color Prints," *Parnassus* 12.3 (March 1940): 34.

27 Guy Maccoy, in an interview with the author at the Guy Maccoy Studio, Canoga Park, California, 14 March 1977.

28 Guy Maccoy, in a letter to Carl Zigrosser, 4 June 1941, now in the Department of Prints, Drawings and Photographs, the Philadelphia Museum of Art.

29 Among the activities of the unit was the publication of the pamphlet by Anthony Velonis, *Technical Problems of the Artist: Technique of the Silk Screen Process* (New York: Federal Art Project, 1938). In the same year a publication directed more toward training and production in the commercial printing trades was issued by J. I. Biegeleisen and E. J. Busenbark, *Silk Screen Printing Process* (New York, 1938).

30 Harry Shokler, "The National Serigraph Society: The First Ten Years," *Serigraph Quarterly* 4.2–3 (May and August 1949): 1.

31 Carl Zigrosser, "Ten Years of Serigraphy," *The New Colophon* 1.1 (January 1948): 64.

32 Zigrosser, "Ten Years of Serigraphy," 63.

33 McCausland, "Silk Screen," 36.

34 Advertisement for the Kleemann Galleries, *Art Digest* 10.9 (1 February 1936): 2.

35 Edwin Alden Jewell in the *New York Times*, 26 April 1936, X, 7.

36 *Art Digest* 15.10 (15 February 1941): 23.

37 Thomas Craven, *A Treasury of American Prints* (New York, 1939), no pagination.

38 Creekmore Fath, *The Lithographs of Thomas Hart Benton* (Austin, Tex., 1969); commentaries by Benton identify the locales of many of his subjects.

39 *Art Digest* 15.16 (15 May 1941): 16.

40 Prints sold by the AAA for $5.00 continued to rise in value and by 1979 Kennedy Galleries listed impressions of lithographs by Wood and Curry at prices of $1,200 and $1,800.

41 Clinton Adams, *American Lithographers, 1900–1960: The Artists and Their Printers* (Albuquerque: University of New Mexico Press, forthcoming.)

42 An announcement of the opening of "A New Print Maker's School" with instruction in lithography, drypoint, etching, mezzotint, aquatint, and wood-engraving to be given by Miller, Lewis, and Landeck appeared in *Art Digest* 9.3 (1 November 1934): 21. Other details about the school and its brief existence were reported in June and Norman Kraeft, *Armin Landeck: The Catalogue Raisonné of His Prints* (Bethlehem, Conn., 1977).

43 Jacob Kainen in the foreword to Sylvan Cole, Jr., *Raphael Soyer: Fifty Years of Printmaking, 1917–1967* (New York, 1967), vi.

44 Norman Sasowsky, *The Prints of Reginald Marsh* (New York, 1976), 53, 56. Sasowsky also indicated that Marsh left prints on random consignments with a number of galleries: Weyhe, Rehn, McDonald, Associated American Artists, Kennedy, Kleeman, and Kraushaar.

45 Stow Wengenroth and Lynd Ward, "George Miller, Master Printer," *American Artist* 30.5 (May 1966): 13, 63.

46 Ronald and Joan Stuckey, *The Lithographs of Stow Wengenroth: 1931–1972*, with essays by Albert Reese, Sinclair Hitchings, and Paul Swenson (Boston, 1974), 17. During the 1950s Miller was assisted by his son Burr.

47 Albert Reese, ibid., 21.

48 Andrew Wyeth, as quoted by William Caxton, Jr., "A Portfolio of Lithographs by Stow Wengenroth,"

American Artist 33.6 (November 1969): 63.

Chapter 5

1 Rosamund Frost, "The Chemically Pure in Art: W. Hayter, B.Sc., Surrealist," *Art News* 40.7 (15 May 1941): 31.

2 A. Hyatt Mayor, "The Artists for Victory Exhibition," *The Metropolitan Museum of Art Bulletin* 1.4 (December 1942): 141.

3 Mayor, "Artists for Victory," 142. Members of the Jury of Awards were Alfred H. Barr, Jr., Museum of Modern Art; Juliana R. Force, Whitney Museum of American Art; Henri Marceau, Philadelphia Museum of Art; A. Hyatt Mayor, the Metropolitan Museum of Art; Daniel C. Rich, the Art Institute of Chicago; Charles H. Sawyer, Worcester Museum of Art; Harry B. Wehle, the Metropolitan Museum of Art.

4 Lynd Ward, "Woodcut Renaissance," *New York Times*, 10 March 1940, VII, 14.

5 *Newsweek* 20.22 (30 November 1942): 72. *Art Digest* 17.7 (1 January 1943): 20.

6 *New York Times*, 3 June 1943, 24.

7 *New York Times*, 20 November 1943, 11.

8 *Art Digest* 15.2 (15 October 1940): 28.

9 Joann Moser, *Atelier 17: A 50th Anniversary Retrospective Exhibition* (Madison, 1977), 9; catalogue for the exhibition at the Elvehjem Museum of Art. A more comprehensive recounting of Atelier 17 is given in Joann G. Moser, "The Significance of Atelier 17 in the Development of Twentieth-Century American Printmaking"; unpublished doctoral dissertation (University of Wisconsin-Madison, 1976).

10 Moser, *Atelier 17*, 17ff.

11 Frost, "Chemically Pure in Art," 31.

12 "Engraved Plasters," *Art Digest* 17.6 (15 May 1943): 30.

13 S. W. Hayter, *New Ways of Gravure* (London, 1966), 134ff.

14 Doris Brian, "Artists for Victory: The Prints," *Art News* 41.16 (1 January 1943): 18. Members of the Jury of Selection for prints were Grace Albee, John Taylor Arms, Kerr Eby,

Paul Landacre, Armin Landeck, Robert Riggs, and Stow Wengenroth. Arms was the Chairman of the Jury and the alternate members were Adolf Dehn, J. J. Lankes, Charles Locke, and Ernest D. Roth.

15 "New Directions in Gravure," *Museum of Modern Art Bulletin* 21.1 (New York, 1944): 3–15.

16 *Art Digest* 21.6 (15 December 1946): 9.

17 Edmund Wilson, "Doubts and Dreams: 'Dangling Man' and 'Under a Glass Bell'," *New Yorker* 20.7 (1 April 1944): 73–74.

18 Moser, *Atelier 17*, 33.

19 José Hernández, *El Gaucho Martín Fierro* (1872–1879), bilingual ed., English version by C. E. Ward; State University of New York Press, 1967. Professor Narciso Menocal suggested the visual and literary analogies of the *domador* of Lasansky's print and the passage in *El Gaucho Martín Fierro*.

20 Hayter, *New Ways of Gravure*, chapter 11: "Cinque Personnages: Description of Execution from Drawing to Final Print."

21 Karl Kup, "Notes Around the World," *Print* 4.2 (1946): 58.

22 Albers, as quoted by Ray Nash in "Josef Albers," *Print* 3.4 (1945): 9.

23 *New York Times*, 9 November 1944, 25; 12 November 1944, II, 8.

24 *Art Digest* 21.6 (15 December 1946): 16.

25 Una E. Johnson, *Ten Years of American Prints: 1947–1956* (Brooklyn, 1956), 11.

26 Jean Charlot, "American Printmaking: 1913–1947: A Retrospective Exhibition Presented by the American Institute of Graphic Arts," *Print* 5.4 (1948): 45. A catalogue listing of the exhibition was printed in the same issue (pp. 52ff.).

27 *Art Digest* 20.18 (1 July 1946): 12.

28 *Art Digest* 21.19 (1 August 1947): 16.

29 *Art Digest* 22.4 (15 November 1947): 14.

30 *Art Digest* 22.6 (15 December 1947): 7.

31 C. J. Bulliet, as quoted in *Art Digest* 22.10 (15 February 1948): 24.

32 Moser, *Atelier 17*, 83, 84.

33 *A New Direction in Intaglio* (Minneapolis, 1949); catalogue of the exhibition. A corresponding exhibition opened simultaneously at the Colorado Springs Fine Arts Center.

34 *Print* 10.6 (December–January, 1956/7): 13. *Arts* 30.5 (February 1957): 11.

35 Una E. Johnson, in the foreword to the catalogue *Third National Print Annual Exhibition* (Brooklyn, 1949).

36 "Master Prints from the Museum Collection," *Museum of Modern Art Bulletin* 16.4 (1949): 3–14.

37 *Technical Processes in Contemporary Printmaking* (Minneapolis, 1949); catalogue of the exhibition. In 1949 the Mid-America College Art Association was known by its former name, the Midwest College Art Conference.

38 Adolf Dehn, "Revolution in Printmaking," *College Art Journal* 9.2 (Winter 1949–1950): 201.

39 Albert Reese, *American Prize Prints of the 20th Century* (New York, 1949), xv.

Chapter 6

1 Leona E. Presse, *Lyonel Feininger: A Definitive Catalogue of His Graphic Work* (Cleveland, 1972), 24, 25.

2 Carl O. Schniewind, in the "News Release" of the Art Institute of Chicago announcing the exhibition The Woodcut Through Six Centuries (Chicago, 1949).

3 *Werner Drewes: Woodcuts* (Washington, 1969); catalogue of the exhibition at the National Collection of Fine Arts, Smithsonian Institution.

4 *Print* 4.2 (1946): 58; 5.1 (1947): 71.

5 Una E. Johnson, *Will Barnet: Prints 1932–1964* (Brooklyn, 1965), 9.

6 Sylvan Cole, Jr., *Will Barnet: Etchings, Lithographs, Woodcuts, Serigraphs, 1932–1972* (New York, 1972).

7 Cole, *Will Barnet*.

8 *Technical Processes in Contemporary Printmaking* (Minneapolis, 1949); catalogue of the exhibition.

9 The author, a member of the audience at the University of Minnesota forum, received confirmation of the comment from Will Barnet in a letter dated 1 May 1980.

10 Louis Schanker, as quoted by William S. Lieberman, "Printmaking and the American Woodcut Today," *Perspectives U.S.A.* 12 (Summer 1955): 50.

11 Joann Moser, *Atelier 17: 50th Anniversary Retrospective Exhibition* (Madison, Wis., 1977), 8. Una E. Johnson, *American Prints and Printmakers* (New York, 1980), 82.

12 Lieberman, "Printmaking and the American Woodcut Today," 50.

13 *Art Digest* 18.17 (1 June 1944): 12.

14 *Art News* 45.12 (February 1947): 44.

15 *Art Digest* 23.8 (15 January 1949): 26.

16 *Frasconi: Against the Grain. The Woodcuts of Antonio Frasconi* (New York, 1972).

17 Antonio Frasconi, as quoted by William S. Lieberman, "Antonio Frasconi: Woodcutter," *Print* 9.6 (1955): 52.

18 Stuart Preston in the *New York Times*, 11 September 1949, II, 6. *Art Digest* 23.20 (15 September 1949): 17.

19 Howard Devree in the *New York Times*, 16 November 1947, II, 9.

20 *Art Digest* 24.14 (15 April 1950): 18.

21 Dorothy Drummond, in a reference to the 21st Annual Exhibition of Prints at The Print Club of Philadelphia, *Art Digest* 24.6 (15 December 1949): 3.

22 Carl Zigrosser, "American Prints Since 1926: A Complete Revolution in the Making," *Art Digest* 26.3 (1 November 1951): 71.

23 James Fitzsimmons, in notices of gallery exhibitions, *Art Digest* 27.16 (15 May 1953): 14. Una E. Johnson, *American Prints and Printmakers*, 91.

24 *New York Times*, 6 July 1947, II, 9. *Art Digest* 21.18 (1 July 1947): 19.

25 Francis Harvey, "You Draw with Brush and Pencil—Style is a Way of Thinking . . .", *Print* 9.1 (1954): 42, 43.

26 Harvey, "You Draw," 38, 42.

27 Rio Grande Graphics issued three portfolios of prints in 1952, one each by Adja Yunkers, Gabor Peterdi, and Seong Moy; published by Ted Gotthelf in New York. Each portfolio offered five original prints for $40, or the set of three for $108. A display of the prints was presented at the Grace Borgenicht Gallery in September. *Art Digest* 27.1 (1 October 1952): 2.

28 Seong Moy, as quoted by Harvey, "You Draw," 38.

29 Irvin Haas, "The Print Collector,"

Art News 47.1 (March 1948): 8.

30 *Art News* 47.1 (March 1948): 7, 9.

31 Worden Day, "Credo," in *Worden Day: Paintings, Collages, Drawings, Prints* (Montclair, N.J., 1959); catalogue of the exhibition at the Montclair Art Museum.

32 *Arts* 29.4 (15 November 1954): 15; 29.5 (1 December 1954): 27.

33 James Robert Spence, "Misch Kohn: A Critical Study of His Printmaking," 4, 7, 12, 13, 16; an unpublished doctoral dissertation (University of Wisconsin-Madison, 1965).

34 Hannes Meyer, *El Taller de Grafica Popular: Doce Años de Obra Artistica Colectiva* (Mexico, D.F., 1949).

35 Peter Selz, "Three Dimensional Wood Engravings: The Work of Misch Kohn," *Print* 7.5 (November 1952): 37.

36 Leonard Baskin, "The Necessity for the Image," *Atlantic Monthly* 207.4 (April 1961): 73.

37 Leonard Baskin, as quoted by Dale Roylance in the introduction to *Leonard Baskin: The Graphic Work 1950–1970* (New York, 1970); catalogue of the exhibition at the Far Gallery.

38 Leonard Baskin, as quoted by William S. Lieberman, "One Classic, One Newcomer: Feininger, Baskin," *Art News* 54.3 (May 1955): 31.

39 *Art Digest* 24.4 (15 November 1949): 4.

40 Peyton Boswell, Jr., "Picasso for Peace," *Art Digest* 24.12 (15 March 1950): 5.

41 George Biddle, "Open Letter," *Art Digest* 24.16 (15 May 1950): 5.

42 Baskin was the featured speaker of the thirty-fifth annual meeting of the Mid-American College Art Association at Bowling Green State University (Ohio) in 1971. Following his presentation, the author queried the artist about such an interpretation of *Man of Peace*. Baskin responded that if the interpretation satisfied the questioner he would offer no other. For another speculation about the meaning of Baskin's *Man of Peace*, see Riva Castleman, *Modern Prints Since 1942* (London, 1973), 98.

43 Baskin, "The Necessity for the Image," 73.

44 From the "Artist's Statement," in *Carol Summers: Woodcuts* (San Francisco, 1977), 18; catalogue of the ex-

hibition at the ADI Gallery.

45 Dore Ashton, "Everything's Made of Wood," *Art Digest* 27.1 (1 October 1952): 10.

46 Irvin Haas, "The Print Collector," *Art News* 53.1 (March 1954): 10.

47 *Carol Summers: Woodcuts*, 20.

48 Lieberman, "One Classic, One Newcomer: Feininger, Baskin," 31.

49 "The Color Woodcut," *Arts* 31.4 (January 1957): 28, 29.

50 Bernard Chaet, "Interview with Edmund Casarella: Paper Relief Cuts in the Renaissance of Printmaking," *Arts* 33.2 (November 1958): 66.

51 Pat Gilmour, *Modern Prints* (London, 1970), 42.

52 Jules Heller, *Printmaking Today*, 2nd ed. (New York, 1973), 178, 179.

53 From Alfred Sessler's handscript notes on materials and procedures for *Larva*, 18–27 April 1957; now in the possession of his daughter Karen Sessler Stein.

54 Charles Smith, *Experiments in Relief Print Making* (Charlottesville, Va., 1954).

55 Arthur Deshaies, "Experiments in Lucite Engraving," *Artist's Proof* 1.2 (1961): 21–23.

56 Zigrosser, "American Prints Since 1926: A Complete Revolution in the Making."

57 Dore Ashton, "Brooklyn Reviews Today's American Print Techniques," *Art Digest* 26.20 (15 September 1952): 7. An illustrated essay for the exhibition was printed subsequently as part of Una E. Johnson, *Ten Years of American Prints: 1947–1957* (Brooklyn, 1957) which also included the catalogue of the 10th National Print Annual Exhibition (1956).

58 Dore Ashton in *Art Digest* 27.15 (1 May 1953): 20.

59 Lawrence Campbell in *Art News* 52.1 (March 1953): 37.

60 "The Woodcuts of Vincent Longo," *Arts* 33.7 (April 1959): 35.

61 Among the new print exhibitions—national or international, annual or biennial, competitive or invitational—were those sponsored by the Cincinnati Art Museum (1950), Bradley University (1950), Portland (Me.) Museum (1951), University of Southern California (1952), Dallas Museum of Fine Arts (1953), University of Illinois (1954), Boston

Printmakers (opened to national entries in 1954), Bay Printmakers, Oakland (1955), University of North Dakota (1957), Hunterdon County (N.J.) Art Center (1957), Pasadena Art Museum (1958), Oklahoma City University (1959).

62 Irvin Haas, "The Print Collector," *Art News* 49.2 (April 1950): 10; 53.7 (November 1954): 13; 54.3 (May 1955): 15.

63 Una E. Johnson and John Gordon, *14 Painter-Printmakers* (Brooklyn, 1955); a catalogue of the exhibition at the Brooklyn Museum.

64 Gabor Peterdi, as quoted by Una E. Johnson, *Gabor Peterdi: Twenty-Five Years of His Prints 1934–1959* (Brooklyn, 1959), 8; a catalogue of the one-man show at the Brooklyn Museum.

65 *American Prints Today / 1959* (New York, 1959); a catalogue of the exhibition sponsored by the Print Council of America.

66 Parker Tyler in *Art News* 54.6 (October 1955): 51.

67 June and Norman Kraeft, *Armin Landeck: The Catalogue Raisonné of His Prints* (Bethlehem, Conn., 1977), 103, 107.

68 Norman A. Geske, *Rudy Pozzatti: American Printmaker* (Lawrence, Kans., 1971), 5, 6.

69 *Bulletin of the Cleveland Museum of Art* 42.9 (November 1955): 201.

70 John Paul Jones, as quoted by Frederick S. Wight, "Three Los Angeles Artists," *Art in America* 50.1 (1962): 89.

71 Una E. Johnson and Jo Miller, *John Paul Jones: Prints and Drawings 1948–1963* (Brooklyn, 1963); catalogue of the exhibition at the Brooklyn Museum.

72 *Art Digest* 27.5 (1 December 1952): 10; 27.6 (15 December 1952): 7. Dore Ashton, "Jury Duty in Philadelphia," *Art Digest* 27.14 (15 April 1953): 21. Dore Ashton, "Modern Museum Sets an Example," *Art Digest* 28.5 (1 December 1953): 23. *Art News* 52.2 (April 1953): 44.

73 *Art News* 50.6 (October 1951): 49. *Art Digest* 26.1 (1 October 1951): 16.

74 Morris Weisenthal acknowledged that Peter Grippe provided the initiative for the portfolio in a letter to *Arts* 33.3 (December 1958): 7. The

two-year delay in publication was cited by Moser, *Atelier 17*, 10, 11.

75 Sonya Rudikoff, "Words and Pictures," *Arts* 33.2 (November 1958): 32ff.

76 Gene Baro, *Nevelson: The Prints* (New York, 1974). Lori Wilson, *Louise Nevelson: The Fourth Dimension* (Phoenix, 1980); catalogue of the exhibition at the Phoenix Art Museum.

77 *Art News* 52.9 (January 1954): 69. *Arts* 29.7 (1 January 1955): 21.

78 *Arts* 32.6 (March 1958): 9, 58.

79 Dore Ashton, in *Art Digest* 28.14 (15 April 1954): 29.

80 Dore Ashton, in *Art Digest* 28.15 (1 May 1954): 14.

81 Dean Meeker, as quoted in "New Talent in the U.S.: Graphic Artists," *Art in America* 45.1 (March 1957): 44.

82 The mural and the technical processes are described in Tom Dewey II, "Dean Meeker: Innovative Printmaker in Modern American Serigraphy," 13ff; unpublished doctoral dissertation (University of Wisconsin-Madison, 1976).

83 Dore Ashton, "Modern Museum Sets an Example," 23.

84 Jules Langsner, "Summer in Los Angeles," *Art News* 53.4 (June–August, 1954): 58.

85 Meeker, in a conversation with the author, 22 October 1982. The incident also was recalled in Frank Getlein, "Printmaker and Painter," *New Republic* 149.2257 (30 November 1963): 30.

86 Lee Chesney, "Printmaking Today," *College Art Journal* 19.2 (Winter 1959–1960): 164; publication of a paper presented by Chesney at the annual meeting of the College Art Association of America in Cleveland, January 1959.

87 Gustave von Groschwitz, "Lithograph Biennial," *Art Digest* 24.12 (15 March 1950): 25.

88 Chesney, "Printmaking Today," 164.

89 Gustave von Groschwitz, in the introduction to *The 1960 International Biennial of Prints* (Cincinnati, 1960); catalogue of the exhibition at the Cincinnati Art Museum.

90 June Wayne's reactions were reported by Donald Goodall, in Dore Ashton, "Prints," *Art Digest* 27.14 (15 April 1953): 21.

91 Dore Ashton, "Color Lithography Annual," *Art Digest* 28.14 (15 April 1954): 31.

92 June Wayne, in the preface to Garo Z. Antreasian and Clinton Adams, *The Tamarind Book of Lithography: Art and Techniques* (New York, 1971), 8.

93 "Tamarind Lithographers," *College Art Journal* 20.2 (Winter 1960–1961): 108.

94 Dore Ashton, "The Situation in Printmaking: 1955," *Arts* 30.1 (October 1955): 15ff.

95 Print Council of America, *What Is an Original Print?*, 3rd ed. (New York, 1967), 5, 6, 7.

96 Fritz Eichenberg, "Editorial," *Artist's Proof* 6 (1966): 4.

97 Luis Camnitzer, "A Redefinition of the Print," *Artist's Proof* 6 (1966): 103.

Chapter 7

1 Francis Valentine O'Connor and Eugene Victor Thaw, *Jackson Pollock: A Catalogue Raisonné of Paintings, Drawings and Other Works* (New Haven, 1978), IV, 142ff.

2 "Note, News, and Notices," *Art International* 2.4–5 (May–June 1958): 16.

3 Jules Langsner, "Is there an American print revival? Tamarind Workshop," *Art News* 60.9 (January 1962): 34, 35, 58–60; James Schuyler, "Is there an American print revival? New York," 36, 37.

4 Calvin Tomkins, "The Mood of a Stone," *New Yorker* 52.16 (7 June 1976): 54.

5 O'Hara was a friend of many of the members of the "New York School" of painting. In 1955 he had joined the staff of the Museum of Modern Art and in 1966 he became Curator of Painting and Sculpture.

6 Richard S. Field, *Jasper Johns Prints 1960–1970* (Philadelphia, 1970), no pagination; catalogue for the exhibition at the Philadelphia Museum of Art (1970).

7 Johns, describing idea and imagery in the painting *Souvenir*, as quoted by Charlotte Willard, "Eye to I," *Art in America* 54.2 (March–April 1966): 57.

8 The lithograph was described at length by Richard S. Field, "The Making of 'Souvenir'," *Print Collector's Newsletter* 1.2 (May–June 1970): 29–31.

9 Tyler, as quoted in "Original Art, Hot Off the Presses," *Life* 68.2 (23 January 1970): 60.

10 Thomas Krens, "Conversations with Jim Dine," *Jim Dine Prints: 1970–1977* (New York, 1977), 14; catalogue of the exhibition at the Williams College Museum of Art (1977).

11 Una E. Johnson, *American Prints and Printmakers* (New York, 1980), 183.

12 John Russell, "Jim Dine," *Jim Dine: Complete Graphics* (Berlin, 1970), no pagination; catalogue for the exhibition at the Galerie Mikro, Berlin (1970).

13 Krens, "Jim Dine," 14.

14 Jim Dine, "Prints: Another Thing," *Artist's Proof* 6.9–10 (1966): 101.

15 Tony Towle, Secretary at Universal Limited Art Editions (ULAE), in the exhibition catalogue, *Contemporary American Prints from Universal Limited Art Editions / The Rapp Collection* [displayed by the Art Gallery of Ontario] (Toronto, 1979), 11. Tomkins, "Mood of a Stone," 68.

16 *Art in America* 53.6 (December–January, 1965–1966): 12.

17 Tomkins, "Mood of a Stone," 68. Edward A. Foster, in the introduction to the exhibition catalogue, *Robert Rauschenberg Prints: 1948/1970* (Minneapolis, 1970), no pagination.

18 A fuller quotation from Rauschenberg's work notes, furnished by ULAE, was printed by Foster.

19 "Original Art, Hot Off the Presses," *Life* 68.2 (23 January 1970): 60.

20 June Wayne, *About Tamarind* (Los Angeles, 1969), 6.

21 Garo Z. Antreasian and Clinton Adams, *The Tamarind Book of Lithography: Art and Techniques* (Los Angeles and New York, 1971).

22 In 1960 the members of the panel which selected artist-fellows were Clinton Adams, printmaker and Associate Director of Tamarind; Kenneth Callahan, artist from Seattle; John Entenza, editor and publisher of *Arts and Architecture*; Ebria Feinblatt, Curator of Prints and Drawings at the Los Angeles County Museum of Art; Alfred Frankenstein, then the art critic of the *San Francisco*

Chronicle; Harold Joachim, Curator of Prints and Drawings at the Art Institute of Chicago; Douglas Mac-Agy, Director of the Dallas Museum of Contemporary Arts; Benton Spruance, New York printmaker; James Johnson Sweeney, recently resigned Director of the Guggenheim Museum; Gustave von Groschwitz, Senior Curator of Prints at the Cincinnati Art Museum; and Carl Zigrosser, Curator of Prints and Drawings at the Philadelphia Museum of Art. A Board of Directors served as overseers of Tamarind, some of them also as members of the panel of selection. *Arts* 35.1 (October 1960): 10, 11.

23 Mary W. Baskett, *The Art of June Wayne* (New York, 1969).

24 *Art Digest* 26.16 (15 May, 1952): 11. The exhibition at the Art Institute of Chicago displayed lithographs by Wayne along with etchings of Ynez Johnston, another Californian.

25 *Art Digest* 27.10 (15 February 1953): 27.

26 Peter Morse, "Jean Charlot's Color Lithograph Technique: An Example," *Print Review* 7 (1977): 29; Clinton Adams, "Lynton R. Kistler and the Development of Lithography in Los Angeles," *Tamarind Technical Papers* 8 (Winter 1977–1978): 101, 102.

27 Clinton Adams, in an interview with the author, 15 March 1982.

28 Baskett, *June Wayne*, 15.

29 The six goals for Tamarind were reviewed in June Wayne, *About Tamarind*, 6.

30 Clinton Adams, in an interview with the author, 15 March 1982.

31 June Wayne, "The Tamarind Lithography Workshop," *Artist's Proof* 2.1 (Spring 1962): 44, 45.

32 *Clinton Adams: A Retrospective Exhibition of Lithographs* (Albuquerque, 1973), 29; catalogue of the exhibition at the University of New Mexico Art Museum.

33 After a year as Associate Director of Tamarind, Adams returned to his faculty post at the University of New Mexico and, thereafter, served as a consultant to the workshop.

34 Garo Z. Antreasian in "Biographical Sketches," *American Prints Today / 1959* (New York, 1959),

no pagination.

35 Clinton Adams, in an interview with the author, 15 March 1982.

36 "Tamarind Artist Grantees" and "Tamarind Guest Artists," June Wayne, *About Tamarind*, 13, 14.

37 William S. Lieberman and Virginia Allen, *Tamarind: Homage to Lithography* (New York, 1969), 9; catalogue for the exhibition at the Museum of Modern Art.

38 Elizabeth Jones-Popescu, "American Lithography and Tamarind Lithography Workshop / Tamarind Institute: 1900–1980," 165; unpublished doctoral dissertation, the University of New Mexico, 1980.

39 *Tête de femme* (or *Nelly*) was published in Album IX of *L'Estampe originale* (Paris, 1885).

40 Maudette Ball, *Nathan Oliveira: Print Retrospective 1949–1980* (Long Beach, Calif., 1980); catalogue for the exhibition at the California State University Art Museum and Galleries.

41 *Sam Francis: 55 Lithographs 1960–1973* (Bonn, 1977); catalogue of the exhibition at the Galerie Pudelko.

42 Bruce Davis, in Ebria Feinblatt and Bruce Davis, *Los Angeles Prints, 1883–1980* (Los Angeles, 1980), 28; catalogue for the exhibition at the Los Angeles County Museum of Art.

43 Baskett, *June Wayne*, 64.

44 *A Definitive List of Chops Used on Tamarind Lithographs for the Ten Years July 1, 1960 to July 1, 1970* (Los Angeles, 1970); a pamphlet published by the Tamarind Lithography Workshop.

45 Clinton Adams, in an interview with the author, 15 March 1982.

46 *Tamarind Lithographs: A Complete Catalogue of Lithographs Printed at Tamarind Institute 1960–1979* (Albuquerque, 1980).

47 Jacob Landau, "In Search of Heaven or Hell," *Print Review* 9 (1979): 49ff.

48 The fifteen artists invited to contribute to *Tamarind—Suite Fifteen* were Clinton Adams, Garo Antreasian, Elaine de Kooning, David Hare, Matsumi Kanemitsu, Nicholas Krushenik, James McGarrell, George McNeil, Nathan Oliveira, Kenneth Price, Deborah Remington, Edward Ruscha, Fritz Scholder, June Wayne, and Emerson Woelffer.

49 Clinton Adams, *Fritz Scholder Lithographs* (Boston, 1975), 9ff.

50 Gustave von Groschwitz, *Tamarind—Suite Fifteen* (Albuquerque, 1977), 18; catalogue for the exhibition at the University of New Mexico Art Museum (1977).

51 *Artist's Proof* 1.1 (1961): 40; 1.2 (1962): 32, 37, 38, 39, 40; 2.1 (1962): 44, 45.

52 Mary Welsh Baskett, *American Graphic Workshops: 1968* (Cincinnati, 1968) no pagination; catalogue for the exhibition at the Cincinnati Art Museum.

53 By the seventies, workshops were considered an important factor in printmaking leading to the publishing of a number of lists and descriptions: "International List of Printmaking Workshops," *Print Review* 1 (March 1973): 108, 109; Michael Knigin and Murray Zimiles, *The Contemporary Lithographic Workshop Around the World* (New York, 1974); Calvin J. Goodman, "Master Printers and Print Workshops," *American Artist* 40.411 (October 1976): 67–74; Marvin Schenck, *Fine Art Presses: A Survey of Master Printmaking in the Bay Area* (Walnut Creek, Calif., 1978).

54 George Lockwood, "Boston Workshop," *Artist's Proof* 1.2 (1961): 32.

55 Sinclair Hitchings, "The Imprint of One Man: George Lockwood: 1929–1969," *Artist's Proof* 10 (1970): 108; Stephen Andrus, in an interview with the author, 21 October 1976.

56 Peter Milton, as quoted by Kneeland McNulty in "The Artist and His Work," *Peter Milton / Complete Etchings 1960–1976* (Boston, 1977), 17.

57 Peter Milton, as quoted by Irving L. Finkelstein, "Julia Passing: The World of Peter Milton," *Artist's Proof* 11 (1971): 74.

58 Peter Milton, "Some Notes on My Use of Photographs" and "Notes on My Techniques of Drawing and Plate Making," in *Peter Milton / Complete Etchings 1960–1976*, 25, 26, 29.

59 Peter Milton, "Daylilies, A History of Source and Development," in *Peter Milton / Complete Etchings 1960–1976*, 113–117.

60 Kathan Brown, in an interview with the author, 17 March 1977.

61 Kathan Brown, as quoted in Nancy Tousley, *Prints* (Toronto, 1976),

58; catalogue for the exhibition, "Prints," at the Art Gallery of Ontario (1976).

62 Nancy Tousley, "In Conversation with Kathan Brown," *Print Collector's Newsletter* 8.5 (November–December 1977): 129–134.

63 Phyllis Plous, *Richard Diebenkorn: Intaglio Prints 1961–1978* (Santa Barbara, Calif., 1979); catalogue for the exhibition at the University of California, Santa Barbara Art Museum (1979).

64 Michael Shapiro, "Changing Variables: Chuck Close & His Prints," *Print Collector's Newsletter* 9.3 (July–August 1978): 72.

65 Nancy Tousley, "In Conversation with Kathan Brown," 133.

66 Sidney Felsen, in an interview with the author, 14 March 1977.

67 Serge Lozingot, Studio Manager at Gemini G.E.L., in an interview with the author, 14 March 1977.

68 Kenneth Tyler, as quoted by Joseph E. Young, "Claes Oldenburg at Gemini," *Artist's Proof* 9 (1969): 46.

69 Riva Castleman, *Technics and Creativity II Gemini G.E.L.* (New York, 1971), 6; catalogue for the exhibition at the Museum of Modern Art and a *catalogue raisonné* of works produced at Gemini from 1966 to early 1971.

70 The two suites were completed by 1965 and displayed at the Ferus Gallery, Los Angeles; *Art News* 63.10 (February 1965): 51.

71 Jo Miller, "Josef Albers and his prints: Notes from the 1960s," *Print Review* 6 (1976): 80.

72 Joseph E. Young, "Jasper Johns' Lead-Relief Prints," *Artist's Proof* 10 (1970): 36–38.

73 "The idea for 'High School Days' appeared in a 1963 sketchbook note [of Johns]," as cited by Richard S. Field, *Jasper Johns Prints 1960–1970* (New York, 1970), no pagination; catalogue for the exhibition at the Philadelphia Museum of Art.

74 Advertisements for Gemini in *Studio International* 181.929 (January 1971) and 181.934 (June 1971): no paginations.

75 Serge Lozingot, Studio Manager at Gemini G.E.L., in an interview with the author, 14 March 1977.

76 *Art News* 50.2 (April 1951): 44.

77 *Art News* 52.7 (November 1953): 65.

78 Lichtenstein, as quoted by John Coplans, "Roy Lichtenstein: An Interview," *Lichtenstein* (Pasadena, 1967), 12; catalogue for the exhibition at the Pasadena Art Museum.

79 Jules Heller, *Printmaking Today*, 2nd ed. (New York, 1973), 299.

80 *Print Collector's Newsletter* 2.2 (May–June 1971): 35; *Art in America* 59.1 (January–February 1971): 101.

81 *Print Collector's Newsletter* 1.2 (May–June 1970): 37.

82 In 1971, Rosenquist created eleven lithographs, including seven with moon/earth themes, at the Graphicstudio, University of South Florida, directed by Donald J. Saff. The prints were reviewed in Roberta Bernstein, "Rosenquist Reflected: The Tampa Prints," *Print Collector's Newsletter* 4.1 (April 1973): 6–8.

83 Richard S. Field, *Silkscreen: History of a Medium* (Philadelphia, 1971), no pagination; catalogue for the exhibition at the Philadelphia Museum of Art.

84 An edited transcript of the panel discussion of November 1974 was published as "Pricing Prints or The Poor Man's Art?", *Print Collector's Newsletter* 6.1 (March–April 1975): 4–11.

Chapter 8

1 Judith Goldman, "The Print Establishment," *Art in America* 61.4 (July–August 1973): 105. The article was followed by Judith Goldman, "The Print Establishment II," *Art in America* 61.5 (September–October 1973): 102ff.

2 Diane Kelder, "The Graphic Revival," *Art in America* 61.5 (July–August 1973): 111ff.

3 Richard S. Field, *Recent American Etching.* (Washington, D.C., 1975), no pagination; catalogue for the exhibition presented at the Davison Art Center, Wesleyan University (1975), and the National Collection of Fine Arts (1977).

4 Philip Larson, "Aquatints Again," *Print Collector's Newsletter* 8.3 (July–August 1977): 61.

5 Goldman, "The Print Establishment," 105.

6 Kelder, "The Graphic Revival," 111.

7 Larson, "Aquatints Again," 61.

8 Field, *Recent American Etching.*

9 "New Prints of Worth: A Question of Taste," *Print Collector's Newsletter* 10.4 (September–October 1979): 109–119. Members of the panel were Brooke Alexander, director of Brooke Alexander, Inc.; Riva Castleman, curator of prints and illustrated books at the Museum of Modern Art; Richard S. Field, curator of prints, drawings, and photographs at the Yale Art Gallery; Alex Katz, painter-printmaker; Kathryn Markel, director of Kathryn Markel Fine Arts; Janice Oresman, purchaser of art for private and corporate clients; and Jacqueline Brody, panel moderator.

10 Gene Baro, *30 Years of American Printmaking* (Brooklyn, 1976), 13; catalogue for the exhibition held in conjunction with the 20th National Print Exhibition at the Brooklyn Museum.

11 Frankenthaler recounted the making of color woodcuts at Universal Limited Art Editions and Tyler Graphics, Ltd., in Thomas Krens, *Helen Frankenthaler Prints: 1961–1979* (New York, 1980).

12 *Print Collector's Newsletter* 4.1 (March–April 1973): 10.

13 Jo Miller, in the introduction to *Eighteenth National Print Exhibition* (Brooklyn, 1972), no pagination; catalogue of the exhibition at the Brooklyn Museum.

14 Karin L. Breuer, "Contemporary American Woodcuts: The State of the Art," 91; unpublished M.A. thesis, the University of Wisconsin-Madison (1976).

15 Chafetz, as quoted in Matthew Baigell, "Sidney Chafetz: Purgative and Penicillin," *Artist's Proof* 6.9–10 (1966): 59–61.

16 Gloeckler, in an unpublished, taped interview with James R. Winker, 23 January 1970.

17 *The Horny Goloch* (Middleton, Wis., 1978). "A Suite of Whimsical Wood Engravings by Raymond Gloeckler Accompanied by Some Favorite Nonsense Verse"; typography by Philip Hamilton; published by the Pixilated Press.

18 Kneeland McNulty, "Juror's Statement," *Fifth Dulin National Print and Drawing Competition* (Knoxville, Tenn., 1969), no pagination; catalogue for the exhibition at the Dulin

States from the Eighteenth Century to the Present. National Museum of American Art, Washington, D.C., 1981.

Johnson, Robert Flynn. *American Prints, 1870–1950.* Baltimore Museum of Art, 1976.

Overland, Carlton. *Americans at Home and Abroad: Graphic Arts, 1855–1975.* Elvehjem Museum of Art, Madison, Wis., 1976.

Exhibitions of late-nineteenth-century American printmaking

Anthony, A. V. S. *Exhibition of American Engravings on Wood.* Museum of Fine Arts, Boston, 1881.

Catalogue of Etchings Exhibited at the Museum of Fine Arts. Boston, 1879.

Koehler, S. R. *Exhibition of American Etchings.* Museum of Fine Arts, Boston, 1881.

Koehler, S. R. *Exhibition Catalogue of the Work of the Women Etchers of America.* Museum of Fine Arts, Boston, 1887.

Tyler, Francine. *The First American Painter-Etchers.* Pratt Graphics Center, New York, 1979.

Van Rensselaer, M. G. [Mrs. Schyler]. *Exhibition Catalogue of the Work of the Women Etchers of America.* Union League Club, New York, 1888.

Exhibitions of early-twentieth-century American printmaking

Charlot, Jean. *American Printmaking, 1913–1947.* Brooklyn Museum, 1947.

Flint, Janet A. *George Miller and American Lithography.* National Museum of American Art, Washington, D.C., 1976.

Flint, Janet A. *Prints for the People: Selections from New Deal Graphics Projects.* National Museum of American Art, Washington, D.C., 1979.

Exhibitions of recent American printmaking

American Prints Today / 1959. Print Council of America, New York, 1959.

American Prints Today / 1962. Print Council of America, New York, 1962.

Baro, Gene. *30 Years of American Printmaking.* Brooklyn Museum, 1977.

Baskett, Mary Welsh. *American Graphic Workshops: 1968.* Cincinnati Art Museum, 1968.

Castleman, Riva. *Technics and Creativity: Gemini G.E.L.* Museum of Modern Art, New York, 1971.

Curtis, Verna Posever. *American Prints, 1960–1980.* Milwaukee Art Museum, 1982.

Field, Richard S. *Recent American Etching.* Davison Art Center, Wesleyan University, 1975.

Friedman, William M., and Lester Longman. *A New Direction in Intaglio.* Walker Art Center, Minneapolis, 1949.

Gale, Peter, and Tony Towle. *Contemporary American Prints from Universal Limited Art Editions / The Rapp Collection.* Art Gallery of Ontario, Toronto, 1979.

Goldman, Judith. *American Prints: Process and Proofs.* Whitney Museum of American Art, New York, 1982.

Johnson, Una E. *14 Painter Printmakers.* Brooklyn Museum, 1955.

Johnson, Una E. *Ten Years of American Prints: 1947–1956.* Brooklyn Museum, 1956.

Liebermann, William S., and Virginia Allen. *Tamarind: Homage to Lithography.* Museum of Modern Art, New York, 1969.

Moser, Joann. *Atelier 17: A 50th Anniversary Retrospective Exhibition.* Elvehjem Museum of Art, Madison, Wis., 1977.

New American Graphics. Madison Art Center, Madison, Wis., 1975.

Spangenberg, Kristin L. *San Francisco Area Printmakers.* Cincinnati Art Museum, 1973.

Sweeny, James Johnson, S. W. Hayter, and Monroe Wheeler. *New Directions in Gravure.* Museum of Modern Art, New York, 1944.

Technical Processes in Contemporary Printmaking. University Gallery, University of Minnesota, 1949.

Von Groschwitz, Gustave. *The 1960 International Biennial of Prints.* Cincinnati Art Museum, 1960.

Von Groschwitz, Gustave. *Tamarind: Suite Fifteen.* University Art Museum, University of New Mexico, 1977.

Additional references to national, regional, group, and one-man exhibitions sponsored by art institutions, universities, print societies, and dealers' galleries, as well as references to awards and purchase prizes, are cited in the text, in chapter notes, and under the prints illustrated.

Books, Catalogues Raisonnés, Exhibition Catalogues, and Checklists—by Artist and Publication Date

Coke, Van Deren. *Clinton Adams, A Retrospective Exhibition of Lithographs.* Albuquerque, N.M., 1973.

Bassham, Ben L. *John Taylor Arms, American Etcher.* Madison, Wis., 1975.

Johnson, Una E. *Will Barnet: Prints 1932–1964.* Brooklyn, 1965.

Cole, Sylvan, Jr. *Will Barnet Etchings, Lithographs, Woodcuts, Serigraphs, 1932–1972.* New York, 1972.

Roylance, Dale. *Leonard Baskin: The Graphic Work 1950–1970.* New York, 1970.

Schniewind, Carl O. "George W. Bellows. Lithographer and Draughtsman," in *George Bellows: Paintings, Drawings and Prints.* Chicago, 1946.

Mason, Lauris. *The Lithographs of George Bellows: A Catalogue Raisonné.* Millwood, N.Y., 1977.

Fath, Creekmore. *The Lithographs of Thomas Hart Benton.* Austin, Tex., 1969.

Field, Richard S. *Prints and Drawings by Lee Bontecou.* Middletown, Conn., 1975.

Breeskin, Adelyn D. *The Graphic Work of Mary Cassatt: A Catalogue Raisonné.* New York, 1948.

Taylor, John Lloyd. *Warrington Colescott: Graphics.* Milwaukee, 1968.

Price, Frederic Newlin. *The Etchings and Lithographs of Arthur B. Davies.* New York, 1929.

Johnson, Una E. *Worden Day. Paintings, Collages, Drawings, Prints.* Montclair, N.J., 1959.

Plous, Phyllis. *Richard Diebenkorn: Intaglio Prints 1961–1978.* Santa Barbara, Calif., 1979.

Krens, Thomas. *Jim Dine's Prints.* Williamstown, Mass., 1977.

Kainen, Jacob. *Werner Drewes Woodcuts.* Washington, D.C., 1969.

Meyer, Jerry D. *David Driesbach.* Baltimore, 1979.

Arms, John Taylor. *Kerr Eby: 1889–1946.* New York, 1947.

Prasse, Leone E. *Lyonel Feininger: A Definitive Catalogue of His Graphic Work.* Cleveland, 1972.

Sam Francis: 55 Lithographs, 1960–1973. Bonn, 1977.

Frasconi: Against the Grain. The Woodcuts of Antonio Frasconi. New York, 1972.

Brite, Jane. *Raymond Gloeckler: A Retrospective, 1955–1979.* Milwaukee, 1980.

Goodrich, Lloyd. *The Graphic Art of Winslow Homer.* Washington, D.C., 1968.

Zigrosser, Carl. *The Complete Graphic Work of Edward Hopper.* Worcester, 1963.

Field, Richard S. *Jasper Johns. Prints 1960–1970.* Philadelphia, 1970.

Field, Richard S. *Jasper Johns. Prints 1970–1977.* Middletown, Conn., 1978.

Johnson, Una E., and Jo Miller. *John Paul Jones: Prints and Drawings 1948–1963.* Brooklyn, 1963.

Flint, Janet A. *Jacob Kainen: Prints. A Retrospective.* Washington, D.C., 1976.

Field, Richard S. *Alex Katz.* Middletown, Conn., 1974.

Jones, Dan Burne. *The Prints of Rockwell Kent: A Catalogue Raisonné.* Chicago, 1975.

Kraeft, June, and Norman Kraeft. *Armin Landeck: The Catalogue Raisonné of His Prints.* Bethlehem, Conn., 1977.

Moser, Joann, I. Michael Danoff, and Jan K. Muhlert. *Mauricio Lasansky.* Iowa City, Iowa, 1976.

Salaman, Malcolm C. *Martin Lewis. Modern Masters of Etching* XXVI. New York, 1931.

Waldman, Diane. *Roy Lichtenstein: Drawings and Prints.* London, 1971.

Lipke, William. *Abstraction and Realism: 1923–1943. Paintings, Drawings and Lithographs of Louis Lozowick.* Burlington, Vt., 1971.

Zigrosser, Carl. *The Complete Etchings of John Marin.* Philadelphia, 1969.

Sasowsky, Norman. *The Prints of Reginald Marsh.* New York, 1976.

Andrus, Stephen, and Kneeland McNulty. *Peter Milton: Complete Etchings 1960–1976.* Boston, 1977.

Comstock, Francis Adams, and William Fletcher. *The Work of Thomas W. Nason, N.A.* Boston, 1977.

Baro, Gene. *[Louise] Nevelson. The Prints.* New York, 1974.

Wilson, Lori. *Louise Nevelson: The Fourth Dimension.* Phoenix, 1980.

Ball, Maudette W. *Nathan Oliveira Print Retrospective: 1949–1980.* Long Beach, Calif., 1980.

Pennell, Joseph. *The Adventures of an Illustrator.* Boston, 1905.

Pennell, Elizabeth Robins. *Joseph Pennell: A Memorial Exhibition of His Works.* Washington, D.C., 1927.

Pennell, Elizabeth Robins. *The Life and Letters of Joseph Pennell* I–II. Boston, 1929.

Johnson, Una E. *Gabor Peterdi: Twenty–Five Years of His Prints 1934–1959.* Brooklyn, 1959.

Richards, Louise E. *Prints and Drawings by Gabor Peterdi.* Cleveland, 1962.

O'Connor, Francis Valentine, and Eugene Victor Thaw, *Jackson Pollock: A Catalogue Raisonné of Paintings, Drawings and Other Works* IV. New Haven, 1978.

Kainen, Jacob. *Michael Ponce de Leon.* Washington, D.C., 1966.

Elsen, Albert. *Paintings, Prints and Drawings by Rudy Pozzatti.* Minneapolis, 1960.

Geske, Norman A. *Rudy Pozzatti: American Printmaker.* Lawrence, Kans., 1971.

Foster, E. A. *Robert Rauschenberg Prints, 1948–1970.* Minneapolis, 1970.

Cowart, Jack, and James Elliot. *Prints from the Untitled Press, Captiva, Florida.* [Rauschenberg and others]. Hartford, 1973.

Adams, Clinton. *Fritz Scholder Lithographs.* Boston, 1975.

Prescott, K. *The Complete Graphic Works of Ben Shahn.* New York, 1973.

Morse, Peter. *John Sloan's Prints: A Catalogue Raisonné of the Etchings, Lithographs and Posters.* New Haven, Conn., 1969.

Cole, Sylvan, Jr., and Jacob Kainen. *Raphael Soyer: Fifty Years of Printmaking, 1917–1967.* New York, 1967.

Baro, Gene. *Carol Summers Woodcuts.* San Francisco, 1977.

Prasse, Leone E., and Louise S. Richards. *Recent Work of Peter Takal.* Cleveland, 1958.

Baskett, Mary W. *The Art of June Wayne.* New York, 1969.

Rubenstein, Daryl. *Max Weber: Prints and Color Variations.* Washington, D.C., 1980.

Spence, Robert, and Jon Nelson. *The Etchings of J. Alden Weir.* Lincoln, Nebr., 1967.

Flint, Janet A. *J. Alden Weir, An American Printmaker, 1852–1919.* Provo, Utah, 1972.

Stuckey, Ronald, and Joan Stuckey, with essays by Albert Reese, Sinclair Hitchings, and Paul Swenson. *The Lithographs of Stow Wengenroth: 1931–1972.* Boston, 1974.

Bacher, Otto. *With Whistler in Venice.* New York, 1908.

Getscher, Robert H., and Allen Staley. *The Stamp of Whistler.* Oberlin, Ohio, 1977.

Zigrosser, Carl. *Harry Wickey and His Work.* New York, 1938.

Wickey, Harry. *Thus Far.* New York, 1941.

Cited in the text and chapter notes are: references to periodical and newspaper articles, notices, and advertisements; unpublished manuscripts, dissertations, theses, and letters; interviews and comments, oral and written.

Index

Designed by Richard Hendel

Composed by G & S Typesetters,
Austin, Texas

Manufactured by Kingsport Press,
Kingsport, Tennessee

Four-color printing by Dai Nippon Printing
Co., Ltd., Tokyo, Japan

Text and display lines are set in Galliard

Library of Congress Cataloging in
Publication Data

Watrous, James, 1908–
 A century of American printmaking,
 1880–1980.

 Bibliography: pp. 323–325.
 Includes index.
 1. Prints, American. 2. Prints, Modern—
19th century—United States. 3. Prints,
Modern—20th century—United States.
I. Title.
NE407.W37 1984 769.973 83-16956
ISBN 0-299-09680-7